Making a Scene!

# Making a Scene!

*How Visionary Individuals*
*Created an International*
*Photography Scene*
*in Houston, Texas*

*by*
Tracy Xavia Karner, PhD

Schilt Publishing

# Acknowledgements

I'm told that photographer Robert Adams once said every photography book needs a miracle.[1] This book, I am humbled to say, has had many. From all those who generously provided support for my time, research travel, and transcription expenses to the angels of the archives who helped me though seemingly linear miles of materials to all the friends who helped in a myriad of ways, and of course to all those who made the time to sit and talk with me, the miracles have been numerous.

I am especially grateful to Anne Wilkes Tucker for without her agreement this project would not have been possible. Throughout the process Anne was a helpful guide, a patient interviewee, and a great cheerleader for the project. Additionally, my deep gratitude goes to all those who agreed to an interview. It was a great pleasure for me to meet and talk with those who had contributed so much to creating a vibrant photography scene, a number of whom I am now lucky enough to consider friends. Of special note, I must thank Sharon Stewart, who was an invaluable resource of ideas and connections, and Ed Osowski, who led me to Sharon. Ed, also, ever the consummate librarian, provided important leads from his personal collection of postcards, announcements, and event memorabilia. Thank you also to Suzanne Bloom, who shared insightful publications from the 1980s in MANUAL's archive, Petra Benteler, who gave me copies of her entire collection of early FotoFest clippings, and Harla Kaplan, who showed me artifacts from 1986 to 1992 FotoFest events, all of which led me to significant contemporaneous materials.

There were several angels of the archives that assisted with this project. At the Museum of Fine Arts, Houston, Lorraine Stuart, Melissa Gonzales, Damian

**6** Brum, and Marie Wise were exceptionally helpful in guiding me through their extensive archive. Additionally, both Del Zogg and Jason Dibbley steered me through the photography collection as I double-checked the timing and purchase of various works. Lisa Barkley, Geraldine Aramanda, and Lilly Carrel, archivists at the Menil Collection, were exceedingly patient and helpful as was David Aylsworth, the Collections Registrar. The Carey C. Shuart Women's Archive and Research Collection, University of Houston Libraries, was also an invaluable resource. My gratitude extends further to the fastidious transcriptionists who worked to turn some of the recorded interviews into text: Trenton Haltom, Jenny Savely, and Laura Halcomb.

Of course, none of this would have been possible without resources. I wish to thank Lois Zamora for believing in me and the project from the beginning and providing the support that allowed me to begin this journey. My time as a Brown Foundation Fellow at the Dora Maar House in Menerbes, France gave me a month to write in the most beautiful setting I've ever had the pleasure in which to work. The Joseph Sidney Werlin Sociology Faculty Award to promote Latin American-U.S. Cultural Understanding provided travel funds to help me understand the Houston photography scene in a broader global context. Development leave granted from the College of Liberal Arts and Social Sciences (CLASS) at the University of Houston offered the most elusive resource — time — for interviewing and writing. Additionally, a CLASS research progress grant provided travel funds to interview Petra Benteler at her home in Germany. Throughout the process, I have been most fortunate to have worked with Deans who encouraged my work in a variety of helpful ways: John Roberts, Antonio Tillis, and Dan O'Connor. The work has also benefited from early

readings by Susan Scarrow, Cynthia Freeland, and Del Zogg, who generously provided insightful feedback.

I could not have asked for a more enthusiastic publisher than Maarten Schilt, who recognized the importance of this book immediately and was eager to publish it. My thanks to Kumar Jamdagni whose copy editing smoothed over any rough spots, and to Victor Levie for a stellar design. An additional thank you to all those who contributed images that help bring a wonderful visual element to the text.

In many ways this project was a labor of love, and from the beginning I have conceived of this book as a community project: it is both a document of what occurred and a recognition that passionate, committed individuals can make a difference in their communities and beyond. I hope this story serves to inspire others to think globally and optimistically about what they might be able to create.

Tracy Xavia Karner, Houston (TX)
August 2022

# List of Interviewees

Armanda, Geraldine
Baldwin, Fred
Benteler, Petra
Block, Gay
Bloom, Suzanne
Brown, Peter
Casey, Mary Kay
Caslin, Jean
Chaney, Jereann
Crossley, David
Daniel, Malcolm
Flemings, Betty
Fluckinger, Roy
Gall, Sally
Goffe, Gwen
Gregory, Diane
Hansen, Mary Margaret
Herbert, Lynn
Hester, Paul
Hill, Ed
Horrigan, Sally
Hunter, Fredericka
Kaplan, Harla
King, Frazier
Kowitz, Len
Krause, George

Marvins, Mickey
Marvins, Mike
McLanahan, Mike & Muffy
McNulty, Debbie
Moody, Betty
Morgenstern, Joan
Osowski, Ed
Randolph, Lynn
Rauschenberg, Christopher
Rueb, Debra
Scarbrough, Daphne
Stein, Janet
Stewart, Sharon
Tennant, Donna
Tucker, Anne Wilkes
Wagan, Sixto
Watriss, Wendy
Willour, Clint
Winningham, Geoff

# Table of Contents

# Introduction

## Making a Scene!

Everyone wants to find their scene. It's the social space where you feel comfortable, meet like-minded souls, and participate in activities that are important and meaningful to you. Whether it's about art making, snowboarding, pinball tournaments, or photography, we all seek connection and belonging with others who share similar interests. What makes the Houston photography scene so interesting is that it began with a few visionaries who were able to grow and nurture others to share their passion for photography. In a sense they grew their own scene by creating compelling, exciting opportunities that drew others to them, and eventually became an international phenomenon.

Scenes need charismatic individuals who provide a captivating vision of what could be — how important it would be to have a photography collection, how wonderful it would be to have a photographer's co-op, and how amazing it would be to host the first photography festival in the United States! In Houston, Anne Wilkes Tucker at the Houston Museum, and Wendy Watriss and Fred Baldwin with FotoFest (and before) made photography seem significant, meaningful and exciting. Wendy and Fred had shown, in their photojournalism work around the world, that documenting life photographically could be a means to promote social justice. Photography could offer new and elegant contributions to the world of art as Anne was doing at the museum. These three visionaries also traveled extensively in the service of photography — a lifestyle that seemed exhilarating and socially relevant. Photography for them was a way to make the world better and improve the lives of others. This belief in photography as a means and a medium fueled their passionate ideas and enticed others.

Scenes emerge in a specific locale and within a specific cultural moment. They draw together people around a shared interest, such as photography, who want

to engage in related activities – like viewing or making or learning about images. Scenes offer members a place to fully engage in a shared creative activity, and to demonstrate who they are – what role they play – within the specified arena. There is often a sense of being part of something new – building a new organization, a new cultural mode, a new lifestyle possibility. In Houston, participants were charting new territory in a variety of ways: supporting a museum to collect photography, creating a co-op for photographers, and then starting the first photography festival in the United States. All new and exciting opportunities to "make photographic history" as an early FotoFest tagline read. Participation in a scene, sociologist John Irwin writes, offers "a sense that something new, wonderful and meaningful is happening, and they are part of it."[2]

Scenes are place-based. They claim a location where interested people can find and join in the shared activities. Houston, an entrepreneurial city, is receptive to innovative ideas that showcase the city. It is also a place that pulls people from all over, and this was especially true during the economic boom time of the 1970s, when this story begins. New residents look for ways to get involved in their new city and seek out places to meet others with shared interests. This lack of social entrenchment encourages an openness to new groups and new ideas. It also leads to higher levels of volunteerism, which can be crucial for new organizations' initial phases. Additionally, while there is 'old' money in Houston, the oil boom brought a lot of new money that was unencumbered and could flow relatively easily into the arts. Though, of course, the boom was followed by a bust economy, but the vision of what could be created had already taken hold and was not to be deterred. The visionary leaders of the Houston photography scene all moved to the city from elsewhere and found their *tabula rasa*. They arrived with a wealth of relevant experience, social skills, and important connections, coupled with passion, tenacity, and hard work, which positioned them for success. The culture of Houston, its openness, entrepreneurial spirit, and desire to be great may have been the added 'secret sauce.'

### *"Doomed to Success"*
How *did* visionary individuals create an international photography scene in Houston, Texas? The answer has all the components of a classic Texas tale of seemingly quixotic ideas, audacious goals, oil booms and busts, generous philanthropists, southern sensibilities, grandiosity, and resolve ... and sustained efforts. Just as art photography was garnering broader cultural interest, a handful of determined individuals sought to create institutional support for

photography in Houston. This historical vantage point provides a unique opportunity to see a scene from its beginning through its recognized success. Various communities and organizations have sprung up all over the world focused on photography, but few rival the vibrancy, stability, and longevity found in Houston. The Houston photography scene "was doomed to success" as collector Muffy McLanahan remembers, "it was a troika. It was Houston Center for Photography, the museum, and FotoFest." And indeed, from these three organizations an internationally recognized photography scene has grown.

> While attending an event in Paris, photographer Susan Barnett was introduced to a young photographer from Japan. He was so excited, Susan recounted, when he learned I was from New York. 'Since you are so close' he asked, 'have you been to Houston?' Never mind that I live in New York, in his mind Houston was *the* place for photography opportunities in the u.s.[3]

The Houston photography scene exists around three primary organizations: the Photography Department at the Museum of Fine Arts, Houston, Houston Center for Photography, and FotoFest. The pages that follow are divided into the three phases of their development. *Part I: Setting the Scene* provides an overview of the history of the visual arts in Houston — the stage, if you will, that others would build upon. *Part II: Visionaries and their Decisive Moments* discusses the origins of each organization and introduces the reader to the backgrounds of the key individuals to showcase the experiences and skills each brought to the emerging scene. *Part III: Making a Scene* details the stabilization and progress of each organization while highlighting their challenges and successes.

Over 40 individuals were interviewed for this project, and some multiple times. All the quotations, unless otherwise noted, come from the interviews. Additionally, personal and organizational archives provided more details as well as contemporaneous documents. It's been over forty years since the first hints of what the Houston photography scene might hope to become appeared in the city. The pages that follow explore just how visionary individuals created an international photography scene in Houston, Texas.

**Understanding a Scene: A Sociological Approach**
The Houston photography scene captured my attention more than a decade ago. I had just returned from my first trip to *Les Rencontres d'Arles,* where

I had spent an inspiring week looking, thinking, and talking about photography in the magical, medieval village of Arles in the south of France. Moonlit meals under the stars in the *Place du Forum* talking about images, their impact and their place in contemporary society reignited and fueled my long-standing interest in photography. Indeed, the first profession I aspired to as a child was that of photojournalist. I spent long, happy afternoons in the darkroom as a year-book and newsletter photographer in high school. After graduation my life took a different direction but my interest in images remained a constant, though often unpracticed, passion.

I returned to Houston after this wondrous sojourn to Arles ready to re-immerse myself in the world of images and began attending any and all photography exhibitions and events in my city. People in the photography community were open, friendly, and engaging. Within weeks, I had made several new friends and had become part of a new social world. As a trained sociologist — I have graduate degrees in the field and teach on the faculty at the University of Houston — my tendency is to see my world and experiences through the lens of sociology. To some extent this means thinking about the political or cultural or economic context within which social life happens, and how some ideas or behaviors are encouraged while others are inhibited. Of course, I have also been sensitized to social hierarchies (class, gender, race, etc.), which are at the core of most sociological theories and the various ways that different people or interests are included or excluded. In addition to my professional training, I grew up in a mobile family. My father was employed in the aerospace industry, and we would be transferred on a regular basis to wherever the company's current contract needed his skills. Thus, I spent my childhood moving from place to place — always being the 'new kid' and being introduced to new communities. At the age of 18, tracing our family trajectory, I came up with twenty places we had lived sometimes for as little as three months and others for as long as two years. This transient childhood experience gave me a broad, intuitive sense about the nature of communities and how one can and cannot integrate into them.

At its core, the story of the Houston photography scene is a story about building community — how it came to be, what the supporting factors were, what the challenges were, and how the various personalities, ideas, and competing needs were mediated over time. It is also the story about organizations, how they develop individually as well as how they inter-relate, compete, and cooperate. For the decade previous to my arrival in Houston in 2001, I held a position at the

University of Kansas, where I worked with a team of researchers in evaluating over 220 different organizations scattered throughout fifteen states in the U.S.[4] From this perspective, I was able to explore why some types of organizations worked well in some environments and not others, where some programs were met with great success while others were utter failures, and the important role of personality and leadership styles in garnering community investments, as well as all the other aspects of community that came into play as committed individuals sought to bring new ideas into being within very different social contexts. This work has been very instrumental in helping me understand program development and cultural shifts within different kinds of organizational structures.

My approach to sociology, I believe, has been enriched and perhaps somewhat biased by my personal experience with so many different kinds of communities and my transient upbringing. And it is these two approaches, sociology and my background as the perpetual 'new kid,' that have structured my understanding of what has occurred in Houston. A sociologically attuned reader will no doubt notice my reliance on the work of Pierre Bourdieu, Howard Becker and other theorists in conceptualizing various aspects of the story, but I have tried to keep the focus on the story rather than illuminating social theories. I see this book as a work of public sociology and by that I mean that I hope to tell the story of this particular community in all its robustness. Rather than a traditional 'case study' approach that necessitates constructing the narrative in a specific manner of variables and correlations, or through focus on theoretical concepts such as habitus, class, or symbolic value, I am attempting to utilize these ideas without constraining the story to only those components. Social life is generally messy; order and trajectory are most often constructed only in hindsight and while that can be heuristic to a point, it is also a process of reduction. Telling a story always involves including some aspects and accounts while excluding others. In this telling, I have tried to privilege the story in keeping with the passion, excitement, and at times disconnected messiness of the participants' experiences over sociological sense making. A tricky balance to negotiate at best, any missteps are born from this intention, and I beg the readers' indulgence for all that I could not include due to issues of space and readability.

# I  Setting the Scene

# Chapter 1

# "The beginning of everything"

The Gus and Lyndall Wortham Curator of Photography, Anne Wilkes Tucker, sat alone in her office surrounded by boxes waiting to be filled. How to sort a life into boxes? Could cardboard hold years of ideas, friendships, and memories? Somehow, she had to fit 39 years of her life into these containers. Some things would go to the museum archives, but much more would be leaving with her. Anne had spent more than half her life leading the Photography Department at the Museum of Fine Arts, Houston, and though somewhat wistful, she decided now was the time to close that chapter in her life. She had actually been talking about retiring after completing her acclaimed *War/Photography* exhibition, co-curated with Natalie Zelt and Will Michels, in 2012. Working on that project for over a decade, Anne had traveled the globe to war museums and military archives steeping herself in the visual documents of violence and brutality. *War/Photography* had been a tour de force, including photographs from more than 280 photographers, spanning six continents and over 165 years of conflicts, and was accompanied by a 600-page catalog.[5] Anne had never done anything halfway, and this exhibition had been a culmination of her all-consuming passion for research and discovery. But now, she was ready to move on. Tonight, as she surveyed everything around her — the several shelves of her beige notebooks where she had carefully detailed years of photographs seen and photographers met, exhibition catalogs she had authored or contributed to, awards of various sizes and all the piles of files filled with research materials that covered every flat surface — the prospect of her retirement shifted from someday to now.

The clear June evening sky bestowed a golden hue to the trees outside Anne's office window, and most everyone else had already gone home for the day.

Anne loved being in the museum at night and taking advantage of her access, after all the visitors had gone, to go up to the third floor. To be alone in the John A. and Audrey Jones Beck Collection, Anne says, "was one of my favorite privileges of working at the museum." In the gallery, Anne had a bounty of masterworks like Vincent van Gogh's *The Rocks* or Claude Monet's *The Japanese Footbridge, Giverny* or Kees van Dongen's *The Corn Poppy* all to herself, but she always stood longest in front of the Derain. *The Turning Road, L'Estaque*, 1906, by André Derain captivated her since she first saw it. Considered a masterpiece of the avant-garde art movement of Fauvism, the painting is in the vibrant and intensely colorful style of the fauves. Trees of red, orange, and blue dot an idyllic landscape aglow with yellow sunlight. For Anne, it was Derain's bravery and audaciousness that called to her — she admired the daring boldness of constructing a scene that is both realistic in terms of trees and people while simultaneously the brilliance of the colors create a fantastical place. After visiting the Derain for years, Anne knew every curve of every tree. She had traced the turn of the road around each bend and explored the vivid intensity of the cool blues adjacent to the flaming oranges. "My favorite painting," Anne explains, "I had to visit it one more time to say goodbye — this would be my last time alone in the gallery at night."

This was not unusual for Anne to be at the museum long into the night. She would often get absorbed in her work and relished the uninterrupted quiet of the silent building. Anne knew most of the night cleaning staff who had long since stopped being surprised to find her at her desk as they slipped in to empty the trash bin. Evenings without a museum event, exhibition opening, or dinner with a donor, Anne could often be found in her office. She had designed the space to fit her requirements during the planning phase for this building, and it was so much better than her first office in the older building that was so small it led to her early moniker as the "closet curator." This office was a long narrow room painted predictably in museum white with floor to ceiling bookshelves running along both side walls. Her sleek modern desk was positioned at one end near the door with two guest chairs facing it though so full of papers and books that it is unlikely anyone ever found a seat there. Looking beyond the chairs to the far end, Anne could see out the large picture window framing the ancient pin oak canopy that shaded the street below. She loved seeing the steeple of the grand cathedral of St. Paul's church across the street and listening to its world-renowned change-ringing bells.[6]

Anne had moved into this office fifteen years earlier, when the museum's second building first opened. Since then, she had managed to fill every space — shelves, chairs, her desktop — and even had begun sorting into piles on the floor. Her office bore witness to all her multiple projects and her extensive research for each. While at the museum, Anne curated over 150 exhibitions, won almost every award and honor in photography, all the while writing extensively on photography, raising funds to acquire photographs for the museum, and delivering lectures throughout the globe. So much had happened since Anne came to the museum, most of it unimaginable in 1975 when she arrived for her interview with Director William (Bill) Agee wearing her earth shoes, jean skirt, and peasant blouse.

## A New Director with a New Idea

William C. Agee was hired as the Houston museum's sixth director. Taking the position in 1974, Bill followed the socially contentious tenure of Philippe de Montebello, who many Houstonians thought looked down on their city and were quite happy when he decided to return to the Metropolitan Museum of Art in New York City after only four years at their museum. Coming from his position as the director of the Pasadena Art Museum, Agee did not exude the kind of New York elitism his predecessor had been accused of, though prior to his time in California, he had been at the Museum of Modern Art in New York City. Agee also came highly recommended by philanthropist and collector Dominique de Menil, who after her husband John's death in 1973, had assumed his role on the Houston museum's Board of Trustees. Dominique had followed Bill's career and had been impressed with his work in California. "He had as good an eye as anyone in the country at the time," recalls Alexander "Mike" McLanahan, chair of the museum Board of Trustees at the time. "Bill was great scholar, great eye," gallerist Fredericka Hunter explains, "He bought some of the most important things they have in 20th-century art ."

Assuming the directorship in Houston in April, Agee promoted the importance of including photography in the museum seemingly from day one. "The first work of art I ever saw was a photograph, and since then photography has always seemed natural and important" he explained.[7] Bill Agee had grown up in the house next door to the photographer Barbara Morgan, Anne remembers, "and had seen photographs on the wall, and knew people who regarded themselves as artists who were photographers, from his early age."[8] At the

Pasadena Art Museum, Bill had actively supported photography acquisitions and exhibitions, and in Houston he found the opportunity to do even more. He wanted to build a photography department.

During de Montebello's four-year tenure,[9] there had only been one photography exhibition at the museum. Tucked into a hallway referred to as the American Corridor, *As Time Developed...Documentary Photography*, is described in the museum archives as "contemporary news clipping" [sic], organized in 1971 by new curatorial staff member, E. A. Carmean, Jr., during his first year on the staff at the museum. Later, in the interim between directors, Carmean mounted a solo show of Rice University photography professor, Geoff Winningham's work that opened one month before Bill's arrival (March 23 to June 30). In stark contrast to his predecessor, Bill Agee set about initiating photography programming almost immediately. The number of photography exhibitions at the museum steadily increased to three in 1975, and four in 1976.

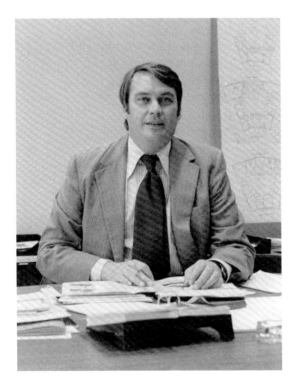

**William C. Agee, 1974.**
From the Collection
of the Museum of Fine
Arts, Houston Archives.

Bill Agee quickly secured two important touring MOMA photography exhibitions for the MFAH in 1975. Both were shown prominently in the large Upper Brown Gallery, the first retrospective of Diane Arbus' work was on view January 23 through March 2nd and was soon followed by an Edward Weston exhibition, May 23 to June 29. Somewhat concurrently, Bill also organized a lecture series called "Focus on Photography." In addition to his general support for photography, this programming may have been his most important contribution to the photography community in Houston. Events like exhibition openings and lectures have a way of bringing people together and encouraging conversations that might not otherwise occur. Looking back, the "Focus on Photography" lecture series changed the trajectory of the Houston photography community and in many ways, laid the groundwork for what was to come.

The MFAH Bulletin advertised "Focus on Photography" as

> A series of eight lectures by prominent authorities in the field of photography begins this month under the cosponsorship of The Museum of Fine Arts, Houston and the Rice University Art Department.
>
> Gene Thornton, photography critic for *The New York Times*, opens the series on Wednesday, January 15, with a lecture on "Photography and the Traditional Subjects of Painting." A discussion by Peter Bunnell, Director of the Art University, Princeton University, follows on Wednesday, January 29. Both lectures will take place in the Museum's Brown Auditorium at 8 p.m.
>
> Admission charge for the entire lecture series, which includes lectures every other Wednesday night through April 23, is $6 for Museum members and $8 for non-members, and individual lecture tickets may be purchased for $1 by Museum members or $1.25 for non-members.

For the lecture series, Bill Agee put together an inspired list of speakers. In addition to Thornton and Bunnell, who spoke on the "Photographs of Alfred Stieglitz," he invited photographers Paul Caponigro, Aaron Siskind, and Geoff Winningham to speak. Ben Maddow, a filmwriter and director, discussed "The Photographs of Edward Weston," and John Szarkowski, Director of Photography at the Museum of Modern Art (MOMA) in New York, talked about "The Iconography of Photography." Among this stellar line-up, Bill also asked

the writer and art historian Beaumont Newhall to participate. Perhaps *the* most important figure in the history of photography at the time, he had been the founding curator in 1940 of the first museum photography department in the country at MOMA and later was the director of the George Eastman House (1958-1971) in Rochester, NY where he also taught the History of Photography classes at the Visual Studies Workshop. In the 1970s, Newhall was teaching at the University of New Mexico. In hindsight, one could say it was his lecture on Wednesday night, February 26, 1975, that the future of the photography scene in Houston gained momentum.

The lecture series was well-attended, filling the newly-opened Mies van der Rohe designed Brown Auditorium to capacity. For Newhall's lecture, the auditorium was overflowing, with 356 people attending.[10] After delivering his talk on "Photography and Impressionism," Newhall found himself in the lobby talking with Bill Agee when he was approached by an elegantly dressed woman. Introducing herself as Mrs. Geraldine "Jerry" Wallace, she mentioned that her daughter Anne had studied with him in Rochester at the Visual Studies Workshop. Mrs. Wallace was also happy to report that Anne had called earlier that very day to say she would be moving back to Houston in just a few months. Agee had previously mentioned his interest in developing a photography department at the museum, so hearing Mrs. Wallace's news, Newhall promptly turned to Bill Agee and said, 'You are looking for a photography curator and one of my students is moving here.'[11]

It is interesting in retrospect to wonder what might have happened had Anne Tucker not called her mother the exact day of the Newhall lecture, or if Newhall had not accepted the invitation to speak in Houston, or if Agee had not been such a champion of photography. What retrospection does make clear is that the current photography scene in Houston began with Bill Agee's vision and the synchronicity brought about by a Beaumont Newhall lecture at the Museum of Fine Arts, Houston on a winter night in 1975.

## Finding her way in Houston

It was a hot, humid summer day in June in 1975 when Anne Wilkes Tucker arrived in Houston with her husband Cal. Moving into a little bungalow in the Museum District, they wanted to be close to Cal's new job at Herman Memorial Hospital in the Texas Medical Center. Cal had recently completed

his residency in Psychiatry at University of Pennsylvania in Philadelphia and was eager to begin his professional life in Texas. The couple had agreed that Cal would look for work only in cities where Anne had some possibility of finding a position, which had narrowed their search to large, urban centers. When the opportunity in Houston came up, it seemed like a good fit both professionally for Cal, and personally for Anne, who having grown up in Louisiana, it was almost like coming home. Her mother Geraldine had remarried and moved to Houston, and Anne's brother Tommy was just a few miles down I-10 in New Orleans.

June, July and August in Houston are slow, languid months with an overabundance of heat and humidity. The majority of those who can, leave the city for cooler climates. For those who stay, the city seems to move at an indolent pace as the temperatures sap motivation for anything that requires exertion. The social calendar is quiet and most of the cultural groups go on hiatus until hints of fall with its promise of slightly less stifling heat breathes life back into the city in September. Arriving in the midst of the Houston summer, Anne and Cal faced heat that only increased, making July the hottest month of 1975 as temperatures soared into the high 90s with similarly high levels of humidity. For Anne, this might have felt familiar but for Cal, who had lived on the east coast his entire life, the South would have been a challenging surprise in more ways than just the weather.

Before coming to Houston, Anne had written to the Museum of Fine Arts, Houston Director Bill Agee as soon as Beaumont Newhall told her of his intention to develop a photography department. After Beaumont's lecture at the museum, he had also followed up with a note to Bill Agee, "I am writing to Anne Tucker (Cohn) — she uses her maiden name professionally. She might be the one to help you."[12] In Anne's savvy letter to the director, she expressed her interests in working with him to build a photography department.[13] She listed her accomplishments as "four years teaching experience and three years working in photographic museums and collections. I have also produced three photographic lecture series for the Cooper Union Forum ... and given lectures throughout the country. I am currently working on my second book." Additionally, she mentions a "major exhibition" she is working on with the Visual Studies Workshop in Rochester that she hopes the MFAH would consider exhibiting. Bill Agee must have been delighted to have someone with such stel-

Anne with her mother, Geraldine "Jerry" Wallace, n.d.
From the collection of Anne Tucker.

lar credentials moving to Houston. He promptly responded, thanking Anne for her letter and vitae which he had "looked at with great interest" and encouraged her to contact him when she arrived in Houston.[14]

While Cal began his new position, Anne set about finding her own way in Houston. Arriving for her interview with Bill Agee, Anne recalls, "I came in wearing earth shoes and a blue jean skirt, a peasant blouse and smoking a long pipe." If it hadn't been the early 1970s, this might have given the director pause but the interview went well. Only lack of funds prevented him from hiring her on the spot. In addition to contacting Bill Agee, who was actively working on a means to finance his goal of a photography department at the museum, Anne also contacted the two university photography programs in the city. She met with Geoff Winningham at Rice University Media Center and with George Bunker, the newly-hired head of the Art Department at University of Houston. George was in the process of building a photography program and immediately hired Anne to teach History of Photography course beginning that

fall semester (which she continued to do every semester until 1980). Both the Rice University Media Center and the new photography department at University of Houston would grow to be important organizations for building the photography scene in the city.

### From Baton Rouge to Houston by way of Rochester, New York City, and Philadelphia

One can look back and find a number of things in Anne's background that prepared her uniquely to initiate and support a Houston photography scene. Growing up in Baton Rouge, Louisiana, Anne's childhood seems like a quintessential Southern novel with a strong-willed grandmother, a great uncle that everyone called Big Daddy who lived on a sugar cane plantation with his grown sons and their families nearby. Baton Rouge was a relatively small town where everyone talked about everyone else, and Anne's close-knit family was enmeshed deeply in local traditions. The Tuckers were a community-minded family with deep roots in their city.

The matriarch, Anne's grandmother Virginia who was known to all as Miss Virgie, was "a remarkable woman and a major influence," Anne recalls. Miss Virgie knew how to make things happen, and she was recognized throughout Louisiana for her civic activities. Anne grew up hearing stories of how her grandmother had spearheaded a Ladies Vigilante Group to solve the problem of merchants who "put their fingers on the scale" when weighing out staples such as flour and beans. "Gammie," Anne tells, "would buy a pound of this and a pound of that ... and go straight to the federal office, who would take their sales slips and weigh the goods." The Ladies Vigilante Group also raised funds to buy a house "in town" for women and children to use, while the men were at the saloons, after coming in from their farms by horse and buggy to do their shopping. "When cars eliminated that need, they gave the land to Baton Rouge on condition [that] the city build its first public library. Later she saved several major historical buildings from demolition."[15] Miss Virgie was a key force in saving the Old State Capital, a gothic building that Mark Twain had written about, and a civil war building known as The Arsenal. In her 90s, she was formally honored in a "room full of legislators and governors and people like that" during which Anne remembers hearing one legislator say, "to you junior legislators in the room, when you see Miss Virgie coming, you might as well say yes now, 'cause you're gonna say yes later." Though Anne did not

share her grandmother's political values, she always admired her community service and ability to create change.[16]

Miss Virgie was a major force not only in the community but also in the lives of her family. Anne "admired her energy and passion." Virginia had two sons, Anne's father Robert ("Bob") and James, both of whom worked at the Exxon refinery. When Anne was almost four years old, at the request of her grandmother, Bob moved his family into the top floor of Virginia's large house in downtown Baton Rouge. Anne reminisces, "My father went downstairs after dinner to talk with his mother and his brother came by her house before he went home every night." Virginia kept her sons and their families close. James lived nearby on a small farm with his wife Donna and their children. Every Saturday, Anne's family had dinner downstairs with grandmother, and every Sunday, they took her to church and to the cemetery to put flowers on her husband's grave. Anne grew up steeped in family responsibilities, rituals, and obligations, "Family was always important."

In many ways, Anne's childhood was idyllic. Time was spent visiting her cousins at her Uncle James' farm or other relatives who lived across the Mississippi river. At these family gatherings, following the gender norms of the 1950s, the "men would go wherever men would go — they would go out walking in the fields or they would go to the barn or they'd go look at a cow or crops," Anne recalls, while the women "would gather around Aunt Donna's kitchen table and talk, or there was a swing set ... and the kids would play on the swings ... and the women would sit around and talk." Undeterred by this division of spheres, Anne seemed to have been exposed to both gender cultures. She went bird hunting with her father and brother and has fond memories of "just walking in the fall pastures." As a young teenager, Anne had asked for a mouton coat for her birthday that was the height of chic at her school, and instead received "a 4-10 shotgun, which I still have ... I was a good shot."

Like many middle-class white children in the South at that time, Anne was raised by an impressive African American woman named Annie Bell Arbour Jones. Bell, as she was called, was blind and had worked for the Tuckers since graduating from the Louisiana School for the Blind. Anne credits Bell for heightening her attention to sensory knowledge. Bell, Anne says, "taught her 'how to see without eyes.'" Impressed with her independence, Anne describes

Bell as "a person with this presumably crippling handicap that lived a normal life — had her own home, a husband, worked, washed clothes, cooked, cleaned, babysat, read a braille Bible and played cards with a braille deck." Bell could tell the color of socks by the different textures the dye would create on the fibers. "I described everything for her," Anne remembers, "She would ask me 'What does he look like?' 'What color is his hair?' That sort of thing." Through Bell's questions, Anne grew up describing how things looked and developing her ability to put visual experience into words. To do this, Anne had to identify the most salient aspects in what she saw, discern the crucial elements for understanding the meaning, and then remember everything to share later with Bell. So even before Anne found photography, she was learning to describe what she saw and developing her abilities for visual recall.

Close to her father, one of Anne's fondest memories is of working in the garden with him. "Daddy and I were very close ... He would come home from work and change his clothes, and we would go out and would work in the garden. And it was big ... a really big garden." Bob Tucker worked as an engineer at the Exxon plant that Anne could see from her bedroom window. Exxon was one of the largest employers in Baton Rouge and many of her male relatives worked there. With the exception of being stationed elsewhere in the U.S. and then in India during World War II, Bob Tucker lived his entire life in Baton Rouge. Anne's mother, Jerry, had grown up during the depression on the family farm in southern Louisiana. When Anne was young, her mother would tell her bedtime stories about her childhood on the farm — about picking cotton, how they survived on the vegetables and fruits they had been able to can or make into preserves and how her clothes had been made out of flour sacks.[17]

Looking back, Anne explains that "Mother was trying so hard to carve out her life apart from her mother-in-law, that I never learned to cook or sew ... as they were so much a part of her identity." In recent years, Anne has stated that her favorite kitchen appliance is the telephone as she still does not cook. Jerry, however, "was a great cook, and there was always cookies or cake ... she loved having the house full of people." Anne remembers that their home was always open to all her and her older brother Tommy's friends. Exemplifying southern hospitality, Jerry claimed her turf as the model hostess. In contrast, Anne was athletic, lettering in both football and swimming in high chool. She remembers her father came to every football game, "Once, I ran the football

the length of the field to score, and he ran along the sidelines cheering." In swimming, Anne set a state record in the breaststroke.[18] "I was never a girly girl, never," Anne recollects, "I didn't like to shop." Early on, Anne was charting her own course rather than passively following gender norms of the time. In her senior year, Anne was prophetically voted most likely to succeed.[19]

Community service was an important value in her family that Anne learned young. Following Virginia Tucker's lead, the entire family was involved in many community organizations. Anne's father Bob served on the church vestry and the Airport Board. Her mother, Jerry, was also active in the community, "she was on the Board at the YMCA ... and she was very, very active in the church." A member of the Altar Guild, Geraldine helped with bake sales and various other activities at the St. James Episcopal Church. Both Tucker children followed suit. "Tommy was President of his class; I was secretary," Anne remembers, "We both belonged to organizations ... boy scouts, girl scouts." Anne was also enlisted in community causes of her grandmother, "I went to school with clipboards under my arm for petitions." Always involved in "tons of things," Anne remembers, "I was always high energy and ... hardworking, but it was totally out of multiple family examples." Anne continues, "Whatever I did, I did to the fullest."

Every summer, the Tuckers would visit her mother's sister in Monroe, Louisiana where Anne's Aunt Toni worked for the Red Cross and her Uncle Bill was a salesman for Fairbanks Morse, which manufactured cotton scales. Her aunt and uncle did not have children, so Aunt Toni worked full time, something unusual in that era and especially in the South as middle class, married women seldom worked outside the home. When in Monroe, Anne had her own initial experience as to what it might be like to work by volunteering as a Candy Striper at the local hospital where she would take magazines and other reading material around to patients. Other times Anne would accompany her uncle on his sales visits, observing the ways and rituals of Southern male business culture. Uncle Bill "would walk up to the cotton gin, say hello to the foreman ... and often they would squat down beside the side of the barn and not say anything, just squat there. ... Bill would [eventually] say, 'Everything okay with the scales?' or 'Do you need...' And business would be conducted, but there was this rhythm that had to be honored," Anne watched. "You didn't just walk in and start talking business." These early experiences gave Anne

insights into both Southern culture and gender variations in communication styles that would prove useful as she made her way in Houston. Time spent with Uncle Bill visiting his clients gave Anne an exposure to "the male culture of the South." When she was with her female relatives, "all the women are talking ... didn't have to be interesting talk, but the men didn't talk like that." Sometimes, Anne observed the men didn't talk at all, but "you knew something was being communicated."

Anne's mother, Jerry, always wanted more for her family and made sure Anne had exposure to the broader world. As a child, Anne remembers her mother finding a newspaper article with the hundred most important books to read. Posting this list on a kitchen cabinet, Jerry encouraged her children to read as many of the books as they could. In contrast to her father's side of the family that was deeply entrenched in Baton Rouge, her mother's family provided different models of adulthood. Jerry's sister Toni had always worked outside the home, and her brother Durwood was quite successful building refineries all over the world. In high school, Anne flew on her own to visit her Uncle Durwood's family in Caracas, Venezuela, where he was working. Uncle Durwood and Aunt Lila had a house beside a cliff and Anne was struck by the beauty of the landscape — the bougainvillea that grew straight up the side of the hill, the orchid farms, the expansive coastline and the temperate climate. This was Anne's first trip outside of the United States and it "certainly whetted my appetite for more travel," Anne explains, "and it certainly increased the pull out of Louisiana — it opened up possibilities of another world."

In a catalog essay, Anne wrote about the ever-present draw of the outside world.

> My room was my safe space. I spent hours with the lights off, looking out my window at the night and wondering what was "out there." Because we were on the second story of a high-ceilinged house with few immediate neighbors, I could see a very long way, especially in the winter when the trees were bare. I'd wonder about the people living in various neighborhoods beneath and about the men who worked through the night at the Exxon refinery with its tall flares lighting the night sky. And beyond all that was the highway that crossed the Mississippi River and headed north and "away."[20]

It was her mother who decided that Anne should leave Louisiana for college. Jerry took her daughter on a "driving trip up east" to look at possible schools. "I don't even remember the other schools we looked at … when I walked on the Randolph-Macon Woman's College campus — that was it for me," Anne recalls, "that was where I wanted to go." Of all her cousins, Anne was the only one to leave the state. Once she left for college in Lynchburg, Virginia, Anne never lived in Louisiana again.

Anne quotes a line by Willie Morris from his book, *North Toward Home,* "Northerners go to school to refine ideas and Southerners go to school to discover ideas," to explain her college experience.[21] Leaving Louisiana for a small women's college in Virginia may not seem like much change to a northerner but for Anne, it was a turning point that led her to discover her three lifelong passions — art, politics, and learning. During a freshman year class trip to Washington, DC, Anne walked through the exhibitions at the National Gallery and "that was it," she says. This was her first visit to a 'real' museum with a stellar collection and professional staff; Anne was entranced and immediately decided to major in Art. "When I stood in front of the paintings at the National Gallery, I thought I had never seen anything as majestic — the grandeur of it all, I was deeply affected by it."[22] Later that same year on November 22, 1963, hearing that President John F. Kennedy had been assassinated, Anne and three classmates immediately drove to Washington, DC. Arriving at midnight, Anne remembers a full moon over the Washington monument and seeing all the flags at half-mast. "We stood in line the next day and watched the cortege. We had a transistor radio with us, and we heard Ruby shoot Oswald on the radio," Anne recalls, "we finally got through the Capitol and walked past the casket about midnight, and you walked out and … there's the reflecting pool and the mall … and, again the full moon … but that was a political moment."

The 1960s were a heady time to be in college as the winds of change and rebellion blew through campuses across the nation. The United States involvement in the war in Vietnam was escalating and the anti-war movement at home was gaining ground. The body count of dead soldiers kept rising and was reported each evening on the television news complete with footage of the fighting. Domestically, the civil rights battles were also raging. Peaceful lunch counter sit-ins and the Freedom Rides began in the early 1960s but in the South these

efforts were often met with violence. Commissioner of Public Safety Bull Connor was using fire hoses and police attack dogs to break up peaceful protests in Birmingham, Alabama, where in 1963, the 16th Street Baptist Church was bombed resulting in the deaths of four young girls. This same year during the March on Washington, Martin Luther King delivered his prophetic 'I have a Dream' speech. Idealism was high during the 1960s, especially among the Baby Boomer generation in their early twenties. There was a belief that things could be changed for the better — that poverty could be eradicated, that inequalities could be addressed, and the values of capitalism could be challenged. Feminism was also beginning to find its way, slowly, into the discourse as Betty Friedan's book, *The Feminine Mystique,* was published in 1963 and was required reading during Anne's freshman year at Randolph-Macon. In her junior year, Anne was accepted as an exchange student for one week at Howard University, which was her first encounter with "really smart, well-educated African Americans."

While the world might have been changing elsewhere, tradition still reigned in Baton Rouge. In many ways Baton Rouge, despite being the state capital, was still a relatively small town with a population of only 152,419 residents in 1960.[23] During college, at her parents' request, Anne returned to Baton Rouge for her social debut. Though Anne had little interest in being a debutante, it was important to her father to introduce his only daughter to society. "My father wanted me to do it, I couldn't imagine not doing it," Anne explains. "It was important to him." So, Anne attended all the luncheons and teas leading up to the debut. For one of the debutante parties, Anne drove herself in the only car available — her father's work truck. By the time she arrived home, Jerry had received "at least four phone calls" because Anne had arrived at the best restaurant in Baton Rouge in a pickup truck. This was not, Anne recalls, the "first or the last time I was out of sync with 'society' in Baton Rouge." Anne's debut took place in the Baton Rouge city auditorium with much fanfare — bands, lights, and ritualized customs. Anne was joined by about fifteen other young women, most of whom she had known since grade school. In keeping with tradition, all the debutantes were dressed in white and escorted by their fathers in the ceremony. To this day, Anne can still demonstrate the deep-kneed curtsey she had practiced to perfection.

Shortly after Anne's debut, her beloved father Bob Tucker died suddenly of a heart attack in February of 1965. Two months later in April, her Uncle James also died of a heart attack. The deaths of both sons so abruptly sent a tremor

through the family. Determined to carry on, Jerry took both Anne and Tommy on the extended European trip that they had originally planned to take with their father. "Mother had huge travel lust," Anne explains. Much like the traditional Grand Tours of the Victorian era, Jerry took her children all over Europe. They went to Amsterdam, Brussels, Paris, Madrid, Malaga, Barcelona, Vienna, Switzerland, Rome, Venice, Nuremberg, Munich, Greece, Copenhagen, Sweden, and London. They visited Jerry's brother Durwood and his wife Lila who were living in Spain at the time, and were joined by her sister, Toni, in Germany and Denmark. Their trip was full of art; they went to museums as well as historic sites every day and studied the modern architecture that Anne had been learning about in school. After spending the summer abroad, Anne returned to Randolph-Macon Woman's College for two more years, receiving her B.A. degree in Art History in 1967.

In college, Anne was able to further her interest in photography. In high school she had photographed for the school paper and the yearbook with a simple point and shoot camera. Looking for a way to get involved at Randolph-Macon, Anne approached the campus newspaper "and the only job open was photographer." Taking on the role of newspaper photographer, Anne was able to get a better camera and continue to improve her photography skills. She also learned to print images in the campus darkroom and was asked to work on the yearbook as well. Like most colleges at the time, there were no photography courses, so Anne was on her own to master the craft. At Randolph-Macon, she was the first art student to exhibit her photographs for her senior show and to write her senior thesis on Alfred Stieglitz. After graduation, Anne wanted to pursue photography, so her school counselor suggested she apply to Rochester Institute of Technology (RIT). Though going to northern New York was not something generally supported in the Tucker family, Anne borrowed money from her Uncle Durwood and set off for RIT. Her brother Tommy later said that after their father died, Anne's strong will intimidated their mother. Though Anne remained close to her family, she was independent in her thinking and plans. Quoting from Virginia Woolf's *A Room of One's Own*, Anne explains, "There's that line where she says, 'I couldn't have lived if my father hadn't died.' Because her father was a very strict, Victorian, controlling person ... and when her mother married somebody else and that opened up a different world." Anne ponders, "Would Daddy have let me go to RIT?" With her newfound freedom, Anne set out to chart her own course.

## *"The beginning of everything"*

Arriving in Rochester in the fall of 1967, Anne began her life as an adult. She rented her first apartment in a close-knit community that she refers to as her urban commune. "We cooked, we all ate, we shared food, we shared grass," Anne reminisces, "these became my closest friends." At RIT, Anne found that she was one of only two women in the entire photography program. She remembers walking into studio portraiture class and having the instructor say 'good, we won't need to hire a model now.' Anne promptly and decidedly declined this request. However, more troubling was that "most of the faculty and students do not believe a woman can, or should be, a photographer," Anne recalls.[24] In spite of RIT's male dominated culture, the technical orientation and bias towards commercial work, Anne earned her A.A.S. in Photographic Illustration in one year, graduating in 1968. Though RIT had not been a great fit for her interests, being in Rochester turned out to be fortuitous. Anne credits RIT for getting her to the right place at the right time so that she was in the audience when photographer Minor White came to give a lecture at RIT in the spring of 1968. Anne said, "I had no idea what he was talking about, but I knew it was more interesting than anything I was hearing at RIT." After his talk, Anne asked about studying with him. "Totally naive person that I was," Anne recounts, "I also didn't have a clue that he was not interested in a female graduate student. ... But what he said was, 'Well I don't think you are right for MIT [Massachusetts Institute of Technology], but Nathan Lyons is starting a graduate school over at the Eastman House.'" And that perhaps is where Anne's career really began — when she met with Nathan Lyons, Associate Director of the George Eastman House (GEH). In the fall of 1968, Anne and Richmond Hare became the inaugural class of Nathan's nascent graduate program that would later become the Visual Studies Workshop (VSW). Being at the Eastman House and studying with Nathan and Beaumont Newhall, the Director of GEH, "was the beginning of everything," Anne recalls.

**Anne Tucker, photographer, at the Aperion Workshop, 1973.** Photo: Linda Connor. From the collection of Anne Tucker

At GEH, Nathan was creating the "first graduate program in photographic stud-
ies" in the country.[25] Developed from the beginning with an interdisciplinary
focus, the goal was to address "the broad spectrum of ways in which images
function in society, with primary research applications in sociology, anthropol-
ogy, psychology, and education."[26] A rather loose program in terms of curricu-
lum, Nathan gave only pass/fail grades and there were no tests. There were also
no "set agendas, nor established courses with specific titles or covering specific
eras."[27] With the Eastman House collection available, Anne took advantage of
her access as a graduate student, she could go into the research department
by herself anytime day or night and pull down box after box to look at pictures.
She began with "A" and looked all the way to "Z" exploring and discovering
the wide array of their collection. As a student she also attended weekly semi-
nars with Nathan, Beaumont, and other Eastman House staff, including Tom
Barrow, Harold Jones, Roger Mertin, and Reg Heron. From Beaumont, Anne
learned how to do research. A consummate historian, he taught Anne "to dig
through as many primary sources as you could locate and then to present your
findings in a clear and direct style."[28] Her first paper for his course was to trace
the photography exhibitions in New York City since 1917 when Alfred Stieglitz
closed Gallery 291 until Beaumont Newhall's landmark *Photography: A Short
Critical History* at MOMA in 1937 — the first photographic history survey in the
U.S. Anne did this by searching through years of publications at the Eastman
House looking for exhibition listings. This attention to detail and the necessity
of consulting original source materials, honed under Beaumont's tutelage at
GEH, remains part of Anne's signature style as a curator.

Writing about her time studying with Nathan Lyons at VSW, Anne identifies
four specific lessons that framed her education and way of working.[29] First,
"it is up to you to show up" as opportunities may be offered but you have to
make the leap of faith and show up. Second, Nathan encouraged his students
to "find your own path." Curriculum was not deterministic on core concepts
but rather on "finding a personal focus and establishing personal working
methods." Third, when Nathan resigned from Eastman House in protest over
an administrative disagreement, Anne witnessed the importance of adapting
to sudden changes and the need to work together as a community to accom-
plish common goals. And the fourth lesson Anne took from VSW was to "keep
working and do not let failures deter you." In hindsight, Anne adds a fifth les-
son, the importance of "acting on principle even with dramatic personal and

professional consequences."[30] At Visual Studies Workshop, students were encouraged to explore and investigate ideas allowing for successes and failures — both of which were celebrated as necessary for learning. Nathan's approach to teaching was similar to the way he curated; it should be "one of discovery rather than directive."[31]

At GEH, Anne worked in the research center and spent a fair amount of her time cataloguing photographs. She would take 35mm contact prints, mount them to 3"x 5" index cards, and then type in all the image details. In addition to her course work, Anne also helped with exhibitions and mounted her first "very modest" show as a curator on the work of Peter Henry Emerson. Watching the different administrative styles at Eastman House, Anne also learned about how arts organizations operate. Anne explains

> Beaumont was the sweetest human being, but he was just not administrative. Nathan really ran the place; Nathan was the administrator. Nathan had the vision. Nathan founded the publication program; he did all the traveling exhibition programs. Beaumont was a great historian … It was a lesson for me.

In Anne's second year of study, the graduate program left GEH with Nathan's resignation in August of 1969. As 28 students were expected to arrive within weeks, Nathan rented an old woodworking factory in Rochester.[32] Students were encouraged to arrive early for "work call" to help fashion the abandoned space into suitable quarters for study. The program was "hands-on" at all levels. As Anne remembers, it was never a question of whether you could or not, "Nathan was just a get it done guy … a figure it out guy." Nathan restructured VSW as a not-for-profit organization, which necessitated finding innovative means to increase the program's visibility and developing support mechanisms. While at Eastman House, Nathan had engaged in several extension activities like slide shows, traveling exhibitions, and publications that took photography out into the world and often had a much wider reach than his activities at GEH. Using this same model, Nathan continued to promote photography through VSW by mounting exhibitions in community spaces and creating traveling exhibitions in addition to continuing with his own photography and essays. Nathan was also known for his inclusive approach to images that ranged from snapshots to hybrid and experimental photography.

Working with Nathan, Anne observed and participated in promoting all kinds of photography beyond the walls of the institution as well as witnessing the benefits of including all the stakeholders in the processes. She continued this inclusive way of working throughout her career.

One of the requirements at vsw was to complete a one-semester internship. Anne selected the Gernsheim Collection, which later became the basis for the photography collection in the Harry Ransom Center, at the University of Texas in Austin, as the place she wanted to intern. When Anne contacted them, the collection did not have a full-time curator but was overseen by a cultural historian. It was, however, an important 19th and 20th century collection that contained not only the earliest known surviving photograph by Joseph Nicéphore Niépce, but significant holdings of work by William Henry Fox Talbot, Roger Fenton, Julia Margaret Cameron, Lewis Carroll, Peter Henry Emerson, Paul Martin, and Christina Broom, among others.[33] The Gernsheim Collection had not had an intern before, but eagerly accepted Anne's offer to volunteer for the summer to help catalog the collection. Anne interned there two summers, in 1969 and again in 1970. Before leaving, Anne wrote a letter to the director "which read in part, 'Recent visitors to the Gernsheim Collection mentioned that there are no lists of the contents of the collection nor any order to the prints … This summer I ordered the collection in accordance with Mr. Gernsheim's own lists and comments. Arranging prints in cases alphabetically by photographer and I got through the letter 's' in writing on each print of which Gernsheim had listed the prints.' This made an easier job for her successor to complete from 't to 'z', keeping in mind that there were no 'x' or 'z' photographers."[34]

35

While alphabetizing photographs in Austin, Anne had also applied for a New York State Council on the Arts Grant and was accepted as a Curatorial Intern in the Photography Department at the Museum of Modern Art (moma) in New York City for the 1970-1971 academic year. Prior to starting that position, Anne drove from Rochester to attend a wedding in Savannah, Georgia. Stopping in Washington, dc to see a college friend from Randolph-Macon, Anne remembers her friend kept talking about this guy, Cal, she wanted her to meet. The next day, Anne called him, and they arranged to meet that evening. After the date, he went home and reportedly told his roommate he had met the woman he was going to marry, while Anne hopped in her British Racing Green mg-b

and drove through the night to arrive in Savannah just in time for the wedding brunch. Anne's friends were horrified that she had driven by herself through the night. "I was just a rogue," Anne explains, as she did not let herself be held back by gender norms or the social expectations of others. Her decision to stay and meet Cal would turn out to be pivotal.

Cal and Anne stayed in touch, writing back and forth. Cal was working as a researcher with the National Institute of Mental Health in Washington, DC and Anne started at MOMA in New York in the fall. Six months after they met, they married in November but still kept their respective positions and had a commuter marriage — something that was quite unusual at the time. Cal was from New York City, and his family helped the couple find an apartment in the city though Anne commuted to Washington, DC on the weekends to see Cal. "It was a very exciting time ... it was all pretty amazing," Anne recalls, "Cal was in the intellectual world of science, and I was in the intellectual world [of art] and then he moved to the Rockefeller Institute in New York. We used to joke that he was working for one Rockefeller, and I was ... working for another one" as David Rockefeller was chair at the Rockefeller Institute and Blanchette Rockefeller was the Chair of the Board at MOMA at the time.[35]

At MOMA, Anne worked with John Szarkowski, head of their photography department, Peter Bunnell, curator in photography, and Grace Mayer, curator of the Steichen archive. Her first task was to work on the bibliography for the Walker Evans catalog.[36] Working with John, Anne recalls, was fascinating just to hear him think. He was writing *Looking at Photographs* and studying images at the time "so pictures were being pulled out and he was thinking — John was thinking out loud." John was just "such an amazing thinker, so original," Anne explains, "but we thought very differently, and we didn't agree." Even so, it was an incredible opportunity for Anne. While at the Modern, Anne was able to curate her second exhibition and chose to focus on the photographs of women. She was also completing her thesis on this same topic. The impetus for her thesis research and exhibition had come to Anne while sitting in the library at the Eastman House and she noticed "every single photo magazine had a picture of a nude or semi-nude woman" on the cover. Her MOMA exhibition also became the basis of a special issue of *Camera Magazine* (February 1972) which was devoted entirely to *Photography of Woman*. Anne's work drew the attention of a book packager who approached her to write a book about

women photographers. With only six months to write it, Anne's first book, *The Woman's Eye*, was published in 1973 by Alfred A. Knopf. Somehow during this same period, Anne also found time to write essays and reviews about photography for important outlets including *Afterimage*, *Camera Magazine*, *Harvard Advocate*, and the brand new *Ms. Magazine*.

By the time Anne finished her graduate program, she had managed to work with the three most important people in photography in the country — Nathan, Beaumont, and John — and curate exhibitions at key institutions, GEH and MOMA. Though when Anne looks back, she notes that she had to carve her own path — not only was photography just coming into its own, but her mentors, Nathan Lyons and John Szarkowski, were very different in their approaches to photography and "neither of them liked each other much," Anne recalls. Furthermore, they each had very "different styles in conveying their tastes and values."[37] Nathan privileged photographic sequences or series of images whereas John focused on single photographs. Nathan was interested in expressive and innovative photography, while John saw photography as a means to precisely document visual phenomena.[38] Between these two important but antithetical thinkers, Anne honed her own approach. Working with Nathan, Anne "learned that photographers should lead me, not the reverse ... I learned to value empathy as well as analysis and to help photographers to find their vision, not to follow mine." Nathan also "believed that recognizing diversity in the practice of photography to be essential to photography's evolution. So, he promoted the study of snapshots and spirit photographs as well as fine prints by iconic practitioners." With John Szarkowski, Anne felt she was "essentially a girl in a man's world ... I had to defend my very different views, which was important training in intellectual dueling."[39] Also working in very different institutions, George Eastman House — a photography museum — and then Visual Studies Workshop as a nonprofit organization, and the Museum of Modern Art — a premier institution with an entrenched bureaucracy, provided Anne with an exposure to various leadership styles and the variety of internal politics inherent in all organizations.

After her year at the Modern, Anne took a position as a Photography Consultant for the Creative Artists Public Service Program in New York City and commuted to Rochester to complete her degree the following year in 1972. Cal had been accepted into a Psychiatry residency at University of Pennsylvania

so in the summer of 1972, Anne and Cal moved to Philadelphia. There Anne joined the ranks of the itinerate adjunct faculty teaching at the Philadelphia College of Art and commuting to New York City to teach at the New School for Social Research and at Cooper Union where she also directed a Photography Lecture series. In between teaching classes, Anne was working on her first book, *The Woman's Eye,* and assisting Lee Witkin in writing a catalog for Witkin Gallery in New York City.

Young and ambitious, Anne and Cal were making their way in the world. They were attempting to chart a new, modern marriage of equals in a society where ideas about gender were only beginning to change and there was still little support or infrastructure to be found for equalitarian relationships. When Anne and Cal married in 1970, very few women were keeping their maiden names. This was also a time when women could not get credit in their own names — they needed to have a male relative (father, brother, husband) as a co-signer. Anne relays the story of when Cal requested an American Express card in the name of Anne Tucker, and he was turned down saying that credit cards could only be issued to members of his immediate family. When Cal replied that he considered his wife part of his immediate family, American Express asked why she did not have his last name. "And he wrote back," Anne laughs, "'None of your fucking business' and they wrote back, 'here's the credit card, and please refrain from using profanity in business correspondence.'"

After *The Woman's Eye* was published, Anne turned her attention to researching the Photo League. Active in New York City from 1936 to 1951, the Photo League was primarily an organization of young photographers but also included a number of important American photographers such as Paul Strand, Ralph Steiner, Bernice Abbott, Aaron Siskind, Lisette Model, and Ruth Orkin. As a group they were interested in using photography to promote progressive social causes. Their efforts, however, were seen as subversive and anti-American by the FBI. The Photo League eventually disbanded after being labeled a front for the Communist party, which resulted in many of the members being blacklisted. Anne had first become intrigued with this group of photographers while working with Beaumont, who himself had been affiliated with the League. Attempting to interview all the photographers from the Photo League who were still alive, Anne traveled as much as she could afford. Using her own funds, she interviewed several people in New York City and then made a trip

through New England, where she interviewed Bernice in Abbott's Village, and Ralph Steiner in Vermont, and Lotte Jacobi in New Hampshire. She then went to Los Angeles to interview Sid Grossman's life partner, Marion Hilly, Marion Palfi, Max Yavno, and others, and then went to Carmel to interview Ansel Adams in "his home with a 180-degree view of the Pacific." In addition, Anne spent "hours and hours and hours and hours in the University of Pennsylvania library reading *Daily Worker* and *PM* Newspaper microfilms."[40] So, by the time Anne and Cal headed to Houston, she had an impressive resume and had cultivated a wide network of photographers and photographic professionals.

It's been almost five decades since museum director William Agee promised to build a photography department, and even he could not have dreamed it would lead to an internationally recognized photography scene in Houston. Hiring Anne Wilkes Tucker, after his serendipitous meeting with her mother and Beaumont Newhall, was an unanticipated turning point for photography in the city. Anne arrived passionate about photography, eager to build her career and with significant experience in the field. She had already published her first book and had worked or studied with the three most important names in photography — Nathan Lyons, Beaumont Newhall, and John Szarkowski. From her time in Rochester at Visual Studies Workshop, she saw how Lyons was able to develop an engaged community scene around photography, and from her research on the New York Photo League she knew how beneficial a supportive network could be for creative work. With Szarkowski, she saw up close how the leading curator of the day worked within the larger organization of MOMA. Her professional experience coupled with her sense of community service instilled in her by her family led Anne to think beyond her role at the museum. Anne brought all of these experiences to bear as she went about cultivating a photography scene in Houston. "I believe for most of us in Houston," longtime friend and collaborator Clint Willour explained, "she is the heart and soul of this photo world."[41]

# Chapter 2

# Bringing Photography, Art,
# and Culture to Houston

After being involved with the New York art world, Houston must have seemed quite different to Anne. Though some described Houston's art community as quite provincial at the time, many important elements were in place by the time she arrived in the mid-1970s. Since the city's beginning, various individuals arrived in Houston with ideas about creating 'culture,' many of which revolved around the fine arts. From the city's inauspicious beginnings as a wide spot in the sparsely populated, swampy lowlands, newcomers have found Houston to be their *tabula rasa*. Often there is a desire by Houstonians to create things that would set the city apart, seeing its potential as a rival to other world-class cities. While important places like New York City or Paris might serve as models of what had been done, Houstonians generally strove for bigger and better, embellishing each endeavor. For example, when Houston set out to build a major sports stadium, they decided to build the world's first multi-purpose, air-conditioned, domed stadium. Dubbed the "Eighth Wonder of the World" when the Astrodome opened in 1965, it showcased a number of engineering innovations. The stadium featured movable lower seating to accommodate both baseball and football, and was the first to install Monsanto's artificial grass, which became known as Astroturf. The Astrodome epitomized the local approach to making it bigger and better.

Discussion about developing the visual arts in Houston started in earnest at the turn of the twentieth century. Proponents of the arts in Houston, while dreaming of approximating European capitals, started less audaciously. Much like it did in other American cities, support for the arts began in Houston primarily through the efforts of the wives and daughters of successful businessmen. These women spearheaded everything from public libraries to an art museum,

a ballet company, a symphony, and a professional theater group. Photography in Houston, however, began earlier and mainly as an economic enterprise.

## The Diamond Years of Texas Photography

Only seven years passed between 1836, when the Allen brothers purchased six thousand swampy acres along Buffalo Bayou with the idea of building the city of Houston, and the first known photographer coming to town. In 1843, "Mrs. Davis advertised her photographic services in the Houston newspaper." A transient daguerreotypist, she is thought to be the first person to produce a photograph in Texas though none of her work remains. The earliest existing daguerreotype made in Texas is quite fittingly an image of the Alamo from 1849. In Houston, the first photographer to set up residence was John H. Stephen Stanley, who opened a Daguerreian gallery in a building on Main Street in 1851. An immigrant from England, Stanley, in addition to daguerreotypes, "experimented with Frederick Scott Archer's wet collodion negative-positive process." Advertising in the newspaper in 1851 and 1852, Stanley boasted "that he had succeeded in making photographs on glass" for his clients. This is particularly noteworthy as Stanley was experimenting with wet collodion the same year that Archer, living in London, published his first article about the new process in *The Chemist* in March, 1851. It wasn't until the following year that Archer published *A Manual of the Collodion Photographic Process*. Given the means of transcontinental communication available at the time, it is remarkable that the information reached Stanley in Houston so quickly.[1]

From the 1850s until the 1890s, Houston was home to one to six commercial "photographic artists" and "tin type artists" — some working out of tents or a "Daguerreian car," and most only in business for a year or so. Often a newcomer would open a photography studio in the same building that had recently been vacated by the last artist. Most studios were located on the top floors given the need for natural light, and " ... it became a concern of some photographers to ensure that their clients did not have to climb too many stairs to reach their studio. ... they advertised on the back of *cartes de visites* or elsewhere that they were 'only up two flights.'" As elevators became more widespread, "this too became another feature which could make your studio stand out from the one next door, so photographers also began to advertise that they were in a building which had these hydraulic or steam powered contraptions." By the end of the 19th century, Houston had eleven photography businesses.[2]

In her book, *The Diamond Years of Texas Photography,*[3] Ava Crofford chronicles the activities of the Texas Professional Photographers Association that was founded in 1898. Members included a number of nationally recognized photographers, including Jack Stiles and Paul L. Gittings, who were based in Houston. By 1919, Bachrach Studios of Baltimore, which had opened several studios throughout the United States, started a branch in Houston and initially hired Gittings to run their Texas studios. When the Great Depression hit in the 1930s, Bachrach was forced to sell many of its holdings and Gittings purchased the Houston business, renaming it Gittings Photography. He moved the studio into the south corner of the newly-constructed Isabella Court Building on South Main Street, designed by architect William Bordeaux.

The complex was built in the Spanish Colonial Revival style for mixed residential and commercial use and is still home to galleries and artists today. Gittings also recruited recent Polish emigrant Kaye Marvins, who had been working in Bachrach's Boston location, to come to Houston to help run the studio. Kaye was a third-generation photographer — his great grandfather had begun the family business with a portrait studio in Poland in the mid-1860s — and was a well-trained, highly skilled colorist and re-toucher. Arriving in Houston in 1935 with his new bride Sonia, Kaye worked for Gittings until World War II began.

By the mid-twentieth century, Houston had a number of thriving photography studios doing commercial and portrait work. In 1948 the Professional Photographers Guild of Houston was formed with just over twenty members. The group met near downtown Houston at the Ben Milam Hotel across from the Union train station, now the site of Minute Maid Park. Though in many ways these photographers were all competitors, Kaye's son Mike Marvins recalls, they were also "all good friends, and some of the other regions in the country that wasn't so, but this is Texas … that's why it's always been successful. … everyone's very good friends, and everyone shares with everyone, and it's no secret this or trying to undercut someone, we're all best friends." In 1945, returning from Arizona, where he had been sent to convalesce after sustaining injuries doing underwater welding for the war effort, Kaye came back to Houston with his wife Sonia and their two young sons, Michael ("Mike") and Edward (known as "Buz") to open Kaye Marvins Photography. Like many entrepreneurs who came to Houston, Kaye and Sonia worked hard to provide a quality service specializing in portrait work, wedding photography and "warm

personal service."[4] From the beginning, son Mike explains, their business model was to focus on quality with "high prices and high-class clientele." Sonia, remembered as the "world's best salesperson," was a "charismatic kind of person," Mike explains, "she was unbelievable." She made it clear that they were "not going to give their work away, [they were] going to start at the top." However, the Marvins also believed in giving back to their adopted community and over the years photographed many of the civic and arts institutions, like the Alley Theatre productions, at no charge. Unlike many white businesses in the segregated South, Kaye also made portraits of African Americans, "after hours and had them come in the back door because he couldn't afford to have his [white] customers see them," daughter-in-law Mickey Marvins explains. As the Marvins' business grew, so did their reputation. Kaye became active in the Professional Photographers of America, serving as the President of local, state, and regional chapters. He also traveled widely, giving courses on portrait photography throughout the United States. Kaye is credited with being one of the first to re-introduce natural lighting in professional portrait work and to take subjects outside the studio to photograph them in gardens or natural surroundings.

As Houston continued to grow and the economy strengthened, commercial photographers had more customers. Photographers were in demand for marketing

**43**

**Kaye and Sonia Marvins arrive in Houston, 1935.**
Photo: © Kaye Marvins. From the collection of Michael Marvins.

**Kaye Marvins, photographer, 1946.**
Photo: © Kaye Marvins. From the collection of Michael Marvins.

images for businesses as well as for annual report photographs. Houston had a rich society life that also provided work for photographers, in addition to the bread-and-butter work of family portraits and school pictures. Though many of the early commercial photographers were extremely accomplished, they, like many others, did not think of their work as fine art but rather a skilled trade. Generally, in the early 1900s, there hadn't been much attention on the arts in Houston, or even in Texas, until much later.

## Cultivating the Arts:
## Forming "splendid manhood" and "pure and noble womanhood"

The first nascent efforts to bring art and culture to Houston began at four o'clock in the afternoon of March 17, 1900. A "number of ladies and two gentlemen"[5] comprised the forty-seven people who gathered in the drawing room of Lavinia Abercrombie Lovett's gracious home. The wife of a prominent railroad lawyer, Robert S. Lovett, Lavinia had gathered schoolteachers, society women, and other prominent individuals to hear a lecture by Mrs. Jean Sherwood of Chicago.

> A number of us had been to Boulder, Colorado for the first session of the Chautauqua in the summer of 1898. There we met Mrs. Sherwood and enjoyed her art lectures. Naturally we began to think about what we could do for Houston, and we dared to ask Mrs. Sherwood if she would come to Texas. I remember now how she smiled as she said, "oh that would be lovely."[6]

One of her popular lectures was titled, "The Value of an Art Museum," and she was also known for a lecture series, "Art in the Schools."[7] Active in a number of voluntary associations and progressive activities, Sherwood believed that "Art should not be something high in the clouds for a few chosen people, but that it must serve all people as something of a religion."[8] She often brought her own traveling gallery of paintings and art reproductions, on loan from Chicago patrons, to use in her lectures.

That March afternoon in Houston, Mrs. Sherwood spoke about the Public School Art Society which she helped to organize in Chicago that placed reproductions of paintings and sculptures into the public schools. She began with two lines from a poem by Charlotte Perkins Stetson, entitled "Mother and Child." Mrs. Sherwood recited, "For the sake of my child, I must hasten to save, All the children on earth, From the jail and the grave." Art, she pro-

claimed, was a concern for all good mothers, who for the sake of their own child, must save all children. Indeed, promoting exposure to art thus became a matter of public good that fell squarely in a woman's domain of motherhood and the instillation of moral values. Mrs. Sherwood also explained the purpose of the Chicago group and pointed out "the benefits that had already been derived from the association."[9] Eager to see similar improvements in their own city, the Houstonians gathered in Mrs. Lovett's living room were inspired to action. Art for the edification of all, but especially for the city's children, had great appeal to the growing community.

At the time, Houston had a number of active women's groups. The Ladies Reading Club, organized in 1885,[10] is thought to have been the first in the city. The club offered a space for women to discuss ideas and literary topics. It also presented a challenge to the Houston Lyceum, a private male literary organization which maintained a library that allowed borrowing privileges only to members. The Ladies Reading Club unsuccessfully petitioned the Lyceum to make their library more accessible by allowing nonmembers, primarily women who were denied membership, to borrow books. Early gender politics played out in access to reading materials and one city alderman is reported to have "grumbled that if women were properly attending to their domestic responsibilities they would have no time for books."[11] In spite of such views, the women triumphed by appealing to Andrew Carnegie who, in 1897, agreed to donate $50,000 for a public library building if the city would provide the land. The Ladies Reading Club joined with four other women's clubs to form the City Federation of Women's Clubs and then worked jointly with the Lyceum members to raise funds for the land. The Houston Lyceum and Carnegie Library Association, chartered in 1900, succeeded in raising the funds for Houston's first free public library.[12]

The Ladies Reading Club and their efforts to develop literary resources within the city could have easily stood as an example that inspired those gathered to hear Mrs. Sherwood.

> Before she had finished her message to us, the forty-seven listeners had become enthusiastic over the idea of placing works of art in the Public Schools of Houston. The earnestness of purpose of the forty-seven who were present was demonstrated in the motion that was made and carried that Houston have an Art League … (Annual Meeting March 18, 1901)[13]

Encouraged by Mrs. Sherwood's moving presentation, the group elected four officers and immediately appointed a committee to draft its constitution. By the following Saturday, March 24th, the new association held its first meeting in the library of the Houston High School for a reading of the constitution, "most of which was adopted."[14] The constitution provided for four officers, nine directors, and the creation of three standing committees: Censorship, Ways and Means, and School. Annual dues were set at fifty cents, and by the end of the meeting enrollment had increased to 54 members. Emma Richardson Cherry,[15] believed to be one of the earliest professional women artists in Houston, served as the head of the Censorship committee, which was charged with selecting suitable works of art to be placed in schoolrooms. The association's first effort to promote art and culture in public schools was the purchase of a life-size copy in marble of *Venus de Milo*, the famous Greek statue in the Paris Louvre that was considered by many to be the epitome of graceful female beauty, to be placed in the corridor of the Houston High School. The League covered all the expenses ("not to exceed $125") in buying and transporting the work from the Paris to Houston.[16]

The Public School Art League set about bringing reproductions into the schools of Houston as a moral imperative for the city's children. Later, Emma Richardson Cherry would recall "loading her buggy with reproductions of famous paintings and trotting up and down Houston's dusty streets to every school in town."[17] In 1902, they began holding "public entertainments" to raise additional funds, the first of which was a "Dutch Tea" that added $130.05 to their treasury. This was followed by an "Evening in Italy" that featured a series of "living pictures" representing samples of Italian art directed by Mrs. Cherry, who had studied art in Italy, as well as Paris and New York City. By 1904, the League had been successful in bringing various "traveling exhibitions" open to the public to Houston as well as having purchased 136 pictures and 12 pieces of statuary for schoolrooms. "We believe much was done to please and encourage not only Art lovers, but Art seekers as well," Mrs. C.R. Cummings commends the league's work in her presidential address, "It is a matter of regret that so few improved the rare opportunity of seeing so many really good pictures." She continued,

> Our aim is to exhibit only good pictures, those which shall stand for some lesson in nature, in art, or in story; principally is our aim towards the artistic,

as that side of child life is the last to be considered. Realizing that children are moulded [sic] unconsciously by their surroundings, we are bringing into the schools the expressions of the best thought of the world.[18]

Concluding her statement, Mrs. Cummings reaffirms her conviction of the moral importance of the League's work to shape and improve the city's youth, "I would we could but convince others as we ourselves are convinced, that a noble and deeply useful work is being done for the children of our city. That we are aiding in the making of a splendid manhood, and in the moulding [sic] of a pure and noble womanhood."[19]

When the prized reproduction of the *Venus de Milo* finally arrived in Houston from the Louvre, it was "refused entrance because of conscientious moral scruples on the part of some" who felt the public school was not the proper place for a statue of such a scantily clad female form. While disappointed that their grand gesture was not well received, the League was undeterred and gifted the statue to the new Carnegie Library. The *Venus de Milo* replica was ceremoniously unveiled at the opening reception of the new building on March 4, 1904. Mrs. Cherry made a presentation speech describing the "Grecian masterpiece" and noted it dated from the fourth century when "the human form was the subject of art, and divinity its theme." The marble Venus "with its graceful pose, beautiful figure, and dignified face, adorns the rotunda of the library under its Grecian dome."[20] Though the city has since outgrown its first library building, the statue is still a prize of their collection and presides over the newly-restored reading room in the Julia Ideson Library built at the site of the original Carnegie building.[21]

With energy and ambition, the ladies of the Art League continued their progress, acquiring reproductions and distributing them to classrooms throughout the city — and promoting the study of art by children. In addition to their public entertainments to raise funds, they also held public lectures, bringing Mrs. Sherwood to town again, as well as other art experts from various eastern cities. The League further became involved in helping to 'tint' classroom walls so that the pictures could be displayed in a more pleasing manner. By 1906, the Public School Art League collection had grown large enough to warrant the implementation of a system to catalog each item and the League also decided to standardize the "school of art" displays placed in each grade throughout

the city. For example, under their "Grading of Pictures," all third grade class-rooms would have one picture from the Dutch school, fourth graders would see paintings by Spanish artists, and fifth graders would have something from the French school.[22] By 1908, the annual dues had risen to one dollar and the League had started exhibiting the purchased work for the public before placing it in the schools.

> During the month of February and part of March, we kept a framed set of these pictures on exhibition at the Pagoda, corner of Capital and Fannin, charging a small admission of ten cents. ... Through the co-operation of parents, teachers, and children, we realized from the exhibition over one thousand dollars. The Pagoda was loaned by Mr. Jesse Jones, and to his liberality is due in no small measure the success of the exhibition. It was a desirable place in lighting and location, and the length of time for which it was loaned, six weeks, enabled each school to have a day, and many public-spirited citizens came also to our assistance. (Annual Address of the President 1908)[23]

At an admission price of ten cents each, 10,000 visitors would have needed to attend to realize $1000.

By 1911, the League had begun hosting annual public exhibitions of paintings by American Artists organized by the American Federation of the Arts of Washington, DC. The paintings were organized for a Texas circuit traveling from Fort Worth, to Austin, to San Antonio, and finally to Houston. In the foreword to the 1913 exhibition, catalog viewers are reminded that

> ... these loan exhibitions can be continued only if the visitors reciprocate by purchase from the collection resulting in strengthening the artistic assets of the cities represented in the circuit but will result in greater interest and more enthusiastic co-operation on the part of artists in future exhibitions. For prices, please inquire of the attendant.[24]

### *"Going out after the adults"*

The same year the organization was newly-chartered as the Houston Art League (April 16, 1913), plans for a proposed art museum were announced at the annual meeting with "Much interest ... evidenced by all present."[25] This charter symbolizes the beginning of a broader community focus in the work

of the League. During the first years (1900-1912), their efforts had been primarily focused on children and public education throughout the city. By 1913, the League had placed reproductions of 545 pictures and 32 statues, valued at approximately $22,000, in the public schools. Membership had grown to well over 600, each paying dues of one dollar per year. With the new charter and name change, the League also restated its focus, as the "maintenance of the League comes from the community, therefore something should be done for the city."[26] This paved the way for promoting the idea of a permanent home for the League that would be a place to show art and continue their efforts to bring beauty and culture to the city of Houston. To this end, in 1914, the League decided to purchase two original works of art "as a neuclues [sic] for Houston's permanent collection of paintings."[27] Valued at $1400, *Autumnal Morn* by Charles Warren Eaton and *The Old Violinist* by Charles C. Curran had been purchased from the 1912 American Federation of the Arts exhibition the League hosted.[28] Both paintings were hung in the Carnegie Library as the desired permanent home for the new Art League was still ten years away.

Soon after the new charter, arrangements were made to lease a suitable space and, in 1914, the League held a 'house-warming' in its new temporary home in a Victorian mansion with a twelve-month lease negotiated with influential Houston businessman Jesse H. Jones for the sum of $75 per month. League President Guerard used the event to announce their new wider focus.

> ... our efforts in the public schools have been an important part of our work and we intend continuing this. But we expect to extend the scope of our influence. We are going out after the adults.[29]

Meanwhile, they continued their work "to locate a suitable, permanent home for the League" and by August of 1916, the League had acquired the deed to a piece of land from the estate of land developer George Hermann at the intersection of Main Street and Montrose Boulevard.[30] The site of the future museum was also in part donated through the assistance of the Cullinan family. Known as the "Dean of the oil industry" and the founder of the petroleum industry in Texas,[31] Joseph S. Cullinan wrote to then League President Mrs. Waldo saying that he has "decided to put you in a position to secure the land by Mrs. Cullinan and myself contributing the amount required, check for which is enclosed herewith." He then closed his letter with a request for anonymity.

I will hold you to strict accountability to refrain from any publicity, as to the source of this contribution, that being a question that is of no interest to our citizens, and, personally, I feel that I have been "featured" entirely too much in the newspapers recently.[32]

With the deed to the land in hand, the League held a dedication ceremony in 1917, and continued to hold a similar observance annually every April 12th until the opening of the museum building in 1924. Once construction was under way in November 1923 with a budget of $115,000 raised from private donors,[33] the League hired Mr. James H. Chillman, Jr. at a salary of $150 per month to be the director of the new museum. Mr. Chillman, the local newspaper declared,

50

... is well fitted for the post he has been selected for. He has the degree of M.S. in architecture from the Pennsylvania Academy of Fine Arts, he is a fellow of the American Institute of Fine Arts in Rome, and at present is associate professor of architecture at the Rice Institute. He has spent years in the study of architecture and in his chosen field of painting, watercolors.[34]

**James H. Chillman, Jr., 1920.**
From the Collection of the Museum of Fine Arts, Houston Archives.

Chillman, recalled former registrar Edward Mayo, "never considered himself full-time director"[35] as he continued in his full-time faculty role at the Rice Institute while serving as the museum's first director.

At the ground breaking ceremony, the then President of the League, Mrs. Florence Fall, declared that "the Houston Art Museum will stand as a symbol of law, order, and progress for Houston and for the whole southwest."[36] The original museum building was designed by William Ward Watkin, head of the architectural department at the Rice Institute, and Ralph Adams Cram, who had designed the Rice Institute buildings.[37] When it opened on April

12, 1924, the museum of Fine Arts, Houston was the first art museum building in the entire state of Texas. Guests were met by Mayor Oscar Holcombe, Houston Art League President Florence Fall, philanthropist Ima Hogg, and other League supporters. Reporters estimated that over one thousand individuals were turned away from the crowded opening reception.[38] The inaugural exhibition included works of art owned by prominent Houston families and the well attended opening event was marked by a dedicatory address by Homer Saint-Gaudens. The son of the well-known sculptor, Augustus Saint-Gaudens, and Director of the Art Museum of the Carnegie Institute of Fine Arts in Pittsburgh, PA, Gaudens added a bit of east coast prestige and art world legitimacy to the opening of the new Houston museum.

**South façade on opening day of the Museum, April 12, 1924.**
From the Collection of the Museum of Fine Arts,
Houston Archives.

### A relative absence of any tradition

Before the Museum of Fine Art opened in April of 1924, there were forty-eight objects in the collection – the majority of which had been donated by George M. Dickson.[39] In spite of this, the new museum ambitiously mounted 35 different exhibitions during the first year. Though the majority focused on paintings, there were two of prints and etchings, one of architecture, one of sculpture, and one of works by children. Museum staff included Mrs. Dee as the front desk secretary, two watchmen and a janitor in addition to the part-time director Chillman, though much was done on a voluntary basis by members of the League. Educational activities included a course on the History of Furniture taught by Dorothy Dawes Chillman as a "free-will offering." Limited to 20 members of the Art League, the class consisted of six talks and no fee was charged. A number of community organizations were granted use of the building for meetings on "special occasions," such as the Girls Musical Club, the Texas Chapter of the American Institute of Architects, Alliance Française, and the Current Literature Club.[40] The new museum was well attended as Mr. Chillman announced they had received over 60,000 visitors in the very first year.[41] It was open seven days a week, 10am to 6 pm on weekdays and 2-6pm on Sundays and holidays.

The museum, Mrs. Fall noted in her 1925 presidential annual report, was "sadly in need" of equipment. "We have a beautiful home, but it is somewhat of an empty shell," she continued. The John McKnitt Alexander chapter of the Daughters of the American Revolution had donated the museum's first major piece of "equipment" – a display case.[42] The emptiness of the space did not deter the League from continuing to enlarge. They immediately began raising additional funds and the museum added two wings in 1926, with the local chapter of the Federated Women's Clubs agreeing to furnish one of the rooms as a gift. As funds were not available to furnish the east wing, it was used to house a nascent museum school.[43] The Houston museum was the first institution in the city to offer classes in painting and other arts.

Like other parts of the South at this time, Houston was a racially segregated city in the early days of the museum. Cognizant of the role of the museum as a public institution with an obligation to serve the entire community, the League sought a means to be inclusive within the social norms of the time. One night per week was initially set aside for African American visitors, who

accounted for just over 20 percent of the city's population, but this was later reduced when attendance was deemed too low to justify weekly admittance, to only one night per month, the third Thursday of every month from 8pm to 10pm. The museum remained segregated until 1950.

Soon after opening, the Houston museum was receiving attention beyond the boundaries of the state. Mr. Chillman had encouraged the Convention of the Southern States Art League to hold their 1926 annual meeting in Houston, which brought a number of key figures in the museum world to town. Noted in a 1928 book by R.L. Duffus,[44] the Houston museum is discussed, along with those in Detroit and Toledo, in the section titled "Dusting off the Museums." Duffus describes Houston as having "the energy, aspiration, and relative absence of any tradition which characterizes the newest South. ... in its transient exhibitions, in its encouragement of picture buying, and in its educational activities, the institution is already notable."[45] Indeed, Houstonians were charting their own course, influenced and aware of how other communities were developing their art institutions, but determined to give the Houston museum a distinctive Texas flair.

Early museum exhibitions consisted primarily of locally organized shows and often included work borrowed from the collections of Houston's elites. As early as 1926, they began hosting an annual exhibition of work by Houston photographers which continued through 1953. In 1934, the museum added an annual show of the Houston Camera Club as well until 1954. Additionally, the museum hosted other annual shows, such as the *Houston Artists Annual Exhibition*, which was held every year from 1925 to 1960. Selected works were chosen from the exhibition to be accessioned into the museum's permanent collection through Purchase Prizes each year. From 1924 to 1941, the Southern States Art League organized an annual traveling exhibition of work offered for sale that was shown in the museum.[46] Donors were encouraged to acquire pieces for the museum, while other work was purchased by local collectors. In these early years, the museum's permanent collection was quite modest and developed mainly through donations by Houstonians, resulting in a rather eclectic mix that ranged from paintings to fine lace and antiquities, to Native American artifacts and western sculpture. There were no photographs added to the collection until 1965 when one *carte de visite* was included in a larger donation of several pieces of art.

Chillman served as the director until 1953 and during his tenure oversaw the construction of the initial building and the addition of three new wings — two built in 1926 with funds raised by Ima Hogg's brother Will,[47] and later a third in 1953, The Robert Lee Blaffer Memorial Wing, with a donation of $250,000 from the Blaffer family.[48] Lee Malone succeeded Chillman in 1954 to become the museum's first full-time director. Malone had studied Art History at Yale and then during WWII, he worked in the State Department and served in the Navy, after which he became the Director of the Columbus Gallery of Fine Arts in Ohio (1946-53) before coming to Houston.[49] Malone brought important traveling shows to Houston as well as mounting exhibitions that drew from significant public and private collections. In 1958, Malone also oversaw a re-modeling project that included the addition of a large open exhibition space, Cullinan Hall, and perhaps even more importantly, the installation of air-conditioning in the museum. Nina Cullinan, a generous patron of the arts and parks in Houston, provided more than $600,000[50] for the new hall in honor of her parents, Lucie and Joseph S. Cullinan, who had earlier given the Houston Art League the funds to secure the initial plot of land for the museum. With her donation, Nina Cullinan included two stipulations. First, that it be de-signed by an architect of "outstanding reputation and wide experience."[51] And second, that the space be available for occasional exhibitions of contempo-rary art organized by the Contemporary Arts Association (CAA).[52] Malone and the trustees chose Ludwig Mies van der Rohe, arguably one of the most im-portant modern architects of the twentieth century. Going against traditional museum design that most often included a garden courtyard, and perhaps appreciating the less than inviting weather of Houston's humid summers, Mies designed Cullinan Hall with a modernist aesthetic as a fully enclosed, glass-walled space with air-conditioning. To this day, Cullinan Hall, with its striking fan-shaped exhibition gallery of 10,000 square feet, remains a core architectural feature of the museum.[53]

By the middle of the twentieth century, Houston had grown in size to just over half a million (596,163 in the 1950 census) and had become the fourteenth largest city in the U.S. In addition to being the 'air-conditioning capital of the world' Houston also boasted the largest concentration of refineries and pet-rochemical plants in the world by this time. Economically, the city was defi-nitely on the world's radar in terms of oil production and refinement. Cultur-ally, however, Houston was still a "pretty dusty place," though many necessary

components of an arts infrastructure were developing. Perhaps most telling is a quote from the architect Ludwig Mies van der Rohe who, after completing Cullinan Hall, was commissioned to design a master plan for the expansion of the museum. "The first problem is to establish the museum as a center for the enjoyment, not the internment of art."[54] Clearly, the museum was established but had not yet achieved prominence.

Additionally, a number of other 'seeds' of Houston's cultural life had also been planted. What was to become the Houston Symphony had been initiated in 1913 with performances for 'fashionable society' spearheaded by philanthropist Miss Ima Hogg. Though the performances were irregular, the group persevered, and the orchestra was officially founded in 1936. The regional theater group was the next to form with the creation of the Alley Theatre in 1947. In addition to the Contemporary Arts Association founded in 1948 by seven Houstonians with a desire to bring new, modern art to the city, the Art League of Houston (not to be confused with the earlier Houston Art League which evolved into the museum) had also been created the same year by sixteen Houston artists. This cultural trajectory continued into the 1950s with the Foundation for the Ballet in 1955, though their first performance did not occur until February of 1959. The Houston Grand Opera was also founded in 1955 but was able to offer their first performance much more quickly in January of the following year (1956). Houston had resident companies for the symphony, theater, ballet, and opera — plus fine arts and contemporary arts museums by the 1950s. Indeed, Houston had the beginnings of an art world in place — wealthy patrons, a few working artists, a museum, various cultural organizations, and the beginnings of a post-secondary arts educational program.

## Education as a Catalyst
Arts education serves two important purposes in the development of an art world — the training of future artists and, perhaps even more importantly, the education of an audience for the arts. From the beginning, the women of the Houston Public School Art League had an educational focus that tied appreciation of art with moral virtue and the betterment of youth. Along with raising funds for the museum building and a permanent collection, they also began the museum school to offer classes in the studio arts. The Museum School of Art began in 1926 with the completion of a second wing to the main building and was the first institution to offer courses in painting and other arts in the

city. Similar to other important institutions, such as the Corcoran Gallery of Art (founded in 1869), the Museum of Fine Arts, Boston (1870), and the Art Institute of Chicago (1879), which included studio schools,[55] the Houston museum school became an important catalyst in promoting the arts in the city. A number of local artists remember beginning their arts education by attending the museum school. Houston artist Gertrude Levy Barnstone recalled being taken by her mother to meet with Mr. Chillman, the first director of the museum.

> I was about seven when my mother took me over to the Museum of Fine Arts and talked to Mr. Chillman and he said, 'Draw a circle.' And I drew a circle, so he put me in the class. It wasn't a children's class. It was an adult class that did oil paintings and nudes and all kinds of good stuff. It was very exciting and alive ... That was during the depression [1932], and it was all pretty vital and it was very exciting for me. It became my life.[56]

The museum school continued to operate out of the museum building until the 1960s, when enrollments had increased to the point that many classes were offered offsite in rented spaces. It became clear that the school needed its own building. Through a series of gifts by museum trustee and oilman Alfred C. Glassell, Jr., the school was moved to its own building in 1979 and was expanded to include a separate, junior school for children as well.[57]

Prior to the development of the museum in 1924, Houston only had one institution of higher learning — Rice Institute, which would later become Rice University. It had been established through the generosity of businessman William Marsh Rice as a gift to the city of Houston. Rice had reportedly been the wealthiest man in Texas at the time he created a trust to create a "competitive institution of the highest grade," though he stipulated that only white students would be permitted to enroll.[58] After the intrigue following Rice's murder by his valet in 1900 and legal challenges to the trust were resolved, the trustees were able to begin hiring staff and constructing the initial campus building. Rice Institute began offering classes in 1912 with 77 students and 12 faculty members. Though Rice Institute did not have an art department, later courses in painting and drawing were taught through the architectural program, where James Chillman, the first director of the Museum of Fine Arts, Houston, was on the faculty. Rice Institute remained Houston's only post-

secondary educational option for fifteen years until 1927 when the Houston Public School Board authorized the development of two junior colleges in the city: one for whites and one for African Americans.[59] Both two-year schools were overseen by the local school Board and were expected to cover all instructional expenses through tuition and fees.

The school for white students, Houston Junior College, began offering night classes at a local high school with an initial enrollment of 232 students and 12 faculty members. In 1934, Houston Junior College became a four-year institution under the formal charter name of University of Houston.[60] With the expansion, University of Houston founded various departments, including one for the study of studio arts. In 1935 Frederic Browne, a prominent painter who exhibited widely throughout the region, left his position teaching painting and architectural drawing at Rice Institute to become head of the newly-formed art department at the University of Houston. Browne was responsible for developing the early curriculum and recruiting faculty; he served until 1950, when he retired from his administrative duties though he continued to teach in the department he founded until his death in 1966.[61]

Surprisingly, when the first art department in the city began in 1935, University of Houston was a chartered four-year school without a permanent location. Classes were still being held in shared spaces around the city. In response to this need, Houston philanthropists Julius Settegast and Ben Taub donated the 110 acres to build the university a campus three miles southeast of downtown Houston. Funds for the first building were secured when oilman Hugh Roy Cullen donated money to construct the Roy Gustav Cullen Memorial Building in honor of his only son, who had died in an oil field accident. "I have only one condition in making this gift," Cullen is reported to have said, "The University of Houston must always be a college for working men and women and their sons and daughters. If it were to be another rich man's college, I wouldn't be interested."[62] A self-made man whose formal education was limited to a few years of public school, Cullen was wildly successful in the oil business and became known as the "king of the wildcatters."[63] A generous benefactor who believed in making education accessible to the less affluent, Cullen gave over $11 million to the university and by the time of his death in 1957, had given away more than 90% of his vast fortune.[64] Cullen's legacy continues to this day throughout the campus, including the first University of Houston build-

ing, still in use today, which opened for classes in 1939. Notably, the Roy Gustav Cullen Memorial Building is believed to have been the first building with air-conditioning on a campus of higher education in the United States.[65]

Across town, the same year Houston Junior College began, under the notion of separate but equal, the Houston Colored Junior College was also founded in 1927 and, like its white counterpart, it offered night classes in a shared space, Jack Yates High School. Enrollment for the first semester was 300 students for the summer session. However, enrollments dropped to 88 students in the fall of 1927, as many of the summer students had to return to teaching jobs.[66] In spite of its uneven enrollment patterns, the school continued to grow. It was later renamed the Houston College for Negroes in 1935, when it became a four-year college, the same year that the University of Houston was granted four-year status as well. In 1947, the name was again changed to Texas State University for Negroes and its management was transferred from the School Board to a separate Board of Regents. Hugh Roy Cullen, University of Houston's benefactor, also donated 53 acres of land in Houston's Third Ward to the school, and through the generosity of two large donors, Mrs. T.M. Fairchild, in memory of her late husband, and the C.A. Dupree family, the university was able to construct its first permanent building on the new campus.[67] In 1949, the university brought the painter John Biggers to join their faculty, charging him with the development of their art department.

As in other cities in the South, most institutions in Houston were still segregated at the time. In 1950, when John Biggers was awarded the purchase prize in a local competition at the Museum of Fine Arts, restrictions on Black attendance did not permit him to enter the building to claim his prize. At the time, African Americans were admitted only on Mondays when the museum was closed to other patrons. In response to Biggers not being able to claim his prize, founding director James Chillman removed race-based admission policies and fully integrated the Museum of Fine Arts.[68] In spite of the challenges inherent in the Southern city, Biggers continued making his art and working to build the art department. By 1950, Joseph L. Mack and Carroll Harris Simms had also joined the faculty. Working together, they were able to draw the attention and support of Houston philanthropists Susan McAshan as well as Jane Blaffer Owen, who was also behind the restoration and development of the utopian community, New Harmony, in Indiana. Simms remembers being called outside to meet with a woman in a car:

She said, "Here's a check, my check for $100. You give this to Dr. Lanier and tell him that this is my promise to get a kiln and that your students will have everything they need to work with." I smiled and said thank you, and she disappeared in her little car. She didn't dress like she was a millionaire. She didn't drive a car like she was a millionaire ... Sure enough, it wasn't two weeks later before [Dr. Lanier] called me one morning and said, "Simms, Mrs. McAshan called me this morning and told me to tell you to get a kiln and get the same kind of potter's wheel they use at Cranbrook, and get everything you need for your students to make pottery."[69]

In true Houston fashion, McAshan, Owens and others were instrumental in making sure students had the supplies and equipment they needed. In 1951, the institutional name was changed yet again to its current name, Texas Southern University, after students petitioned the Texas state legislature to remove the phrase "for Negroes."

So by the middle of the twentieth century, both public universities in the city, Texas Southern University and University of Houston, had growing studio art departments. At Rice University, painting and drawing courses were taught through the architecture program, while the museum school provided art courses to the public. Interest in the arts was growing but photography had yet to become part of the discussion.

# Chapter 3

# The Texas Medici:

# Modernism Comes to Houston

While interest in fine arts was growing in Houston by the middle of the twentieth century, such notions about art were generally centered on classical works. This approach was about to be challenged. It would be hard to overstate the importance of the arrival in 1941 of Paris natives Jean and Dominique

**John and Dominique de Menil, 1962.**
Photo: Adelaide de Menil. Courtesy of the Menil Archives, the Menil Collection, Houston.

de Menil to the history of the arts in Houston. Their influence in Houston is legendary and has been felt in a variety of arenas. Wartime refugees, the de Menils maintained residences in Paris and New York, but ultimately settled in Houston, where the headquarters of Schlumberger had relocated. Dominique had been born Dominique Isaline Zelia Henriette Clarisse Schlumberger and was heiress to the lucrative Schlumberger oilfield services company. Jean, who later anglicized his name to John when he became a u.s. citizen in 1962, was born Jean Marie Joseph Menu de Menil, the son of the Baron Georges Auguste Emmanuel Menu de Ménil.[1] As is befitting European elites, the two met at a party at Versailles in 1930 and married the following year in Saint Dominique-Saint Matthieu Chapel in Paris, honeymooning in Morocco.[2]

In spite of her background, Dominique reportedly enjoyed reminding people that she and John did not start out wealthy. Even though John had been born into a titled military family, he had dropped out of school to help support his family and was working in a bank when they met. It wasn't until 1939, eight years after their marriage, that John joined her family's business at the insistence of Dominique's uncle, Marcel Schlumberger. When the Nazi invasion of France occurred in 1940, John was in Romania on Schlumberger business and upon hearing the news traveled directly to the United States. In Paris, Dominique, pregnant with their third child and unable to travel, took her two older daughters, Christophe and Adelaide, and fled to her maternal grandmother's home in the southwest of France to await the birth of the child. Once their son Georges was born, Dominique and her three young children went to Spain where, after great difficulties in obtaining visas, they boarded a freighter for Havana.[3] John went to meet his family in Cuba and together the de Menil family made their way to Houston.[4]

## The Texas Medici

John and Dominique had a strong and wide impact on the cultural life of Houston. Their interests were varied and far-reaching, earning them a reputation as the Texas Medici.[5] In 1941, when the de Menils arrived, "Houston was a provincial, segregated southern city with 390,000 citizens."[6] Friends wondered why they "were reduced to living in such circumstances, so far removed from all civilization."[7] Perhaps they were taken by the sense of opportunism the new world city represented, the lack of entrenched traditions, or the great potential a serious contribution might make. Dominique, however, was particularly struck by the absence of art and architecture like that she had grown up with,

In Europe the poorest person can enjoy the most beautiful works of art without having to spend a cent — art is everywhere — there is not a village that doesn't have a lovely old church, an impressive castle. In Paris there is Notre Dame and the Louvre available for everybody. Art is ... just like the air one breathes. We become conscious of it when we lack it. I became conscious of art and particularly beautiful architecture when we made our home in Houston.[8]

In Houston, the de Menils found their *tabula rasa*[9] upon which they could shape their ideas of modernism. Responding to a New York friend who expressed surprise in their decision to make their home in the "cultural desert" of Houston, John is reported to have answered "It's in the desert that miracles happen."[10]

Once they settled in Houston, the de Menils began their patronage of the city in earnest and became tireless advocates of Houston's development into a vibrant, modern city.[11] Indeed, the intensity with which they set about bringing forth their vision of the importance of art in life is nothing short of amazing. The cultural transformation John and Dominique sought, however, was not readily embraced by the local benefactors.

Very old Houston money was agricultural, like the cotton fortunes of Anderson, Clayton & Company and of William Marsh Rice (he funded the Rice Institute in 1912). John Henry Kirby, who started the Houston Oil Company and the Kirby Lumber Company in 1901, was the city's first industrial millionaire. The families of the founders of Humble Oil (organized in 1917) were old oil money — the Blaffers, Fondrens, Wiesses, Farishes, and Sterlings. Those families were the first patrons of the arts in Houston; along with oilman and developer Joseph Cullinan ... they formed the nucleus of support for most ... institutions of culture in town.[12]

Wealthy Houstonians were not especially receptive to the modern art the de Menils were championing and were said to have closed ranks against the newcomers. "Not only were they considered radical, but really different. They had a foreign accent, and political views that for Texas were extremely liberal," recalled Isaac Arnold, Jr., former museum trustee and head of Quintana Petroleum.[13] Undeterred, John and Dominique began a campaign of benefaction, supporting endeavors promoting modern art, education, social justice, and spirituality throughout the city.

Beginning in 1945, with the purchase of their first painting by Cézanne, *Montagne* (Mountain), 1895, for a mere $300 from a New York City gallery, the de Menils went on to amass one of the largest and most important contemporary art collections.

> "I would never have started collecting so much art if I had not moved to Houston," Dominique explains in heavily accented, graceful English. "When I arrived in Texas there was not much you could call art. Houston was a provincial, dormant place, much like Strasbourg, Basel, Alsace. There were no galleries to speak of, no dealers worth the name, and the museum..." she trails off helplessly. "That is why I started buying; that is why I developed this physical need to acquire."[14]

In their pursuit of modern art, John and Dominique were guided by a Dominican priest, Father Marie-Alaine Couturier, whom they had met in Paris shortly after their marriage. Couturier believed in the spiritual aspects of modern art and encouraged the de Menils to buy art as a moral duty. This was in direct contrast to the puritanical thriftiness Dominique had grown up with in her Protestant household. "For many years I felt that purchasing art was a *slightly bad* action, too pleasure seeking, too hedonistic," Dominique wrote for a catalog, "Father Couturier made it almost a duty to buy art we could afford."[15] Couturier counseled the now Catholic Dominique — she had converted from Protestantism to Catholicism when she married John — that collecting art could be a spiritual vocation. He argued that "they should be acquiring great works and allowing them to enrich the lives of others, just as they themselves had been enriched in the galleries and museums of New York."[16]

Prior to entering the priesthood, Couturier had studied art and worked as a stained glass window designer in the *Atelier des Sacrés Arts* (Studio of the Sacred Arts). After ordination, Couturier founded and edited an influential journal of Christian art, *L'Art Sacré,* which was highly critical of the state of church art. Couturier advocated a new approach to ecclesiastical commissions that he hoped would "reverse the trend toward insipid sacred art."[17] Trusting in providence, Couturier believed that all true art revealed something of the sacred and all great artists were great spiritual beings in their own way. Thus, for Couturier, art was ecumenical and nondenominational, transcending ideological divisions. He argued that the church leaders should

enlist the most important artists of the time for church projects regardless of their personal religious beliefs. Couturier's efforts cleared the way for a number of such projects, including the Matisse commission of the *Chapelle du Saint-Marie du Rosaire* (1949-1951) in Vence, Le Corbusier's *Chapel of Notre Dame du Haut* (1955) at Ronchamp, and the work of Braque, Matisse, Léger, Chagall, and others in the *Eglise Notre-Dame De Toute Grâce du Plateau d'Assy*, (1938-1949).[18]

With Couturier as their guide and taking it as their spiritual mission and moral duty, the de Menils set out to bring modern art to Houston. In 1947, John joined the Accessions Committee at the Museum of Fine Arts, Houston, and became active in the institution.[19] Family friend and University of Houston regent (1963-1979), Aaron Farfel, remembers John "begging and pleading" with the museum staff to let him hang some modern art "but he was refused every single time."[20] Undaunted, the de Menils decided they would bring modernist architecture to Houston and commissioned Phillip Johnson to design a home for them in the tony Briarwood section of River Oaks. At the time, Johnson was a relatively unknown 42 year old disciple of Mies van der Rohe, the architect who would design the important Cullinan addition to the Museum of Fine Arts, Houston. In 1948, when the de Menils approached him, Johnson was just breaking ground on his soon to be famous Glass House in New Canaan, Connecticut, which would eventually put his name on the architectural map. Given a tight budget of $75,000, the home Johnson designed for John and Dominique was one of the first International-style residences in Texas. The long, lean, flat roof house of 5,500 square feet was built around a glassed-in courtyard and sits at the end of a curving driveway. The clean stark lines stand in pointed contrast to the neighboring mansions of old Houston and caused quite a stir when it was completed in 1951. Dominique was warned that she would never be able to sell such an odd house. She reportedly replied that she wasn't concerned because she wasn't building to sell.[21] And neither she nor her heirs have — the house is still owned by the Menil Foundation.

### Contemporary Arts Association

In May of 1948, a group of seven Houstonians founded the Contemporary Arts Association (CAA). Drawing artists, architects, and collectors together, the CAA was volunteer-run and supported through membership dues. The CAA, which

would later become the Contemporary Arts Museum Houston (CAMH), was organized specifically to present new, modern art to the city by offering exhibitions, lectures, and other activities. John de Menil accepted an invitation to serve on the initial Board of this fledgling organization. Early exhibitions were organized on a rotating basis by members and relied heavily on local art collections. However, when it was John and Dominique's turn as curators in 1951, they decided they should do something "really first class" so they decided to mount an exhibition of Vincent van Gogh's work. Dominique recalled, "I with my incredible naiveté ... I went straight to Theodore Rousseau at the Metropolitan Museum of Art and asked to borrow his van Gogh sunflowers. And then I asked him to write something for the catalogue and I never offered him any honorarium because I didn't know you were supposed to!"[22] The de Menil-organized *Vincent van Gogh* exhibition made Houston the first U.S. venue outside New York or Chicago to mount a solo show of the artist's work. The de Menils were also able to include four van Gogh paintings that had never before been seen in the United States.[23]

By 1950, the CAA had moved into its own building near downtown.[24] The building had been paid for by John de Menil and built on land leased from museum trustee John Blaffer[25] for $1.00 per year.[26] It was in this space that the CAA organized their well-remembered *Vincent van Gogh* exhibition, February 4-25, 1951. John and Dominique had secured the loan of twenty-four well-known paintings through letters and visits with numerous private collectors. The de Menils personally traveled by train to pick up the paintings and travel with them back to Houston. At the close of the show, they returned the work to the lenders also personally by train.[27] An impressive feat for such a young, volunteer organization, the exhibition reportedly drew international attention as well as 6,000 visitors during the first week. Like the transportation, security for the van Gogh work was also provided by the CAA volunteers,[28] and they took turns sleeping in the building to protect the paintings throughout the exhibition. The show reportedly caused quite a bit of excitement in Houston, artist Stella Sullivan recalls of the CAA exhibition, "the first time I ever saw a real-live van Gogh was at the one-man show of van Gogh that they had."[29] An ambitious organization, the CAA also mounted pioneering exhibitions of the work of Joan Miró, Alexander Calder, and Max Ernst. Additionally, they showed the work of local university professor John Bigger and his students.

Soon after the success of the *Vincent van Gogh* show, the CAA had arrived at a dilemma that many arts organizations face — whether to strive for recognition and acceptance from the broader art world or remain focused on supporting local interests and artists. This tension inherent in the aims and aspirations of many arts groups is a theme that will occur again and again in Houston, though it is hardly unique to this city. When the CAA arrived at this juncture, John de Menil was in favor of raising funds to hire a full-time director who would lead the organization to become a nationally recognized contemporary arts center. For many CAA Board members this seemed rather audacious and premature, as the Museum of Fine Arts, Houston still only had a part-time director, while others believed firmly that the role of the CAA was to support and develop Houston artists.[30] Within the Board, a compromise was struck and it was decided to invite well-known curator Douglas MacAgy to evaluate their organization. Because he was too ill to travel, he suggested his wife Jermayne could conduct the assessment. Heralded as "the art world's answer to Rosie the Riveter," Jermayne MacAgy had distinguished herself as the youngest museum director in the country when she served as acting director at the California Palace of the Legion of Honor in San Francisco, 1943-1946. Described as "a wonderful comet … [full of] vim and vigor and gusto," MacAgy was also applauded as a curatorial genius for her abilities to juxtapose similarly themed pieces from very different moments in art history. A San Francisco Chronicle article reported that "There is probably no museum in the United States where the art of displaying art has been developed to so fine a pitch" under her tenure. By all accounts, MacAgy was a star and made quite an impression during her visit to Houston. Assessing the four-year-old association, she recommended in her lengthy report that they hire a full-time director. Though the CAA Board did not initially accept her recommendation, a few years later Jermayne "Jerry" MacAgy was hired as the first director of the CAA in 1955.[31]

In general, 1955 seems to have been the tipping point for the arts organizations in Houston. By this time, the Symphony, the Alley Theatre, the Ballet, and the Opera had all been organized and were in various stages of development. Additionally, the Museum of Fine Arts, Houston had just hired its first full-time director, Lee Malone, in 1953. The Contemporary Arts Association (CAA) was in transition having just lost their lease on the Blaffer land. Soon a similar $1 a year lease agreement was made with Prudential Insurance Company. The CAA's original building was then moved to a new location at 6945

Fannin Street, where it was expanded and a sculpture garden added. The President of the CAA at the time, Preston Boulton, recalled,

> [The] building was moved out to the Prudential site ... they picked it up and moved it right down Main Street. It was a wonderful party. All of us were riding on the truck, you know, Nina Cullinan, Winifred Safford and all of the early people. And Prudential paid for actually putting it there on their grounds.[32]

It was September of 1955 when Jermayne MacAgy arrived in Houston to begin her position at the CAA. With a doctorate from Western Reserve University in Cleveland, Ohio (later renamed Case Western Reserve), she was the first professionally trained art historian in the city.[33] When she arrived, the exhibition schedule for the year had already been set by the exhibition committee and included bringing the legendary show *The Family of Man*, organized by Edward Steichen for the Museum of Modern Art, to Houston in January of 1956.[34] In MacAgy's four years at the CAA, with a budget of less than $20,000 per year, she mounted 29 exhibitions, each with a catalog, a number of which received national attention. Known for innovative and provocative installations, MacAgy continued her unique and compelling approach to displaying art in Houston, such as her *Monumentality in Modern Sculpture,* which was comprised of works eight inches or smaller. Her exhibitions at the the CAA demonstrated her wide and varied interests with shows on Calligraphy, Graphics, Yard Art, and Films. Additionally, MacAgy did solo exhibitions of Mondriaan and gave Mark Rothko his second solo show. Five of MacAgy's shows were held in the Museum of Fine Arts, Houston, the most notable being *Totems Not Taboos* (1959), an exhibition of primitive art organized for the inauguration of the new 10,000 square foot Cullinan Hall that was hailed as a "remarkable and important exhibition."[35] MacAgy had included objects from Australia, French Guinea, French Equatorial Africa, and Melanesia and arranged them in her unique "really extraordinary"[36] manner, which included placing work on tall white columns interspersed with numerous potted plants for an aestheticized organic environment.

MacAgy brought a new sensibility to Houston. Karl Killian, a former student, remembers "Jerry was an oversized individual ... she had this great visual instinct. ... She saw everything in terms of arrangements."[37] Dominique de Menil wrote of her that she "was a master of seduction. She could cast a spell on practically anything."[38] However, MacAgy failed to cast her spell on the Board of the CAA

as they decided not to renew her contract when it expired in 1959, stating there was insufficient financial support for her salary. A group of MacAgy supporters quickly formed, no doubt led by the de Menils, seeking a means to keep her in Houston. The group first approached the museum proposing a three-year position for her that they would underwrite. The museum declined the offer as their current director, Lee Malone, was also not going to have his contract renewed. John and Dominique then approached University of St. Thomas, a small Catholic school that the Basilian Fathers had opened in 1947, about a

**Dominique de Menil and Jermayne MacAgy, 1960.**

Photo: Maurice Miller. Courtesy of the Menil Archives, the Menil Collection, Houston.

position for MacAgy. The de Menils had been involved with St. Thomas from the early 1950s and had become serious benefactors in 1956 when they offered to support the construction of campus buildings — if St. Thomas would hire Phillip Johnson to design them. John de Menil also had begun acquiring additional nearby property for the school as well.[39]

The de Menils were 'hands-on' benefactors. As with the CAA, the de Menils didn't just write checks, they got involved with the institutions they supported. At the University of St. Thomas, Dominique was on the Arts Council and in 1958 had proposed to give the de Menil art collection to the University on extended loan for teaching purposes. Seeing a need for art history education in the city, Dominique encouraged St. Thomas to develop a program, lamenting "In the whole southwest there is no good art department or art historian to be found."[40] Thus MacAgy, with de Menil backing, was soon hired to be the chair of St. Thomas's new art department and the de Menils had agreed to underwrite the department's entire budget.[41] Immediately, the new department launched an ambitious schedule including courses, visiting artists, lectures, and exhibitions. Over the years, the program hosted many important artists who came to town at the de Menils' invitation, like Marcel Duchamp, René Magritte, Roberto Matta, Max Ernst, and Andy Warhol, to name only a few. Moreover, MacAgy in her new role would also curate three exhibitions a year for the museum, two of which would be shown in the expansive Cullinan Hall.[42] After the raving success of the *Totems Not Taboo* installation, John de Menil must have finally felt he was making some headway introducing modern art into the museum when he was able to negotiate this opportunity for MacAgy.

At St. Thomas, the Arts Council, chaired by Dominique, began integrating art into the life of the university. They installed art in the public buildings and initiated an art rental program where posters, prints, and reproductions could be lent to students or staff for fifty cents per semester.[43] The de Menils continued to support St. Thomas broadly, providing the funds for the Art Department as well as for the faculty in other areas. Their involvement was amplified in 1964 when on February 18, just four days after turning fifty, Jermayne MacAgy died suddenly of diabetic shock. Dominique, who had been actively engaged with the department, stepped in to finish MacAgy's work by teaching her courses, completing her exhibitions, and taking over the administrative duties as acting chair. Under Dominique's leadership, the department continued to grow, attracting more students, and hiring more faculty members. Art Historian

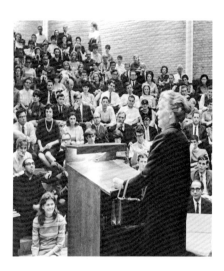

Dominique de Menil speaking to students at University of St. Thomas, 1967.
Photo: Hickey-Robertson. Courtesy of the Menil Archives, the Menil Collection, Houston.

Bill Camfield had joined the faculty the previous fall and after MacAgy's death he was given the responsibility for the curriculum, while Dominique oversaw the exhibition schedule, lectures, and events.

Within the larger Houston community, the de Menils started two groups to broaden appreciation for contemporary art and to encourage the development of collecting activities in the city. Members of the Print Club would have the option to purchase contemporary prints and signed lithographs at cost.[44] Using their connections and relationships in New York City and across Europe, the de Menils carefully selected prints of important emerging and recognized living artists that ranged in price from ten dollars to a thousand dollars.[45] Membership dues were five dollars per year or one dollar for students. For those with deeper pockets, the de Menils established Art Investments, Ltd., a syndicate of ten members each of whom contributed $10,000. Art was purchased collectively and then would rotate among the members' homes every six months. "Houstonians," John said at the time, "would think nothing of spending $100,000 for a prize bull, but they would not pay $1,000 for a work of art."[46] Art Investments, Ltd was "John's baby," long-time de Menil staff member Geraldine Armanda recalls, "he wanted to introduce his businessmen to contemporary art because they were buying old master prints ... he wanted to introduce them to contemporary art, to the Surrealists and the French modern painters, so he started this art investment group ... they would meet at a very exclusive restaurant, formal dinner wear in a private room, and they would have a staff who installed the artwork and they would select what they wanted to take home." Prior to this, the de Menils had also encouraged a successful rental program at the CAA so that members could live with art for

a modest cost. It was like a "lending library" for art, painter Mildred Dixon Sherwood recalls, "you'd put your paintings in it and people could rent them by the month."[47] Given Dominique's belief that art's importance was "just like the air one breathes,"[48] she was involved in innovative ways to widen support and appreciation among Houstonians of all income levels.

### The Media Center

With remarkable foresight, in 1967 the de Menils decided to begin a Media Center at the University of St. Thomas for the study of film and images in society. Analysis of contemporary media as a separate field of study was quite new at the time. Marshall McLuhan's ground-breaking book, *Understanding Media*, the cornerstone of media theory, had only been published three years before, in 1964. John de Menil's interest led him to persuade Gerald O'Grady, who was teaching in the English department at Rice University, to come to St. Thomas to set up a program to investigate the influence of television and film in society. During his five years at Rice, O'Grady's interests had moved from

**John de Menil, Jim Love, and Dominique de Menil (standing) at Art Investments, Ltd. dinner party to select art at the Ramada Club, Houston, 1965.**
Photo: Hickey-Robertson. Courtesy of the Menil Archives, the Menil Collection, Houston.

language and literature to film and media, which may have had something to do with his not getting tenure at Rice. He had become fascinated with the new "mediacy" and was advocating for "new ways of experiencing, understanding, and creating media."[49] Having left Rice, O'Grady was on his way to teach at State University of New York (SUNY) in Buffalo when John and Dominique asked to meet with him. Initially, the de Menils hoped he would agree to teach a cinema class at St. Thomas University, where they were establishing an Art Department. O'Grady declined but offered to write a "white paper on the development of film studies in Houston."

His white paper became more of a manifesto, O'Grady recalled, "arguing for the use of film to (1) educate college students to become the field's first cohort of academics, (2) initiate experiments in teaching elementary, junior high, and high school students, and (3) provide continuing education courses for the general public."[50] Finding O'Grady's approach compelling, John and Dominique proposed to implement the plan but only if O'Grady would spearhead the initiative. When SUNY Buffalo granted O'Grady a semester's leave of absence, he accepted the role of founding director of the newly-formed Media Center in 1967. Almost immediately, O'Grady began a whirlwind of film studies programs throughout Houston schools and public film screenings, in addition to teaching three classes at St. Thomas University — History of Cinema, World Cinema, and Experimental Film.[51] By spring semester, his leave from SUNY had ended, and O'Grady began commuting weekly between Buffalo and Houston with de Menil travel funds.

In 1968, the Media Center expanded to hire Stan VanDerBeek, an artist in residence at the Center for Advanced Visual Studies at M.I.T., to teach filmmaking, and O'Grady's former student at Rice University, Geoff Winningham, to teach photography courses. Geoff had just finished his master's degree in photography at the Illinois Institute of Technology's Institute of Design which had been founded by László Moholy-Nagy, a photographer and painter, and former Bauhaus professor. While there, Geoff studied with important photographers Aaron Siskind, Harry Callahan, and Wynn Bullock. Excited by the prospect of a full-time teaching job and working with his former professor, Geoff returned to Houston to begin teaching photography at University of St. Thomas in the fall semester of 1968.

### "A place of dreams and opportunities"

Thus, Houston's first university-level course in photography was due to the de Menils' vision and generosity. Geoff remembers this as an astonishing time in many ways. Houston, he found, was a "great place of dreams and opportunities" with seemingly endless possibilities. Enthusiastic de Menil support allowed him to purchase whatever equipment he wanted. "There was no budget ... I could do whatever I wanted in the way of setting up courses and we could take students from the greater community ... I was told it would be a good idea to have a guest artist program ... and that the Museum of Modern Art was ready and willing to lend us a show if I could simply identify what we would like to have come to campus."[52] Geoff wasted no time; *Images of Light*, curated by John Szarkowski and on loan from MOMA, was exhibited at St. Thomas in January of 1969. In conjunction with the exhibition, Geoff organized a lecture series that included curators Peter Bunnell, Nathan Lyons, and John Szarkowski with photographers Robert Frank, Arthur Siegel, Frederick Sommer, and Jerry N. Uelsmann. Within the first year of the Media Center, they also had experimental filmmaker Stan VanDerBeek as artist-in-residence, Jean-Luc Godard came to present his film *La Chinoise*, Andy Warhol premiered his film *Imitation of Christ*, and they sponsored Houston's first film conference at the famous Shamrock Hilton, which drew important scholars and practitioners in the field.[53] When VanDerBeek left at the end of 1968, O'Grady hired filmmaker James Blue to head the cinema studies courses. "Blue had graduated first in his class in film production from the prestigious Institut des hautes études cinématographiques (IDHEC) in Paris," had won the 1963 Critic's Prize at the Cannes Film Festival for his first feature film, and personally knew "all the young film directors of the French New Wave." With Blue teaching filmmaking and Geoff heading up the photography program, the Media Center's reputation and outreach continued to grow.[54]

Though primarily residing in Houston, John and Dominique, in addition to their relationships with arts groups in the city, maintained a wide and varied network of highly influential people in the arts throughout the world. In 1962, John became a trustee at the Museum of Modern Art in New York City and remained so until his death in 1973. Earlier in 1960, he had also joined the Board of the Museum of Primitive Art also in New York City. The de Menils had a townhouse on East 73rd street that "served as a base for New York friendships with artists, dealers, scholars, and curators not only in the field of modern art, but in ancient and non-Western art as well."[55] Additionally, they had homes in

Geoff Winningham (standing far left) teaching his photography class in downtown Houston, 1971. From the collection of Geoff Winningham.

Paris and Pontpoint, France, which facilitated continued relationships with French institutions and artists throughout the globe. They were generous in their support of these institutions, assisting with the purchase of important additions to the collections, and many commissions for the artists they believed in. This broader, global network also brought interesting people and opportunities to the Houston art community. John and Dominique "were very generous and very much aware of the Houston environment and [wanted] to elevate people's experiences," former de Menil archivist Geraldine Armanda explains; they were "bringing in performing artists as well as visual artists and scholars and newspaper people, anyone who had information." The de Menils were as munificent with their social capital as they were with their economic resources — both of which were highly instrumental in the development of the arts community in Houston.

With their philanthropic gestures came clear ideas about how they thought things should be done. Artist Mildred Dixon Sherwood recalled the de Menils "were very concerned with controlling the arts scene in Houston, but they ... stirred things up, there's no question, and they brought good people here. I don't think Houston was ready for some of them, but they brought them here anyway."[56] The de Menils were somewhat infamous for supporting organizations like the CAA for example, and then withdrawing their support when an impasse was reached as to what direction the group should take. In late 1968, when just such a moment of discord occurred with the University of St. Thom-

as, the de Menils moved the art department and the media center across town to Rice University. John and Dominique had been pushing St. Thomas, encouraged by Vatican II ideals, to allow lay members to serve on their Board, but this did not sit well with the Basilian brothers, who wanted to maintain their role as a Catholic-run university. The separation between the university and the de Menils was completed within a year and the transplanted art department began at Rice in the fall of 1969. The de Menils were able to retain much of the works of art in the teaching collection, previously donated to St. Thomas, by exchanging adjacent real estate John had been acquiring for their needed campus expansion.[57]

At Rice University, the de Menils had agreed to underwrite the program costs for the first five years and then it would fall to the university to continue its support. Moving into two new buildings constructed with de Menil funds on the outskirts of the Rice campus, the art department was folded into Rice's department structure while the Media Center and the Institute for the Arts, with Dominique serving as director, remained separate. As Rice was uninterested in having Gerald O'Grady back on staff, his involvement with the Media Center ended with the move.[58]

**Rice Media Center and Rice Museum, Rice University, Houston.**
Photo: Hickey-Robertson. Courtesy of the Menil Archives, the Menil Collection, Houston.

At the time of the move, John had managed to negotiate the university as one of only three venues for an exhibit from MOMA, *The Machine As Seen at the End of the Mechanical Age*. Scheduled to open in March of 1969, the de Menils needed an exhibition space urgently and within three months the Rice Museum, a corrugated metal building that came to be known fondly as the Art Barn, was constructed and the MOMA show installed.[59] Once again, the de Menils began their ventures with a splash. Dominique de Menil, writing in the new Institute's first newsletter, declared,

> The Institute for the Arts has now settled in alongside the Department of Fine Arts at Rice University. After hectic months of moving spiritually and bodily from the University of St. Thomas to Rice, we are happy to be able to concentrate once again on developing the Institute's programs. We will continue to expand and diversify our exhibitions, films, and lectures to highlight the best traditions of history and the innovative trends of today. Our aim is to excite the campus and Houston with new ideas and new approaches to art.[60]

With this foray of modernism into the museum, the various initiatives to develop the city culturally seemed to be blossoming, and hints of the diverse and vibrant art world to come were almost recognizable. Efforts were led, sometimes kicking and screaming, into modernism under the de Menils' determined interventions. Looking back, "... any sign of modernism in Houston today — the glass towers of the skyline, the abstract paintings in museums and galleries, the new music and dance in concert halls — is there largely because of the battle the de Menils waged to challenge and push forward the tastes of the city."[61] Moreover, local artists and supporters had built up the CAA that became the Contemporary Art Museum Houston (CAMH). By this time, the Museum of Fine Arts had some professionally trained staff along with a strong, committed group of trustees. Galleries were beginning to pop up, supported mainly by institutional collectors, but some individuals were buying art as well. Clint Willour, photography collector and supporter, remembers that it seemed that everything was happening: "It was just this real incubator period in the early to mid-70s." The economy was booming and John de Menil's prediction of a desert miracle was blossoming. Yet for fine art photography, things were just beginning ...

# II    Visionaries and their Decisive Moments

# Chapter 4

# Houston's Art World —
# "a small club-like thing"

In the 1970s, Houston's art world was small and the photography community even smaller. The de Menils were promoting and supporting modernism, the three universities now had art departments, and various arts organizations and a few galleries were active in the city. For the visual arts, the Museum of Fine Arts and the Contemporary Arts Museum were the important supporting organizations. "It was a smaller art community, there were fewer galleries, so the openings were quite special," gallerist Betty Moody explains. "Everybody got dressed up to go to them — they were major events." Openings were "a small club-like thing," Anne remembers, "where people from the art world came to see each other." This made it easy to meet anyone who was anybody in the art community.

## The Gallery Scene
Galleries in Houston have historically been rather hit and miss financially. In the 1960s, Houston had a number of art galleries — New Arts, Kiko, Cushman, and Dreyer Galleries that did not last long but played a key role in helping shape prominent Houston collections. Additionally, Louise Ferrari was an important art consultant who worked with the likes of collector and philanthropist Audrey Jones Beck.[1] In addition to the short-lived galleries, Houston had three other prominent art galleries, none of which showed photography, and none of which are still in business: Meredith Long, DuBose, and David Galleries. The longest running gallery in Houston, the Meredith Long Gallery opened in 1957 and closed 63 years later in 2020 with the owner's death. Specializing in 19th- and 20th- century art, critic Peter Schjeldahl called Meredith Long Gallery "the Woolworth and Tiffany of Houston dealers, the biggest, busiest and most eclectic."[2] In the mix, Long carried work by Houston artists like

painters Dorothy Hood, Richard Stout, and Bill Anzalone in addition to many other artists from elsewhere. Dianne David, daughter of a "self-made drilling mud tycoon" opened David Gallery in 1963 and "enlivened the Houston art scene with creative exhibitions."[3] Dianne focused on contemporary work and her stable included her brother Dorman David as well as Bob Camblin, Lucas Johnson, Earl Staley, Larry Rivers, Seymour Leichmann, Guy Johnson, and others. David Gallery closed when Dianne left Houston in the early 1980s.[4]

One of the early galleries in Houston, DuBose Gallery, was run by Ben DuBose and had begun in a side room of the Bute Paint Company where Ben had been employed. "Artists came to see him all the time to buy paint and supplies," Betty Moody remembers, "so Ben opened a little space in a side room, and it grew into James Bute Gallery." As the little room became more successful, Ben DuBose decided to open his own place in 1966. DuBose Gallery primarily handled Texas artists though from the beginning Ben had a diversified business model. In addition to framing services, he also imported "marvelous antiques … primarily English, Welsh … beautiful old Jacobean chests and things" from Europe, Betty explains. Ben is remembered as being the first person to show Aubusson tapestries in Houston. He also sold Pre-Columbian, Oceanic and African art. The frame shop was the economic backbone of his business and his clients included many of Houston's elite, including Dominique de Menil and many of the Menil Print Club members.

In 1969, Ben hired Nashville native Betty Moody, who had recently moved to Houston. At the University of Kentucky, Betty had studied art and pursued painting. She also worked at the University Art Gallery. "I loved working in the gallery, and I loved installing the shows," Betty explains. Working at DuBose Gallery, Betty learned a lot from Ben. "He was really a wealth of knowledge in so many ways for me; I just loved him," Betty recalls, "he was a great character ... he called me child, child or chief, it had to be chief for a guy and child for a woman." Ben had a unique way of displaying the art mixed in with the furnishings and other items. "He would install the art and have furniture with Pre-Columbian art and Oriental rugs — he made it look like a home." However, the main challenge Betty remembers from the four years she worked for Ben "was that you had to convince people that they should buy art ... [from] people making art in Texas." Unfortunately, Ben died of cancer in the early 1970s and Betty decided to leave the gallery — it just wasn't the same without Ben. Surviving a few years in the hands of others, the business was ultimately absorbed into another gallery and disappeared in the early 1980s. During her time at DuBose, Betty Moody learned what was to become her trade well under Ben's tutelage. She opened Moody Gallery in 1975 and, like Ben, specialized in representing Texas artists. But unlike DuBose, Moody Gallery is still in business and going strong.

### Houston's first photography gallery: Latent Image

Since its invention, photography has always had enthusiastic followers and collectors. The London art gallery of P. & D. Colnaghi was selling images to collectors as early as the 1850s.[5] In Houston, though, collecting photography had a much slower start. Geoff Winningham was 25 years old and a new faculty member at the Media Center when he opened his gallery, Latent Image, in December of 1970. "I was too green to know what I didn't know," Geoff reminisces, "it was founded on an idea of something that would be fun to do." Partnering with a former classmate and friend from Rice University, Jack Whitmore of Whitmore and Company Printing, they opened the gallery with $2000. Geoff remembers renting a house for $300 a month, where he lived upstairs with his family and ran the gallery downstairs. Latent Image was open in the afternoons Tuesday through Saturday as Geoff taught his classes at the Media Center in the mornings.

Latent Image was one of the first galleries in the country to focus exclusively on photography. "We were too early" Geoff laments. Indeed, Geoff was at

the forefront. While Alfred Stieglitz's galleries and Julien Levy Gallery in New York City had shown photographs along with paintings and sculptures as early as 1905, commercial galleries specializing only in photography were yet to blossom. Helen Gee opened Limelight, "the first gallery devoted exclusively to the exhibition and sale of photographs," in 1954 but was only able to keep it open for seven years with the profits from an adjoining coffee shop.[6] The following year, photographer Roy DeCarava opened A Photographer's Gallery in a remodeled exhibition space in his apartment in New York City, which lasted only two years (1955-1957). A semi-cooperative gallery, Image, was opened by Larry Siegel in 1959 but also closed two and a half years later. Elsewhere, Hal Gould spearheaded the collective that opened Colorado Photographic Arts Center and the Upper Level Gallery in Denver in 1963.[7] It wasn't until 1969 that Witkin Gallery in New York City, Siembab Gallery in Boston and the Focus Gallery in San Francisco opened.[8] This was followed by LIGHT Gallery in New York City in 1971 and Grapestake Gallery in San Francisco in 1974. By the mid to late 1970s, the photography market had begun developing and galleries started opening throughout the country.

In Houston, according to some accounts, the de Menils were thought to be the only individuals seriously collecting photographs in the 1960s and 70s. Dominique asked Geoff for a list of important photographers that they should purchase. In a detailed memo, Geoff listed sixteen established photographers and ten younger emerging ones that should be considered for their collection. Meanwhile, the museum had yet to purchase any images for its photography collection until 1971, when Philippe de Montebello purchased a NASA print from Latent Image.

In its brief existence, Latent Image had a number of strong exhibitions. Geoff remembers

> There were all these terrific photographers who were willing to exhibit just to have a show. Paul Caponigro had a show here. Ansel Adams had a show. There was a group show when we opened of Aaron Siskind, Arthur Siegel, Harry Callahan, Ray Metzker, and Charles Swedlund. These were people I had known in graduate school at the Institute for Design. One could just write and say I would like to have a show of your work, and would you send me some work on consignment? The answer would be yes.[9]

There would be a large turnout for the openings, but few people would visit in between. Photographer Paul Hester, then one of Geoff's students at Rice University, was the gallery sitter. Though business was slow "because no one ever came in," Paul spent his time happily "look[ing] at a lot of books, looked at a lot of prints." At the gallery, Geoff was attempting to sell images he had on consignment as well as some prints from his own collection. During his graduate work at the Institute for Design, he had purchased work from his teachers — Aaron Siskind's prints for which he had paid $5 each, 10 Robert Frank prints he'd paid $25 each for, and work by Arthur Siegel for $5-10. Latent Gallery also offered prints by Ansel Adams for $75 or $150 for the large ones. In the short time the gallery was open, they sold only two Ansel Adams prints, "after doing it for a year and a half and selling almost nothing — it just got old," Geoff recalls. Latent Image closed in May of 1971 with a going-out-of-business auction that raised only a portion of the $1000 they needed to pay off debts. A number of the prints that were sold at auction were purchased by E. A. Carmean, Jr. for the Houston museum. Geoff recalls, "they came and took advantage of the auction." Prior to the auction, the museum had 99 items in their photography collection, after the Latent Image auction, it had grown by an additional fourteen photographs.

### Seeing Photography in Houston

With the exception of Geoff Winningham's short-lived Latent Image gallery, photography shows were pretty much limited to Bill's efforts at the museum, and Geoff's offerings at the Rice Media Center. Geoff would alternate between showing historical and contemporary work in an ongoing exhibition schedule.[10] The Contemporary Arts Association (CAA), now called the Contemporary Arts Museum (CAM), had included John Baldessari in a group show in 1972 but in general photography was seldom seen at the CAM. It was, however, starting to be seen in the budding, oil boom-fueled new art galleries. One of the earliest gallerists to show photographs in Houston was Fredericka Hunter at Texas Gallery. Like Bill Agee, who grew up next to photographer Barbara Morgan, Fredericka was exposed to photography as a child. She remembers tagging along with her relative who was showing Henri Cartier-Bresson around her hometown as he photographed for the *Galveston that Was* book project. Later, Fredericka left Galveston for Wellesley College, and like Anne Tucker, became another southerner who discovered art once she ventured into the world of academia and had access to world-class museums. Frederic-

ka spent her time while at Wellesley soaking up art in the museums of Boston and New York City. However, after dropping out of Wellesley in 1967 which Fredericka remembers "almost everyone in the class did," she came back to Texas and landed in Houston. Her brother-in-law, Gene Aubry, an architect who worked with Howard Barnstone on several de Menil projects, suggested that she meet with Dominique about the Art History program at University of St. Thomas. The meeting went well, and Fredericka enrolled in the St. Thomas program, completing her degree there.

The de Menils "were amazing people; very interested in all kinds of art," Fredericka explains. "Mrs. de Menil believed students should be included in everything," Fredericka recalls.[11] When artists came to install work, John de Menil "would come at lunchtime and gather all of us at once and take us to The Stables for steak dinner for lunch," former student and archivist Geraldine Armanda remembers. From picking Andy Warhol up at the airport, to chauffeuring Jean-Luc Godard and hobnobbing with whatever international celebrities the de Menils were hosting at the time, students were included. While working towards her degree, Fredericka spent a year in New York City working for Richard L. Feigen, who opened the first gallery in SoHo. Her then life partner and later business partner Ian Glennie was interning with architect I.M. Pei at the time. The late 1960s was a heady time to be in New York City, and they met many of the emerging avant-garde artists of the time. Returning to Houston, Fredericka completed her degree and became involved as a co-owner of Contact Graphics, which was selling prints by the likes of Jasper Johns and Robert Rauschenberg. Fredericka ended up buying the other partners out in 1972 and reinventing the business as a contemporary art gallery. Once Fredericka was at the helm, the renamed Texas Gallery began focusing on showing contemporary work of all kinds, including photography. Fredericka had a William Wegman show in 1973 and included the work of Ralph Gibson in a group exhibition in 1974.

**Houston was Booming**
As the price of oil in the 1970s continued to rise and the economy continued to grow, galleries in New York and elsewhere began looking to Houston. Clint explained, "Marvin Watson, who was a local architect, had been talking to Tibor de Nagy in New York, while Houston was booming. ... Everything was happening throughout the state and so Tibor said, 'I think that we should

**Robin Cronin, Marvin Watson, Fredericka Hunter, Janie C. Lee, Clint Willour, and Betty Moody. Houston Gallerists.**

Photo: © Janice Rubin 1979. Courtesy of Janice Rubin Photographs, Special Collections, University of Houston Libraries, Houston, Texas.

have a branch in Houston.'" In 1973, they opened Watson/de Nagy Gallery in Houston and hired a young Clint Willour as their director. A few years earlier, drawn by the strong economy, Clint had come to Houston seeking his fortune. Growing up in a small mining town in Puget Sound, Clint never studied art. Though he had been admitted to Stanford, he chose to stay closer to home, attending Whitman College and later transferring to finish his degree at University of Washington in Seattle. Like Anne Tucker and Fredericka Hunter, Clint discovered art when he went to a university in the big city. In Seattle, Clint discovered galleries and museums and began spending time in coffee

shops with artists. After college he briefly took a job in Ohio before making his way to Houston. "This was the city of the future," Clint explained. "There was no recession in Houston."[12] Initially, Clint "worked for an interior design firm," he recalled, "but mostly I installed carpets." When the owner of the carpet business died, leaving Clint's job precarious, he happened to be talking with Marvin Watson at just the right time. Clint's position at the gallery was the beginning of what would become an impressive, self-created career in art.

Watson/de Nagy handled mostly abstract expressionism, sharing the stable of Tibor de Nagy's gallery in New York, though the Houston space also had some representational work in inventory as well. As the boom economy continued, the gallery did so well they opened a second space, Watson/Willour, which offered a wider selection of work "in all media" though no photographers were in their stable. It was a prosperous time as the oil-driven economy continued to grow. "Sales have been particularly good," Clint said at the time, "to a new class of 'young collectors,'" professionals in their 30s and 40s.[13] Everyone "was making money in the 70s," Betty Moody remembers, "if you didn't, something was wrong." Hoping to capitalize on the Houston economy, Janie C. Lee opened a branch of her Dallas gallery in Houston in 1973 with a stable of well-known contemporary artists including Claes Oldenburg, Morris Louis, Jasper Johns, Helen Frankenthaler, Hans Hoffman, Dan Flavin, Ellsworth Kelly, Donald Judd, and Frank Stella.[14]

### *"A gigantic overripe challenge"*

While oil money was fueling the economy and drawing gallerists to town, both the Museum of Fine Arts and the Contemporary Art Museum hired new directors in 1974. Arriving within a month of each other, Bill Agee in May, and Jim Harithas in June, each sought to engage their respective organizations in new, dynamic ideas. The Contemporary Art Museum had been struggling financially and pinned their hopes of survival on their new maverick director. Jim Harithas was "a swaggering, flamboyant museum director for a swaggering, flamboyant city," wrote journalist Lisa Gray.[15] Indeed, Jim seemed to specialize in wild and edgy 'happenings' that made museums *the* place to be. From 1965 to 1971, he was responsible for increased relevance and attendance at the Corcoran in Washington, DC and then in 1971, Jim took the directorship of the Everson Museum in Syracuse, New York, where he staged his biggest coup with his exhibition of work by John Lennon and Yoko Ono. More than 8,000 people showed up for the opening, including celebrities like Ringo Starr and

Eric Clapton, which put Everson on the national art radar. By 1974, "not only had he positioned the out-of-the-way Everson firmly in the avant-garde, but he'd made the bookkeepers happy," according to Gray. "He'd quadrupled the museum's annual attendance, doubled its budget and wiped out its deficit."[16] Not a bad record for any director, but doing all this in less than three years distinguished Jim as a serious up-and-comer in the art world.

Though friends warned him that moving to Houston would be the end of his career, Jim "saw the CAM as a gigantic overripe challenge. Houston was the fourth-largest city in the United States but a hopeless cultural backwater, a place that needed to be woken up."[17] Focusing on the possibilities, Jim accepted the directorship and arrived in Houston in June of 1974 to rescue the nearly broke Houston Contemporary Arts Museum. Board Members were hoping desperately for a Harithas miracle like his feats at Everson. When he arrived, Jim stepped squarely in the middle of the ongoing tension as to whether the CAM should focus on local artists or exhibit only work of the internationally known — a strain that had plagued the organization since the Jermayne MacAgy years. "I feel Houston shouldn't follow New York, it should lead it," Jim clearly stated his agenda in a *Houston Chronicle* article.[18] So right from the beginning, Jim became known as a champion of Texas artists and Texas art. Artist Lynn Randolph remembers that before Jim arrived, "nobody had ever paid any attention to Texas art, in New York or Los Angeles or anywhere else in the world. And he simply got in his car and visited the studios of every artist he could find and came back and announced that Texas art was as good as any art that was being produced anywhere else."[19] Jim also began creating an informal salon-like atmosphere near the museums at the Plaza Hotel (now a bank). The hotel's breakfast room became "a bar in the evening and Jim Harithas and artist Jim Surls, who was teaching Sculpture classes at University of Houston, and the art community would gather there." These gatherings are remembered as a bit of a "boys club" but quite a scene.[20] It became the informal hub of the Houston art world.

### Professionalizing the museum

While Jim was setting out to promote Texas artists and create art happenings at the Contemporary Art Museum, across the street — literally — Bill Agee, having arrived in Houston only a month before Jim, was getting to know his new organization. When Bill Agee took the directorship, the institution had just opened the new Brown Pavilion, an impressive Mies van der Rohe addition that more

than doubled the museum space. This expansion added on to the earlier 1958 Mies-designed Cullinan Hall and included a new entrance and lobby area, an expansive second floor gallery, and one of the few Mies-designed theaters that is still in use to this day. The museum's first major capital campaign had raised a stunning $15,287,638, surpassing the original goal of $15 million. A trustee gift of $45,000 had provided for the museum library to acquire the *Lester Beall Collection* of approximately 1,200 volumes with an emphasis on photography and twentieth century art. The general membership was up 40% from the previous year to 6,688, and the first *Handbook of the MFA Collection*[21] was at the printers with an expected summer delivery. Things were looking bright for the new director. His two most recent predecessors, James Johnson Sweeney (director 1961 to 1967) and Philippe de Montebello (director 1969 to 1974), though skilled in many ways, had not been well liked by many in Houston and some recall that the feeling had been mutual. Indeed, both men were seen by some as rather hostile and demeaning to the Houston community. In contrast, Bill had a pleasant interpersonal style and seemed much more interested in engaging the residents of his new home than either of his recent predecessors. Betty Moody remembers Bill as the "antithesis" of Sweeney and Montebello. He was, Betty continues, "a very, very smart man. He really was a great curator. Had a very certain eye, … he had a shy personality, … he was one of those people who are brilliant in what they do. He was so smart, well read, loved art, loved curating shows." Described as "a great person," Ed Hill recalls, "Agee was one of those directors you don't find very often who just hang out with artists. He was very sociable and easy, just a regular guy." Bill was an artist's curator, "One of the finest men I've ever met. Just lovely, and super knowledgeable, but almost too nice," George Krause explains. "Bill Agee seemed to me to be such a kind, interesting, smart pleasant guy," Sally Gall recollects, "he sure was nice to young artists, which was very appreciated." Sally remembers running into Bill at a party and telling him she was disappointed that her work schedule would not let her get to the museum to see a show he had curated. "And he offered to walk me through the exhibition on Monday [when the museum is closed] … he took me all through. I couldn't believe it, I mean, the museum director, and I was just a young artist."

## A Clear Vision and a New Agenda

Photography was clearly at the forefront of Bill Agee's agenda from his first days in Houston. Inviting the luminaries of the photography world to speak in Houston had not only provided a means to generate interest in the local community, but it also put awareness of the museum, and his agenda, out in the

broader photography community. Gene Thornton wrote after his talk, "The facilities for giving the slide talk are the best I have ever encountered, and the collection seems to me to be unusually comprehensive and well-planned for a museum that size."[22] Beaumont Newhall, in addition to suggesting his student Anne Tucker to Bill, wrote "I was really overpowered by the amazing architecture," he continued, "lecturing in the auditorium was an experience ... I have a feeling that Wednesday's lecture was my biggest audience. And may I congratulate you on such immaculate and efficient facilities. No 'Next slide please' and all that."[23/24] John Szarkowski, who had been the concluding speaker in the lecture series, was impressed enough to write to Agee proposing an extended loan from the MOMA collection "of perhaps one hundred and fifty prints that would constitute a superb historical survey of the medium."[25] Agee responded by conveying his "deep interest" in the possible loan and clearly stating his intentions for the Houston museum, "As you know, I am committed to developing a major program in the exhibiting and collecting of photography."[26]

In addition to his Photography Lecture Series, which showcased the newly-opened Brown Theater, Bill also began to acquire photographs for the museum including 39 Edward Curtis photogravures from *The North American Indian* for $1000. He also bought 51 Lewis Baltz photographs, *The New Industrial Parks Near Irvine, California 1974*, and a number of Geoff Winningham photographs. Photographic exhibitions at the museum also increased under his direction. In addition to the Weston and Arbus exhibitions he had arranged for on loan from MOMA in early 1975, Bill also supported Alvia Wardlaw's proposal to do a retrospective exhibition of Roy DeCarava's photographs at the museum. "I wanted to do this exhibition, and I proposed it to Bill Agee, who said, 'Go ahead and do it.'" Alvia recalls, "I think that's one thing about Houston, people have this can-do and positive kind of attitude. If you've got an idea, and it's a good one, they're going to encourage you. They're going to say, 'Well, do it. ... The DeCarava retrospective was my first major exhibition."[27] Alvia Wardlaw included 120 prints in the retrospective exhibition (Sept 12-Oct 26, 1975), which opened a few months after Anne's arrival in Houston. The museum purchased four DeCarava prints from the exhibition. This began the policy of acquiring work from photography exhibitions that the museum organized that would continue for the next four decades.

At the time, the Houston museum, like many others across the country, was still largely run by a relatively small staff and volunteers. When Bill Agee ar-

rived, the museum had three full-time curators — in the areas of 19th-century, 20th-century, and European art. Indeed, one of the goals he announced was to create an entirely professional staff which he announced he would accomplish with the hire of a curator of Tribal Arts in 1980. Despite the small curatorial staff, a "Facts Sheet for 1974" found in the museum archive, notes that there were 107 full-time employees and 34 part-time employees so, though still small, it had grown considerably in its fifty years of existence. Anne remembers when she arrived, it was a "very provincial museum."[28] The town, she says, was still "basically conservative about art in general and photography in particular."[29] Bill Agee was ready to change all that.

### Early photography exhibitions at the museum

Prior to Bill Agee's tenure, photography exhibitions had not been totally absent at the Houston museum. The Museum of Fine Art had shown photography as early as 1926 with the *1st Annual Exhibition of Works by Houston Photographers*, which later became the *Annual Exhibition of Photography by Texas Photographers* in 1929, and the *Annual Salon of Photography* in 1941. This group continued to have yearly exhibits at the museum through 1953. The Houston Photography Club also held annual group shows from 1938 to 1948 at the museum. An eclectic mix of other competition exhibitions were also shown, such as the *Prints from the 1931 Members' Show and Competition of the New York Camera Club* (1932), *Photographs and Plans of Houses selected by House Beautiful Magazine* (1932), the *Prize-winning Photographs from the Kodak $100,000 International Competition* (1932), and *Photographs, Models, Plans and Sketches of the South Texas Chapter of the American Institute of Architects* (1940). A few special interest shows made their way to the museum walls, *Defense Aviation Photographs* (1942), *Photographs of Celebrated Dancers by John Lindquist* (1946), and *Design Down Under* (1951), which is reported to have included twenty-two photo-mural panels of Aboriginal art and design by Martin Metal. These group shows were augmented with a mix of solo exhibitions of Eugene Delcroix (1929) a New Orleans photographer, the first exhibition of Edward Weston vegetables including the now famous peppers (1930),[30] Austro-Hungarian portraitist František Drtikol (1932), the pictorialist work of surgeon Dr. Max Thorek (1933), Rice Institute professor and later founder of the University of Houston Art Department Frederic Browne (1934), a prominent Houston commercial photographer, Paul Gittings (1948), and Laszlo Moholy-Nagy (1948).

Photography exhibitions at the museum had ebbed and flowed with each director. In 1953, when the museum hired its first full-time director, Lee Malone (director 1953-1959), there was a shift from local to a more professionalized approach regarding what was to be shown that did not include much photography. Malone curtailed the annual group shows and during his six years mounted only one photographic show, *Photographs of Peter Fink* (1956), which was shown offsite in the third-floor gallery of the Texas National Bank. In 1959, Malone's contract was not renewed and the previous director, James Chillman returned in an interim capacity (1959-1961). During Chillman's second term, three photographic exhibitions were mounted — a solo show of *Jeannette Klute Photographs* (1960) borrowed from Gallery Montaigne in Paris, *Hiroshima to Houston* (1960), a photo exchange exhibition, and *Photography in the Fine Arts II* (1960) organized by a New York City group that was brought to the museum by Chillman himself. In 1961, James Johnson Sweeney, having recently resigned as the director of the Guggenheim, was enticed by John de Menil to accept the role of director for the Houston museum. The Menils agreed to underwrite Sweeney's salary and housing as well as provide funds for acquisitions during his tenure.[31] Under Sweeney's direction (1961-1967), interest in showing photography was revived with the *Photographs of Japanese Gardens and Architecture* in 1961; Walker Evans' *Corpus of African Art* in 1964 from MOMA; four George Eastman House exhibitions (1964-1965) — *Adam Clark Vroman* (1964), *Photography '64*, *Harry Callahan* (1965), *Direct Approach: Photographs by Edward Weston, Ansel Adams, Pirkle Jones, and Brett Weston*;" two shows in 1966 — the Gersheim Collection from the University of Texas (later to become the Harry Ransom Center), and work of *Houston Chronicle's* White House photographer Ted A. Rozumalski; and his last installation, Frances Benjamin Johnston's *The Hampton Album* from MOMA in 1967, one of John Szarkowski's early shows as the new head of photography.[32] With Sweeney's departure, the interim directorship fell to Mary H. Buxton (1967-1969), who had been the Museum Docent Coordinator in the Education Department. During her time, Buxton oversaw one photography exhibition borrowed from the MOMA, *Perceptions in Photography: Peter Fink* in 1969. Leaving a position in the curatorial department at Metropolitan Museum of Art in New York City, Philippe de Montebello[33] (director 1969-1974) arrived in Houston in September of 1969 to become the museum's fifth director. Photography does not appear to have been on his priority list as only one exhibition of photographs was mounted during his directorship. Despite this, and perhaps ironically, de Montebello was the first to purchase an image for the museum's photography collection.

Within the collection, the museum owned very few photographs. The first photograph wasn't acquired until 1961, when prominent patron of the arts Miss Ima Hogg donated a *carte de visite* of Sam Houston, among other items. This was followed four years later with 97 photographs by Henri Cartier-Bresson, of Magnum fame, and Ezra Stoller, the premier architectural photographer in the U.S., which had been commissioned for the book, *The Galveston that Was* (1966). The project, funded by John and Dominique de Menil, who were good friends of Cartier-Bresson, was intended to be a "requiem for the faded city."[34] Photographer Geoff Winningham sold the museum the first photograph they purchased — a NASA print through his Latent Image gallery. "I remember going over to the museum with a framed, probably 48 by 48 inch print of Neil Armstrong on the moon ... [I had] the opportunity to show photographs to Philippe Montebello, who was the museum's director at the time ... Here I am this nobody photographer walking into the director's office ... and he looked at it and said that is the one I want." Geoff closed Latent Image in May of 1971 and the museum purchased another fourteen images in the going-out-of-business auction. Thus, the sum total of the photography holdings when Bill Agee arrived was 114 images.

### *The Target Collection* of American Photography

By 1976, interest in photography in Houston was gathering momentum and behind the scenes the key event that would change everything was in process. In a trustee meeting at the Museum of Fine Arts, Bill Agee made the pivotal announcement in March:

> Mr. Agee announced a $28,000 grant from Target Stores to build a collection of twentieth century American photography. He explained that this grant was not only important to our collection of photographs, but also a breakthrough in our concept of corporate funding. A special exhibition with catalogue of the 70 photographs from this grant will be shown here and then circulated to other museums. Joan Alexander has been our contact with the Target Stores.[35]

Fortuitously, Joan Alexander was serving as a trustee at the right time and in the right place. Joan's husband, Stanford Alexander, was the President and CEO of Houston-based Weingarten Realty, which had the contract to purchase the land for Target Stores. When Target wanted to donate funds to a

cultural institution in Houston, Joan thought immediately of the museum and called Bill Agee to see if he had any special projects in mind. Later, when Bill met with the Target representatives, he is reported to have told them that with their donation he could either buy one painting, a few prints, or begin a photography collection. Happily for Houston, the Target representatives chose the latter option. Their grant provided for $20,000 to purchase photographs and $8,000 for a catalog of the exhibition. This is "how the *Target Collection* was born," Joan documented in a handwritten note to Bill, "I'm proud to be a part of it."[36] With the funds secured, Bill brought Anne Tucker on board as a photography consultant specifically to build the Target Collection. In the beginning, Anne was paid $6 per hour and worked approximately two days a week on the museum project. "I've always credited Target with being the reason that I am here," Anne says with a smile.

Both Bill and Anne were Americanists, so it was quite logical that they decided to focus on work by American photographers, and specifically those in the twentieth century as those images were more affordable. With the budget of $20,000, they set out to create a survey of twentieth century American photography and decided to include only one image by each photographer. With those parameters Anne put together a "priority list" of photographers to be included and particular work to concentrate on acquiring. Conceptually, the list "went from camera work images up to the classic Edward Weston and Ansel [Adams], West Coast, East Coast, Stieglitz, through contemporary," Anne recalls. For the next few months, Anne traveled widely, visiting galleries, studios and museums in Washington, DC, Rochester, Philadelphia, and New York City to identify and purchase images.[37]

### Selecting Photographs

As is befitting a student of Nathan Lyons, Anne considered each image not only as to its importance in the history of photography, but how it would relate to the other photographs in the collection. She chose the Brett Weston *Untitled (Kelp), 1955* because the image visually complemented the Harry Callahan image of telephone lines that had already been acquired. Though hard to come by, Anne wanted a Frederick Sommer landscape because Ansel Adams and Paul Caponigro landscapes were early acquisitions.[38] Through perseverance and charm, as well as being in the right place at the right time, Anne was able to get a sought-after Frederick Sommer image, *Arizona Landscape,*

*1945.* "I happened to meet him [Frederick Sommer] in New York and I told him about the *Target Collection* we were forming," Anne reports. "He told his gallery to put our museum in Houston at the top of his waiting list and we got one."[39] With the standard 10% museum discount, the museum purchased the image from LIGHT Gallery in New York City for $2070.

In selecting which images to include, Anne remembers being "this kid with more confidence than she should have had." In the pre-internet days of the 1970s, there were some photography books but nothing like the resources available now to familiarize oneself with images prior to making a purchase. "I would just see something," Anne explains,

> ... I made sure we had landscapes and portraits and commercial, but it is shocking to me now that I didn't get Penn or Avedon. ... I bought pretty classic images like Sommer's *Arizona Landscape*, and Ansel's great expansive western landscape. ... I bought a Bob Adams with the construction in the foreground and the western landscape in the back. And as the collection built, I would be aware 'Okay, I have the Ansel Adams, what is Bob Adams doing, well his prints are these beautiful subtle grey, silvery grays, not Ansel's dramatic darkened mountains, and the Lee Friedlander is one where there is a pole right in the middle of the picture which broke every rule.' So I was aware of moving from kind of classical kind of compositions to these contemporary issues. Even then I was socially sensitive, I mean, James Van der Zee is in it. I have always been cognizant of the social side of it. Issues were part of it. The great Bob Heineken collage, a large picture, was one of the more popular pictures in the show. ... [From] the 60s movement away from straight photography, you've got [Jerry] Uelsmann and [Robert] Heineken. I was just trying to get into the show that range of photographic processes. I was just trying to get diversity into that first collection. Classic images by well-known photographers.

As with other museums, each purchase must be approved by an acquisition committee that at the MFAH was comprised of museum trustees and consultants. Curators present work to the committee, which is then either accepted or refused. Each of the photographs for the collection would be identified and discussed with Bill Agee, and then it would be presented to the committee for approval to make the purchase. An image by Paul Caponigro, *Stonehenge,*

*1967*, has the earliest acquisition number in the *Target Collection* so it's likely that this was the first photograph Anne presented to the committee. In preparation for her first presentation, Anne remembers nervously beginning with a discussion of the photography-collecting practices at the other important U.S. museums — MOMA, the Met, Art Institute of Chicago, and the Boston Museum of Fine Art — that acquired photographs. This, she thought, would help committee members understand the importance and relevance of the image she was presenting. As Anne was finishing, one of the consultants on the committee "said in a mumble that was clearly meant to be loud enough for people to hear," Anne recalls, "Yeah, and some people collect coke bottle tops too." It was clear one of the roles Anne would need to play was that of educator within the conservative, old guard of Houston's cultural elite.

### Diving for Art

In the midst of identifying photographs for the collection, on June 15, 1976, Houston experienced one of its memorable tropical storms with a downpour of more than ten inches and devastating results. Within two hours the lower level of the new Contemporary Arts Museum was under nine feet of water. This was only four years after the iconic all-steel parallelogram building designed by Gunnar Birkerts had opened in March of 1972. The water-filled lower floor of the CAM, that included an exhibition space as well as "housed all of the physical and technical operations and equipment, office equipment, documents, files and other irreplaceable records, as well as work from the exhibition currently on view and other works being stored before shipping."[40] Houston photographer Suzanne Paul's exhibition had opened on May 27 and all her work was damaged in the flood. CAM staff reportedly went 'diving for art' trying to save what they could but the devastation was estimated at a $1 million. The community rallied with an immediate response. Politicians came to view the damage, and volunteers arrived throughout the following days to help remove artwork, equipment, documents, and files, much of which went to the Museum of Fine Arts for safe keeping. Johnson Space Center of the National Aeronautics and Space Administration (NASA) dried out the damaged files in their vacuum chambers. CAM received an emergency grant for $17,500 from the National Endowment for the Arts, the highest possible amount available under these circumstances.[41] Among the volunteers was Clint Willour, who remembers meeting Anne Tucker for the first time as they helped with the cleanup. An auspicious meeting, as they would become

close friends and conspirators in promoting photographers and photograph-
ic interests. Indeed, they would later refer to themselves as "Siamese twins
joined at the eyeballs."[42]

Within months, the CAM was mounting exhibitions in various spaces around the
city and was aggressively pursuing their Emergency Building Fund drive. At the
MFAH, Anne and Bill Agee were moving forward with the *Target Collection*. By
September of 1976, only six months after the award of the Target grant and while
working only part-time, Anne had built the *Target Collection* to 50 prints and the
exhibition was scheduled for February of the following year.[43] Anne stretched the
original $20,000 by applying for NEA matching grants for the purchase of con-
temporary art, as well as receiving a few gifts — most notably the donation of
funds for the FSA images printed by the Library of Congress.[44] The initial *Target
Collection* included 70 photographs. Mimi Crossley, an art writer for the *Houston
Post* newspaper, noted that this was the "first, in-house collection of 20th-centu-
ry art" for the museum. Taking a thoughtful and directed approach to building
a specific, survey collection had not occurred prior to this at the MFAH as most
of the acquisitions had come from donor generosity and opportunism resulting
in an eclectic depth in some areas and large gaps in others. In many ways, the
attentive and considered process of the *Target Collection* was a coming-of-age
moment for the Houston museum as well as for its photography consultant.

**Anne Tucker
and Clint Willour, n.d.**
Photo: Lawrence Hitz.
From the collection of
Anne Tucker.

In addition to working part-time for the museum and teaching the History of Photography course at University of Houston, Anne was continuing her research on the Photo League and was traveling to conduct interviews. She was also hoping to find full-time employment that would allow her to move forward in her career. When a curator position was authorized for the Gernsheim Collection at University of Texas in Austin that Anne had helped to organize as an intern, this seemed like a great opportunity. In mentioning her interest in the position to Bill Agee, he wisely and quickly decided it was time to offer Anne a full-time position. At the trustee meeting in October of 1976, Agee announced that the Museum Ball had raised $83,923.85, they had just hired the landscape architect Isamu Noguchi from New York City to design a sculpture garden for the museum, and that Anne Tucker had just been appointed as Adjunct Curator of Photography.[45]

Houston was growing and oil was flowing, and the museum was following suit. Under his direction, Bill Agee initiated several insightful programs in addition to developing a photography stronghold. He began the CORE program fellowships, which bring innovative, emerging artists to town for two years. One of whom, Amy Blakemore, came to Houston in 1985 as a Core Fellow and stayed as an influential photography faculty at the museum school. Agee also oversaw the construction of the new building for the school — a two-story, rectangular building of 42,000 square feet, filling the one-block site on Montrose Boulevard with an exterior of glass-block finish meant to reflect and filter sunlight to reduce the omnipresent Houston heat.[46] Though it was to be completed under his successor, Bill Agee also secured the funding to purchase the land and selected Noguchi to design the museum's sculpture garden — framed by concrete walls that vary in height, the interior space flows among broken curves and abrupt angles that set off masterworks of 20th- and 21st-century sculpture by artists including Louise Bourgeois, Dan Graham, Henri Matisse, Auguste Rodin, and David Smith.[47]

### In only eleven months

Remarkably, only eleven months after the museum had received the Target funds, the *Target Collection of American Photography* exhibition opened on February 25, 1977. Seventy photographs were exhibited throughout three spaces — the main Andrews Gallery and two adjoining corridor galleries. A preview reception for museum patrons was held the night before from 7pm to 8pm and

was followed by an invitation-only cocktail buffet at the gracious home of Joan and Stanford Alexander. "I remember the first Target show ... it was great," recalls Houstonian Daphne Scarbrough, "the museum had fabulous parties to go with all of that ... you just had an incredible art community, and they would have the bands, they would have the bar, and it was just very nicely done." The event was quite a coup for the new director – Bill had been in Houston only twenty-two months and he now had a photography collection of note, a Photography Department, and an ambitious, talented Photography curator among his various accomplishments. *The Target Collection* exhibition and catalog were also a stellar professional debut for Anne and was a professional turning point for her career. Though she had curated a show at George Eastman House and at MOMA, Anne had now claimed her own turf by building a collection with her own vision, and as a full-time curator of photography. "It's almost certainly a once-in-a-lifetime experience," Anne said at the time. "Even as a professional photographic historian, the *Target Collection* has allowed me to clarify in my own attitudes and values, ideas about the history of American photography in a way I couldn't have otherwise."[48] Given the way museums work today, it seems quite extraordinary to acquire a thoughtful survey of important work, create a catalog and mount an exhibition in less than twelve months. From the beginning, the intention had been to "emphasize the diversity of photographic expression" and to put it into "historical and thematic context."[49] The images ranged from the classic landscapes of Caponigro, Sommer, and Adams to the more experimental ones of Minor White and Jerry Uelsmann. Street scenes included work by Berenice Abbot and Walker Evans as well as Lee Friedlander and Garry Winogrand. Important series were represented work by Lewis Hine, Robert Frank, Russell Lee, Weegee, and Eugene Smith. Portraits by Man Ray and Edward Weston were accompanied by Les Krims' *Moms Snaps, 1971* and a four by six-foot collage by Robert Heinecken. Examples of abstraction varied from Harry Callahan's *Telephone Wires* to Aaron Siskind's wall graffiti to Barbara Morgan's light drawing and Lotte Jacobi's evocative *Untitled*, 1963. The exhibition concluded with an array of contemporary work by Eve Sonneman, Meatyard, MANUAL (Suzanne Bloom and Ed Hill), Emmet Gowin, and Bea Nettles. Perhaps the most unusual acquisition for the collection was the entire set of 134 *Baseball-Photographer Trading Cards* by Mike Mandel. Alfred Stieglitz's *The Steerage* (1907) was selected as the signature image for the show and collection. It appears on the cover of the catalog and was used on the poster for the exhibition and on the invitations to special events – like the Alexander's cocktail party. Bill Agee consid-

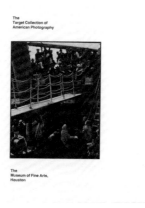

The
Target Collection of
American Photography

The
Museum of Fine Arts,
Houston

*The Target Collection* Catalog, 1976.

From the Collection of the Museum of Fine

Arts, Houston Archives.

ered *The Steerage* "as the *Demoiselles d'Avignon* (a pivotal work in 20th-century painting) of modern photography."[50] With the museum discount, the MFAH had paid $2000 to acquire this photographic *"Demoiselles d'Avignon"* from Cronin Gallery in Houston. The only other photograph purchased for over $2000 was the sought-after Frederick Sommers, *Arizona Landscape*, for $2070 from LIGHT Gallery in New York City. Together, these two pieces were the most expensive images acquired through the initial Target grant.

*The Target Collection* also includes work by Anne's mentors, Nathan Lyons and John Szarkowski. In response to Bill Agee's request to purchase his work, Szarkowski responded,

> It is very exciting to be rediscovered as a photographer, and I would be delighted to be in your Collection, which I am sure will be superb. I do however admit to a certain sense of vague discomfort at the notion of selling my own photographs, especially to other museums. How would it sound when we explained it to the Congressional Investigation Committee? Would it be better or worse if I were to give them, or perhaps I could give them to Georgianna Childs, my sister to give them to the Museum. Laundered photographs?[51]

And indeed, his print *The Schlesinger Meyer (now Carson, Pirie, Scott) Department Store, 1899-1904* was acquired by the museum through a gift of Mrs. William L. Childs. Szarkowski also wrote to Bill Agee that he was delighted to be "a recalcitrant artist for a change, rather than a sweet and reasonable curator," and stated that he would need "about six months of spring training before I got my arm back in shape to print the way I used to."[52]

### The Photographic Process

On view at the same time as the *Target Collection* was *The Photographic Process*, an educational exhibition for the Masterson Junior Gallery that was guest curated by Norma Ory, Dean of the museum's junior school. A well thought out companion exhibition, *The Photographic Process* focused on the technological aspects of photography. It included a display of cameras that ranged from nineteenth century view cameras to "amateur or 'snap-shooters,' such as Kodak #2 from the late 1800s, one of the earliest roll-film cameras made, as well as an early Polaroid, Instamatic, and children's cameras such as Girl Scout, Dick Tracy, and Mickey Mouse cameras," as well as "serious cameras" used by professionals, and spy and detective cameras. Along with the cameras, the variety of the types of photographs made with various cameras were shown: "daguerreotypes, ambrotype cufflinks with photograph on porcelain, tintypes, and gelatin silver prints." The exhibition also included a simulated photo studio and darkroom. Anne lent fourteen of the objects shown in the simulated darkroom including the enlarger that was later donated to the museum school after the exhibition. Most intriguing in *The Photographic Process* was a section dedicated to examining the difference between photographs that are considered fine art and those that are not. This distinction was illustrated with portraits by Laura Gilpin, Arnold Newman, Edward Curtis, and Chester Michalek, as well as landscapes by Jim Alinder, Paul Caponigro, and Ansel Adams from the museum's collection. This is the question that was at the forefront in discussions of photography in the 1970s, and still rises up at times now nearly a half century later. Attempting to answer the question, what makes an image fine art, the exhibition wall text proposed a distinction based on intention:

> It is difficult to say why the refreshingly honest snapshots across the room are not "Fine Art" and why the photographs on these three walls are fine art. The answer lies in the intent of the photographer, and in his or her success in achieving the goals set. The "snapshooters" wanted to make documents: of their lives, of their possessions, of their children, of their pets. That the resulting pictures should interest us — total strangers to their children and their children's children — might have delighted them, but was not part of their initial desire to record their lives.

> Artists do hope that they have made a photograph which will interest future generations. Photographic artists have ideas which they work to express in

pictures, and to be artists, they must be able to express their ideas; they must be able to sustain creative expression. That is why we have chosen to display several photographs by a few photographers in the fine arts section, to emphasize that each photographer included here made many fine pictures over a prolonged period of time. Edward Curtis worked on his series "The North American Indian" for 35 years..."[53]

The pairing of *The Photographic Process* with the *Target Collection* shows the desire, and perhaps need, to educate the audience, not only about photography in general, but as to why this new museum department and the *Target Collection* were so important for the institution and the community. In hindsight, it is easy to see how pivotal the Target grant, Bill's vision, and Anne's talents were to engender the photography scene in Houston. Though at the time everything was still in flux, energy was gathering, and things were beginning to happen, but the outcome remained uncertain as to whether interests in photography would grow and flourish in Houston.

### Wide praise and recognition

A review of the Target exhibition appeared in the Sunday Magazine of the *Houston Chronicle*. Sandwiched among celebrity gossip (Raquel Welch's love life and Chevy Chase's post *Saturday Night Live* plans), numerous ads for backyard swimming pools ("Nassau Pools: The Pool that is built better than it has to be"), and Vivarin pills ("How to Feel more Alive at 5:00"), and a photograph of third graders learning to floss as part of a new Health department program, readers found John Scarborough's article, "The museum's new photo treasure." With five pages of text accompanied by 11 photographs (including the magazine cover), Scarborough stressed the importance of the new collection, and curator, for the Houston museum.[54] Though Mimi Crossley, art writer at the *Houston Post*, found the collection "weak on photojournalism and on American 'primitives'" while applauding it as the museum's first, thoughtfully selected collection of 20th-century art.[55]

*The Target Collection* exhibition went on to tour the country for more than two years, bringing attention to not only the collection but to the Houston museum and its new curator as well. As is still customary, Anne was asked to speak at several of the museums that rented the exhibition, building her reputation as an expert in American Photography. While at the Hudson River Museum

in Yonkers, New York, the *Target Collection* exhibition was reviewed by Gene Thornton in the *New York Times*. Thornton contrasted the thoughtful way the *Target Collection* came together with the "haphazardness" and" hodge-podge" nature of a concurrent exhibition *101 Photographs from the Brooklyn Museum*. "Fifty years from now the *Target Collection* will undoubtedly be studied as a key to the advanced taste of the 70's," he wrote, "and the thematic grouping of pictures in the catalogue is far more persuasive than the grouping in the Museum of Modern Art's recent survey, *Mirrors and Windows*."[56] High praise indeed for the young curator and her efforts.

### "Photography activity in Houston is up 300 percent"

In an article written in 1977,[57] Anne estimated that in the preceding "two years, photography activity in Houston is up 300 percent" but she is not sure that will continue as the "public needs to acclimate itself." All the arts organizations in Houston were expanding in the mid-1970s and perhaps for the first time, a "healthy but serious competition" among the various arts institutions was developing which necessitated cultivating an audience beyond the city's elite families. The museum continued a steadfast commitment to photography with an ambitious schedule. Following the *Target Collection* exhibition, there was a show of 55 Farm Security Administration images donated by trustee, Alvin S. Romansky. Then an exhibition of *Contemporary American Photography Works* was guest curated by Lewis Baltz, which focused on contemporary trends and included 134 images by 15 artists — Robert Adams, Thomas Barrow, Joseph Deal, Bevan Davies, William Eggelston, Lee Friedlander, Ralph Gibson, Jan Groover, John Gossage, Anthony Hernandez, Nicholas Nixon, Robert Cumming, John Baldessari, William Wegman, and Geoff Winningham. Baltz's stipulation that the museum would acquire one work from each artist added breadth to the nascent collection and included a work that would become iconic, John Baldessari's *A Different Kind of Order (The Thelonious Monk Story)*, making the Houston museum the first American institution to collect Baldessari's work.[58] On view during Baltz's show, Anne also mounted a small exhibition of photographs, *Archaeology and Photography: Troy*, in the museum library. The "photographs taken of the excavation of Troy ... were, for me," Anne recalls, "so like all these [New Topographics] construction photographs of sites in modern cites. But nobody, nobody got it. I thought it was a sweet connection."

Anne recalls that the catalog for the Baltz exhibition "was the first of too many late catalogs" in her career but perhaps the most memorable. Receiving a call from the printer's salesperson the day before the opening that the catalog would be late, Anne asked why. "He said I wouldn't believe him. I pushed for an answer; he demurred. Finally, he admitted it was late because an elephant had gotten loose in the bindery. When I could only say that I didn't believe him, he complained that although he had lied to people much of his sales career, the one time he was trying to tell the truth, no one would believe him." In fact, a circus was unloading nearby, and an elephant did get loose, running down the railroad track and into the bindery.

Despite loose elephants and late catalogs, momentum for photography was growing in Houston, and many of the key visionaries had arrived in the city. With a booming economy, Houston had the lowest unemployment rate in the country and more people were moving to town. Everything was expanding and "everyone was making money ... Downtown [was full of] cranes building those high rises, it was an amazing time ... it was phenomenal," gallerist Betty Moody remembers. Gerald D. Hines, who had moved to Houston in 1948, created his own real estate development company and by the mid-1970s seemed to be single-handedly transforming the city's skyline. Houston was still the land of opportunity but "contrary to rumor, the streets of Houston are not paved in gold," Anne wrote. "For now, the scene, so optimistic on the surface, hangs at a point of fragile balance. With pressure, the beams could conceivably shift either way."[59]

# Chapter 5

# "Everybody was talking about photography"

With the stellar national success of *The Target Collection* exhibition and the appointment of Anne Tucker to build the photography department, Bill Agee had used his position at the museum to legitimate photography as an art in Houston. He had been visionary and strategic in his approach, but his interests were also shaped by the times. In the 1970s, "It was *the* deal," photographer and Rice faculty member Peter Brown recalls, "it wasn't painting, it wasn't sculpture, it wasn't multi-media, it wasn't film, it wasn't cartoons, it wasn't T.V. — it was photography, it was hard photography." Susan Sontag was writing about it in the New York Times and the museums were taking notice — as an art form, photography was coming into its own. "Everybody was talking about photography," Peter summarizes. And more and more people wanted to see photography and make their own photographs.

### "The place to be is Houston"

Sometime in spring or summer of 1975, Bill Agee remembered a visit from a young couple, Tony and Robin Cronin. They were visiting Houston and thinking about opening a photography gallery in the city. "Tony asked me point blank what the Museum's intentions were concerning photography," Bill recalled, "I replied that I planned to expand our then embryonic program, including the development of a major collection."[1] The Cronins met in college; Tony was an Anthropology major at University of Massachusetts and Robin was an Art History major at Smith College. Robin enrolled in a Photography course at Smith College that was taught by Ed Hill (who would later teach at University of Houston). The campuses were part of a reciprocity agreement that allowed students to take classes at various local universities, so Tony attended the class with Robin. By graduation they had developed a serious in-

terest in photography as well as each other. When Robin's grandmother died, they used her inheritance to begin collecting photography. They also started thinking about opening a gallery so they consulted with one of their dealers, Carl Siembab, who owned a photography gallery in Boston. They asked Carl if he was going to open a gallery at that time, where would he go? And Carl reportedly told them the place to be is Houston, that Houston was booming and if he was going to start over, that's the place he would do it.[2]

Following Siembab's advice, Tony and Robin did come to Houston, opening Cronin Gallery in October of 1975 with a 62-print exhibition of Minor White photographs. The show "included a rare 1939 print of *Junk Shop, Portland Oregon*, a seven-print version of *Sequence 15*, the *Jupiter Portfolio,* and contemporary and vintage single images from 1949 to 1971."[3] The Cronins brought Minor White to town for the opening. Photographer Debra Rueb, who was then the President of her high school photography club, remembers how exciting it was to meet Minor White at the opening. While in Houston, he also gave a lecture at the Museum of Fine Arts and taught a seminar at Rice University. Both Houston newspapers reviewed the show favorably. Sales were encouraging as the Cronins sold three of the *Jupiter Portfolios*, the *Sequence 15*, and 13 single images from the show.

Perhaps even more importantly, Cronin Gallery increased the visibility of photography in Houston exponentially. Writing in 1977, Anne Tucker noted that since the Cronins opened their gallery, there had always been at least two and sometimes four or five photography exhibitions on view at any one time in the city. Though Cronin Gallery began by showing established masters like Minor White and Harry Callahan, they also showed younger, less known artists in addition to some of their former instructors from Massachusetts, including Al Souza and MANUAL (Ed Hill and Suzanne Bloom). The gallery quickly became a gathering place, a nascent scene, and focal point for Houstonians interested in photography. The openings were well attended, and people would often gather at the gallery to talk about photography. Much like Geoff Winningham's earlier gallery, Latent Image, Cronin Gallery became the hub of the emerging Houston photography scene. Though unlike Latent Image, the Cronins were also able to attract the collectors necessary to remain financially viable. Once the Cronins opened their gallery and started bringing photographers to Houston, everything got much more interesting as Anne explains, "It wasn't New York or Chicago, but there was energy."

## Shaking Things Up

The mid-1970s were a watershed moment for the Houston photography scene. Many of the visionary players were arriving in Houston: Anne Tucker and Bill Agee at the museum, Geoff Winningham at the Media Center, Tony and Robin Cronin, and George Bunker at the University of Houston. Photography, it seemed, was generating interest and support in many arenas.

In 1974, George Bunker was hired to lead the University of Houston Art Department after teaching painting and drawing at the Philadelphia College of Art (PCA)[4] for nearly 20 years. He came to Houston with new ideas, arriving in town just a few months after Bill Agee and Jim Harithas had taken up their directorships. Influenced greatly by Cezanne, George had lived in Aix-en-Provence in the early 1950s where he honed his formalist painting style. His work primarily concerned the "translation of landscape motifs into structural arrangements of line, shape and color."[5] When he arrived at the University of Houston, he wanted to enliven the department as it was "drowning in old ideas and old timers and George wanted to shake things up," a colleague remembers. George became "famous for his memorandums that went to the entire faculty … and they were brilliant, and they were critical," painter Lynn Randolph explains, "he was very sophisticated and very smart. He was, for my taste, a little too limited in his sphere of interests in art; but in politics he was wide open." Despite whatever limits others may have perceived, George Bunker thought photography was important and set about making it part of the arts curriculum at the University of Houston. This by itself was a new idea. Photographer Debra Rueb remembers that in the 1970s the only public universities in Texas with a photography curriculum were Sam Houston State in Huntsville and Stephen F. Austin in Nacogdoches — though neither of which were in art departments.

### *Bringing Photography to the University of Houston*

After only one year in Houston, in 1975, George Bunker invited former PCA student George Krause to come to the university to build a photography program. He also hired newly-arrived Anne Tucker to teach a History of Photography course that same year. Previously there had been only one course at the university in photography, which was taught by Richard Paine in the Architecture department.[6] On a visit back to Philadelphia, Bunker had run into his former student George Krause at a party. When Bunker asked how he was doing, George Krause told his sad story. Though he had grown up in Philadel-

phia, Krause had married a southern woman, Patsy, who found the northeast weather too cold. He had tried a number of jobs and moves to please Patsy, including a position at Bucks County Community College in South Carolina. Not southern enough for his wife, George asked just where Patsy placed this new Mason-Dixon Line? Patsy declared that she could only be happy living in San Antonio or New Orleans, two cities she had lived in prior to her marriage. Continuing to try and please his wife, and ready to simplify his life with one job rather than the many hats he was wearing — adjunct teaching at a few schools, doing advertising photography and working on his fine art career as well — George was looking for a job near Patsy's hometown of San Antonio.

Despite the turmoil of his personal life, George Krause had achieved an impressive amount of success. In 1960, Edward Steichen had purchased his work for the Museum of Modern Art. Then when John Szarkowski took over the photography department in 1963, he added seven more of George's pieces to the collection. Additionally, Szarkowski included work by George Krause in the very first show he mounted at MOMA called *Five Unrelated Photographers* (May 29-July 21, 1963) putting George in the very good company of Garry Winogrand, Ken Heyman, Jerry Liebling, and Minor White.[7] Interestingly in the MOMA press release, George is referred to as a "free-lance graphic designer" and is represented with twenty-five images that include his "studies of people in an urban environment and by a recent series on cemeteries."[8] This exposure lead to his first Guggenheim award (he received two over the course of his career) and to being the first photographer to be awarded the Fulbright-Hays fellowship.

While catching up at the party, Krause told Bunker about his wife's interest in moving south and his subsequent job search. George Krause remembers Bunker responding, "that he was now the chair of the art department at the University of Houston and coincidentally Houston was halfway between San Antonio and New Orleans. 'Would I be interested,' Bunker asked, 'in coming to Houston to create a photography program?'" Houston appeared to be just the opportunity George had been searching for, so the Krauses and their two young children moved to Houston in the summer of 1975, and George began teaching at the University of Houston that fall. George was 38 at the time, and though he had studied with Bunker at the Philadelphia College of Art and taken many courses, he never actually graduated so he did not even have a

bachelor's degree. Despite this, given his reputation as a photographer, Bunker was able to offer him a full-time, tenure track position. His photography course quickly became quite popular though it was, George concedes, known as "a very easy course," which may have contributed to the high enrollments. Retired now, George is remembered as an intense and passionate teacher. Though attendance was not mandatory, former student Debra Rueb remembers the critiques were "about the image capture and conversation … it was so very intense you didn't want to miss [class] … [he] got really deep with his critiques." Known for bringing students to tears, "he would never say anything nice," Muffy McLanahan explains, "that would not help you improve."

The following year, George Krause was awarded his second Guggenheim and also became the first photographer to receive the Prix de Rome, which would allow him to spend the next academic year in Italy. To keep momentum in the nascent photography curriculum, Bunker had to find someone to teach the courses while Krause was away. Fortuitously, Tony and Robin Cronin had their mentors, Smith professors Ed Hill and Suzanne Bloom, visiting from Massachusetts that spring. On sabbatical from Smith College for the semester, Ed and Suzanne had come to Houston to see Cronin Gallery, talk about their upcoming September exhibition, and generally meet the community. While in Houston, they gave a talk about their collaborative work under the name of MANUAL at Rice University and the Cronins gave a party where they met Anne Tucker, George Krause, Geoff Winningham and various other members of the photography community. Ed and Suzanne also began photographically exploring the city, which later developed into their Houston/Northampton Connector series where they paired images of a city (Northampton) they knew well with "Houston … a place that we didn't know at all." Using square format and a 120mm lens, the resulting 40 pairs create a "selective view of both places" that are both familiar and ambiguous.

### *University of Houston goes MANUAL*

Ed and Suzanne's first trip to Houston had "been a scouting trip." Ed remembers, "we enjoyed ourselves, we had a wonderful time courtesy of Tony and Robin." Having become disillusioned with teaching at Smith, Ed and Suzanne were looking to make a change and had been considering moving to New York at the time. At Smith, Ed recalled "the politics were so, so, so conservative, and so, so stultifying, really awful." Though they enjoyed teaching their stu-

dio courses — Ed taught life drawing, photography, and video courses and
Suzanne was teaching classes in painting and design — they were ready for
something new. To Ed and Suzanne, Houston seemed the antithesis of their
lives in Northampton. "We fell in love with Houston," Ed explains. "It was a
very stimulating atmosphere."[9] For a small art community, there was a lot of
energy and a lot of opportunity.

After their visit to Houston, word of their talents and availability got back to
George Bunker, who called Ed and asked him to come back to Houston to in-
terview for the one-year position. Though Bunker only had one position to
offer, he agreed to hire Suzanne as well to teach a Visual Perception course
as a faculty affiliate. Discussing the Houston proposal back in their loft in
Northampton, Ed and Suzanne decided to embrace the Texas adventure, even
though it was only for one year, and arrived in Houston the summer of 1976.
George Bunker must have been delighted with his good fortune to get two ac-
complished artists to replace Krause for the year. After completing his under-
graduate degree at Rhode Island School of Design, Ed had studied under the
modernist legend Joseph Albers, best known as a former member of the Bau-
haus and color theorist, as well as "virtuoso figurative draftsman Rico Leb-
run"[10] while earning his MFA at Yale in 1960. Initially focused on drawing and
printmaking, Ed had published a book, *The Language of Drawing,*[11] that is a
poetic treatise on tactile seeing and the phenomenology of creating images. In
1966, after watching Michelangelo Antonioni's film *Blow-up* about a fashion
photographer who unknowingly captures a murder in the background during

a photo shoot, Ed took up photography. "I saw the film the day it came out on a Friday," he recalls. "On Sunday I went back and saw it again. On Monday I went out and bought a Pentax."[12]

Suzanne also came to photography after beginning her career as a painter. She had studied with two Italian artists, abstract painter and modernist Piero Dorazio and conceptual and minimalist sculptor Angelo Savelli, at the University of Pennsylvania, where she earned her MFA. "Dorazio talked a lot about how we could approach our work as artist-scientists," she says. "Solving problems, making statements."[13] As a painter, Suzanne sought to create paintings "formally perfect to the point of transcendence." In preparation for her first summer trip to Europe in 1970, Suzanne bought a camera — a Pentax — and somewhere in the south of France became mesmerized with the play of light she could explore through the lens. Immediately after her whirlwind trip through Europe, Suzanne began teaching painting — the first woman ever hired to teach a studio course — at Smith College. Ed was on the faculty and had been teaching painting and drawing there for several years. Within three years of Suzanne's arrival, they had become a couple and were beginning to make art collaboratively. "We were creating another entity that needed its own name," Ed reconstructs. "The conversation went something like this: 'We need a name that has multiple readings, something like, well, Manual.' 'Well, that sounds good. A manual for art. You do make art manually.'"[14]

Ed and Suzanne arrived at the University of Houston full of energy and the exuberance that comes from escaping a less than supportive work environment. Taking one year leave from Smith, they set about engaging with their new, if seemingly temporary, community. Unlike George Krause, whose work at the time was primarily black and white social documentary, work by MANUAL was conceptual and sometimes veered into color and video images. Not only did Ed and Suzanne come with degrees from prestigious institutions and pedagogical links to important artists of the time, but their work was also unlike anything anyone else in Houston was doing. Indeed, New York art critic Peter Schjeldahl, described their work as "challenging" and "very appealing" full of "wit, variety, and flair." MANUAL's "aesthetic mode," Schjeldahl continued, "puts them in a distinct minority — practically all by themselves, in fact — in Houston."[15] Bunker was so heartened by the dedication and innovative artistic diversity the couple brought to his new program that he was able to

argue for the importance of a second permanent position in photography, and was able to hire Ed Hill into a full-time, tenured position and promised to try to do the same for Suzanne in the future. He succeeded in securing a tenure track position for her in 1979. So, during the summer of 1977, they returned to Northampton "and had a sale and packed up the rest of our stuff" and relocated to Houston permanently. They purchased a bungalow near White Oak Bayou in Woodland Heights, an area that had yet to become desirable, and set about turning one of the bedrooms into a darkroom. Thus, by 1977, University of Houston had an undergraduate program in Photography with two full-time faculty plus Suzanne Bloom and Anne Tucker as faculty affiliates. Soon after, in the early 1980s, they would also have a graduate program in photography — the only one in the city.

## Expanding the Rice University Media Center Program

The same summer of 1977 that Ed and Suzanne put down roots in Houston, photographer Peter Brown moved to Houston. Peter had just finished his MFA at Stanford as the first photographer to go through their program. "The painting faculty," Peter remembers, "wasn't convinced that photography was an art form." But Peter charted his own path. "I was just really smitten by photography." While at Stanford he had worked for Albert E. Elsen, the noted Rodin scholar, doing "a lot of kind of advance work for photography, because he was teaching art history at Stanford and didn't, of course, mention photography." So early on, Peter found himself taking on the role of "ambassador" of photography. After completing his masters and looking for something adventurous to do, Peter applied for a one-year, half-time teaching position at Rice University in the unknown lands of Texas. He interviewed with Geoff Winningham and other Rice faculty during a conference in New York City and Peter remembers, "I told them I worked on a ranch in Wyoming, so I certainly knew what rural culture was about," but in reality Peter says he didn't even know exactly where Houston was on the map. Despite his lack of familiarity with Texas, or perhaps because of it, he was offered the half-time position at Rice.

Peter and his girlfriend, Debby, came to Houston, arriving in the heat of August with its thick, sticky air and white, humid skies. They had rented a house near the de Menil-owned Rothko Chapel and upon their arrival found the air-conditioner was not working. Elsewhere this might be a mere inconvenience but in Houston in August it is beyond unbearable. Immediately, Peter and Debby

went in search of someplace to cool off. The very first place they went into was a small convenience store, Shopkwik, at the corner of Alabama and Mulberry Street — the building that would later become the home of the Houston Center for Photography. Peter and Debby asked the man behind the counter whether the food they had was any good, and he told them no and gave them directions to a grocery store. While walking down the aisles of the Krogers grocery store, they saw "all these guys in wife beater t-shirts and flip-flops and tattoos, and my girlfriend at the time, Debby, burst into tears, and when we got back to the house it was so hot and so muggy," Peter reminisces, "so the beginning was not that great." However, the next day, Geoff Winningham gave a party for them to meet the rest of the faculty "so we were kind of off to a good start."

The Rice Media Center was active under Geoff's leadership. He organized exhibitions that alternated between contemporary and historical work in addition to hosting a number of speakers and events, often partnering with the Museum of Fine Arts, Houston. By the mid-1970s, the de Menil support had ended and thus, the center was dependent upon the university for funding, which resulted in considerably less resources to host events. In spite of the large enrollments in the photography courses, "from day one we had more students than we could take," Geoff recalls.[16] Rather than expand the program with more faculty, they relied heavily on guest instructors — part-time and temporary positions. Most notably, Garry Winogrand taught during the Fall 1976 semester (while Geoff was on leave) and Lee Friedlander was in residence for the Fall 1977 semester as the Mellon Chair in Fine Arts. Unlike the many visiting faculty that came through, Peter Brown stayed on, acquiring a full-time, tenure track position the following year. So, like University of Houston, by 1977 Rice had an undergraduate photography program with two full-time faculty and a number of visiting faculty from time to time. Unlike University of Houston, Rice would not develop a graduate program in photography.

Peter joined Geoff as the core photography faculty at the Rice Media Center. When Peter arrived in Houston, he continued his "ambassador" approach to photography that he had honed at Stanford and began teaching Continuing Education courses for the community to supplement his part-time income the first year. Finding these community courses so enjoyable, Peter continued to teach them even after becoming a full-time faculty member.[17] In addition to their faculty responsibilities, both Geoff and Peter were actively photograph-

ing and pursuing their own personal photographic projects. Geoff immersed himself in Houston culture. "I remember specifically saying to myself: 'I love this city and nobody can see it like I can, so I'm going to be Houston's Weegee.'"[18] So Geoff set about photographing everything from ribbon cuttings to entertainers to politicians in Houston. This all changed, Geoff recalls, when he found wrestling, "there was the subject I'd looked for ... lights, action, powerful emotion, great drama." Convinced that if Shakespeare had been alive, he would have been writing the scripts for wrestling matches, Geoff photographed wrestling as dramaturgical events. This work became his first book, *Friday Night in the Coliseum* (1971). His second book followed quickly, *Going Texan* (1972), which documented the spectacle of the distinctively Houston Rodeo and Livestock Show. Six years later, he published *Rites of Fall* (1978), his now classic study of Texas high school football. Geoff focused intensively on subjects that were uniquely characteristic of Texas in the first decade of his career.

In stark contrast to Geoff's fascination with Houston's ruckus and dramatic social rituals, Peter's work was quiet and subtle. Peter photographed "the open landscape and small towns of the Great Plains."[19] When he arrived in Houston, Peter was asked to show his portfolio, *Seasons of Light*, in the Media Center Gallery. Peter remembers meeting Tony and Robin Cronin, Anne Tucker and others at the opening. "It was such a tiny little community" at the time, and everyone came out for these events. Peter continued with the project and *Seasons of Light* was later published as a boxed portfolio of twenty dye transfer pictures of interiors paired with twenty letter press printed texts by Peter, and then was eventually expanded into a book. Peter was recognized with the Imogen Cunningham Award for this body of work. In his introduction to the book, Leo Holub writes, "The photographs, charged with quiet emotion, collected in the still moments of Peter's various travels, are not about scene or moment or even about subject matter; they are about space and time — time past and time not yet arrived — and about a pervading quality of light which illuminates his every environment."[20]

While university programs can lend credibility to areas of pursuit, perhaps more importantly for the development of the Houston photography scene, both the University of Houston and the Media Center at Rice University allowed community members to enroll in courses. These courses became another point of contact for interested enthusiasts to gather and meet each other, as well as hone their photography skills. Places to learn also meant more people

**Peter Brown at the Rice Media Center, 1978.**
Photo: Geoff Winningham. From the collection of Peter Brown.

were taking photographs, wanting to see photographic work, and even to col-
lect photographs. The university courses served an important role in growing
the photography scene both by providing a place to learn and talk about imag-
es, but also fueled interests that supported other aspects of the scene, such as
Anne's work at the museum and an audience for local galleries.

## "One of the fastest-growing cultural centers"

Writing from Cologne, Germany, Bernd Lohse hailed Houston as "one of
the fastest-growing cultural centers of the United States"[21] as the interests
in photography fueled the local gallery scene. Harris Gallery opened in 1978
offering art by regional and international artists as well as "the finest in cus-
tom and museum framing."[22] Director Harrison Itz took a chance with pho-
tographer Geoff Winningham and sold fifty of his prints within the first eight
months of representing him.[23] Harris Gallery later included Peter Brown in
their stable and eventually came to represent George Krause as well. Mean-
while, Fredericka Hunter of Texas Gallery continued to show photography by

Eve Sonneman, Robert Mapplethorpe, and Lee Friedlander as well as work of local photographers Casey Williams, Sally Gall, and Nic Nicosia.[24] Other contemporary art galleries such as Hooks-Epstein (1970), Gremillion & Co. Fine Art, Inc. (1980) and Davis/McClain (1979) opened during the boom years as well. After running galleries in New York and Paris, William Graham followed the advice of "the well-known New York art dealer, Marilyn Fischbach, who told him to 'go to Houston' where he started out as a private art dealer" and later opened Graham Gallery in 1981. He focused primarily on Texas artists, including showing the work of Houston-based photographers Gay Block and Alain Clement.[25]

In addition to the increasing number of galleries, a new alternative art space opened in a 100,000 square foot warehouse in 1979. The former cable factory at 5600 Lawndale Street was on the east side of Houston and far from the other art venues. After a fire damaged one of their campus buildings, the University of Houston Art Department relocated the painting and sculpture studios into the warehouse that the university had been using for storage. "It was a huge building and a very problematic one from the point of having students work in there," Suzanne Bloom recalls, "it had holes in the floors." When the President of the university accepted her invitation to visit the warehouse, Suzanne remembers, "he came over to visit and I thought 'Oh, I'll show him how great these studio spaces are for the students,' and his response was, 'These students have too much space' — exactly opposite of what I was hoping." James Surls, who was teaching sculpture at the time, came up with the solution: a gallery space. In 1979, Surls took the lead, creating an exhibition area and initiating programming. Known simply as Lawndale Art Annex, this space became the first artist-run, alternative space in Houston. Though still a University of Houston sponsored organization, it was located a couple miles from the main campus and thus able to operate without a lot of close oversight. Surls encouraged artists to experiment as well as perform and show work. Music shows and performance art "drew audiences that loved the club-scene atmosphere."[26] Artists from Houston as well as elsewhere showed or performed in the space ranging from the likes of Allen Ginsberg and Spaulding Gray to Black Flag and the Meat Puppets. Houston's famous Art Car movement got its early start at Lawndale when Ann Robinson Harithas curated a show called *Collision* that featured two art cars.[27]

### *Three more photography galleries open*

Perhaps most pivotal for the developing scene, in 1979 three new photography galleries opened in Houston. Philadelphia-based David Mancini Gallery opened a branch and eventually moved their entire operation to the city. David and his wife, Yvonne Coty, "thought the rich and booming energy capital looked like a good potential market for private sales."[28] Mancini Gallery was the "first to show 19th-century European and turn-of-the-century Pictorialist masterpieces in Houston."[29] Additionally, they hoped to expand beyond the vintage work that had been their primary market in Philadelphia and begin to represent contemporary photographers. Houston seemed like it would be a good market for the newer work. "Local taste," Mancini said, "is progressive in this respect: it is also distinctly partisan, strongly favoring the work of local artists. If it is made in Texas, apparently, it must be good, even if it's a photograph."[30] Mancini Gallery represented local photographers George Krause, Patsy Arcidiacono (Cravens), and Sally Horrigan, as well as Keith Carter from Beaumont, and Bill Kennedy from Austin. Collectors John Cleary, who would later open a photography gallery of his own, and Mike Marvins, who later donated a notable collection to the museum, both were early clients of Mancini Gallery.

The same year, Houston photographer Buddy Clemons opened a gallery in his home. Clemons exhibited work by Elliot Erwitt, Alfred Eisenstaedt, and Harry Callahan in addition to his own photography and work from his personal collection that ranged from Stieglitz photogravures to Richard Misrach and Larry Fink. Beyond a place to see work, Clemons Gallery would become important to the growing photography community as a place to gather and meet. Clemons Gallery was where the early meetings of the Houston Photography Center would be held before they secured their own space.

In the fall of 1979, Petra Benteler moved to Houston from Kassel, Germany, opening her gallery in the front room of her attractive, skylit home in the West University neighborhood. Benteler Gallery was one of the first, if not the very first U.S. gallery to focus solely on European photography. In addition to bringing work that most Houstonians were not aware of, Petra's arrival is another key moment in the history of the photography scene. Both Petra and her gallery would come to play a foundational role in the expansion of Houston as an internationally known destination for photography. With Fred Baldwin and Wendy Watriss, Petra would go on to start FotoFest — one of the largest pho-

tography festivals in the world and the very first in the U.S. In the early years, Petra provided the initial infrastructure from which to launch the big idea of creating an international festival in Houston. Benteler Gallery staff became FotoFest staff as well, and the gallery office doubled the office space for FotoFest for its first three years.

Petra Elizabeth Benteler grew up in the small village of Heepen, near Bielefeld, Germany. Born on June 14, 1945, Petra was the middle daughter of Erich and Alix Benteler. She had an older sister, Alexandra, and a younger brother, Hubertus. While her siblings were given family names, Petra once asked her father why she was given such an unusual name. Erich reportedly answered, 'it was 1945, and we thought maybe that name helped you to be like a rock' as Petra means rock or stone in French. Perhaps it was also rather subversive for a German family in 1945 to give their daughter a French name as Petra was born into a chaotic world. The Second World War was just ending, the destruction was widespread, food and supplies were limited. It was estimated 70% of housing was destroyed in Germany during the war.[31] The Benteler home remained intact throughout the war; it was a large house with extensive grounds, which made it a perfect place to be requisitioned by occupying troops. "The big house was taken by the Americans, the English, and the Russians — one was always there," Petra explains. "It was my baptism, it was in April [and father] said the weather was beautiful [and] we were all sitting outside" when the first of the occupying forces arrived. Family members were allowed to go into their home once and bring out only what they could carry. The military forces moved in and a large fence topped with sharp spikes was constructed along the property. The family did not have access to their home until the last group, the English, departed in 1951.

Once their home was taken over, Petra describes having her family scattered — her grandmother came and took her older sister to live with her in southern Germany, her brother and cousins went to live with the gardener and his wife in a small house on the property, and Petra and her mother went to her father's company building and lived in his office. Petra's only real memory of this time is riding her tricycle down the "long, long, long hallway" outside her father's office. Erich, her father, was quite resourceful and began remaking the stables into living quarters for his extended family. The stables allowed for the family members to be reunited. Erich's family and his brother Helmut's family

and other assorted relatives lived there together. However, turmoil continued to swirl around young Petra. When she was only four, her mother, Alix, died from a complication during an operation. Petra has a vague memory of her mother leaving for the hospital and never returning. Alix died the day before Petra's younger brother Hubertus' third birthday in 1949. So, Erich found himself unexpectedly left with three young children. Erich was the only stable figure in Petra's childhood — in the midst of all the chaos of war and its aftermath coupled with family tragedy — "father was always there." Indeed, Erich had been fortunate to be wounded early in the war and had been sent home to convalesce before the worst of the fighting began. Erich spent the majority of the war taking care of his family and overseeing the family business.

Petra's father, Erich, along with her Uncle Helmut, were third-generation heirs to the family-owned Benteler Company. Beginning in 1876, when Petra's great grandfather Carl, at age 23, took over a small ironmongery store. Through the generations, the company has grown into a large international enterprise. When Carl's son Eduard took over the leadership, he began manufacturing specialized tubes for brakes for the German and French railways. Eduard continued to grow the business, expanding into automotive technology, and soon they were manufacturing exhaust pipes axles, axle modules, and other vehicle components for major car companies. During WWII, the Benteler factory in Bielefeld manufactured anti-aircraft guns until it was destroyed in 1944 during an air raid.[32] After the war, it was left to Petra's father and uncle to rebuild the company. Under their leadership, the product range increased to include refrigerators and heating systems. For a few years, they even built a car, the Champion.[33]

Erich and Helmut were "both very inventive" Petra remembers, and big risk takers. When she was a young teenager, she recalls her father telling his children, "if this invention doesn't work there's no more school for you, then you have to go to work." Petra adds with relief, "but it worked." Not only was Petra able to continue her education, but her father sent her to a boarding school in Switzerland. It was in Switzerland that Petra "got in touch with art." Periodically, the school would designate an "art week" where they would focus solely on art. Petra remembers various people coming to the school to talk about art and show slides during these times. While art weeks were a highlight for Petra, she found the remote Swiss school not to her liking. "They didn't like

Germans, and I wasn't an easy child," Petra explains, "that was even worse." After three years in Switzerland, Petra transferred to a boarding school closer to her home in Germany where she completed the Gymnasium.[34] After graduation, Petra moved back into the family home in Heepen and began, at the urging of her father, to study to be a teacher at the University of Bielefeld and later University of Göttingen. "Father said, 'It would be a good idea for you — you get along with children very well,'" So Petra tried it, "but it was not the profession for me."

All of Petra's siblings had moved out of the family home, leaving her father to pay close attention to her activities. Each morning Erich would make sure she was up and on the train to school in time. Each month, he would ask to look over her lessons. Petra did not enjoy the university, often spending her days with friends rather than going to class. She found "it was pretty boring ... except Psychology — that was great." During this time, she met the man she would marry. "I wanted to get out of the home," Petra recalls. "We lived one year together, and then we were married four years, which was in a time I couldn't tell anybody I lived together with my boyfriend," Petra explains. "I had a tiny apartment, one tiny room on the same floor, and here was his apartment." After six semesters of study, she quit school when she married, even though her husband wanted her to finish.

After her divorce in 1974, Petra found photography. She went to live in a house her sister owned in the Bahamas for six months to figure out what she wanted to do next. In the Bahamas, she "met a German American, and he made underwater films," Petra recalls, "and I got so interested, I bought myself an underwater camera." Petra fell in love with photography, "I took my first pictures ... under water, and also over water, on the island itself." When she returned to Germany, her plan was to study photography. Her father Erich was not encouraging, "your mother already tried that, and she got the worst hands. She was allergic to all the chemicals. You don't even have to try it." Undaunted, and through friends of friends, Petra found a school that would let her enroll. Most schools did not take older students, and Petra was nearly thirty, but connections got her a place at the University of Kassel in 1975.

At the University of Kassel, the photography program was under the Graphic Design curriculum, so Petra had to take courses in design and painting as well

as photography. After the third semester, Professor Floris Neusüss asked to see Petra's work. She spread her images out on one of the big tables in the classroom and Floris walked around and looked at them for a long time. Petra remembers, "I said, Mr. Neusüss tell me the truth — I'm not 18 years [old] — I don't have much time." Most students do not want to hear the truth she recalls him telling her. Petra pressed him, "I want ... [and] he said, 'why don't you give up photography?'" Initially crushed with the disappointing assessment of her work, Floris then suggested she might want to work in the school's gallery. From then on, Petra remembers, "I was always there planning and hanging ... and I knew this was it ... I had a good eye for that." So, for three years (1976-1979), Petra worked at Fotoforum Kassel, involved with all aspects of hanging the exhibitions. For her senior project, Petra mounted the exhibition *Deutsche*

119

*Fotografie Nach 1945* (German Photography Since 1945) in August to September 1979. The degree requirements stated that she also had to take pictures, so at Floris' suggestion she photographed each of the artists included in the exhibition. Her portraits were printed in the exhibition catalog. The show was so successful that an important art gallery in Kassel took the show and it was widely praised.

Approximately four weeks after the exhibition, Petra's father announced to his daughters that he "had opened a company in America" and "one of you girls has to go to the States." Alexandra, Petra's older sister had a young child and did not want to move. Petra, on the other hand, jumped at the idea. She had been visiting Houston every year since the mid-1970s to see friends and enjoyed the city. She told her father, "If I go, it has to be Houston." Her family was a bit alarmed and thought she should move to New York City, so her brother Hubertus called a family friend in Michigan asking about the wisdom of Petra going to Houston.

**Petra Benteler preparing for her exhibition *Deutsche Fotografie Nach 1945* at Fotoforum Kassell, 1979.**
Gift of Petra Benteler. From the collection of the author.

The friend reportedly said 'he wished he was going to Houston' as the economy was booming, so the family agreed, and Petra moved to Houston in late 1979 with the idea of opening a gallery. She had just inherited some money from her grandfather and used it to drive around Europe buying the work she liked as inventory for the gallery.

### *Petra brings European Photography to Houston*

Arriving in Houston, Petra purchased her first home, a brown bungalow in the West University area of Houston. It was an adventure and Petra recalls, "[I] just loved it ... it was always sunny and warm ... [and] because there were so many nice people. ... I met Anne Tucker and she was just an admirable woman." Petra opened the gallery in the front room of her home and had a little room off to the side she used as an office. "I thought I should introduce the States to European, especially German, photography," Petra explains, "I was crazy about photography ... every time to hang a show I get this tickling in my fingers." Petra garnered a lot of attention from the photography community as she began bringing well-known artists to Houston for the openings. Muffy McLanahan remembers being impressed at the opportunity to meet André Kertész at Benteler Gallery. Photographer Debra Rueb vividly remembers meeting Kertész at the opening of his exhibition, "I shook his hand, I've never had anything like that before, and it was like energy in his hand ... and it was just amazing, this little old man ..." Petra's openings were not to be missed.

In less than a decade since Bill Agee had come to town with the idea of building a photography collection, Houston had four photography galleries: Cronin, Mancini, Clemons, and Benteler. Both University of Houston and the Rice Media Center had strong programs teaching photography. Those interested in photography now had several places to gather. The Houston photography scene was building momentum — there were now specific locations to meet and see and talk photography.

### University Art Museums

In addition to being the focus of new galleries and educational programs, photography was also finding its way into the university art museums. Dominique de Menil was still actively directing the Institute for the Arts that she had founded at Rice University. In her role as director, she curated the exhibitions held in the Rice Museum — the corrugated metal building (affection-

ately called the "Art Barn") the de Menils had quickly commissioned in 1969 in order to have a place to display the exhibition John de Menil had arranged for through the MOMA, *The Machine as Seen at the End of the Mechanical Age*, in the midst of their hasty departure from University of St. Thomas. In 1977, Dominique mounted a show at the Rice Museum by two documentary photographers who had been traveling the backroads of Texas documenting the different cultural and geographic regions of the state. They had been photographing in Grimes County while living in their trailer on the back pasture of a farm owned by an African American family for three years.[35] Harris Rosenstein, an art historian the de Menils had hired to teach at the Institute for the Arts, and Dominique de Menil were taken with this work. They mounted the exhibition that introduced the photographers to Houston, *Frederick Baldwin, Wendy Watriss: Photographs from Grimes County, Texas*. The duo continued with this project in addition to their magazine and journalism assignments for another few years before eventually moving to Houston in 1980 — renting one of the "Menil Houses" near the Rothko Chapel — and later founding FotoFest, one of the most important and significant photography festivals in the world, making the Houston photography scene international.

The Menil Foundation, which John and Dominique had formed to oversee their art collection in 1954, had been actively collecting photographs since developing the Media Center. In 1981, Dominique invited Beaumont Newhall back to Houston to select images from the Menil Collection for exhibition at the Rice Museum called *Transfixed by Light*. In the catalog foreword, Dominique writes, "Through the magic of photography, people, things are snatched out of time; through the gifted personality of the artist using this medium, they are glorified, elevated to monumental beauty." She goes on to consider photographs as "admirable as classical sculpture, as moving as romantic paintings, as intriguing as surrealist works."[36] Newhall's selections include works by a who's who of the time — Ansel Adams, Eugène Atget, Brassaï, Harry Callahan, Paul Caponigro, Cartier-Bresson, Edward Curtis, Lewis Hine, André Kertesz, Aaron Siskind, Eugene Smith, Edward Steichen, James van der Zee, and others. In keeping with the de Menil's educational interests, the catalog contains a rich list of suggested readings that includes a number of monographs about individual photographers as well as Szarkowski's *Looking at Photographs* and Newhall's *History of Photography* — the classics of the time.

On the other side of town, the University of Houston had opened its own art museum in 1973. It was named after Sarah Campbell Blaffer, a Houston art patron and collector, who was also the daughter of the founder of Texaco Oil Company and wife of the founder of Humble Oil (later Exxon). Her generosity facilitated building a new Fine Arts Center at the University of Houston. She also promised to give major works of art from her collection so the university could have a teaching collection — much like the de Menils had done at University of St. Thomas. And like the de Menils reacquired their teaching collection from St. Thomas, the Blaffer Foundation reacquired their donated works from the University of Houston in 1979.[37] Indeed there had been a long-standing competition between the native Houston elite Blaffer family and the modern newcomers, the de Menils, which had played out in various arts institutions around town. In the end though, Houston benefited as each doyenne sought to claim her status in the city's art scene. And in 1973, it was the University of Houston's turn to profit. The Blaffer Art Museum opened under the direction of assistant professor of art Richard Stout, a painter and sculptor.[38] A full-time director was hired the following year, William Robinson, who set about exhibiting popular shows like *French Royal Jewels* from the Smithsonian (1975) as well as "world-renowned artists such as Pablo Picasso and Georges Braque (1976), Edvard Munch (1976), Willem de Kooning (1977), and Frida Kahlo (1978)." Eventually, Robinson brought the first photography show to the Blaffer Art Museum in 1978 with an exhibition of Harry Callahan's work that had been organized by the Museum of Modern Art in New York City.[39]

In addition to activities at the museum and galleries, developing photography curricula at the major universities was key in further legitimating photography as an art form. University programs also brought talented, enthusiastic faculty to Houston and provided a space for students (and community members) to gather around their interest in photography. Many of the educators also gave talks in the community or taught community classes or workshops, which extended the reach of their influence. Mike Marvins, who had grown up in the commercial photography business as his father was Kaye Marvins of Kaye Marvins Photography, remembers meeting John Cleary, who later opened John Cleary Gallery specializing in photography, in an evening course taught by Anne Tucker on collecting photography. These two men became friends, and both began collecting during the course. Visiting the new Mancini Gallery together, they both bought the same picture at the same time — Robert Doisneau,

*The Carousel from Monsieur Barré. Place de la Mairie, Paris 14ª*, 1955 — and thus beginning their individual collections. Both men went on to play important roles in the photography community, John with his gallery and Mike through donations to the museum collection as well as supporting various organizations and events over the years.

## A Growing Community

Within the few years between 1975 and 1978, the "tiny little community" was growing in strategic and important ways. However, as Anne wrote at the time, the future was not assured as the "situation is tenuous."[40] During March and April of 1977, Anne had organized a photography lecture series of ten events that was co-sponsored by the museum and the Friends of Photography which had failed to sell out the auditorium. Tickets, at the time, were modestly priced at $1.75 for museum members or $2.00 for nonmembers per lecture or $15.00 for members and $17.50 for nonmembers for the entire series. The "Houston public needs coaxing," she surmised. Speakers included Ralph Steiner, Garry Winogrand, Arnold Newman, Ray Metzker, Ralph Gibson, Nathan Lyons, Peter Bunnell, and others. In conjunction with the lecture series, the Friends of Photography workshop held at the University of Houston "almost folded, and was conducted in an abbreviated form" due to lack of interest.[41] Through committed organizations and partnerships among them, both the lecture series continued and the workshop "was kept alive" with Nathan Lyons and Ralph Gibson as instructors. This style of coordination — working partnerships among the various institutions — is the hallmark of many Houston successes. Early on, it became a key means to build strength and support by working with as many partners as possible toward the common goal of advancing photography throughout the city.

So by 1980, Houston had four active photography galleries: Cronin, Mancini, Clemons, and Benteler, and the two prominent university programs were attracting well-known faculty and talented students. In addition to George Krause, Ed Hill, Suzanne Bloom, Geoff Winningham, and Peter Brown, Houston was also home to a number of nationally known photographers, Gay Block, Sally Gall, Paul Hester, and Charles Shorre — all of whom had been awarded National Endowment for the Arts fellowships.[42] Gay Block grew up in Houston and studied photography at Rice and University of Houston, working with Geoff Winningham, Garry Winogrand, Anne Tucker, Ed Hill, and Lee Friedlander. She was represented by Cronin Gallery and had exhibited nation-

ally. In her work, Gay was intrigued by individuals, "people are my passion, ... my purpose, and my push."[43] Sally Gall had been born in Washington, DC and moved to Houston in the fifth grade. She returned after going away to Rhode Island School of Design for her BFA. Settling back into Houston, at various times Sally worked at Cronin Gallery, taught photography workshops through Rice University, served as the Coordinator of Special Projects at the Contemporary Arts Museum, taught photography courses at the museum school, and taught History of Photography courses at University of Houston. In the 1980s, Sally's work focused on "an extensive series of Diana camera images of European formal gardens."[44] She showed at Cronin Gallery and later moved to Texas Gallery. Paul Hester grew up in Nashville and earned an undergraduate degree

from Rice University before going to Rhode Island School of Design for his MFA . Primarily an architectural photographer, Paul's work had been collected by a number of important institutions including Bibliothèque Nationale de Paris, Stedelijk Museum of Amsterdam, and the Museum of Fine Arts, Houston. He, too, was represented by Cronin Gallery.[45] Charles Shorre grew up in rural Texas and came to Houston in the early 1950s to teach painting and sculpture at the museum school. Working in many mediums, he was known for his paintings, drawings, writing, graphic design, and photography and was represented by DuBose Gallery.[46] Additionally, photojournalists Frederick Baldwin and Wendy Watriss, who would later create FotoFest, had just moved to town. The photography community was growing and by 1980 most of the key leaders had arrived in Houston. Both the city and the arts community were riding high on the oil boom of the 70s. Everybody was "having a good time ... people [were] throwing money on eating and drinking and partying" Daphne Scarbrough remembers, and the Houston art scene was a party not to be missed.

The growing interest in photography in Houston also rode this wave of oil and optimism. Passions ran high — passion for the times, for art, and for acceptance of photography as fine art. Hosting the after-party at her house for the opening of a show Lewis Baltz had guest curated, *Contemporary American Photography Works*, Anne recalls Gary Winogrand and Ed Hill nearly coming to fisticuffs. Gary had been arguing aggressively with Suzanne about the value of conceptual work, though both Anne and Ed remember the disagreement seemed much more about Gary's response to not being included in the exhibition. Heated discussions were part of developing the community — ideas needed to be explored and shared — and boundaries drawn around what was

contemporary art and what was fine art photography. Fredericka Hunter of Texas Gallery recalls Anne coming to her gallery while they were showing *Ten Photographers* that had been curated by Marvin Heiferman, and included the work of Ellen Carey, Mark Cohen, Bernard Faucon, Nan Goldin, Len Jenshel, Sherrie Levine, Kenneth McGowan, Richard Prince, Cindy Sherman, and Sandy Stoglin. Fredericka remembers having a three-hour, passionate discussion with Anne as to whether certain kinds of work should be considered photography or not. Later, Anne returned to purchase Ellen Carey and Cindy Sherman pieces for the museum.

It was a heady time. Oil prices continued to climb, bringing money and economic refugees seeking their fortunes in the city of the future. The tallest building west of the Mississippi was being erected downtown — the Texas Commerce Bank Tower, designed by I.M. Pei, was a five-sided, 75-story skyscraper that transformed the city's skyline. Signs of growth and prosperity were everywhere. "It's getting to be luxurious living in Houston" Karl Killian wrote to Anne Tucker in 1979,

125

> Things you once could never expect you can now begin to take for granted. The presence of photographs in this case. Once we got outside of the museum last night, standing under the overhang of the Brown Pavilion on Bissonnet waiting for the rain to wind down, we looked back into Cullinan Hall and had the same feeling of things being so correct at the MFA . This is really a roundabout thanks to you and Agee for supervising the transition ... into what a Museum can be, should be. I realize it's only just the beginning and it makes me restless and greedy for things to come.[47]

There seemed to be abundance enough for everyone; unemployment was low and opportunities plentiful. In 1980, the price of oil was reaching the unheard of height of $33 a barrel. Houston boom years began with the oil embargo in October of 1973 when oil was selling for $3 a barrel; when it ended in March of 1974, oil was at nearly $12 per barrel. This increase in only six months resulted in gasoline rationing, long lines at the pumps, and a reduction in the national speed limit from 70 mph to 55 in the rest of the nation. For Houston, with such a strong investment in oil, the embargo made millionaires seemingly overnight and millionaires quickly found themselves billionaires. Throughout the 70s, oil prices continued to climb, fueling Houston with money and opportunity.[48]

# Chapter 6

# "Mostly what everybody seemed to want was community"

The heady times of the 1970s were short-lived, as what goes up, often comes down. In the early 1980s the price of oil began to slip and slide to an eventual low of $10 a barrel in January of 1986.[1] While the scarcity of oil in the 1970s benefited Houston's energy industry, the oil glut of the 1980s devastated it. Reduced demand and increased production resulted in an overproduction of two million barrels per day in 1981 creating a "miniglut" that was continuing to grow.[2] The price of Texas crude sank "to the point that it was hardly worth digging for more, the state's economy collapsed with it."[3] A *New York Times* article claimed, "Suddenly, oil is so plentiful that prices are falling by amounts that impress even big-time corporate decision makers."[4] Houston was particularly hard hit as 70% of the area jobs were directly or indirectly dependent upon the energy business. Thousands lost their jobs. By "January 1983, unemployment in the six-county Houston metropolitan area rose to 9.1 percent, the highest among the state's largest metropolitan areas."[5] During the recession, Houston lost one job in seven,[6] resulting in a foreclosure rate on homes and businesses averaging 3,000 a month, causing real estate prices to fall by 30 percent in some areas.[7] The national unemployment rate was over 11% so even though things were bad in Houston, they were still a bit brighter than most other places. Though in Houston, "construction all but came to a standstill, and some financial institutions failed, while others tightened credit."[8]

As the Houston economy slowed down, so did resources for the arts. In 1983, gallerist David Mancini gave a presentation where he described the fate of photographic galleries as ricocheting "from famine to feast to fasting."[9] The years prior to 1975 were considered the formative, famine years when photography galleries were beginning to be opened by courageous, visionary individ-

uals. From 1975 to 1979, Mancini described as the peak, feast years for selling photographs as large corporations began accumulating extensive collections. The years of fasting began in 1980 when "photographic galleries entered a transition period where 40 percent left the business," Mancini explained, "and almost 80 percent moved."[10] By this time, two important New York galleries had quietly closed to the public: LIGHT Gallery and Photography Gallery. Mancini went on to note the general decline, "The roll call of commercial photographic galleries in leading cities gets shorter and shorter: Philadelphia, none; Los Angeles, none; San Francisco, two; Chicago, one; and Dallas, one."[11] Houston, at the time of Mancini's talk, had only three remaining photography galleries: Mancini, Clemons, and Benteler. However, within a few months, Mancini ended his 'fast' and closed his gallery too.

In addition to a few camera stores, Cronin Gallery had been the central gathering place and social hub of the photography community — "the place where we could talk" about photography.[12] Three years after opening the gallery, Tony Cronin was killed in a tragic car accident in 1978. Only twenty-seven at the time, his sudden and untimely death led to the creation of the *Anthony G. Cronin Memorial Collection* at the Museum of Fine Arts. Sixty-seven donors contributed 107 prints in Tony's memory. The collection includes work by photographers that had been represented by the Gallery — Garry Winogrand, Carl Chiarenze, Geoff Winningham, Tod Papageorge, Al Souza, Chester Michalik, MANUAL, and George Krause — as well as work by other friends and colleagues. Though at the time of his death, Robin and he had divorced, and she had taken a job in real estate leaving the gallery to Tony to run. Tony, many recall, had been the passionate force behind the gallery. After his death, Robin kept it open "as a way to honor Tony" but also transitioned it from focusing solely on photography to handling paintings and ceramics as well. For the next four years, Robin continued to be active in the art community and hired photographer Sally Gall, who had come to Houston temporarily to print a portfolio on her way to New York City, to help at the gallery. Sally remembers "I started working for her and she left immediately and went to India because I think his parents lived there and she went to see them." Sally ended up staying in Houston "because I ended up working for Robin Cronin, which I think was really interesting and really fun." She worked at Cronin gallery for about two years until it closed in July 1982.

The loss of Cronin Gallery as a photography-focused space created a void in the community, not only as a venue to show work but they had lost their gathering place — their nexus. Anne, who found "a lot of pleasure in encouraging that community" with a shared interest in photography, went into action. As it was later reported in *Image* magazine, "In a desperate attempt to get a growing, clamoring horde of voracious photographers off her back, Anne Tucker, the Curator of Photography at the Museum of Fine Arts, sat down at her typewriter and whipped out a little note calling interested parties to sit down at the Paradise Bar and Grill to have a few drinks and figure out what to do."[13] Recollections vary but somewhere between twenty[14] and thirty-five people showed up on October 14, 1981 to discuss this dilemma and "within minutes the Houston Center for Photography was born."[15]

## A Photographer's Co-op

When Houston photographers gathered at Betty and Freck Flemings' Paradise Bar and Grill on October 14, 1981, they dreamed big.

> While the critical need was for gallery space, other needs surfaced as photographers around the table reeled off a shopping list of dreams: galleries, lectures, workshops, a library, touring exhibitions, restaurants, bars ... But mostly what everybody seemed to want was community. Some place where photographers could hang around with each other and begin to raise all this scattered photographic endeavor to a fever pitch.[16]

In the six years since Anne had moved to Houston, and the five since she was hired by the museum, interest in photography continued to grow in popularity. The Contemporary Arts Museum opened the year with two photography exhibitions — *The New Photography* created by their new director Linda Cathcart with curator Marti Mayo and an exhibition of Ansel Adams work that had originated at MOMA. Throughout the city, institutional support for photography continued to develop at the museums and in the robust educational programs at Rice University and University of Houston. A few individuals had even started to collect photography and support the fledging galleries. As the galleries began closing, the void of exhibition spaces in Houston to show work by the young and talented became more apparent; and thus there were limited places to see new, innovative work. Even for those artists lucky enough to be affiliated with one of the few galleries that existed, exhibitions happened on a rotating basis, which might mean an artist could have a show every two years

or so. "I thought Houston not only needed more exhibition space, but it needed different kinds of space," Anne explained, "I had started to see all these portfolios and realized there were more good, young photographers than the MFA, Blaffer, Contemporary Arts Museum, Rice and the Galleries could respond to."[17] Using her familiarity with Visual Studies Workshop and the Photo League, Anne proposed the idea of a member-run organization and invited those interested to meet and discuss the idea.[18]

Anne typed up a simple note,

> What are the benefits for the photographers in Houston
> to meet, organize, form a co-op?
> Let's meet to discuss the possibilities.
> All photographers and anyone else who is interested
> are invited
> Wednesday, October 14, 1981
> 6:00p.m.
> Paradise Bar & Grill
> Bagby & McGowen
>
> Please pass on this invitation
> and please come.[19]

Word of the meeting moved quickly through the photo community. Paradise Bar and Grill was becoming a popular gathering spot for Houston artists. Photographer Sharon Stewart remembers meeting a friend there for dinner one night, and owner Freck Flemings stopped by their table to mention the upcoming meeting for photographers. Freck, a photographer himself, was known in the community and had shown his work with Cronin Gallery. A native Texan, Freck had owned a cattle ranch in Bear Creek near the small town of Addicks and had been one of the charter breeders of Brangus cattle — a cross between Angus and Brahman breeds. In 1973, Freck sold his land to developers, who turned it into the Deer Field subdivision in the northwest of Houston. Realizing a nice profit, he and his wife Betty relocated to Houston though they spent the majority of the next seven years traveling the world. Betty remembers wondering why they lived in Houston as there were so many other nice places. She decided "we live here because of the art community — that was the best thing in the 1970s — and we started doing the artists' brunch on Sundays."

These monthly gatherings, Betty says, were "the main thing that got me over my yen to travel; we had this community of artists that was just wonderful."

Betty, ever the gracious southern hostess, began hosting "Sunday Art Brunches" once a month at their home. "We would invite everybody we knew and put out a big buffet. At the first brunch there were six who came, the second time there was 12, and one Easter 60 people came." Betty would send out postcards — everyone was included and once you were on the invitation list you were perpetually invited "and could always bring a friend." Many people from the photography community became regulars — Anne Tucker, Gay Block, Suzanne Bloom, Ed Hill, George Krause, and Charles Schorre, who had taught Geoff Winningham at Rice University, and others like artist Lynn Randolph and museum registrar Ed Mayo also attended. "It just became a community; it was our family," Betty explains. Betty and Freck invited photographers, painters, and musicians, and were very inclusive. Anne remembers "they might have had a waiter from some restaurant ... there was no hierarchy."

At some point, the Flemings decided it would be good to have a local investment and Freck had the idea of developing the old fairgrounds, a forgotten parcel of land near downtown Houston, into an entertainment and urban living community with a vibrant arts scene and proposed to call the area 'The Fairgrounds.' Freck put together a group of 25 investors, including Anne Tucker, Gay Block, and Len Kowitz, who in addition to sharing his interest in photography was also his broker, to purchase the land and invest in a restaurant. Len recalled photographer Gay Block had stipulated that she would only invest if Freck ran the restaurant himself and thus, he began his new career as a restaurateur. In true Texas fashion, Freck dreamed big, and time has shown he was a visionary man ahead of his time. His 'Fairgrounds' has now become a trendy area in Houston called Midtown and is full of high-end housing, fashionable restaurants, and a new 25 million dollar Midtown Arts and Theatre Center Houston known as MATCH. Unfortunately, Freck had the idea in the early 1980s, right before the big oil bust, and his dreams only got as far as a single commercial development that included a theatre group, space for a few small businesses and his restaurant — the Paradise Bar and Grill at 401 McGowen. The building had previously been the George Lewis Funeral Home, so Freck thought naming it Paradise seemed most appropriate, but he also referred to it as an "oasis during the Reagan years."

The Flemings had been interested in the arts and collected broadly — photographs, paintings, and sculptures. Betty remembers "I went to Tony Cronin's gallery when they were over on Bissonnet[20] and I said I just want to know why my husband will spend $250 for a Paul Caponigro black and white when he's [meaning Freck] doing photographs ... I need to know. And Tony could be so crusty, but he was so good. He talked to me; and I got it. Then I saw the Cartier-Bresson show at Rice and went twice to see it, and that [is when] I forgot about color photography at that point ... so we started collecting and built a really nice collection and loved doing it." Between their collecting, artist brunches, and Freck's photography, the Flemings became a beloved fixture in Houston's photography community.

When they opened Paradise Bar and Grill on September 28, 1981, it was natural for their friends, many of whom were also investors, to patronize it frequently. With movie posters on the walls, black and white tile floor, Paradise had both a bar along the side wall and dining room that could seat 120. In the corner was a stage where they had live jazz on weekends. As a young man, Freck had hitchhiked out to Hollywood in hopes of being in the movies and while that did not work out, he was able to express his passion for films in the restaurant decor. The men's room had a life-sized portrait of Humphrey Bogart on the door and the women's room had one of Marilyn Monroe. Pushing several tables together, the interested photography community gathered in the dining room on October 14, just three weeks after Paradise opened and four days before Anne's thirty-sixth birthday.

In her notes, Anne had jotted down some "possible benefits of a photographer's co-op" to prepare for the meeting. She listed the following

Dialog with other photographers
Space to show your work
Space to view work by others
Place to invite lecturers
Mailing list of photographers in Houston
Exchange of information: technical, photo competitions, events, artists' insurance[21]

A number of member-run photographic organizations and artist collectives had developed across the country — Light Factory in Charlotte had started in 1972, Light Work in Syracuse began in 1973, and Photographic Resource Center in Boston opened by 1979, among others, though many have now closed. This trend had yet to come to Houston. Anne had been part of a women's artist collective in New York and had also seen how Nathan Lyons built Visual Studies Workshop seemingly from scratch into an important focal point for photographic activities. The Houston photographic community, she believed, was ready to have its own organization.

### Houston Center for Photography

Over Paradise burgers and beers, photographer Paul Hester remembers "we all went around the table and everyone said what they thought and why we were there." Gay Block remembers everyone was "very enthusiastic and eager to participate." It became clear that Anne's hunch was right, there was not only a need but a hunger for community — a place to grow together as photographers. Since there had been pressure from local artists for Anne to show Houston artists at the museum — it was, Paul said, "a smart move to help them organize." With little discussion, the decision was quick and unanimous to start an organization. What to call it became the longer discussion. First and foremost, people wanted Houston in the name, and they were familiar with International Center for Photography (ICP) in New York City. "I remember there being these sort of highfalutin 'Houston Center for Art Photography,'" David Crossley recalls, "I was always trying to say that photography is not just art, it is everything else too." After much discussion and consideration of several possible names, Houston Center for Photography (HCP) was born. Next the group needed a leader and a plan. By the end of the evening, they had both.

Paul Hester was given the role as the first President of the new organization. A passionate and articulate man, Paul was the son and grandson of Texas preachers. As a child, his family spent much of their time caravanning as "salesmen for the church" and Paul had learned that fervent, persuasive manner of speaking. When it was his turn to speak at the first meeting, "I channeled my father's sermon style," he said to explain why he was selected as the President, "... whatever I said that night at the [Paradise] Bar and Grill, heartfelt, emotional, passionate kind of thing ... about what we needed ... it

probably had to do with a sense of community. And I think Anne gave us that rallying point, and to her credit, she didn't need to be the center of it."

With Tony Cronin's death, the subsequent changes at Cronin gallery, and infrequent exhibition openings, the camera stores were the only places photographers might run into each other in Houston. The community wanted a gathering place, where they could not only show work, but come together to learn techniques and discuss the various debates happening in the photography world at large. In short, they wanted their own scene — a place and community focused on photography. "And so," Sharon Stewart summarizes, "we just came together and started talking about it and said it would be nice to have a photographic community and that is how it started."

Paul Hester had originally moved to Houston to attend Rice University in 1966. He chose Rice, he says, because they had the most interesting yearbooks. Working on his High School Yearbook, the faculty sponsor took a group of students to Dallas to visit the publishing company where their school's year-

**Paul Hester, self-portrait, 1971.**
Courtesy of Paul Hester.

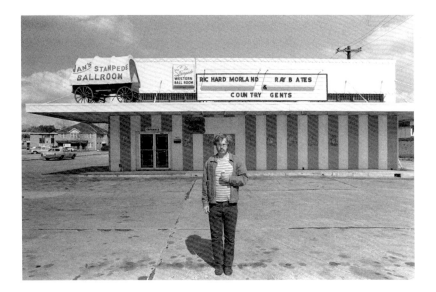

book was printed. They "went in this room with all these yearbooks, and the Rice yearbooks really stood out." At Rice, "the architectural student who was the editor had designed his own typeface, he was his own photographer, and that minimalist, modernist aesthetic went all the way through this book." So, Paul chose to go to Rice, where he worked on the yearbook and majored in Architecture. Though he had been photographing all throughout high school, it wasn't until college that he learned darkroom techniques from the other staff photographers on the yearbook. Paul specifically remembers a "student-initiated course" taught by a graduate student in architecture, Rick Gardner, where he learned the zone system. Rick, Paul says, went on to become an important architectural photographer in Houston.

As an architecture student, Paul was allowed to also take a photography course at nearby St. Thomas University where Geoff Winningham had recently begun teaching. The courses were held in a little house near St. Thomas chapel. It "was great fun," Paul recalls. It was in Geoff's course that Paul began to question whether architecture was the major for him.

> One day, Geoff told students to bring cameras, they were going to photograph in Charles Schorre's class ... He [Schorre] with the architecture students had designed and built a protective screen made of canvas and two-by-fours and ropes that created a shielded space where they could photograph [a nude model] ... when we walked in she was standing there naked, under sunlight and dappled light from the trees, it was the most sexy thing I'd ever seen in my whole life. It was amazing. Who wouldn't be a photographer after that....

The following year, the Media Center moved from St. Thomas to Rice University with all de Menil funding and Paul continued to study with Geoff. Much like Geoff's student days with Charles Schorre, Paul remembers spending a lot of time with Geoff. "I'd go over to his house and look at his photography books; I'd read and ask him questions." When Gary Winogrand visited, Geoff asked Paul to drive him around. Paul drove Gary out to NASA where he wanted to photograph and "I was photographing Winogrand," he recalls. After visiting NASA, they stopped to get sandwiches and Paul remembers there was an older couple sitting at the cafe. Gary began photographing the couple and "they never saw him ... like he was invisible." Then a group of girl scouts came by and Gary "just kind of circles around photographing them and for me it was just

a revelation — like you can do this? And get away with this? It was just like — wow — this is fun."

After college, Paul interviewed for a position at MOMA. Though they did not hire him, while in New York Paul was able to show his portfolio to John Szarkowski. After looking through his images, Paul remembers Szarkowski looking up and "he said, 'Well do you want to be a teacher or a photographer? If you're going to be a teacher you have to be interested in all kinds of stuff, but if you're a photographer you gotta be just one thing.'" This advice stuck with Paul but did not deter him from both teaching and focusing on his photography.

Paul's first job out of college was in the registrar's office at the Museum of Fine Art Houston. His initial task was to deinstall the Cartier-Bresson images from *The Galveston that Was* installation. Working at the museum for a year, Paul "had a great time going through the folders and finding letters from Edward Weston, André Kertész, [and] arranging exhibits." He later left Houston to use a traveling fellowship he had been awarded at Rice. The university had deferred it while Paul completed his Conscientious Objector military service (the Vietnam War was still in full force) and the only stipulation with the grant was that he had to leave the United States for one year. So Paul, who had only left the country once before as a boy scout to visit Japan, set out for Europe. In his own words, he was "not a comfortable traveler" and found it all a bit overwhelming. In spite of this, he spent the year photographing for a project on street rituals. Running out of money in Rhodes, he took a boat to Crete hoping to catch a plane home. On the boat he got so motion sick that he got off at the first stop in the "middle of nowhere [and] ended up sleeping on the porch of a church — there was no café, no B and B — and the boat didn't come back for a week."

After his year abroad, Paul went to the Rhode Island School of Design (RISD) to study with Harry Callahan and Aaron Siskind for graduate school. However, once Paul arrived, the students were told that both Callahan and Siskind were retiring at the end of the year and would be on sabbatical for the spring semester. RISD had also over-enrolled so first-year students were not allowed to use the school darkroom. Undeterred, Paul rigged up a makeshift darkroom in his small apartment. It was not quite what Paul thought he was signing up for, but the upside was that RISD brought in Minor White, Lisette Model, and other

talented people to teach the courses. After graduating, Paul took a teaching job at Dana Hall School for Girls in Wellesley, Massachusetts, which included being the house parents for the 16 girls while his wife attended law school in Boston. It didn't take long before Paul wanted to return to Houston, so he contacted his former professor, Geoff Winningham, to see if there were any openings. His timing was fortuitous as the person running their lab was leaving so Paul moved back to Houston in 1977 and began managing the Rice Media Center photography lab.

It was the perfect job, Paul remembers, "I got benefits and full-time pay, but it only required four hours work per day." The rest of the time, Paul spent on his own work. "I have never been so productive. I have hundreds of contact sheets from that year. I would just get up every morning and go out to photograph. I'd been away from Houston for three years at that time and it really looked different. The Pennzoil building had just been built. Things were starting to change. It was becoming more of an interesting city [architecturally] and the Vietnamese, the fishermen, had started to come by then so the diversification was happening."[22] In addition to running the Rice Media Center lab, Paul would help with curating and installing exhibitions. He also got involved in other photography projects — Ed Oswoski, a librarian and photography enthusiast at the Public Library, commissioned Paul to do several projects photographing around Houston. Thinking of himself as "a 35mm Atget," though also using a 4x5 view camera and a Hasselblad Superwide camera which used 120mm film, Paul began documenting Houston in very systematic ways. He also started doing architectural photography and eventually became a regular contributor to CITE magazine, "a quarterly publication that has always mixed an appreciation of high design with a shot of down and dirty civic engagement" published by the Rice Design Alliance.[23]

By the time Paul took a leadership role with this newly-formed organization, he was familiar with Houston and had many connections throughout the city. The initial meetings of HCP were held at Buddy Clemon's house and gallery. Photographer Sharon Stewart remembers that they decided things should be a bit more formalized, so on November 19, they held an election for the officers. Paul was officially elected President with Sharon as Vice President and Jim Tiebout as Treasurer.[24] One of the first tasks was to get nonprofit status and to do that the organization had to have bylaws. "It was over the Christmas

break," Sharon recalls, "Anne Tucker, Paul and Maggie[25] and I met and hammered out those bylaws in my apartment." Initially the bylaws centered on the idea that HCP would be an artists' collective and a creative consortium. It was "the residual 60s" Anne explains, with the focus on inclusion and democratic process. In keeping with the creative consortium ideal, the initial Board Members needed to be working photographers and were expected to be very hands-on with the various activities of the group. In the early days, it was "all volunteer" and everything was accomplished collectively by the members.

Joining Paul at the helm of the nascent organization, Sharon Stewart had only recently moved to Houston a few months before in 1980. Coming from a long line of photographers beginning with her great grandfather and his two siblings, who ran a portrait studio in Iowa in the 1880s, Sharon says she "had been photographing all her life." Growing up in rural Edinburg, Texas, sixteen miles north of the Mexico border, Sharon jokes that she didn't have a cow like all the other kids in 4H, but she had a camera and a love of food so her 4H projects revolved around photography and cooking, which to this day remain her two great "passions in life." Supportive, her parents gave her "a little bitty, like a toy darkroom almost with a little processor ... I remember going into the bathroom in the house and darkening the windows and processing the film and making contact prints." Sharon was also able to take classes with a photojournalist who worked at the local newspaper, the *Edinburg Daily Review*. "He was my first teacher," Sharon remembers, "other than the fact that it is in my genes."

As soon as she graduated from high school, Sharon went to Austin to study business at University of Texas. During this time, she continued her work in photography and after college had various jobs in arts administration. At one point she also worked for the Texas Arts Alliance, where her role was to work "with wealthy arts patrons in Texas to lobby ... their legislators to increase the per capita funding for the arts in Texas because we were at the bottom." After being involved with the arts scene in Austin for a number of years, Sharon met a man in the theater arts and moved to Houston she says, "for love." Moving into her boyfriend's apartment on Sunset Boulevard that did not have air-conditioning, Sharon remembers, "1980 was a horrible, horrible, horrible heat year."

Sharon Stewart at HCP's
*Coast to Coast* exhibition,
1983.
Photo: Paul Hester. Courtesey
of Houston Center for
Photography.

One of the first things Sharon did after she arrived in Houston was to make an appointment to show her portfolio to Anne Tucker at the museum. She remembers distinctly arriving home the night before she was to meet Anne and finding the apartment without electricity. While her boyfriend had gone to his parents' home in the Bellaire section of Houston, Sharon was left with no lights or hot water, finding out later that "he had forgotten to pay the electric bill." In spite of this, Sharon arrived at the museum the next morning ready to meet with Anne. Thinking of the first time she met Anne, "I always thought she looked a little bit like Harry Callahan's wife Eleanor," Sharon muses. During the late 1970s and 1980s Anne regularly set aside time in her schedule to meet with photographers and many who arrived in Houston remember meeting and showing her their work. While getting to know the local arts scene, Sharon ended up working for a commercial photographer named Joe Baraban. He was one of the "top two commercial photographers in Houston at the time" and the other "was Ron Scott." Sharon's role was to organize Baraban's stock photography business, which gave her a great inside look at how the commercial photography business worked. More importantly, it also gave her the steady paycheck that allowed her to continue with her own projects as well as "pick up portrait work here and there."

With Paul and Sharon at the helm, and an eager membership, HCP had a robust beginning. "HCP started out almost immediately with the goal of being a big deal," David Crossley remembers. "There was a lot of ambition and it paid off."[26] Things happened fast. Running on volunteer efforts, Paul remembers "everybody was enthusiastic." It was new and it was exciting to be a part of something so dynamic. Quickly the group found an exhibition space upstairs in the east wing of the Bering Methodist Church. Someone knew someone who knew the church was losing members and "had all this empty space ... they were looking for things that would serve the community and bring people there,"

Paul explains. It was not in good shape, but HCP was able to use the space in return for doing the repairs. "It needed a good bit of work, which we all pitched in and did," Sharon remembers getting the space ready for the first exhibition which was organized, but not curated, by both Paul and Sharon. Facing the crumbing walls, Ginny Camfield remembers "Debra Rueb saying, 'Just paint the room white, it'll be fine,' So the two women spent the weekend painting."[27] Volunteer efforts "gave the organization momentum and resources that made up for limited funds."[28] Paul Hester recalls using rub-on lettering for exhibition titles, "What we didn't have, we would make."[29] HCP's inaugural exhibition was a members' show in the newly-spruced up, second floor of the Bering Church.

A democratic process for choosing the images for the exhibition prevailed. Those interested in being included in the members' show met at the gracious South Boulevard home of Sally and Joe Horrigan. Sally along with Ginny Camfield, Muffy McLanahan, Janet Caldwell, and Patsy Arcidiacono (later Cravens) had taken photography classes with George Krause. Though sometimes wrongly dismissed as the "housewife brigade," these women were serious about photographing and tremendously important to HCP as they brought connections and resources along with their commitment and passion for photography. So, it was in Sally's living room that the first members' exhibition took shape. Members came and put out their work, and everyone walked around looking at the images deciding which should be in the exhibition. "You would go around and vote for the ones you wanted in the show," Peter Brown remembers, "it was such a pure democratic organization." Opening July 10,

1982, the exhibition included 121 prints by 21 photographers, and ironically and sadly, Cronin gallery closed its doors for the final time only 21 days later at the end of the same month.

Mimi Crossley, who would later become an art writer for the *Houston Post* newspaper, reviewed the exhibition for the group's newsletter.[30] All the work, Mimi wrote "seems under the spell of real things: faces, places, bodies, and spaces," she continued, "And the initial reaction to most — not all — is a response to the thing photographed rather than the eye of the photographer." Though she discusses many of the images, Mimi singles out one for praise, "The strongest strain in the exhibition, in fact, is a kind of poetic realism, seen most vividly in the work of Paul Hester, or, even more specifically, in one print, possibly my favorite in the show: an image of moss-hung trees in knife-sharp light and deep shadow along a bayou, with empty chairs pulled alongside the water."[31] She concluded her review by raising the question of what role HCP might play and where its focus may lie. "Will HCP emerge as a place for a return to a more literal concern in art photography? One show does not a trend make, nor a regional school, and just now at stage right the documentary photographers are arranging shows and at stage left, the experimenters, the risk-takers are getting ready."[32]

The new democratic organization was off and running with a venue to show work, a newsletter, and an active membership engaged at all levels. The group mounted four more exhibitions at the church that year — *Chillysmith Farm* work by Mark and Dan Jury that was published in the book *Gramps* and

described as "a moving document of a favorite grandfather's last year and death,"[33] a show from the collections of the Harris County Heritage Society and the Houston Metropolitan Research Center, *Early Texas Photographers: Vintage Impressions of Houston and the Southwest* curated by Alicia Hathaway and Dannehl Twomey, work by the actor Dennis Hopper called *Photographs of his Friends* that had been printed by HCP member David Crossley,[34] and Fred Baldwin's first photographic essay, *Saturday Night in Reidsville, GA 1957*.

Continuing with their collective process, decisions were made by the whole group. Peter Brown explains, "everyone would have a say as to what was going to be shown and even vote on it and it wasn't a curator or even a curatorial committee, ... it was an exhibitions committee but it was basically the entire populace of HCP, which was fun." This allowed for ongoing discussions "about photography and what makes a good photograph and a bad photograph and an interesting series and something that has been done before and clichés, all of these things." Peter remembers it as a dynamic time, "everyone was doing a lot of work and everyone was being educated — and it was a community that was kind of busting at the seams." Passion and commitment ran high. "The most important thing to remember about HCP starting was the number of people involved, how passionate they were and how much fun we had," David Crossley summarizes, and "how many arguments we had — we learned a lot."[35]

**Participants in the first Houston Center for Photography members' exhibition in front of Bering Church, 1982.**
Photo: Paul Hester. Courtesy of Paul Hester.

### The first HCP Auction

As with most nonprofits, money needed to be raised to continue their efforts. The group set upon the idea of a photography auction and was successful in soliciting images from a number of prominent photographers as well as several local ones. Prior to the auction, the photographs were exhibited at the Rice Media Center December 4-10 and the work to be raffled as door prizes could be viewed at Mancini Gallery[36] November 27 through December 10. Though fundraising auctions are now rather commonplace, Sharon Stewart remembers that HCP was one of the first nonprofit arts organizations to host a photography auction. Held December 11, 1982, on a Saturday afternoon at the Paradise Bar and Grill, the "event proved to be a tremendous boost for HCP morale as well as its budget" raising $24,330 between the auction and the raffle.[37]

George Krause allowed the group to use his image *Swish* for the auction announcements and each poster was hand-printed in David Crossley's darkroom. Members solicited print donations and sold raffle tickets for the door prizes. Paradise Bar and Grill was the natural place to hold the event as Betty and Freck were great supporters of the arts and other community efforts. They were involved with a number of other causes and often hosted community-oriented events during their eight years in business. An event for the NOW convention was held at the Paradise, as was the after-party for the William Christenberry exhibition at the Rice University Museum, and numerous fundraisers of one kind or another. Betty and Freck organized a number of events as well — "we did a jazz festival, a Beaujolais festival" and hosted New Year's Eve bashes. Given the location near downtown, Paradise Bar and Grill had a consistent lunch crowd of lawyers, businessmen, and politicians, many of whom became good friends of the Flemings and often helped to support their causes. Betty remembers Mayor Kathy Whitmire would bring her staff in for lunch and that she would often bring job candidates to dinner there. Freck would joke with the politicians saying they "should check their weapons at the door" as Paradise was open to all political persuasions. Betty tells of how they used these connections to 'encourage' bids for the HCP auction. The Flemings would do their best to sell tickets to their well-to-do customers. Betty remembers several lawyers sent their secretaries over to bid on work.

On the appointed Saturday, Betty and Freck opened the bar serving silver dollar hamburgers and champagne for the auction. Betty remembers they made

Howard Zarr,
Lynn McLanahan,
Clint Willour, and
David Mancini
at the HCP Auction
in 1984.
Photo: Paul Hester.
Courtesy of
Houston Center
for Photography.

about two dollars total profit on the event; their intention had been to just break even. Described in retrospect as a 'three ring circus,' Charles Stillwell served as the auctioneer for the live auction with gallerist Clint Willour providing an introduction for each piece. Highest bids went for photographs by Ralph Steiner, Jerry Uelsmann, and George Krause. In the second arena, there was a silent auction with images by Ralph Gibson, Eve Arnold, and Gilles Larrain, among others. Finally, there was a table set aside for the sale of assorted photographica. At the end of the afternoon, Anne Tucker drew the winning raffle tickets for the door prizes — photographs by Aaron Siskind, Lotte Jacobi, Edward Curtis, Charles Schorre, and Paul Caponigro.[38]

A simple catalog had been assembled listing 87 photographs with an additional loose sheet slipped in listing 13 more images that arrived after it had gone to press. In Anne's personal copy, she noted the prices each image went for and sometimes who had been the successful bidder. Ralph Steiner's *Always* (1922) received the highest bid of the afternoon at $600, while Jerry Uelsmann's untitled 1976 print sold at $525 and George Krause's "Swish" went for $500. The list of donors to the auction is extensive and impressive, including Ansel Adams, Eve Arnold, William Christenberry, Dennis Darling, Lee Friedlander, Les Krims, Danny Lyon, Ray Metzker, Richard Misrach, Aaron Siskind, Ralph Steiner, George Tice, and Jerry Uelsmann, in addition to a host of Houstonians. Additional gratitude is expressed in the HCP magazine to unnamed others who donated work by George Barnard, Margaret Bourke-White, Linda Connor, Paul Caponigro, Edward Curtis, Mario Giacomelli, Hedrich Blessing,

Lewis Hine, Laton Huffman, Lotte Jacobi, John Edward Sache, and Marion Post Wolcott. It was quite a line-up for any auction let alone one by a newly-formed collective.

The group was off and running and now even had money in the bank. After an exhilarating but exhausting first year, elections were held again, and David Crossley became the second HCP President with Patsy Arcidiacono (later Cravens) as Vice President. Under their leadership, two major infrastructure changes occurred. They put together the first Advisory Committee that included Anne Tucker, Dr. William Camfield (Art History Professor at Rice University), Muffy McLanahan, Mary Margaret Hansen, Anne Bohnn, Amanda Whitaker, Sally Horrigan, and Wei-I Chiu. Additionally, they initiated the evolution of the newsletter into a formal quarterly publication with a subscription rate of $10 per year. A journalist by trade, David viewed writing and the need to have a formal communication platform as an important direction for the collective. The magazine would not only provide information to the members but offer yet another means of sharing work. As Paul Hester remembers at the time, "the only way to see photography was through books and the LIGHT Gallery and Witkin Gallery mailing lists — each month you would get a beautifully printed announcement that would have one photograph on it." Beginning a quarterly photography publication so quickly after forming HCP was an audacious move. It was the kind of thing Houstonians did. And the kind of challenge David enjoyed.

David Crossley had, for the most part, grown up in Houston. He was eleven when his family moved from Massachusetts to Houston so his father could take a position at Sakowitz, an upscale, family-owned department store chain based in Houston. Part of the job offer to encourage the Crossley family to move to Houston included a scholarship for David to be able to attend the elite private school, Kinkaid. David remembers the family being happy to leave the northeastern winters behind and has fond memories of barbecuing on New Year's Day in shorts and t-shirts. At Kinkaid, David found himself going to school with the children of many of the most important and powerful families in the city. For college, David first attended Rice University and eventually found his way to the University of Texas in Austin, where he majored in Journalism. After graduation David headed to New York City — he didn't really have a plan except to find a job once he arrived. "My first job was working for a medical magazine called *M.D.* for doctors," David recalls, "then I moved to

another magazine called *Toys and Novelties*" as the managing editor. "I used to like to go to the photo shoots for the cover" and thought "that looks like fun — so it planted some seeds."

At some point, David got curious about the last page in the magazine, which would report all the toy and novelty stock prices. As managing editor, David would call a broker to get the prices for publication. One day he eventually asked the broker

> What is this stocks? How do you do that? He says 'I'll tell you what, can you send me $100? I'll just do some stuff for you and we'll see what happens.' So I sent him $100 and within about four months I had $5000. And so I quit my job and lived in Greece for two years on $5000.

David chose Greece after someone at a party told him and his girlfriend that they should go to this wonderful place on the island of Rhodes. Eventually, as they heard more and more about it, "we just said 'Okay, let's go do that.'" And off they went to Rhodes in 1965. David was 25 at the time, and they found themselves in Lindos, "this white village nestled into the side of a hill and had a giant beach and an unbelievable acropolis and just was really cheap and beautiful and fun and I was going to write a book." About six months later, David ran out of money and when he was down to his last $100 he took a Turkish freighter to Israel. "People had told me that you can go there without a cent and get a ride to Tel Aviv, go to the kibbutz office and they will put you on a kibbutz somewhere and feed you. So I did that." Once he arrived, he was put on a bus and taken to a kibbutz in the Gaza strip. "UN troops would have been right there and I worked right at the border and I have no pictures of that." Unfortunately, David had run out of film as well as money. After a few months of kibbutz life, David was ready to return to Houston. Calling one of his Houston friends whose father was a Vice President with Hilton Corporations and ran the extravagant Shamrock hotel[39] in Houston, David asked for help returning home. "I didn't have any money, I didn't know what I was going to do and so he arranged for me to come into Tel Aviv, stay in the Tel Aviv Hilton for a couple of days and see if I could arrange a ship back and he gave me $200 to do that and that was just what it cost." David returned to New York, where he married Mimi, his first wife, and together they went back to Lindos, where they stayed for a year and a half.

On Rhodes, David found himself doing more photography than writing. Realizing he enjoyed photographing people in their surroundings, David began doing portrait work. "I just set up a little studio," David remembers, "all these houses have a big courtyard, and they were all white so it was easy to set up a pretty good situation for photographing and I did a lot of portraits, mostly kids, and got paid to do that too." Though David did not write a book — "It turned out that wasn't my thing" — he did publish his first photographs. "I met a German guy who wrote children's books and he wanted to do a picture book." Published in Germany, *Paulinchen*,[40] by Hans Limmer with photographs by David Crossley, is the story of a young girl and her baby pig. Initially published in 1970, a new edition was reissued in 2013 and additional versions have been published in Australia and Korea.

Back in Houston in 1969, David and Mimi went separate ways and David found a job at the Camera Center in the River Oaks Shopping Center. David also began volunteering with the new Pacifica radio station KPFT in Houston and by 1971 was producing their newsletter. The radio station had been established by journalist Larry Lee "who was just determined — he was a fireball ... a radical political dude," David remembers, "It was great." Still on air, KPFT is an independent, listener-supported station, with a tumultuous beginning. On March 1, 1970, "the first sound to emanate from 90.1 FM was the song 'Here Comes The Sun' from the then-brand-new *Abbey Road* album by The Beatles."[41] However, within two months the station was bombed by the Ku Klux Klan and off the air for a few weeks for repairs. Then in October of 1970, the nascent station was bombed again. This time with more extensive damages that took until January of 1971 before the station was back up and running. They went back on the air with Arlo Guthrie live in the KPFT studios playing 'Alice's Restaurant,' the song that had been playing when the October bombers struck."[42]

Someone once said that the culture of the 1970s had more of the values of the 1960s than the 1960s actually had. And indeed, Houston saw its share of the youth culture, civil rights challenges, and optimism about changing the world for the better. As an independent media source, KPFT was squarely in the middle of such sentiments internally as well as externally. Trying to do everything democratically, staff meetings would continue until a collective agreement was reached. Various interest groups — Women's Liberation, Black Power, Chicano Power — were all represented in the programing. Everyone was pas-

sionate and politically engaged. When David had been at the radio station for a short time, the entire staff went on strike because the Board of Directors had fired the manager. "For some reason the staff coalesced around me," David explains, "wanting me to be the manager." With the strike, the station was off the air for two months and when the dust settled, David was the new manager. Most of the staff were all living together, sharing everything commune style. "I remember one time when things were so bad and staff, everybody, made the same amount, so instead of firing somebody when we didn't have enough money, we would lower everybody's salary," David recalls, "I remember once when we were each making $34 a month."

In addition to his time in the kibbutz, David's year at the radio station and his next venture, the Peaceable Kingdom, provided a philosophical as well as expe-riential background for his approach to leading HCP. The Peaceable Kingdom is quintessential of the early 1970s ideas. By this time David was with Jody Blazek, his second wife. Jody worked as a CPA with a specialty in nonprofit tax-exempt organizations and had a friend, Libby Rice Winston, who had a couple hundred acres up in Navasota County where she "had started something up there she was calling the Peaceable Kingdom." It was a classic 'back to the land' idea popular at the time. Jody took one look at the Peaceable Kingdom and suggested Libby create a foundation to support her efforts. Enticed by the idea, she asked Jody to put together the paperwork to create the Peaceable Kingdom Foundation. Libby then thought it would be a wise idea to have Jody come and manage the place. So, Jody and David moved to Navasota and lived in the Peaceable Kingdom. Though perhaps more importantly for Houston Center for Photography, Jody had just secured a new client — John de Menil. Over the years, Jody continued to work with the de Menils and eventually became the treasurer for all their non-profit interests. After the Peaceable Kingdom, David and Jody bought land on Lake Whitney, near Waco, where both of their children were born. Jody would commute to Houston to see her clients and David would commute to Austin to work on *Texas Monthly* magazine. It didn't take too long before this got to be a bit wearing — so back to Houston they came in 1976 and settled into one of the houses near the Rothko Chapel that was owned by the de Menils.

Jody's connections to the de Menils and their friendship with many of the key people managing the various de Menil interests gave David several opportu-nities to use his photographic skills. One of his favorite memories was being

asked to photograph at the colloquiums held at the Rothko Chapel. "It was this huge circle of those little thin tables they have with the royal maroon felt covers on them and all these incredible people from all over the world," David recalls, "so the Dalai Lama, the priest from Brazil Dom Helder Camara, ... [later] Nelson Mandela — I mean these people were sitting at the table talking about the world and about religion and compassion and I get to do the pictures, sat right in the middle, sat on the floor, right in the middle of this big circle for three days and of course visited with them at dinner." This led to David becoming the photographer for the chapel and then later he was asked to photograph the artwork in the de Menils' collection. It was good and steady work. David used his living room as his first studio but then in 1979 purchased

a property at 1412 West Alabama Street and, with a partner, Bill Pogue, started a commercial photography business, calling it Crossley and Pogue Photography. Without knowing it, David had set up his new studio almost across the street from the building that would become HCP's home — the same Shopkwik at 1441 West Alabama that Peter Brown wandered into for air-conditioning and food on the day he arrived in Houston.

### "What we did with the magazine changed everything..."

Like other HCP efforts, the new magazine started strong from the very beginning. "I love that magazine," David says, "I thought it was more important than galleries or anything else — and I loved writing." The magazine "had a dozen people who worked on it, who wrote for it." David remembers,

> I had a lot of fun working with people who weren't really accomplished writers ... but knew a lot about the topics. And some of them were kind of eclectic ideas and all that stuff just poured into ... [the magazine]. It was thrilling.[43]

The first issue came out in March of 1983, edited by John Hall, and was called *Image*. They printed 10,000 copies which were distributed for free. It had 24 pages with an article on the history of HCP to date, reviews of six of the recent and current HCP exhibitions, text from three lectures — one on the history of photography in Texas though the speaker's name is omitted, one on legal rights for photographers by David Portz, and notes from gallerist David Mancini's lecture on the "ups and downs" of photo galleries, as well as book reviews and a summary of a workshop on Infrared materials. The issue also had an excerpt from Peter Brown's *Seasons of Light* series and a page of "Members' Work" which

included one image from each of the five members selected for a solo show in the Members' Gallery. The final page is devoted to a calendar of photo events in the area and the back cover has two half-page advertisements — one for an upcoming workshop with George Tice and one for NPL Incorporated, "The most complete audiovisual production facility in the southwest." The magazine set HCP apart from all the other photographic centers in the U.S. "What we did with the magazine changed everything because nobody [else] was actually doing that," David remembers. In true Texas fashion, HCP put itself on the photography map with *Image*.

In this first issue, David recounts all the accomplishments of HCP's first seventeen months. The center has "gained a gallery, a meeting space, nearly 170 members, a pretty good chunk of money, and a lot of experience." He goes on to list the activities. HCP has shown six major exhibitions as well as "a dozen smaller shows of local work in the new Members' Gallery" as well as three exhibitions in other spaces (Rice Media Center, Houston Independent School District Headquarters, and University of Houston-Clear Lake). They calculated that approximately 1,800 people had viewed nearly 900 photographs through the exhibitions. In addition, they have sponsored lectures by photographers William Eggleston, Geoff Winningham, Fred Baldwin, Wendy Watriss, and gallery owner David Mancini, as well as others on topics of interest to the group. Another focus of their efforts has been on providing workshops. By this time, they had hosted workshops on the dye transfer color printing process, photographers as filmmakers, studies of the nude, documentary photography, use of infrared materials, and platinum printing. Additionally, they had created the Houston Center for Photography Documentary Awards Program that gave three awards of $1000 each to photographers pursuing documentary projects.[44]

By the second issue of *Image*, September of 1983, the organization reached an unexpected snag. "While we didn't set out to be controversial, it seems as

149

**First issue of HCP magazine, 1983.**
Courtesy of Houston Center for Photography.

though we were," wrote Marty Hidalgo in the issue.[45] The September issue featured a cover story by George Krause about photographing nudes. When the issue arrived at the printers, they refused to print it due to the content. Two additional local printers also turned the organization down. Finally, a fourth printer was approached who would take the job "without passing judgement on the content." So, after scrambling a bit, the issue did come out but to mixed reviews. Some readers "were disgusted by the nude photos and threw the magazine away after a quick glance," Marty continued, "others thought the kind of nude photography we pictured was outdated." Debates and discussions ensued about what constituted art photography and what the focus of the new organization should be. Voices were heard from all sides echoing the variety of different backgrounds and perspectives of the membership.

After only five issues, the name of the magazine was changed at the encouragement of the lawyers for George Eastman House, which had been publishing their own magazine called *Image* for decades. Anxious to avoid a lawsuit, HCP quickly realized the wisdom of George Eastman House lawyers' suggestions. As noted in the group's newsletter, "They [George Eastman House] had seniority by several decades, so we had to change names."[46] The search for a new name fell to the magazine editor David Crossley. Running into artist Ed Hill at an art event, they discussed the dilemma over a beer. Ed tells the story of how he came up with the name *SPOT*

> So, I'd been thinking about what to call it. Photo things are always so boring. So I asked the administrator's secretary at the art department, if she had a dog, what would she call it? ... and she said Spot. ... So, I called David and he said, "yep."

"After many meetings with many people, we had about 100 names to choose from, some of them horrible, some zany but wonderful," a newsletter article explains. "We decided to go the zany route, thanks to a suggestion by Ed Hill."[47] When the change in names was announced, the rest of the membership was not so quick to accept the suggested name. David explained the decision-making process in an article titled "Why not SPOT?"[48]

> The idea didn't necessarily go down very well around the Houston Center for Photography which publishes the magazine. But every subsequent

emergency name meeting before the very last one produced worse and worse names.[49]

Eventually, when all other ideas had been dismissed, "it was *SPOT* by a landslide."

The next task was to come up with the graphics and typeface for the new name, which turned out to be another challenge. Designer Peter Boyle originally came up with a design in Bauer Bodini font with the o as a perfect, solid, black circle. David showed it to artist and Rice professor, Charles Schorre, thinking he was the most accomplished designer associated with the HCP and "he went berserk. He hated the name, and he didn't understand what all those letters were doing on either side of that terrific spot. He started sketching and then we pulled the s, p, and t off the board, and voila! The spot."[50] Beginning with the Fall 1984 issue, the next several issues were published with only a black circle at the top left-hand corner — though by the Fall issue of 1989 the s, p, and t had reappeared.

### A telephone and a paid director

Despite a few missteps, the ambitious programing and the success of the auction continued to move the group forward. The center had 24 members serving in volunteer positions, and in March of 1983 would hire their first paid staff member — an Administrative Director. The organization was getting more stable and formalized. "After a year and a half of using various members' phone numbers, [the center] will actually get a telephone."[51] Regular meetings were held twice a month — one meeting was a business meeting combined with the presentation of a specific topic and the other was set aside for the presentation and discussion of members' work. The group was still meeting at the Bering Church but they had begun to look for their own space.

Paul Hester remembers not being all that comfortable with the idea of hiring a paid staff member. "Why spend the money on that when you had volunteers?" he asked. Partly, Paul reflected that he hadn't wanted the members to lose control of the organization. In hindsight, though, early members remember that hiring Lynn McLanahan was an important step for the center. It was a turning point — "Lynn came with all her knowledge," David remembered, and we were able to "break out of the box" and begin to search out more high-end

photographic work to exhibit. Having a full-time staff member gave the organization a point person and some consistency, which would help stabilize the already engaged photography community. The Board leadership would change yearly, though it seems that everyone took a turn so that leadership kept rotating throughout the membership. In the first ten years, Board Presidents included Gay Block, Dave Crossley, Herman Detering, Paul Hester, Sally Horrigan, Joan Morgenstern, April Rapier, Amanda Whitaker, and Clint Willour.[52]

HCP's newly-hired director, Lynn McLanahan, had just returned from graduate school at University of New Mexico, where she had been studying with Beaumont Newhall. A native Houstonian, Lynn grew up in a well-to-do River Oaks household that appreciated art. Her father, Alexander McLanahan, whom everyone calls Mike, had grown up in France in a small chateau near Burgundy surrounded by art and medieval tapestries. Lynn's mother, Mary Ann, whom everyone calls Muffy, was from Houston but said her family "went astray" moving to New York for a number of years before returning to Houston 1947. Both Lynn's parents were very active in the arts as philanthropists and supporters. Mike had been on the Board of Trustees for the Museum of Fine Arts, Houston since the 1970s and was the Chairman when they wisely hired Anne Tucker. Muffy had been an active volunteer with Houston Grand Opera and helped with the early museum Balls as well as being a founding member of HCP.

**Beaumont Newhall,**
**Hollis Frampton,**
**Estelle Jussim,**
**John Szarkowski,**
**Anne Wilkes Tucker,**
**and Peter Bunnell:**
**panelists for**
**Ruth K. Shartle**
**Memorial Symposium,**
**October 26–28, 1979.**
From the Collection of
the Museum of Fine
Arts, Houston Archives.

Growing up in Houston, Lynn remembers attending a symposium that Anne Tucker had organized at the museum that included Beaumont Newhall, John Szarkowski, and Peter Bunnell. They were the three leading photography historians and "I was so excited by what all three had to say," Lynn recalls, "also they made it clear that this was a relatively new field." She had been planning to major in art history but thought to herself "Ooh, wouldn't that be fun to study something that hasn't been studied before." So, Lynn went off to Princeton to study with Peter Bunnell. While there, she was not lucky enough to win the lottery to study photography with Emmett Gowin. There was such demand for his courses, that only seniors were allowed to enter the lottery for coveted slots and being a photo history major rather than a studio major further removed Lynn from that opportunity. However, she was able to do quite a bit of studio work in her graduate program at University of New Mexico. Lynn went primarily to study with Beaumont and the program was flexible enough that "I did a lot of photography when I was in graduate school" Lynn explains, "and then kept up a little bit when I got out of graduate school but was smart enough to see that there were a lot of people better than me." Between undergraduate and graduate school, Lynn spent a year in London working in Sotheby's photography department. Returning to Houston, she was one of a handful of individuals who had degrees in photography and perhaps was then the only person in town, besides Anne Tucker, to have focused on the history of photography. Lynn finished her master's program and returned to Houston at the perfect time for HCP.

"Lynn's just one of the most creative, most brilliant people I know," Sally Horrigan says of working with the first director, "very sweet and down to earth — just a wonderful human being." Lynn remembers it was an exciting, dynamic time working together to get things done, often "by the seat of our pants" but making things happen nonetheless. "Lynn and I had so much fun, there was so much laughter, we did everything," Sally explains, "I mean we swept the floor before the openings!" Indeed, it was an all hands on deck spirit. Lynn remembers "a lot of people putting in a lot of volunteer hours to get a gallery physically ready for an exhibition or to go out and decide what an issue of *SPOT*[53] was going to be about and going out and doing it. That was in the days of cut and paste and, my god, it was so much harder to do all that stuff then." Lynn continues

... it was just, the energy and the people, yes there were good exhibitions and we put out a good product, but it was pretty exciting working with all those people from different walks of life who all came together with a shared passion. It was really fun ... It spills over into your social life because you are working so hard you would end up eating breakfast, lunch, or dinner with people you were working into the night with so I made a lot of good friends that have remained good friends like Gay [Block] and Sally Horrigan and Paul Hester and Dave Crossley ...

Looking back, it is impressive "that we did as much as we did, it was really exciting and there was always new stuff, learning curve was always up up up, " Lynn summarizes. Everyone was pitching in, discussions were long and open, and things were happening. Sally Horrigan looks back fondly, "It was just a wonderful group of folks." HCP was seemingly "a blank palette, there were no rules — we went whole hog," David explained.[54] Looking back, Lynn remembers "It was kind of crazy, exciting all the time because every day it was like 'well what else do we want to be?' — there was no limit." The Houston group was eager to catch up with all the photography activities happening in other cities — like International Center for Photography in New York City, Friends of Photography in Carmel, Light Factory in Charlotte, Light Works in Syracuse, and Photographic Resource Center in Boston that David recalls "were so far advanced".

## Anything is Possible

In many ways, it was the vision of what a photography community could be that fueled the Houston efforts. Anne's knowledge of the importance of the Photo League in supporting photographers and their work can be seen in the development of the Houston Center for Photography. In a 1983 interview in the *Houston Post*, Anne explained

Many of the things that the Houston Center [for Photography] does and wants to do parallel the [Photo] league, not necessarily because the league is a role model, but because there are stimuli working artists feel they need — one, a place to show their own work in order to get some feedback; two, a chance to see other people's work; three, a place of communication where you can find out about invitational exhibitions, talk cameras, technical things, trade information, have people come lecture. It's supplying things

working artists need. It's what makes many artists' organizations similar throughout the country, because those needs never change.[55]

Photographer Gay Block remembers that HCP is "how I realized we had a photography community." Once people came together, they realized the potential and the possibility of working collectively to support one another. By doing so, they were also building community and increasing broader interests in photography as well. Lynn McLanahan wrote at the time, "interest in photography has flourished thanks to the efforts of a group of dedicated people in the right places. ... The 'anything is possible' spirit lives on here and, as a photographic center, Houston is young, but growing."[56]

And grow they did. With Anne's efforts at the museum — developing the collection in international directions — and her own growing reputation, the Houston community was gaining legitimacy as a serious photography town. Houston Center for Photography, especially with their magazine, kept their goals and aspirations high, striving to be an important and respected center. With several committed individuals and the growing infrastructure of these two organizations, the groundwork was being laid for the next phase. Across town, photographer Sally Gall remembers inviting photojournalists Wendy Watriss and Fred Baldwin to dinner. They were talking about the possibility of hosting an international photography fair in the city. No one else in the United States was doing such an audacious thing ... so why not Houston?

# Chapter 7

# "Two people that have had the same ideas"

After nearly a decade of opulence, Houston was still riding the oil boom as the 1980s began and Wendy Watriss and Fred Baldwin moved into town. The *Houston Chronicle* described the times, "Sleek company cars plied the streets of the city. Membership at tony golf clubs soared. Corporate jets stood at the ready to whisk executives to anywhere in the world."[1] Ideas were Texas-sized big, money flowed, and Houston's economy continued to pull in people from elsewhere. Houston seemed to be a place where interesting things could happen and did. *The Target Collection of American Photography* exhibition traveled widely, putting both the Houston museum and its photography curator, Anne Tucker, on the photography world's radar. Photography programs at both University of Houston and Rice University were being recognized nationally and began to draw students from throughout the country. Exhibition spaces continued to be developed throughout the city and Houston Center for Photography, with their magazine and ongoing exhibition, workshops, and events programing, became the local scene for those interested in photography.

"Houston," Wendy Watriss wrote for an early issue of Houston Center for Photography's magazine, "has begun to put in place the kind of infrastructure in which a serious photographic community can grow and sustain itself: nationally recognized teaching programs; important public institutions showing photography; major public collections; a diversity of exhibition spaces; a broad base of working photographers; and a committed, educated audience for photography."[2] Houston, she concluded, had the possibility of becoming a national center for photography. The seeds of an art world had indeed been sown and Houston was well positioned for a tipping point. Though as the bottom began to drop out of the oil prices in 1982 and the decline accelerated in

1986, support for photography looked precarious at best. During the down-turn, one in seven Houstonians lost their jobs, office vacancies rose 20% and more than 200,000 homes stood empty. Even in the posh River Oaks neighborhood of Houston's elite, roughly eight percent of the homes were put up for sale.[3] At the end of the decade, the worst of the bust was over, and more than 130 Texas banks had failed. Yet, amid this economic turmoil, two visionary photojournalists managed to bring international attention to photography in Houston. The first photography festival in the United States in 1986, original-ly called Houston Foto Fest, a Month of Photography,[4] was the tipping point that jettisoned Houston from a place with the potential to become a national center for photography to an international photography scene and art world in its own right.

## A Chance Meeting

When photojournalists Wendy Watriss and Fred Baldwin landed at Italian Duchess Torta Di Giovanni's cocktail party in New York City in 1970, they were both in transition. Wendy, at 28, had just returned from her first photography assignment in Africa and Fred, 42, was doing freelance work based out of New York City. "We just sort of took one look at each other when I walked in the room," Wendy recalls, "it was frankly instant chemistry."[5] Fred distinctly re-members Wendy's Pucci mini skirt, "oh she was the sexiest little thing!"[6] They spent the entire party talking only to each other. "He had his adventurous life," Wendy remembers, "and I was just getting into the field, and I had my adventurous life, and it was like two people that have had the same ideas, the same kind of rebelling against one's social class." While rebelling against the privilege of their families and childhood, they both had kept "one foot in, one foot out." Wendy explains, "My idea is, don't constrict your life, keep expand-ing it … [and] somehow figure out a way to have your own space while you're doing that."

Their chance meeting led to a "torrid affair" and a summer full of adventure among the privileged.[7] Wendy had an assignment to photograph the thor-oughbred yearling sales in Sarasota, and Fred had one for the America's Cup, and another at a resort in Jamaica. They worked and played together all sum-mer, staying in tony mansions of friends and high-end resorts. "It was a wild, wonderful affair," Wendy explains, "but I was not planning to live in the Unit-ed States." She adds, "I was very attached" to a Hungarian aristocrat she had

been living with in Vienna. So, back to Vienna Wendy went to continue her international photojournalism work. Her life in Vienna "was really interesting because I was getting commissions from the *New York Times* and *Newsweek*, and Vienna was the middle point between the East and the West, and the Jewish intellectual life was coming back ... Vienna was a wonderful place to live." And, Wendy adds, "Peter was a wonderful guy to live with" who spoke six languages and "could talk about any place in the world." Vienna felt like an epicenter of so much that was happening in the world that Wendy found exciting.

In Vienna, Wendy was in contact with various political leaders, dissidents, and other journalists in the midst of the post-Prague Spring upheavals. Contacted by "a famous dissident writer who was living in Vienna at that point," Wendy recalls, "he said, 'my sources are telling me that there are trials going on and nobody knows about it.'" At his request, Wendy drove alone from Vienna to Prague to pick up the evidence in a clandestine meeting that could have been straight out of a movie. She met her contact in the library of the cavernous twelfth-century Strahov Monastery, where she was given the documents. After, as she began to leave Prague, "it started to snow, it was just kind of heavy flaky snow [and] at the outskirts of the town, I saw lights — Tatra cars, those were the cars that were driven by government and security officials ... they had this very distinctive headlight shape that started to follow me." The Tatra followed Wendy the entire four-hour drive, through the snow, to the Austrian border. "The cars stayed probably two car lengths behind me the whole time," Wendy explains, "I had hidden the papers as best I could, but anybody could have found them, any person that knew how to search a car would have found them." Wendy remembers being "very scared" and talking to herself as she drove, "I had read so much about Russian secret police and Czech secret police." Her mission successful, "the Czech underground in Vienna broke the story and it became a front-page story of the *New York Times* and showed what was really happening."

In contrast to Wendy's compelling life in Vienna, Fred, only half-jokingly, says he immersed himself in yoga after Wendy left for Vienna. He also left New York City, returning to Savannah to "clean up my life ... trying to avoid thinking about Wendy and suffering too much at her absence." From Savannah, Fred continued photographing high-end resorts for work but also "took up with a very good-looking yoga teacher" enjoying the fact that "there were all

women in the class." After a few months, a local doctor took Fred to see a rural area in southeast Georgia that was steeped in rumors, myth, and scandals since the 1800s; it was a small community just outside Savannah that many were even afraid to drive by.[8] An isolated community "off the beaten path and down several dirt roads," it was "a difficult place to find ... [and] ill-advised to visit."[9] Secluded by both topography and choice, outsiders spun stories of inbreeding, claiming the locals had "birth defects ranging from dwarfism to extra fingers."[10] Captivated by what he saw there, Fred began photographing there, furthering his investigation of white poverty in the region. This venture was a turning point in Fred's work; he began to focus on social justice issues in contrast to his earlier, more self-directed projects.

While apart, Fred wrote long, illustrated letters to Wendy. "I would send photographs back to Wendy to show her what I was doing ... I was basically trying to lure her back by showing her all these very bizarre things that were as seductive as anything she could find in Europe or in the Balkans or whatever ... that we could unearth exotica in the United States." It took some months, but Fred's strategy worked in the end. "Fred," Wendy explains, "was a more powerful force and I thought, we could do these great things, Fred and I, together." Fred had found a publisher interested in a book project he was calling the 'Back Roads of America.' "The idea was to go off the main trace, go to rural America," Fred recalled, and this prospect turned out to be very alluring to Wendy. A year and a half after their summer affair, and numerous letters later, Wendy returned to New York. Within a week, traveling in Fred's venerable handmade Mercedes Cabriolet with a 13-foot trailer he'd bought third hand for $800,[11] they were off on their adventure to experience and photograph rural America.

Before they met, Wendy and Fred had each begun to use their cameras as passports to larger lives and as a way to bring attention to social justice issues. As with many of their generation, they shared a desire to make a difference in the world and improve the lives of the less fortunate. As Xavier Canonne sums it up, "Each had their own path, their own method, and each of them had lived through great social change and upheaval in the U.S. society since the end of the 1950s."[12] In many ways, they were both products of the 1960s as rebellion and ferment for social change brewed among the young and idealistic. Both had been born into well-to-do circumstances that gave them access and op-

**Wendy and Fred's living arrangements while photographing in rural Texas.**
Photo: Wendy Watriss and Fred Baldwin, 1971. Courtesy of Wendy Watriss.

portunities to pursue adventuresome, international projects. Perhaps more importantly, they believed in their own ability to do something that would matter. Confidence coupled with their passion for the work, and for each other, ensured that they would continue until they succeeded.

### *"I think maybe there's an aura about Fred."*
Wendy Watriss

Fred was born in Lausanne, Switzerland on January 25, 1929, the second son of Frederick William Baldwin and Margaret Gamble. His father, though born in Connecticut, was raised primarily in Europe as his father, Fred's grandfather William Wilberforce Baldwin, was a famous cardiologist in Florence, Italy whose patients included Queen Victoria, Princess of Teck, the Duchess of York, Mark Twain, Edith Wharton, Henry and William James, and Pierpont Morgan, among other notables. He was described as a "brilliant diagnostician" and very "clever, intelligent and ingenious and remarkable in his way."[13] With his elite

European upbringing, Fred's father was a natural for the diplomatic corps. First serving as the Vice Consul in Florence (1920-1925) and then Lausanne (1925-1928) where he rose to the position of U.S. Consul (1928-1932), before taking up his final post as U.S. Consul General to Cuba (1933-1934). With the unrest of the Provisional Revolutionary Government coalition just rising to power in Cuba, the young Baldwin family moved to the Bahamas, living in Nassau while Frederick conducted his consular duties out of the Hotel Nacional de Cuba in Havana.

Though he never knew his famous grandfather and barely knew his father as he died when Fred was five, both men loomed large in the family myth and lore. "I was terribly influenced by my father all my life," Fred explains. "My memory of him is like little snatches of a movie that you saw 20 years ago — not very many and not very much, but yes, I've missed him all my life." As a daily reminder, Fred kept a picture of his father on his dresser — a tall, tan, muscular man in a bathing suit on the beach in Barbados looking the perfect, handsome specimen of a man. The photograph was taken, somewhat poignantly, only three months before he died from a lung infection just shy of his 49th birthday. Being so suddenly widowed seemed to unmoor Fred's mother. She initially moved with her two sons back to her family home in Jacksonville, Florida but then unrest sat in. Fred remembers moving 22 times before he turned 11. They would travel during the hot summer months either going north or abroad, and then return to various places in the south during the winters.

Growing up, Fred and his older brother, Gamble, had a series of nannies — one of whom, according to the family lore, turned out to be a German spy in their diplomatic household. After she had been "shipped off," Fred received a postcard from her. "Dear little Snookie," it began, using Fred's family nickname. The picture was of "storm troopers marching out of the Brandenburg Gate — in the corner of the postcard are little swastikas" and was mailed with a Hindenburg and Hitler stamp. Once the brothers reached school age, both Baldwin boys went to boarding schools. Fred attended boarding school in Switzerland until concerns about the coming war mounted, and his mother brought him home to a military school in Jacksonville. After that, as his brother before him, Fred went to the elite, private preparatory school, St. Mark's, outside of Boston, "a bastion of propriety and 19th-century values."[14] Poet W. H. Auden, who taught at St. Mark's briefly in 1939, said of the school, "it sets out to be an American Eton."[15]

Fred did not last long at St. Mark's, though his time there was formative. "I got tough at St. Marks. It's a very brutal system, that sort of English Public School system. ... They don't call it grades, they call it forms," Fred recalls, "and, the forms are segregated. You're not allowed to talk or socially ... I mean it's by tradition. The older and younger kids, you don't fool with them, you stick with your own form. That's a little tight thing. And, quickly, ... the tough guys get to the top and the bullies take over ... there's a pecking order that develops very fast. If you're gonna survive, you learn how to hit harder, then if you punch back, then you survive." Asked to leave St. Mark's because he wasn't "able to pull the academics," Fred found himself at "the lowest point in my life ... because St. Marks, in my mind, was automatic. We automatically went to Yale, Harvard, or Princeton. Then when you graduated from Yale, Harvard, or Princeton, you went on to a job where you could run the world from Wall Street or some equivalent."

Indeed, Fred's brother Gamble had done just that. Six years older than Fred, he had followed the expected family path. Graduating from St. Mark's, Gamble went on to Princeton and joined the prestigious Colonial Club — the fifth oldest eating club that accepted members through a highly selective bicker system. As World War II started, Gamble joined the Army Air Corps and was a "much-decorated member of the 379th Heavy Bomb Group." Shot down over Germany, Gamble was held as a P.O.W. Once the war ended, he returned to finish his degree at Princeton and then spent five years working for American Express throughout Europe. Years later, returning to New York City, he became quite successful on Wall Street as "the nation's top natural-gas analyst for many years" and later co-founded Natural Gas Partners, an energy investment fund.[16] Watching his older brother glide through the "automatic" path to success must have deepened Fred's own disappointment. "As soon as I left St. Mark's," Fred said, "my rebellion started" and he began to chart his own path, "I wanted out of the ordinary."

At thirteen, Fred also found himself with a new stepfather. His mother, Margaret, married Delavan Munson Baldwin, though no relation to her first husband, he had the same surname. "I always speculated that she didn't want to bother to change her name tags on her luggage," Fred said wryly. Delavan came from a wealthy New York family and raised polo ponies. After their marriage, Margaret and Delavan bought a horse farm in Virginia, where Fred remembers being "stuck there for a couple of summers," he adds, "which was horrible." With his brother Gamble away in the war, Fred recalls feeling quite

isolated there, "No matter how ideal it is, if there's no companionship of any sort, and a stepfather you don't particularly like ..." so Fred spent most of his time with one of the grooms, Willie, who taught him how to ride. The horses became Fred's escape, "I used to get on one of those polo ponies with my friend Willie and we'd take off."

After attending three different high schools, Fred graduated and went to University of Virginia for a year. His rebelliousness and desire to escape the ordinary intact, his focus had not been on his coursework, so Fred ended up in Savannah working in the family ice factory. "I was exiled there after I flunked out of college," Fred said with irony. Once there, he saw his whole future laid out before him, "I was going to be President of the factory someday." He started there as a laborer "getting 34 cents an hour." Fred explained, "I was working with poor whites and poor Blacks who were being exploited by my family — I began to understand exactly how the system worked." Initially, Fred "was in the engine room in the beginning, looking after a machine. Putting oil in it, the cleaning, scrubbing, sweeping." Eventually he began to work in the office, "which wasn't any better. ... I just hated that boring routine." The factory ran six days a week, though Saturday was a half day. Sunday, Fred remembered, "was spent dreading Monday."

It wasn't long before Fred decided he needed "to get the hell out of here." Since his stint at university had not gone so well, Fred, at 20, decided his best option was to go into the military. He chose to enlist in the Marines because "the elitism appealed ... because I was getting elitist in a different way." Fred continued, "I flunked out of elite St. Mark's, but I wasn't about to flunk out of the Marines, which is considered to be the toughest." Once in, Fred got a friend to change his status to "basic infantry" so he could be sent into combat. "My brother ... [and] two uncles had been in the military, and this was only five years after WWII, and so there was still that war feeling and by '52 or '53 it had gone, but 1950 it was still around, in my mind it was, and I wanted to prove myself; I wanted to see combat, and I got to Korea."

Fred served as a rifleman in Korea, were he saw "a lot of combat," including participating in the pivotal Chosin Reservoir Campaign. During his time in Korea, he was wounded three times and awarded two purple hearts. "I refurbished my reputation by joining the Marines," Fred said. Sent home on a hospital ship, Fred wrote to University of Virginia hoping they might readmit him.

"Just to make it more dramatic," Fred explained, he signed the letter in blood he 'borrowed' from a "Turkish soldier who had his arm and leg shot off and ... was leaking blood a little bit." Despite Fred's dramatic flourish, University of Virginia did not readmit him so after his military duty ended, he went to stay with his family in Paris. His brother Gamble was working for American Express at the time and had a large apartment in the 16th arrondissement "near where the Duchess of Windsor and the Duke were living." Fred spent eight months enjoying Paris and trying to sort out his future. He ended up returning to Savannah and attending Armstrong Junior College, where he improved his grades to the point he was able to transfer to Harvard. As an older student, and returning veteran, Fred found Cambridge was not a good fit for him — "There were no people like me around." So, he transferred to Columbia University in New York City, where he majored in English Literature and Russian Affairs.

During Fred's junior year at Columbia, he received word that his grandmother in Florence, Italy had died and left him a small inheritance. Since the funds were in lira, Fred had to go to Italy to collect the money. Equal to about $1000, the funds allowed Fred to spend the summer traveling through Europe. "From spending time with Mormon missionaries in Orleans to drinking with King Farouk in Paris, his life became a galaxy of contrasting experiences. After spearfishing on the Riviera, he ended up in a nudist colony."[17] While in the south of France, Fred decided to try and visit the man he envisioned as his "imaginary father" — artist Pablo Picasso. "I was dreading graduating from Columbia because I didn't know what the hell I was going to do." Thinking some fatherly advice would help, Fred said, "I thought it would be nice if I was with Pablo in the south of France and so I could chat about life."[18] Fred borrowed a Rolleiflex from a friend and headed to Picasso's home, Villa la Californie, in the outskirts of Cannes.[19]

After three unsuccessful tries to see the artist, and nearly out of gas and money, "I did something that I thought was the silliest thing that would get his attention," Fred recalled, "I would write him an illustrated letter telling him what it was like trying to get in to see him when I'm living in my car on his doorstep, and drew little pictures of myself."[20] Finding a shop girl to help him translate his letter into French,[21] Fred explained that while waiting to see Picasso, his beard was growing so long he would soon look like Moses. In the letter, he added small drawings of himself sleeping in his car, Moses with tablets, himself with his camera and finally, cutting his beard off in Florence.

July 28, 1955

Dear Monsieur Picasso:
I am a student at Columbia University and this summer I am a freelance journalist. I know that you are very busy but I am here in my car and each day that you won't see me, my beard grows longer and longer. I will soon look like Moses. If you would let me take some color photographs then I could go to Florence, where I have some money and cut off my beard.

With hope I am,

Fred Baldwin[22]

Fred's hunch paid off, and Picasso's daughter Maya came to the door saying that Picasso would see him. Fred remembers Picasso as very nice to him, "We talked for about 30 seconds, and he said, 'You can take pictures — do what you like,' because he wanted to see my beard." While Fred had actually been sleeping in his car, he had not grown a beard. "I was very unbearded and so I told him it was my imaginary beard, I imagined it had grown quite long and he thought that was very funny and he spent the whole day with me."[23] Trying to be unobtrusive, Fred spent the time photographing Picasso, his studio, and the other visitors with his borrowed camera. "I was totally inexperienced," Fred recalls, "I had no light meter and was using Anschochrome film."[24] He had also brought two posters and a book he hoped Picasso would autograph for him, which the artist did.

Though Picasso did not offer Fred any fatherly advice, the meeting was still a turning point. It "released me psychologically — it just opened a door. I said, 'I can do anything. If I can talk my way into seeing Picasso, I can do anything.' I went back to Columbia not worried at all about what I was going to do when I graduated, and decided, well, I could either be a writer or a photographer." After his European summer, with a diary full of his adventures, Fred returned to finish his senior year at Columbia. It was then that he began trying to write in earnest. Amused and impressed, his writing instructor encouraged him and even contacted an editor at E.P. Dutton to look at his writing. While "that didn't go anywhere," Fred said, "it did form the basis of starting my interest in writing."

Since he was a child, Fred had been writing amusing letters as a means to win friends. He learned early that if you could make someone laugh, they were likely to treat you well. In grade school, he would write to girls at nearby boarding schools so that they would save all their international stamps for his collection. Later in military and preparatory schools, he learned that humor and jokes were essential for survival in those challenging settings full of bullies and hierarchies. His Picasso story, as he referred to it, "actually changed my life," and led Fred to develop a mantra that he lived by: "You have to have a dream, you have to use your imagination, you have to overcome your fear, and you have to act."[25]

After graduating from Columbia, Fred returned to Savannah. Still writing, he decided to also develop his skills as a photographer. He had started photographing while in the military and continued in college working on school newsletters. In Savannah, Fred began photographing children professionally and learning to make prints by reading photography textbooks and magazines.[26] Wanting to expand his efforts to include magazine work, he decided to give himself an assignment to photograph a Tobacco Auction in the nearby town of Reidsville. That Saturday afternoon, Fred only got as far as Pooler — a small town known mostly for its speed traps — where Fred happened on a group decorating cars with Ku Klux Klan symbols.[27] This was 1957 in Georgia and racism was front and center. "I remembered the Picasso mantra and I decided to go up to the meanest looking one there and I dragged my feet across the highway and I said 'I spotted y'all and I would like to take some pictures of you'," Fred said with his best Southern drawl, "and he said 'Are you working for *Time* Magazine?', 'No, sir', '*LIFE* Magazine?', 'No, sir' so they said 'yes, you can follow us to Reidsville, Georgia, the county seat where we are going to have a demonstration for the folks in Reidsville'. So, I did."[28] This work later became Fred's exhibition, *Saturday in Reidsville, Georgia 1957*.

His Reidsville experience fueled not only his belief in the 'Picasso mantra' but his taste for exploring different cultures and peoples photographically. His work photographing children was successful enough that after a few months Fred had saved sufficient money to move back to New York City. There, he showed his work to Edward Steichen at the Museum of Modern Art, who bought one of Fred's prints for $5 as he often did to encourage young talent. Fred only showed him the portraits of children; it did not occur to him to show Steichen the Reidsville images. "There were so many mistakes I had made,"

Fred explained, "I only shot eight rolls of film, and the biggest mistake I made … I should have stayed right there and spent six months to a year working with the Klan." In hindsight, Fred's wish that someone had given him good advice stayed with him and drove much of his later efforts to connect young photographers with experts who could help guide them.

Rather than returning to spend time photographing the KKK, Fred set about organizing adventures far and wide. Within the next ten years, Fred accomplished an impressive list of photography credits — Wild Horses in Mexico and men's fashions in Bahamas (*Esquire*), Peace Corps Doctors in Afghanistan (*M.D.*), Lapland Reindeer Roundup and Square Rigger Voyage (*Sports Illustrated*), Polar Bears (*LIFE*), Boar Hunting in Belgium and Quail Shooting in Georgia (*American Sportsman*), an "official" English witch on Long Island (*True*), Cumberland Island, Georgia (*Holiday*), Lapland Reindeer Migration and Arctic Fisherman (*National Geographic*), and Underwater with Marlins (*Argosy*).[29] Most of these stories he back-sold — coming up with the idea, talking his way in, photographing and then selling the images afterwards. "When I was starting my career as a photojournalist," Fred explained, "I was lying, cheating, and stealing." While this may be a bit of an exaggeration, Fred did often say he was working for a magazine to gain access for his self-motivated stories. But usually, he was able to back-sell the images to the magazine for which he had originally claimed to be working. Though adventuresome, Fred's chosen lifestyle "caused some trouble" with his family as he did not follow the expected path. His brother Gamble considered him a bit of an "irresponsible non-dues paying world roamer."[30]

Undeterred, Fred continued his far-flung adventures, often skirting with danger. He was the first to photograph polar bears and marlin fishing from underwater. He was willing to go to dangerous (one might say crazy) extremes to get the images. Fred was always running to the edge of his funds, equipment, or food. Returning from his first 1,000-mile expedition to the North Pole, on a thirty-foot fishing trawler through rough, arctic waters, he arrived back in port with only one liter of oil in the tank and almost completely out of food. Another time, to photograph polar bears' wide-open mouths, Fred wrapped raw meat around the camera lens and used a shutter remote 200 feet back. However, when the ice with the bear and the camera began to separate from the ice with Fred and the remote, to save his camera he had to chase the

1,200-pound bear away by blowing snow off his rifle and firing a bullet near the bear's feet.[31] In between international adventurous projects, Fred also worked in the U.S. In 1963, he photographed street gangs and drug pushers as part of New York City's Mobilization for Youth program. Later that year he also began his civil rights work as a volunteer photographer for Southern Christian Leadership Council, which became the impetus for his exhibition and book, *"We ain't what we used to be": Photographs.*[32]

**Fred Baldwin in the arctic, 1960.**
Courtesy of Wendy Watriss.

In the midst of all his travels, Fred had been seeing a Swedish woman, Monica, off and on. They met in 1956 while Fred was at Columbia and she was working as a secretary for the Swedish Consul General. Monica later returned home to Stockholm, where Fred would spend time between arctic expeditions and other adventures. Marrying in the fall of 1961, they settled in Savannah. Their first son, Frederick Breckenridge Baldwin, was born in 1963.[33] Fred's civil rights work changed his life and work trajectory; he began using his camera to focus on social justice issues. This interest in making a difference led Fred to take a position in the Peace Corps as the Director in Sarawak, Borneo. A new program begun by President John F. Kennedy in 1961, the Peace Corps was designed to aid the poor of the world through the efforts of U.S. volunteers.

As Director, Fred was allotted a good salary that enabled him to have a nice Malay-style house with servants, though he oversaw volunteers that were living very simply in local villages throughout the area. Prior to Fred's arrival, the Sarawak program was experiencing a high rate of volunteer turnover, often due to the variety of living circumstances that were much more primitive and challenging than many had expected. Cleverly, Fred devised a way

to better match volunteers with assignments. He "issued film for everybody, and made it possible for them to buy inexpensive, but good-quality cameras in Singapore." Fred directed the volunteers, "I wanted everything that they did recorded. Who they talked to, where they peed, where they washed their clothes, what they had to eat, I wanted a picture of everything." Fred then used those pictures to let new volunteers select their own assignments with a better understanding of the living situations they would be facing. Using photographs in this way, Fred solved the turnover problem. Fred lost only one volunteer during his two years as Director, and he grew the Sarawak program from 82 to 180 volunteers.

Nearing the end of his time as Director, Fred and Monica had their second son, Charles Grattan Baldwin, in July of 1965. When it was time for the family to leave Borneo, their nanny took the two boys to Beirut to meet up with Fred's mother, who took the boys to stay with her in Ireland. Fred and Monica took the time to travel. The Peace Corp had agreed to Fred's idea to photograph Peace Corp efforts in various countries for a book project. They traveled first to the Philippines, then on to Thailand, before spending time in India and Afghanistan with Fred photographing Peace Corp projects along the way. Returning to Savannah in 1966, they bought a house and Fred went back to freelancing. "When I came back to the United States," Fred explained, "I wanted to do something useful. I decided to get involved with the poverty program ... and I started looking into extraordinary, dreadful situations in that, near Savannah, in South Carolina and Georgia, of just unbelievable poverty, and disease — pellagra. Diseases that were thought to only exist in Africa, were existing in these little areas." For income, Fred was doing commercial work for high-end resorts like "Rockefeller resorts, and the ones in Puerto Rico, and St. Croix" and "getting paid very well, $1,200 a day for shooting." Shifting between contrasts of luxury and poverty, Fred found himself doing less of the resort work and more of the poverty work. The poverty photographs, "for which I was not getting paid, but which had another kind of payoff," Fred discovered, "I was able to give my poverty pictures to the doctor who I'd been working with, he went up and was testifying before the McGovern Committee in the Senate. We were able to get $550,000 to build a clinic in one of these areas."

The doctor that Fred had been working with ran a local clinic and was challenging community norms about race. "He refused to have a white and black

wing, he had an integrated wing," Fred explains, "he refused to differentiate between color." Unfortunately, the doctor was found to be using pain drugs, had his office raided, was arrested, had his license revoked, and was basically run out of town. "This left a huge hole in the medical possibilities of these people that he had been taking care of" that Fred wanted to address. He learned that it would take $14,000 to reopen the clinic and thought that if he made the community aware of the need, he would be able to raise the funds. To do this, Fred arranged to show his images at a museum in Savannah, "I thought showing desperate white people would work better than showing desperate Black people." It turned out that Fred was wrong, "A week before the exhibition was to go up, the museum sent over a friend of mine who was on their Board. They said, 'Fred, we're very sorry, it's too controversial. We can't do it.'" Disappointed, Fred approached a prominent doctor and the top banker in Savannah who were also family friends. "I really looked up to these two — they were very, very dignified, cultured, and intelligent people — so I called them in and explained we had to raise fourteen thousand dollars to get this thing going, and would they help me get it started?" They also felt Fred's project was too controversial, "Oh, they went ballistic," Fred sighed.

Disheartened and dismayed by his inability to raise the funds for medical care for the neediest, Fred moved to New York leaving behind both Savannah and his family. "Everything that I thought was right turned out to be wrong," Fred recalled. "I had a family breakup, and it was a very tough period for me psychologically," he explains, "and the whole Picasso mantra crashed." This was 1968 and Fred's own disillusionment mirrored much of the challenging of taken-for-granted beliefs occurring socially and culturally throughout the world. In New York, Fred continued to do freelance work but also began to write about his life. He wrote in great detail in an attempt to better understand himself. When he finished, he had compiled over 600 pages. The exercise showed him, "I could live, absolutely fully, if I was curious about something." Moreover, Fred realized that he had been chasing his own curiosity in his adventures. It was "my own curiosity that gave me stories to tell ... the camera became my passport." Soon after his epiphany, Fred's brother Gamble urged him to attend the cocktail party where he would meet Wendy and his next lifelong adventure would begin.

*"Wendy is non-stop ... [and] is better at more things than I am."*
Fred Baldwin

Wendy was born February 15, 1943 in San Francisco. The oldest child of James Barney Watriss and Lorraine Ames, she spent her early years in the tony Hillsborough neighborhood surrounded by the elite families of the San Francisco Bay area. It was "where much of the wealth of San Francisco at the time lived in these very big estates," Wendy explains. Her childhood neighbors, "were the people ... who ran the banks, the newspaper ... the first families of the city." Her parents met at the Burlingame Country Club while her father was in the Navy. Lorraine came from one of the old families and her father, Frank H. Ames, owned the National Ice Cream Company.[34] Though her family was hard hit during the stock market crash of 1929, Wendy does not remember hearing of any privation. Indeed, as a young socialite helping with the war effort, Lorraine was featured on the cover of *LIFE* magazine. "In peacetime Lorraine's life was strictly social. The war changed that. When this picture was taken," the caption continues, "Lorraine was surrounded by gauze, adhesive tape and medicines in the San Mateo Community Hospital where she trained to be a volunteer nurses' aide. The Red Cross pin on her blue pinafore, the peaked cap, and warm smile are emblematic of her new purpose in life."[35]

Wendy's father, James, came from New York society. His maternal grandmother was part of the old moneyed Whitney family and his mother, Helen Tracy Barney, inherited two million dollars at the death of her father Charles T. Barney, President of the Knickerbocker Trust Company. After divorcing her first husband, Helen married James' father, Frederic Newell Watriss, a prominent Harvard-trained lawyer with his own practice in 1917. A second marriage for both — Frederic's divorce from first wife Sara Thompson had only been finalized one month before their engagement was made public.[36] Though Frederic and Helen's marriage lasted only five years, before her death at the age of 40 in 1922, they had two sons, Frederic and James. James, born in 1921, was still an infant when his mother died. From Helen's first marriage, James had an older half-brother, Archibald Stevens Alexander, who later became the Undersecretary of the U.S. Army, and three other half siblings from his father's earlier marriage: Martha, Frederica, and William Watriss.[37] Widowed, James' father married a third time to Brenda Williams-Taylor Frazier, whose daughter became the celebrated "number one glamour girl" debutante of 1938, Brenda Duff Frazier, and would also inherit nearly four million dollars when she turned 21.[38]

James grew up in the high society of New York City. When Frederic married Big Brenda, as she was called to distinguish her from her daughter also named Brenda, the family moved into a seven-story townhouse at 7 East 75th street in New York City. The three children, Freddie, Jimmy, and Brenda "lived on the top two floors with their governesses."[39] The Watriss brothers remembered their stepmother "as a caring, if superficial, woman" that encouraged them to call her 'mummy.'[40] Big Brenda was known as a relentless social climber — she "was socially extremely ambitions," Wendy recalls. They had been married twenty-one years when James' father Frederic died. This was the spring of 1938 during James' senior year of high school and just as the media swirl around debutante Brenda was heating up. James graduated from St. Paul's in

Concord, New Hampshire, the same preparatory school his father had attended, and the following year, 1939, went to study at Boeing School of Aeronautics in Oaklawn, California.[41] Later, as the war became more inevitable, James joined the Navy and continued his interest in aviation, becoming a test pilot for helicopters.

On leave from the Navy, James and Lorraine eloped to Reno on April 27, 1942, accompanied by Count and Countess Marc de Tristan, who served as witnesses.[42] The de Tristan's remained close family friends and Wendy remembers "the Count was so funny. He was sort of this big, blustery man and drank a lot." They had "a beautiful house," Wendy continues, his wife "Jane had a white rat, like a pet, that used to run up and down [her arm] ... Aaron, I think, was his name." It was "always very sophisticated and very bizarre, in their house," Wendy summarizes. When James returned from overseas, the family settled in nearby San Mateo.[43] Wendy was born in 1943 followed by the birth of her sister Helen Whitney in 1946. The Watriss girls grew up with wealth and privilege, being taken care of by nannies and maids. Wendy remembers in terms of domestic affairs, "at home there seemed to be maids that did everything, and my mother was only partly concerned, and my father wasn't at all." In 1950, Wendy and her sister went to stay with her godmother, glamour girl number one Brenda Frazier, in her New York duplex at 563 Park Avenue that had a staff of ten to take care of their needs.[44] During this time, Wendy's father James went to Washington, DC for special aviation training with the State Department and her mother, Lorraine, would visit the girls in New York, commuting between her husband and her children.

Wendy remembers "Madmoiselle," the French nanny that Brenda hired to care for her daughter Victoria, taking the three girls to Central Park each day for fresh air. It "was a year without school essentially," Wendy recalls, "and it seemed to me we just had a lot of time — Central Park — that's what I remember particularly." As a young girl of eight, Wendy also remembers being mesmerized by Brenda's ritual each evening before going out. Brenda, who in 1942 had come into her millions, was one of the most photographed women of the time. "There were paparazzi all over Park Avenue," Wendy remembers. Each evening to get ready, Brenda "would sort of start at seven, and this wonderful elderly white Russian ... Uncle Vava would come up and they would have a vodka. Then Brenda had this elaborate dressing table that had gold objects all over it ... wonderful little objects of jade and coral and things. It was very kind of beautifully lit," Wendy recalls watching. "They would have maybe a second vodka as she was sitting at the dressing table." Later, "she would go probably at eight o'clock, eight-thirty, to take a bath, and then emerge smelling like lavender and violets. Then she would sit in front of the dressing table and then she had ... a beauty spot ... [and] there was a woman always there that would help her with her hair, and her makeup. She didn't wear a lot of makeup except on her eyes. Then lipstick but everything had to be just perfect." It was all quite glamorous and made an impression on young Wendy. Though she also remembers that it wasn't easy for Brenda, "she had the nightmare of her feet swelling all the time, she would sit for an hour as she was at the dressing table with her feet in ice water, to kind of bring that down."

Once James finished his training assignments in Washington, DC, the family moved to Greece. James traveled on ahead, and Lorraine brought the girls and the family dog over on the luxurious, newly commissioned, SS Constitution.[45] Wendy remembers at least ten days crossing, "It was quite exciting actually." From New York they sailed to Naples, where they then took a smaller boat to Athens. Taking a residence in the Athens suburb of Palaio Psychiko, "home to some of the wealthiest people in Greece,"[46] their neighbors were some of the most influential people in the country. Historically, Psychiko was where the aristocrats and members of the Greek royal family lived, and where all the foreign embassies were located.[47] Wendy remembers "the nice thing is that there weren't very many Americans there, it was mostly Greeks [and] some Turks."

This was a pivotal time in the history of the region as well as for Wendy's growing sense of the world. In Greece, James did not work for the State Department but was "affiliated." In hindsight, it's likely that James might have worked for the CIA, which was quietly referred to as 'The Agency.' Her father had been "pretty tight-lipped about what they did," but later as a teenager, Wendy "dissected what was going on" though her father never confirmed it. After the Greek Civil War (1946-1949), the U.S. saw northern Greece as "extremely important because if Greece had gone communist, that was such a strategic area relative to the Soviet Serb influence," Wendy explains, "they also needed people who had aviation expertise" like her father. While in Greece, Wendy remembers the family had a lot of Greek friends. Her parents "entertained a lot when my father was in town, so there were always people that were coming to visit or Greek friends that were there and we had these bizarre holiday things ... strange Easter hunts and things — it was just a lot of fun." On weekends, the family would sail out to the islands with colleagues. "There was a group of people working together who were extremely interesting ... kind of buccaneering people," Wendy recalls, "they all sailed." Most had boats custom-built for them, "they were 35, 40 feet ... [with] the mainsail and the jib." Wendy remembers these idyllic times, "There were like eight or ten of us, with various children at various ages, and wine and olives and cheese and retsina, it was great; it was wonderful."

Other times the family would explore the countryside, driving through small villages. "One thing that left a lasting impression on me and I think very much solidified my interest in war, conflict, foreign affairs," Wendy summarizes the impact Greece had on her development, "is when we would go to the villages ... these kind of gleaming white painted stucco villages, and nothing but women in black — there were no men." The Greek Civil War had reduced the population, and especially for men of fighting age, with a heavy death toll on both sides. The visual image of women in black against the stark white facades came to symbolize the human cost of geopolitical machinations that stayed with Wendy.

Three years in Greece gave Wendy a taste of the broader world, but her parents sent her back to San Francisco. "All by myself," Wendy explains, "my mother wanted me to start school at a proper time and so they sent me back to live with friends of theirs." Wendy began seventh grade at Miss Burke's girls'

school in San Francisco while living with the Pope family. Miss Burke's had been started as an alternative to the more fashionable 'finishing' schools to prepare girls for college and "what the next generations needed in order to rise to positions of responsibility."[48] By the mid-1950s when Wendy attended, Miss Burke's was considered one of the best schools in the area. While reading Aldous Huxley in class, Wendy was surprised to discover that none of her classmates "knew what an olive tree was or had seen an olive tree, and so I had to explain to the class the meaning of olive trees." This experience crystalized the difference between privilege and awareness for her. "All these other sort of privileged people," Wendy remembers, "and it was a shock and a recognition, and also a sense of I was never going to be like that."

Living with the Popes, Wendy found a sense of family life she had not previously known. Of her parents, Wendy explains, "it was really a quite a good childhood ... but it wasn't a kind of family house. Everything worked and there were nice things that happened and all that, but it wasn't that sort of family feeling, whereas this other house, the Popes in San Francisco, it was that kind." Wendy loved living with the Popes, "when I got to a house where there really was this kind of family, it was wonderful, and they gave me a lot of responsibilities and sense of taking care of the dogs." They also ate dinner together every night, something that rarely happened in the Watriss home. Wendy remembers when her mother came to collect her, "my heart just sank; I didn't want to leave."

James' next position took the family to Washington, DC, where Wendy and her sister Whitney attended Potomac School, a private school on 55 acres in McLean, Virginia.[49] Living just outside Georgetown, Wendy found the area "cliquish and closed in that sense — a lot of life revolved around the Chevy Chase Country Club," which Wendy found very "patrician" and uninteresting. In contrast, her parents continued to entertain, and their circle included many interesting and smart individuals — foreign friends, government officials and intellectuals as well as some colleagues from Greece who were also in DC at the time. After two years of living near Georgetown, Wendy finished middle school and went off to boarding school at Garrison Forrest outside of Baltimore, Maryland for High School. Looking back at her time in Washington, DC, "It was useful, but not particularly positive," Wendy reflects, "I knew enough about it so that later in life when we were in and out of Washington, I could

talk about Washington, and I knew people in Washington that were consequential to know in that sense."

While the Watrisses were living on the east coast, Wendy also saw a fair amount of her father's extended family. "My father's family ... is a family of very interesting people," Wendy explains, "one founded the Aspen music festival, another was quite high up in the CIA and then one of their sisters married John O'Hara the writer, and then C.D.B. Bryan, who wrote *Friendly Fire*,[50] he was a first cousin in that family." James' older brother Frederic "was an aeronautics expert," Wendy remembers. He graduated from M.I.T. with an SB degree in Industrial Management and was involved in aircraft testing at the Wright Brothers Wind Tunnel during World War II, later becoming the associate treasurer of M.I.T.[51] They also spent time with James' half-brother Archibald Alexander, who was also Wendy's godfather, at his home in Bernardsville. Uncle Archie, as Wendy called him, moved in top government circles. He had been Assistant Secretary of the Army (1949 to 1950), Undersecretary of the Army (1950 to 1952), Treasurer of the state of New Jersey (1954 to 1957), and later became director of the anti-communist, National Committee for a Free Europe (1959 to 1963) where he oversaw the broadcast service known as Radio Free Europe while Wendy was in high school.[52] Dinners at Uncle Archie's, were, Wendy recalls, "a combination of extremely good food and good wine and conversation about foreign affairs all over the world." From Wendy's point of view, these were "the elite of the United States ... they were all involved in government service." In addition to world affairs, "art was very much a part of the conversation," Wendy recalls, and everyone knew the "latest books or concerts or visual art." James' relatives were cosmopolitan, well-traveled, and well connected.

At Garrison Forrest High School, Wendy again had classmates "from privileged, Anglo, white families" like herself but with narrower life experiences. Though many of them had traveled, "they hadn't traveled the way I had traveled," Wendy explains, "going to Europe for summer or somewhere is not the same as living in a place." Furthermore, the school was isolated, and girls were not allowed to leave the campus "except for Christmas, Easter, Thanksgiving, [when] you are in that school, you are not going anywhere." Midway through her sophomore year, her parents moved to Madrid, so on weekend holidays Wendy went to the home of friends, and only saw her family over Christmas and summer breaks. One summer, Wendy remembers her father had become

involved in the movie business, so the family stayed in Benidorm while James was assisting with technical advice to director John Farrow, who was in the south of Spain filming *John Paul Jones* (Warner Brothers, 1959). Wendy spent that summer with the Farrow children and "going down to the movie set, actually, and watching the filming going on." John's daughter, Mia, was a bit younger, but "she had an older brother, Pat Farrow, who was more my age," Wendy says, "that was quite a lot of fun."

While based in Spain, Wendy's father had "various jobs in different parts of Europe and there were a couple of trips to Africa." Wendy remembers that it was about this time that the cracks in her parents' marriage were starting to show. "My mother was in Spain a lot on her own," Wendy recalls, "I think my father was just dallying about as well." One summer, "my father had installed my mother, and therefore my sister and myself, in the house of a woman with whom he was having an affair, outside Biarritz" on the southwest coast of France. The woman who owned the house was living in New York, but Wendy suspects her mother knew of their affair as she recalls, "it was a terrible summer for her."

Wendy graduated with honors from Garrison Forest "but I decided that I did not want to go to any of the exclusive women's universities that I'm supposed to go to — I'd had it with women's schools." Before coming to this conclusion or to appease her mother, "I was up actually visiting schools, by myself, because my parents didn't come back, so I did these visitations ... by myself; I didn't take it very seriously." Having started school a year ahead, Wendy was a year younger than her classmates. As they all went off to Bryn Mawr and Smith and such, Wendy decided to go to University of Madrid for a year. "It was a New York University Junior year abroad program at the University, my Spanish was good enough that they just let me in." Wendy lived with her mother that year, studying drawing and spending time at the Prado. During that year in Spain, "my mother convinced me that I should become a debutante. So, I said, 'No, no,' I didn't want to do that. I thought that was very provincial, but she had persuaded me." Wendy returned to San Francisco for her debut in December 1960. "My mother had this beautiful dress made for me, actually. So, I did. I mean, there were a number of articles in the *San Francisco Chronicle* about 'Glamor Girl Number One,' and things like that," Wendy recalls, "actually, I had a very good time." The formal coming out was held at the

St. Francis Hotel and Wendy was escorted by Alex de Tristan, son of long-time family friends Count and Countess Marc de Tristan. During the holidays and the weeks of debutante parties, Wendy's parents took the opportunity to tell their daughters that they were divorcing.

After her year in Madrid, Wendy went to Paris to improve her French language skills and to be near Jacques, "a very sophisticated Guatemalan guy." Wendy began auditing classes at the Sorbonne, but soon lost interest, finding it "stifling" so then she went to Mademoiselle Anita Pojninska's finishing school. In the sixteenth arrondissement, Mademoiselle Anita's as it was known, Wendy found a wider variety of people to interact with, "there were South Americans, Africans, a lot of Arabs." A Paris institution, Mademoiselle Anita's was where elites from all over the world sent their daughters to be 'finished.' Mary Robinson, the seventh President of Ireland and later United Nations High Commissioner for Human Rights, attended Mademoiselle Anita's at the same time Wendy was there. She remembers "an emphasis on savoir faire, or the appropriate manners and behavior to exhibit in social settings" but more important was the quality of the teaching. Instruction was given by professors from the Sorbonne and students were taught history of philosophy "the way the French teach it — in a deep, conceptual way." They read Hegel and Marx, Descartes and Sartre. Robinson continues, "We were taken to the Louvre and the Jeu de Paume and shown how to look at pictures, how to see works of art in the context of their time and in the context of the medium the artist was using."[53] Later, Robinson summed it up as "teaching to make you think."[54]

After a year and a half in Paris, Wendy returned to the U.S. to attend New York University. Majoring in English and Philosophy, Wendy also took one journalism course because she wanted to do an internship in that field. She lived with Jacques, who had moved to New York for business; they were together until he went to Paris two years later to work in a bank where he "became a very successful investment banker." They had gone to visit his family in Guatemala a number of times, "his family was one of the top families in Guatemala and they had lots of land," Wendy explains, "and he had this very stern grandmother — she was actually American, brought up in Paris, and she queried me at great length about why I was interested in Jacques, and was I interested in Guatemala, and I had visions of myself building schools and a clinic on one of his family's sugar fincas." He was "a wonderful man but, it was not to be."

When Jacques left for Paris, Wendy went to stay with her mother, who had returned to New York from Madrid, moving into an apartment at Lexington and 75th, until she found her own apartment near Chelsea. While in New York, when her father would visit, they would "do our usual number, we would go to 21 for dinner and then go to El Morocco and have a drink." One time in particular, Wendy remembers after a couple of drinks, her father asking her "Well, what were you doing in the Dominican Republic?" Wendy had recently gone to the Dominican Republic with a girlfriend who was having an abortion. A civil war was brewing in the Dominican Republic and her girlfriend's partner was active in the communist party there. In the U.S. in the 1960s, abortions were illegal; "there were a couple of doctors in New York on Park Avenue that would do them, but they were very expensive." Since Wendy spoke Spanish, her friend asked if she would come along to translate for her. After the procedure, two U.S. officials had come to their hotel and "asked us all sorts of questions." The irony was that Wendy had not told anyone she was going. Her father, it turned out had been told about the trip by the U.S. security officials, which confirmed Wendy's assessment that he was connected to an intelligence gathering organization.

While completing her undergraduate work, Wendy also interned summers at the *Baltimore News-American* staying at her father's house near Baltimore. By then, James had remarried to Paula and bought a farm where he was breeding thoroughbreds and beginning an aviation company, Pegasus Air Transport, which shipped racehorses around the world. Wendy found life with her father and stepmother a "completely different family situation" as Paula "loved to cook" and was more of a "family person" than life with Wendy's parents had been. James and Paula had two sons, Wendy's half-brothers Patrick and Michael, which added to the family feel of the home. Wendy's time as an intern in the journalism world only fueled her passion for the work. She finished her degree in three years at NYU and began graduate school in Anthropology.

Wendy soon decided that she'd rather be in journalism than graduate school. "My interest in journalism came out of my interest in the world and world affairs, what was happening," Wendy explains, "and wanting to be a part of that, and wanting to know more than other people knew." Her experiences of living in Greece, her father's colleagues and dinner parties with Uncle Archie's inner circle reaffirmed that there could be more to life than "living the kind of

life that ... women [of] my social class, would live." When she told her mother she was going into journalism, "That's not a very respectful profession," Wendy reports Lorraine had looked askance, saying "What am I going to tell my friends?" Some of her friends thought it was "just shocking," Wendy says wryly, "journalism had none of the glamor that it has today." In hindsight Wendy speculates that her mother also admired her a bit for charting her own path.

It was 1965 when Wendy finished her degree, "if I hadn't come of age in the 60s, I probably would have gone into the State Department," Wendy explains, "I was angry about most things that my government was doing, so I decided to go into journalism." She spoke three languages, graduated from a good school and had completed multiple internships in addition to 'knowing people.' When she went to look for a job, Wendy went to the "*New York Times* and the *Herald Tribune* and then *Time* and *Newsweek*" and they all offered her positions in the women's department, which was not at all what she wanted. Wendy had a friend "who had graduated from Radcliffe and was very bright ... had languished in the research department for seven or eight years." Wendy wanted something very different. "I thought I was kind of a hot shot, I had been around, I knew a lot about the world, I was multi-lingual." Wendy had no intention of writing for a women's page or getting trapped in a research department. She remembers the head of the Washington Bureau telling her, "well I am not going to hire you as a novice reporter because I am going to invest in you for one or two years and then you are going to go off and get married." This comment was not unusual in the 1960s and illustrates the challenges many women faced in the workplace.

Disappointed but not deterred, Wendy consulted family friend Rowland Evans for advice. Evans had a well-respected nationally syndicated column, "Inside Report" with colleague Robert Novak, which focused on political investigative reporting. He advised Wendy to go to one of the top five regional newspapers considered to be the feeder papers to the top national newspapers as they would hire her as a general assignments' reporter. So, Wendy went to the one Evans recommended the most strongly, the *St. Petersburg Times*[55] in Florida and was hired as the city hall reporter. The newspaper was run by Nelson Poynter with his wife Henrietta, who also started the *Congressional Record*, so Wendy was in good company journalistically and politically. "It was rather wonderful working for them because they were very smart," Wendy sum-

marizes, "The editors were very, very good." Wendy enjoyed her two and half years at the paper, "it was stimulating and a lot of different kinds of people." She was able to do several stories that she initiated. "It was that kind of paper," Wendy recalls, "if you were young and you were energetic and you had ambition, you could do things."

Just as the paper was about to promote her to covering state politics in Tallahassee, Wendy heard about this experiment in television journalism that Fred Friendly was promoting. Friendly, who had recently left his role as head of CBS News and had joined the faculty at Columbia School of Journalism, was a broadcast consultant to the Ford Foundation. Due to his influence, the Ford Foundation provided a two-year, $10 million dollar grant to fund a public broadcasting experiment called the Public Broadcasting Laboratory (PBL).[56] An advertisement in the New York Times stated

> PBL's goal is to demonstrate every Sunday night just how inventive, provocative and important Public Television can be. It will offer two hours (or maybe more) of incisive reporting, examinations of the arts and sciences, live dramas, strong opinion and probing comment. It will venture into subjects commercial television has not touched. It will be completely free of commercial interruptions and advertiser influence.[57]

"I applied, and they accepted me," Wendy says, "they were mixing people that had been in the print business with television people. It was top of the line people you were working with." PBL hired Wendy as an associate producer. At the time, Wendy explains, "there were very few women associate producers ... there was only one woman producer in all of television." Wendy had been hoping to use her time in St. Petersburg as a step back to New York as a journalist, and PBL was her ticket.

Working at PBL, Wendy was part of the team producing a news show every Sunday that "covered everything, civil rights, Vietnam — we covered Vietnam very heavily, farm workers, regular politics." As an associate producer, Wendy's role was to chart out the overview of the story and the whole script with the producer. Then "you would list the places you're gonna have to go to, and the people you're going to have to see, and then the associate producer basically made all the arrangements," Wendy explains, "you called the peo-

ple, and you convinced them to do an interview or whatever." In a later in-
terview, PBL President and Executive Director, Avram Westin, said the show
"ran into a buzz saw almost immediately" because of the controversial con-
tent.[58] For Wendy, one of the most provocative documentaries she worked
on was called 'Marijuana — A Proposal' with Joseph M. Russin.[59] Russin had
previously been an Education Editor for *Newsweek* and Editor of the *Harvard
Crimson* before coming to PBL. In their documentary, they made the case for
decriminalization of marijuana by comparing it to alcohol use. Experts and
users were interviewed and a number of 'pot parties' were filmed. Narrating,
Russin says that "you don't need beads and long hair to turn on," and that
"normal middle-class" individuals smoked marijuana.[60] "We filmed a number
of marijuana parties among professional people and upper middle-class and
middle-class people," Wendy recalls, "then we laid out the reasoning for why
it should be decriminalized."

After the segment aired, PBL was accused of staging the parties, and all their
materials were subpoenaed by the House Investigations Subcommittee.[61] The
Federal Communications Commission (FCC) also investigated as "participants
in Boston are said to have told investigators they volunteered to light up for PBL
after hearing of its interest in featuring that kind of event."[62] Which, Wendy
is quick to clarify, "was not the case." However, it was a challenging "defense
because a lot of those people didn't want to necessarily talk or go to court."
While PBL defended their actions, Wendy and Russin had to hire their own
lawyers and the case dragged on for over a year and a half before the charges
were dropped. However, Wendy was able to turn this in her favor — when she
proposed that PBL send her to Europe to "collaborate with the BBC on the evo-
lution of Socialism in three East Central European countries." This was just
as the Prague Spring was beginning in 1968. PBL agreed and Wendy surmises,
"They actually wanted to get me out of town because of this investigation."
Wendy went to Prague for five months, then to Hungary and on to Romania. "I
was in Romania when the Warsaw Pact countries invaded … it was an incredi-
ble, I mean, incredible, moving time."

Before leaving for Eastern Europe, Wendy had begun to expand her journal-
ism skills into photography. Though she enjoyed working at PBL, she missed
the freedom of the lone journalist. "I loved working with the visual image, but
the problem with television was when you went out to do a story in those days,

[you had] the camera — and there were four and five hundred pounds [of equipment] — so you didn't go out as kind of the Lone Ranger finding your own story, you went out with four people and every move you made cost $25,000." Talking with her friend noted photographer Mary Ellen Mark about her interest in images, Mark suggested she think about taking up photography. Wendy remembers, "she said, 'look, there is this really wonderful photographer, Harold Feinstein, who has this course downtown in the village, and Lisette Model studied with him, and maybe you should try it.'" So, for the next year

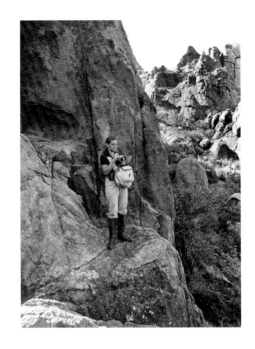

**Wendy Watriss, 1971.**
Photo: Fred Baldwin. Courtesy of Wendy Watriss.

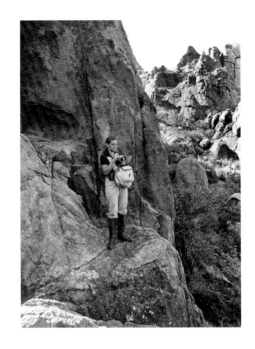

and a half Wendy studied with Feinstein, who had been part of the Photo League. The classes were small, with only three or four students. "What we did mostly was look at work, analyze it and then he would say, 'okay put your ASA at twelve hundred and your F-stop at eight and just photograph,'" Wendy explains, "Don't think about changing the aperture or the shutter speed ... He said 'just look and think,' and it was very good training actually."

While Wendy was in Eastern Europe, she began photographing more seriously and "did a couple of stories for newspapers with pictures when I came back." When the funding for PBL ended, Wendy decided "that what I would do was try to sort of sell myself as a photographer and a writer." She began stringing for *Newsweek* and the *New York Times*. Her first 'real' photojournalism assignment came through her friend Timmy Burke, wife of Michael Burke, who was President of the Yankees baseball team at the time and had been in the CIA during the Cold War. Timmy was well traveled and had acted as a courier

for Michael during his spying days.[63] Timmy had "convinced the *Diner's Club Magazine* to let her do this long trip throughout West Africa, starting in Senegal, and she asked me if I would photograph it for her," Wendy recalls, "it was an amazing trip; it was absolutely amazing." Together they traveled to Senegal, Niger, Nigeria, Dahomey, Gabon, Chad, Mali, and Cameroon. For a portion of the trip, Wendy's mother Lorraine joined them. "Now that I think of it, to go to the kind of places we went to and have the kind of experiences, I mean A, being a Westerner, B, just being women," Wendy says with amazement, "we got stopped at border crossings, but knowing French ... and just knowing how to behave yourself we got through mostly everything."

"Once when we were in Dahomey, or was it Cameroon, I photographed an execution," Wendy recounts one of many memorable occurrences, "then the police saw that I had photographed it, confiscated the camera, I couldn't get the film out in time. Then I was locked up in this ... police station for about six or seven hours until they finally let me out." Another time, Wendy "was with the French Foreign Legion for four or five days photographing in the northern part of Chad, where there was the beginnings of a civil war." There were, Wendy summarizes, "a lot of adventures along the way." In many ways, her Africa assignment was a turning point for Wendy both in terms of her career and life. The camera had given her the freedom to discover her own stories throughout the world, and Africa showed her how exciting this path could be. When she returned to New York, Wendy was "thinking about that life and what I had learned and what I had experienced there; it had been raw and often tough, physically, but just thrillingly exciting." Still jetlagged and only a few days after her return, Wendy went to the cocktail party where she would meet Fred and the seeds of her next lifelong adventure would be planted.

### The Back Roads of America

While Fred readied the car and trailer, Wendy went to the New York City Library to read about Texas. When a young librarian learned of her plan to drive through Texas, he offered a caution: "Oh, be very careful, Texas is a very dangerous place." He had earlier driven through the panhandle and been stopped. "I'll never forget that look on his face," Wendy recalls. Undeterred, Wendy and Fred set out for rural America. "What we wanted most to do was investigate our own country," Wendy explains, "experiencing it directly through the experiences and stories of different people whose lives were intimately tied to

the U.S."[64] It was 1972 and as Simon and Garfunkel sang at the time, "*They've all come to look for America,*"[65] it had become a popular notion with white, well-educated individuals from middle-class or wealthy backgrounds to look to rural life for answers to the social upheaval prevalent in U.S. society at the time. Author Kate Daloz writes of the time: "To a privileged generation exhausted by shouting NO to every aspect of the American society they were raised to inherit, rural life represented a way to say yes." Daloz continues, "While there have always been individuals, families, or groups who walked away from city life with high hopes, no other moment in American history has seen anything like the shift that happened as the 1960s turned into the 1970s." As many as a million young Americans left the cities and suburbs for the countryside "*to look for America.*"[66]

Wendy and Fred began their journey driving through Tennessee, Alabama, Mississippi, and Arkansas on their way to Texas. "From the outset," Fred explains, "we began the process of traveling the back roads, stopping to meet people in small towns and along the road."[67] They often "went down a dirt road and found ourselves on somebody's land," Wendy remembers, "and went up to the door, left the trailer and the car a little behind … and said, can we spend the night there? People would let us do it. Then if we somehow didn't connect during the night, in some personal way, then we would somehow have breakfast together." They made their way across the South this way, photographing and talking with people. They had chosen Texas as their focus, believing that it symbolized much of the American dream of rags to riches and a vast frontier of achievement. Once they crossed the border, their project started to take shape. In a small east Texas town, Wendy and Fred noticed a grade school letting out and all the students begin their walk home. "The twenty students were all Black," Fred recalled.[68] Wendy adds, "in all our Texas research, there had been no mention of Black settlement or history in Texas." The myth and the lore of the Lone Star state at the time was the story of white settlers, cowboys, and oilmen. This discovery of the ethnic diversity of the state coupled with its geographic diversity captured their attention. "Texas turned out to be so interesting and so far beyond the cliché version that is in the minds of most Americans and the world that we abandoned the 'Back Roads of America' concept and decided to concentrate on Texas as a microcosm of the country," Wendy explains.[69]

### Exotic Texas

*"Texas was the most exotic place I could possibly imagine." Wendy Watriss*[70]

Wendy and Fred continued their exploration of Texas for eight months on their initial trip, using their own funds and living on $3 a day in their trailer. Many times the old Mercedes needed coaxing to continue, "that poor car broke down over an eight-month period 75 times," Wendy remembers.[71] They lived on back lots and in towns with the people they photographed and interviewed, researching the local history and customs. An integral partnership, they both participated in all aspects of the project. Yet once, Wendy recalls, "we were out in Gillespie County in the German Hill country in the very pretty area of Edwards Plateau, and we stopped the trailer. It was at night. There was a crescent moon, and you could really see the stars. And it was really beautiful. We had a bottle of wine, and I don't know what we cooked ... Fred turned to me, and he says, 'you see what I brought you?' I was so pissed off at him. 'What do you mean you brought me? I came here on my own from Vienna.'"

As they discovered more and more of the untold stories of Texas, Wendy found "it was a great privilege ... because I think that I learned more about what it means to be a citizen of this country going through hundreds of other people's experience," she continues, "it was just a constant struggle for some kind of survival, some kind of next go. It wasn't ever easy, and democracy never came easily. The relationship of the state and citizenry was never easy. I mean, the fight to get public education into the state and into the country as a whole was huge. And then when I am reminded now that Medicare only came into existence under Lyndon Johnson ..." Wendy sighs. They later wrote of their experience: "This is a project which has grown out of a desire to explore this country and, through this exploration, come to a fuller understanding of ourselves and our own cultural identity. It is a personal journey ..."[72] Wendy and Fred traveled throughout the state, "every big section but the panhandle." Wendy says, "We carved out four areas, but it was East Texas, Grimes County, ... the hill country where we did the most work." They spoke with people from all walks of life. At one point they contacted Lloyd Bentsen, Sr., father of a senator from Texas. "We just called him on a pay phone ... he invited us out," Fred explained. They were in a Hidalgo county barrio with no running water, "and he took us out for the best steak dinner I've ever had [and] took us on a tour of his ranch." This was a Texas hospitality that they found throughout the state.

After their research trip, Wendy and Fred returned to New York to begin printing the images and fundraising to continue the work. Once they had photographic prints, they could begin to show the work. They met the director of the Phillips Collection. "He liked it a lot and was very intrigued by it and offered us the show," Wendy recalls. The early work was first exhibited in January of 1975 and contained work from two counties, "Hidalgo, in southeast Texas, where the population is predominantly Mexican-American, and Gillespie, in central Texas, where most of the people are of German origin."[73] The next exhibition of their work was in Texas in 1977. By then, Wendy and Fred were again living out of their trailer in Grimes County having returned to continue the project in 1975. Fred's friend, Thomas Hess, who had been an editor at *ARTnews* before accepting a position at the Metropolitan Museum, told the couple they should look up Harris Rosenstein, who had also been an editor at *ARTnews* before moving to Houston to work with the de Menils. "Harris was completely intrigued by what we were doing and he really liked the sort of combined populous slash academic idea of it," Wendy explains, "and then, he came to Grimes County three or four times and he was completely captivated when he came up for Juneteenth[74] and he saw that on all the sides of the barbecue area on top of the hill were the blocks for doing the barbecuing for Juneteenth. They had tacked up our pictures of the previous Juneteenth, and so he saw that integration of real life and the record of art, so to speak." Harris organized an exhibition of the images from Grimes County at the Rice Museum April 12 to June 19 (Juneteenth), 1977.

The exhibition brochure shows that Wendy and Fred had been successful with fundraising as a number of Texas foundations are listed as supporters, as is the Rockefeller Foundation of New York. The installation included 306 images that "are nearly all arranged in sets, varying from a few up to 27. Each set attends to a specific event or place, examples being: an independent Black farmer in his fields; elderly Polish-American tenant farmers picking cotton; life and work on a large mechanized cotton farm; rural activities such as blacksmithing, the making of cane syrup, and a pig slaughter; the buildings and street scenes in small and large towns; church meetings; an outdoor baptism; high school sports events and proms; county youth fair; family reunions, birthdays, weddings, and a funeral; political rallies; voting; the Nineteenth of June ("Juneteenth") celebration by Blacks commemorating the emancipation of slaves in Texas; fundraising party for a volunteer fire department; Fifties dance; and local rodeos," Harris described in the press release.

The exhibition at the Rice Museum was also Wendy and Fred's introduction to Houston. The opening reception was well attended and many of the names in the guest book are those who are important in building the photography community in Houston — Geoff Winningham, Gay Block, MANUAL (Suzanne Bloom and Ed Hill), Sally Horrigan, Ed Osowski, as well as others important in the broader art world — Susie Kahill, Molly Glaser, Joanna King, Diana Hobby, Andy Mann, and Don Sanders. Anne Tucker and John Biggers also saw the exhibition.[75] Dominique de Menil was "beside herself with joy," Wendy recalls, as eight buses of people from Grimes County came to the opening night.[76] The show was favorably reviewed in both Houston newspapers. The *Chronicle* described the work as "sociological in nature" yet its "sheer weight and voluminousness" take it beyond mere photojournalism,[77] while the *Post* reviewer heralded the "overriding style is of a very human documentary."[78]

After photographing in Grimes County for three years, Wendy and Fred moved to Austin, renting an apartment for the first time since joining forces. While in Grimes County, they began making connections in Austin. Even for "Austin that's used to almost anything," Wendy recalls, "we were a little exotic ... [and] one wonderful thing about Texas, in the right circles, is they understand characters, exotic characters." No doubt this helped Wendy and Fred find their niche among supportive circles in Austin. Fred knew Austin architect and midcentury home builder A.D. Stenger from his earlier adventures in Spitsbergen, and the couple would stay on a mattress in a little alcove in the corner of his small house when they would come to town. The lawyer that had represented Wendy in the PBL marijuana case suggested she contact Dave Richards, husband of Ann Richards, who later became governor of the state. "And so we called him up, and the next thing I knew," Wendy says, "Ann, who gave wonderful parties, had this party for us." Ann had invited "the Austin academic and political liberal group," Wendy remembers, "it was great, it was a wonderful intro." At the party they met Lawrence Goodwyn, a journalist and historian, who later wrote the essay for their book about the hill country, *Coming to Terms*[79] and helped them have a better understanding of the historical forces in different areas of Texas. Later, Wendy and Fred came to know the Pulitzer Prize-winning historian and head of the American Studies Program at the University of Texas, Professor William H. Goetzmann, and he invited them to teach an oral history course for the American Studies Program. Goetzmann introduced them to Alfred Hunt, one of his doctoral students and the three

of them taught an American Studies course during the spring of 1975. Fred taught photojournalism, Wendy the oral history, and Alfred Hunt archival research as three components for a course called *The Changing Face of Austin,* where students investigated different areas of Austin.[80] Fred and Wendy designed the course based on the *LIFE* magazine model of sending both a writer and a photographer into the field as a team.

Through their connections at University of Texas, Wendy and Fred were named the first Winedale Associates in American Studies at the University of Texas at Roundtop, positions that were created for them. This affiliation allowed them to accept funding as a nonprofit, as well as apply for grants targeted to university researchers. In 1978, the couple moved to the hill country to begin their work in Gillespie County. Receiving an NEH grant for the project permitted them to rent a house this time rather than living in their trailer. Wendy remembers the house fondly, "it had a wonderful backyard, it was a very large vegetable garden ... But it looked on hills and this huge sky, it was really a very nice place." Wendy and Fred spent just over a year in the hill country photographing and interviewing. Lorraine, Wendy's mother, came and stayed with them too, as she enjoyed the work they were doing. "I think she admired what I did," Wendy says, "underneath it was part of her own personality ... [she] recognized that eventually." Once Wendy and Fred completed that work, it was time to find a place to put the book project together. Rather than return to New York, in 1980, Wendy and Fred made the decision to move to Houston. They were ready to be in an urban environment and though Fred was teaching photojournalism at University of Texas, Wendy says, "we didn't want to go back to Austin ... it didn't have the level or sort of sophisticated culture that Houston did."

# Chapter 8

# "Houston is going to be the most exciting photographic city on earth"

Wendy and Fred looking at slides in the darkroom of their Menil Foundation house, 1980s. Courtesy of Wendy Watriss.

After nearly a decade of working on a documentary project — photographing, interviewing, and researching in rural Texas counties, Wendy and Fred decided to settle in Houston to stay close to their research sites while finishing the project. They had been introduced to the Houston art and photography community when Dominique de Menil exhibited their images from Grimes County at the Rice Museum in 1977. When they came to town in 1980, they rented a house from the de Menils across from the Rothko Chapel and near where Dominique would later build her museum, the Menil Collection in 1987. "We admired the Menils' work in the arts and human rights, and we liked the entrepreneurial character of Houston," Fred explains, "it seemed much more adventurous to stay and work in Houston than return to New York."[1] Fred continued to teach at University of Texas, commuting each week "I'd go up for four days, I'd go up maybe Tuesday and come back Friday or something like that ... and I'd stay with Ann Richards or with my friend A.D. Stenger, or I'd sleep on the desk." Within a year, Fred was able to secure a position locally and began teaching photojournalism at the University of Houston, which he continued to do until 1987. Wendy began stringing for the *New York Times* and taking other freelance photojournalism work, so she was traveling a fair amount. Lorraine, Wendy's mother, also joined them in Houston, "I wasn't here regularly so she was very helpful," Wendy explains, "getting the house fixed up, in furniture, and so forth."

While Wendy thought she and Fred were seen as a bit exotic when they lived in Austin, Houstonians were impressed with the couple. "Fred and Wendy coming to town was a big deal," gallerist Fredericka Hunter recalls, "because they had been in *Time*, LIFE ... it was a fairly big deal." The *Houston Post* did a feature on the newcomers, "At Home: Fred Baldwin and Wendy Watriss." In-

trigued with their photojournalism work in rural Texas as well as their current projects, the article sought to explain their unusual lifestyles. In the article, Fred explained that they "keep their lives at home simple because both are on the road a lot on assignment." While Wendy explained they "tend to get involved in stories that have social and political implications." The reporter made a point of specifying that the couple was married despite the different last names. "Baldwin and Watriss (they are married, but Watriss maintains her professional byline) are more interested in what they *do* than where they *live*," reporter Elizabeth Bennett wrote.[2] While this was untrue, Wendy and Fred had made a point of letting others believe what they wished, and a number of newspaper articles at the time made same inaccurate mention of their marital status.[3] Letting people know they were not married would have raised more than a few eyebrows as this was still the South and rather conservative.

Socially, Wendy and Fred began getting to know Houstonians involved in the arts and human rights issues. "For the first six years, at least, we had candlelit dinner parties," Wendy explains, "Fred does a very good Italian pasta with good olive oil and cheese, and good wine. We'd have six or eight around the table."[4] Building relationships and making connections just as they had done in many areas of rural Texas, they also got involved with the newly-formed Houston Center for Photography. Fred's KKK project *Saturday Night in Reidsville, Georgia 1957* was the first HCP exhibition in their temporary space in Bering Church, and Wendy wrote a number of articles for the HCP magazine. Additionally, they were active giving workshops and serving as jurors for the HCP Documentary awards. They also had several friends and family come to visit. Wendy's father came to Houston on business and came by their house. As the driver let him out in front of their house, Wendy heard the driver say, 'Oh Mr. Watriss, be careful. This is a very dangerous neighborhood.' While the Menil neighborhood was not as swanky as it later became, the driver's caution might have been a bit overstated. Though Wendy does recall their home being "broken into about five or six times in the first couple of years, it wasn't a dangerous neighborhood. But ... it was a little raunchier than it is today."

### Agent Orange and World Press Photo

When Wendy's longtime friend and well-known journalist Gloria Emerson came to visit, they talked about the war in Vietnam. Emerson had been one of the first women foreign correspondents for the *New York Times*, covering

the U.S. involvement in Vietnam from 1965 to 1972. She also wrote *Winners and Losers: Battles, Retreats, Gains, Losses, and Ruins From the Vietnam War*,[5] which won the National Book Award in 1978. As they talked, Emerson mentioned 'you know, nobody has ever done anything on Agent Orange and the effect.' Wendy explains, "She started to talk to me about that and then I thought, 'Well that is very interesting Gloria, I'm going to look into that.' So, then I did some research, and then I knew how desperate veterans had been, really, to get any attention about this." Wendy "found out the names of some veterans group and called and talked, then went to Austin" to begin her project on the impact of Agent Orange on veterans and their families. "From there I contacted other veterans groups," Wendy recalls, "I spent a lot of time with a veterans group in Wilkes-Barre, Pennsylvania, then Boston, then Long Island, then California, then Florida." She began by self-funding the project and spent a year and a half covering this subject. "Halfway through," Wendy explains, "I took some photographs to *LIFE* magazine, which paid for the balance of the work and published the story."[6]

In hindsight, this work, published as "Tracking Agent Orange"[7] in the December 1981 issue of *LIFE* magazine, was a turning point both for Wendy professionally, but also for Houston, as this circuitously led to the idea for the international photography festival, FotoFest. Once published, the images received attention almost immediately. Wendy was awarded the World Press Photo first place prize in News Feature stories and was the first woman to win the Oskar Barnack Award (which later became the Leica Award) for 1982.[8] This recognition brought international visibility and increased demand for her as a freelance photojournalist. The award ceremony was held in a 15th-century gothic church, *De Nieuwe Kerk*, in Amsterdam, with the prizes given out by Prince Bernhardt of the Netherlands. During the event, Wendy and Fred met Lorenzo Merlo, the director of the Photography Gallery of the Canon Foundation in Amsterdam, and a photographer himself. Excited by their work, Lorenzo invited them to attend the *Rencontres internationales de la photographie d'Arles* later that summer in the south of France.[9]

### Amsterdam and beyond
Wendy and Fred used the trip to Amsterdam as an extended family excursion. Wendy's sister Whitney and her boyfriend and later husband, Nat, came along as did Wendy's mother Lorraine. Lorraine had been diagnosed with lung can-

cer and had given up her New York apartment to stay with Wendy and Fred while she underwent various chemo and radiation treatments at the Texas Medical Center in Houston. By the time the family headed to Europe in the spring of 1982, Lorraine had exhausted all the treatment options and was using marijuana for the pain. The trip turned out to be quite an adventure, Wendy recalls, "my mother was carrying marijuana in her Louis Vuitton bag at the airport. All the dogs came up, wagging their tails, sniffing" when they landed in Amsterdam. After settling into a hotel, Wendy and Fred took the train down to southern Germany to pick up Wendy's new Audi. When they returned, they found they had missed a lot of excitement. Wendy tells the story, "My mother was three doors down [in the hotel] from us. She had marijuana tea that night, and she sort of woke up, and she thought she saw somebody at the window. There was a big ledge outside hers and our rooms. She screamed. He was coming in. She wasn't sure whether she was hallucinating or not. She did manage to call the reception downstairs, and it turned out to be the man who had robbed our room. He dropped all the camera equipment … left it all on the ledge."

After the award ceremony, the group headed to Venice as Lorraine wanted to stay in the Gritti Palace one more time, and then they traveled to Florence to see the palazzo where Fred's grandfather had lived. They also visited the Uffizi to see the seven-foot-tall portrait of Dr. William Wilberforce Baldwin by the Bavarian-born British painter Hubert von Herkomer that the family had donated to the museum. While in Florence, they were walking along the Arno and the classic tourist event happened. "Someone came and got my purse," Wendy recalls, "my mother sets out running after it." Wendy had the hotel information, prize money check, airline tickets, passports, cash, and American Express Travelers checks for the group in her purse, when a guy on a Vespa came along and took it from her arm. "So, while my sister and I were making the report at the Carabinieri, … Fred and my mother went back to the hotel." They found that someone had called the hotel saying, "they had found this purse in the bushes somewhere, and they left an address where it was." Fred conveyed this to Wendy and Whitney at the Carabinieri so they took a taxi to the address.

"We walked in, it was a very large Mussolini-type building in the southern part of Florence, where I had never been before. There was nobody in this grand hallway, but on the left, there was a bar you could see through part of the glass and wood doors. So, we opened the door, and it's a very long bar, and

the bottles are stacked up on three shelves. On the top of one was my purse. We walked in and explained who we were, they got the purse down, and in this great ceremony laid everything out on the bar. We were the only women in there. All of them were men with blue working overalls. So, we said, 'Can we buy you a drink? How did this happen?' A couple of men who were coming in for their regular, early evening or late afternoon drink, saw someone go by and throw something into the bushes. They went and looked, and it was my purse." Wendy continues, "They said, 'No, you can't buy us. We will buy you a drink.' I used Spanish, basically. It turned out to be the center of the Communist Party in Florence. I was completely at home. We drank to Alexander Dubček, we drank to Palmiro Togliatti, [and] 'down with Georges Marchais,' the French Communist leader who supported the Warsaw Pact invasion. It was great, we had a number of drinks. Then I think Fred had gotten a cab and come in. It was a wonderful experience." It was also a lucky experience as the purse thief had only taken the cash and travelers checks and left everything else.

When they returned to Houston, Lorraine "died a month and a half later." Wendy explains, "The trip kept her alive." Since there was no hospice at the time, they found two visiting nurses that had been trained in hospice care. They cared for Lorraine in the front bedroom of their home, where she died surrounded by family. "It was a very sort of meaningful experience for all of us," Wendy remembers, "my mother died in May ... we were invited to Arles in July." The *Rencontres internationales de la photographie d'Arles,*[10] the first annual photography festival of its kind, was founded in 1970 by the Arles photographer Lucien Clergue, the writer Michel Tournier, and the historian Jean-Maurice Rouquette. Photography exhibitions and events were scattered throughout the medieval roman city in the south of France. Wendy and Fred attended at the invitation of Lorenzo Merlo, whom they had met in Amsterdam at the World Press Photo Awards.

### *Rencontres internationales de la photographie d'Arles*

Arles is a magical city with a roman theatre, cloisters, an abbey, numerous churches, a coliseum among other notable historical buildings, and during the opening week of the *Rencontres*, photographers from all around come to see photography, and eat and drink together in the *Place du Forum,* where Vincent van Gogh painted his *Café Terrace at Night* in 1888. "We had a terrific time," Wendy reports, "we loved the kind of grand fraternity of photo people

that were there. ... Europeans, French, British, Germans, a lot of Germans, and a few Scandinavians, and some Japanese, the idea of this kind of fraternization, and then this very disorganized kind of portfolio review." Wendy and Fred "participated in an informal portfolio review that resulted in exhibits, assignments, and print sales," Fred remembered.[11] "We got four or five exhibitions for our work as a result of this, and forged very good relationships," Wendy adds, "and we saw the benefits and the excitement of what Arles was creating in terms of a place for photographers to meet ... and how much work was not getting to the United States that wasn't either extremely well-known or from other parts of the world than, say, Europe or three countries in Europe."

"We felt, when we learned what they were doing in Arles and the benefits that had accrued to us from that experience, that this was an organizable structure that would be very stimulating to do in Houston," Fred and Wendy explained. "This informal, delightful experience was special to Arles at that time and sparked an idea that changed our lives. Coming home on the plane we thought, 'Why don't we do something like this in the U.S., in Houston?'"[12] There was nothing like it in the U.S., Wendy recalls, "the United States is very provincial, or parochial, in terms of what it sees." By the time the plane landed in Houston, they had decided, "Let's start this," and the idea that would become the first photography festival in the U.S. was devised.

Jacques Chirac, then mayor of Paris, had also begun *Mois de la Photo*, a bi-annual, month-long celebration of photography throughout Paris in 1980. "We combined ideas from Arles and Paris to create what would eventually become FotoFest," Fred explained. Returning to Houston, Fred and Wendy began talking to anyone who would listen about the idea of a major photography event in Houston. Early on, Fred went to Benteler Gallery, which specialized in European Photography, to introduce himself to owner Petra Benteler. Petra was showing important European photography in her gallery, often bringing well-known artists to Houston for the openings. Trying to think of ways to develop her gallery business and grow her collector client base, Petra had been mulling the idea of doing something "more in Houston for photography." Moments before Fred's timely arrival, Petra remembered telling her assistant Susie Morgan, "We have to do something, I don't know what it's going to be, but we have to do something about photography in the city." She

had been pondering the notion of an event and, driving back from Dallas,[13] she came up with the idea of an art fair focused on photography. When Fred arrived at her gallery, they had both been thinking similarly, so Fred invited Petra to brunch. Together Fred and Wendy shared their Arles experiences with Petra and their desire to do something similar in Houston. They "came up with the idea of something else to happen in Houston," Petra remembered, "I had the same idea and [I said] yes, even if I didn't know him, I thought 'that's right.'"

"Petra," Wendy remembers, "wanted to get the AIPAD dealers to Houston." Relatively new, the Association of International Photography Art Dealers (AIPAD) had been organized in 1979 and held an annual art fair. This idea seemed like a good fit with the models of the Arles and Paris photography events, and this was Texas, so bigger always seems better. Given Wendy's other commitments, Fred and Petra joined forces, becoming the initial directors, and began trying to engage others in their plan for a photography event. They met with Houston Center for Photography board members and others interested in photography in town to generate interest and support. From these discussions, they began by putting together a small board: Anne Tucker from the museum, gallerist Betty Moody, and philanthropist and photographer Muffy McClanahan joined. "Wendy," Fred explained at the time, "was already too involved in other projects to take this on."[14] Though she was part of the process from the beginning, "I decided not to go on the board, because neither Fred nor I wanted it to look like this kind of nepotistic small, tightly-run organization," Wendy explains. Houston Foto Fest, a Month of Photography, was incorporated in 1983. And the adventure began....

### "Let's start this"

As tipping points go, once Fred, Wendy, and Petra decided to create Foto Fest, Houston was on its way to becoming an internationally recognized destination for photography, and a photography scene in its own right. Together, Petra and Fred began cultivating other interested colleagues in Houston. Petra offered her gallery office to also serve as the Foto Fest office, and her gallery assistant Susie Morgan also became the festival's administrative coordinator. Fred described the beginnings, "Apart from our collaboration with Dominique de Menil, Wendy and I were newcomers to Houston, but we came with a network of national and international relationships, and this was Houston. We proceeded by drawing on lessons that we had learned surviving as international freelance

Initial Foto Fest staff members: Petra
Benteler, Fred Baldwin, Harla Kaplan, and
Susie Morgan at Benteler Gallery, 1985.

Courtesy of Harla Kaplan

photographers. We developed relationships, thought out of the box, took risks, and worked very hard. It turned out we were in the right place. Houston was a city where early entrepreneurs learned to poke holes in the ground — a million dollars a poke until they went broke or became multi-millionaires."[15] During the summer of 1984, Wendy and Fred attended a fundraiser for the MS Foundation called the Stars of Texas Gala, and met the organizer, Harla Kaplan. Harla was a veteran Houston fundraiser who had arrived in town sixteen years earlier and had built connections in a variety of interest areas. She had also organized numerous events in her previous roles as Executive Director for the Muscular Dystrophy Association and United Cerebral Palsy organization. Impressed with the Stars of Texas Gala — socialite and philanthropist Carolyn Farb chaired the event and the special guest "stars" included Gloria Steinem, Marlo Thomas, Phil Donahue, Dabney Coleman, Loretta Swit, and Marvin Hamlisch — Wendy and Fred asked Harla to help organize the introductory events for Foto Fest. Harla understood the community and had the local connections that the new festival would need.

Fred, Wendy, and Petra spoke with everyone about this idea, engendering enthusiasm mixed with a bit of skepticism throughout the photo community. "They dreamed of this festival," Anne Tucker remembers, "I must admit when I sat in on one of the early meetings, when they talked about bringing photographers from all over the world and having exhibitions all over the city, I nodded and smiled and said, 'You go guys,' but they did it."[16] Wendy and Fred also "brought an international sophistication that I think the rest of us were missing," Anne recollects, "both in Houston and in photography."[17] While they were spreading the idea of a festival in Houston, all three were still working

at other pursuits. Fred and Wendy continued their photographic work. Fred was still teaching photojournalism at University of Houston and his book about civil rights struggles in Savannah, *We ain't what we used to be,* was just published.[18] Wendy was in high demand as a freelance, award-winning photojournalist, which kept her very busy. *LIFE* commissioned her to do the photos for an article on "Arson Sleuth" for their September 1983 issue. Additionally, Wendy was curating exhibitions for Houston Center for Photography — *Agent Orange: Evidence of a Horrendous Mistake* in 1983 and *Eyewitness: News Photographers in Houston* in 1984. And Petra continued to run her gallery, mounting strong work and educating collectors and enthusiasts about European photographers.

To create the festival, Fred, Petra, and Wendy focused on building strong, supportive relationships both in Houston and abroad. Fred and Wendy had been instrumental in inviting Lorenzo Merlo, director of the Photography Gallery of the Canon Foundation in Amsterdam, who had originally invited them to the Arles festival, to curate an exhibition, *Contemporary European Photography*, at Houston Center for Photography in 1983. The following year, they invited Jean-Luc Monterosso, then the director of *Mois de la Photo* in Paris, to Houston to tell possible funders how successful the Paris event was — the 1982 event reported a half a million people came to see 64 exhibitions of 12,000 photographs.[19] "There was one problem," Fred explained, "we didn't know a lot of businessmen, foundations executives, or city officials. However, this was Houston." Just like when they were freelance journalists, they cold-called "Mayor Kathy Whitmire and Councilwoman Eleanor Tinsley, Roy Cullen, and developer John Hansen, explaining that Paris had a good idea and they needed to know about it because it was good for the city," Fred recalled.[20] They were able to convene a group of businessmen active in the arts for a breakfast meeting. Before "developer John Hansen, oilman Sandy McCormick, investment adviser Mike McLanahan, and oil industry supplier Wallace Wilson had finished their eggs Benedict ... Foto Fest had their support."[21] Fred later recollected, "When Monterosso arrived he was given the keys to the city by the mayor. Tinsley hosted a luncheon and our new business friends listened with interest. When Monterosso returned to Paris he was convinced that we lived in a city where streets were paved in gold and that we were major power players."[22]

At the same time, *La rime et la raison, Les Collections Menil (Houston-New York)* was being shown by the National Gallery in the Grand Palais in Paris

(April 17 to July 30, 1984), demonstrating the high level of art and sophistication happening in Houston. This exhibition was the first important art show organized after François Mitterrand was elected on a socialist platform and was inaugurated by Mitterrand and Minister of Culture Jack Lang with many important art world luminaries in attendance. It was in many ways a preview of the museum Dominique was building in Houston, though with over six hundred objects displayed it was still only a fraction of the Menil Collection. *La rime et la raison* put Houston squarely on the minds of French elites and government officials. It became a celebration of the de Menil's being French and both born in Paris as well as a taste of the amazing gift to Houston the Menil Collection would become.[23] The French cultural world was astounded by both the scope of the collection and its depth in such important areas. Alfred Pacquement, the contemporary art curator at the Centre Pompidou, was quoted as being "struck by the quality of many of the works and the desire to gather an ensemble." Due to the tax laws in France, most French collectors were reticent to show their holdings, which made *La rime et la raison* even more of a novelty for the country. Pacquement continued, "So it was very impressive for everyone to see how one person, one family, could have brought together such a large number of objects of such quality."[24]

In July, just as *La rime et la raison* was nearing its conclusion, Petra and Fred went to Paris to meet with Jean-Luc Monterosso, director of *Mois de la Photo* in Paris, other important French curators, and galleries about coordinating for Houston's month of photography scheduled for March of 1986, to coincide with the Texas sesquicentennial. They proposed a "twin festival" agreement between Houston and Paris. Monterosso was quoted at the time, "I'm sure that, in combining our efforts, we can create a great cultural and international event which will favor Houston, Paris, and photography in general."[25] They spoke of Houston exhibitions, one on Texas photography and another on NASA that would travel to Paris after the Houston event, while Foto Fest would receive a show curated by the *Bibliothèque Nationale de Paris*. Additionally, they were working together to have a copy of the "world's first photograph by Nicephore Niepce" which resides in the Gernsheim Collection in Austin, sent to *Mois de la Photo* via satellite. Petra summed up their ambitions, "Given its central location, growing arts community, and educational facilities, we believe that Houston has the proper ingredients to mount a festival that is as successful as that in Paris."[26]

With a year of planning, the festival now had an impressive International Advisory Board that included a number of members from important European and American photography institutions and a local Board of Directors comprised of key Houston photography curators and educators. Mayor Kathy Whitmire was quoted in the *Houston Post* as delighted "that Houston will serve as host city to welcome such an exhibition/festival."[27] Additionally, the *Houston Chronicle* reported that 17 local galleries and museums had agreed to participate in Foto Fest 1986, and that conferences and educational programs were planned as part of the Month of Photography — one on documentary photography and another on the ways photographs are used in the social sciences.[28] Word of the festival was growing, Wendy and Fred knew how to push a story out with their experience and many contacts throughout the world of journalism. Petra communicated as a member of the Association of International Photography Art Dealers (AIPAD) and with her European contacts to make sure Foto Fest was on their radar as well.

Though they had yet to land any sizable funders, they continued to move forward with enthusiasm, "Our purpose is to make Houston one of the important national, maybe international centers for photography," Fred said at the time, "The ingredients are there: the museums, teaching institutions, the Houston Center for Photography, the collectors. There is nothing like the Fest anywhere in the U.S. but Paris just had its second, very successful festival in 1982."[29]

### *"It had to be big"*

People in Houston were impressed that important Parisians were paying attention to something in their city. External value created internal interest but that had not yet turned into dollars of support. Initially, Fred and Petra "drew up the names of three hundred people who had given money to the arts in Houston." They sent letters introducing the idea of a festival and how wonderful it would be for the city, asking for support. Money did not begin rolling in, in fact, they had no response whatsoever.[30] "We decided that in order to make it work in Texas, it had to be big," Fred explains. While some suggested a more cautious approach — educating the public by starting with Ansel Adams and such first. Seemingly always audacious, Fred said, "We decided to do the opposite."[31] In what turned out to be a brilliant move, they invited four internationally prominent photographers to town to photograph the Houston Livestock Show and Rodeo in the spring of 1985. Using the "criteria, first you had to be very well-

known and secondly they had to have never seen a rodeo," Fred explained, "so we got Ikko Narahara from Japan and we got Franco Fontana from Italy and William Klein from Paris, and Helmut Newton from Monaco."[32] An exhibition of their images would be shown at the first Houston festival in March of 1986 and then would travel to Paris for *Mois de la Photo* in November.[33]

Fred and Petra flew the photographers to Houston using their own funds and found Houstonians to host them. Betty and Freck Fleming of Paradise Bar and Grill hosted Ikko Narahara and his wife Keiko. Former honorary Italian consul Achille Arcidiacono hosted Franco Fontana and 'the Italian contingent,' including photographer Ernesto Bozan and art magazine publisher and photo collector Franco Panini. William Klein, his wife and son were houseguests of photographer and philanthropist Gay Block. Helmut Newton, whom Wendy and Fred had met in Arles, stayed in the Meriden Hotel. Fundraiser and event planner Harla Kaplan worked with Fred and Petra to organize two weeks of extravagant parties in elegant Houston homes, including one hosted by "Houston socialite-wife-mother-thoroughbred horse breeder Dolores (Mrs. Stuart) Phelps" who in her modeling days had been photographed by Newton for French Vogue.[34] Relying on Harla's connections to local philanthropists and Petra's collector base, with Fred and Wendy's enthusiasm, the introductory events for Foto Fest were spectacular. Seemingly all of Houston society came all out to meet the famous photographers. "When Helmut hit town, this place went crazy, suddenly we were forced into visiting prestigious house balls in River Oaks one after the other, one dinner party following the next, trailing behind Helmut Newton, with television cameras and with press," Fred recalled.[35] "I went to one of those parties and I have never seen a smoother operator in my life," Anne Tucker adds, "The women coming up and inviting Mr. Newton to photograph them, and I was imagining pictures of people with saddles on their backs and all the rest of the time trying not to imagine that, but watching him ... until he found a woman he did want to photograph and then he started. ... So, it was a lesson in life watching Helmut in a river of women."[36] Bringing well-known photographers to town to photograph a rather unique Houston event implied an international prestige which captured the interest of important power brokers with the means to support organizations that showcased their city. The Fest promised to do just that. Fred recalled, "Well the result of that two weeks was we became fairly well-known in Houston, Texas, and that was when the fundraising started."[37]

The two weeks of photographing at the Houston Livestock Show and Rodeo by day and fancy parties in tony River Oaks mansions by night culminated in a large celebration cosponsored by the hotel at Le Méridien Houston.[38] Originally, Fred wrote to Dominique de Menil, they had planned for the February 20th event to be a fundraiser but "on the advice of a number of experienced hostesses and businessmen, we were persuaded to underwrite the party ourselves because it was felt that we were not yet sufficiently known in the community to raise money by charging people to come to such an event." This decision created a $24,000 commitment they had not planned on. However, with their own credit cards and a few individual donations, they hosted a cocktail party for 500 to introduce the four photographers and Foto Fest to Houston. It was quite an event. Co-Directors Petra and Fred announced the "official cooperation" between the Houston Foto Fest and Paris' *Mois de la Photo* that had the support of both Jean Luc Monterosso, who had visited Houston the previous April, as well as Paris Mayor Jacques Chirac.[39] Many French and Houston luminaries attended the party. "French Consul General Didier Quentin took center stage at the party to read a telegram of congratulations from Paris Mayor Jacques Chirac [and] City Councilwoman Eleanor Tinsley, representing Mayor Kathy Whitmire, read a Foto Fest proclamation," the *Houston Chronicle* reported. Wendy and Fred's old friend, *Camera International* publisher Lorenzo Merlo of Amsterdam introduced each of the photographers.[40]

It was a big, bold beginning for the festival, the directors were "extremely canny in bringing these four world-renowned photographers to Houston, and lining them up with the local aristocracy," art writer Robert Boyd explains, "Houston was an insecure city in the mid-80s (and in many ways still is). The city was then riding very high on high petroleum prices — as the oil business grew and got rich, so had Houston. (Oil prices would crash one year later. If they had decided on a "start small" model, they might have expired then and there.)"[41] After the Le Méridien cocktail party, money began to arrive. Fred recalled, "Thirty days after our American Express bill arrived, Foto Fest received its first grant from the Wortham Foundation, and we didn't go broke or land in jail." Oil man Roy Cullen also supported them, "he gave us $150,000, he said 'you know the oil industry is having a tough time right now,' this was 1985, 'but I think we need something like this to sort of boost our morale,'" Fred explained. Additionally, Fred credited Houston culture as important for their success, "We couldn't have done this in New York, or Washington or Boston or any of these places, but Houston was willing to take the risk. Houston is a place where somebody

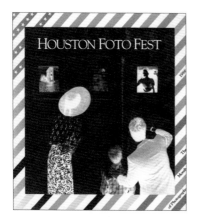

HOUSTON FOTO FEST

204

The first Houston Foto Fest: Month
of Photography catalog, 1986.
From the collection of the author.

takes a million dollars and they poke a hole in the ground then they borrow another million till they go flat broke or they are billionaires and this [Foto Fest] was looked at in somewhat the same way."[42]

The resulting fundraising success after the two-week extravaganza allowed them to hire Harla Kaplan as a full-time Executive Director. Just as with the introductory rodeo photographers and non-stop parties, Harla explains that it was her role to take Fred and Petra's big ideas "and put them into a concept that was real." Fred, who journalist Lisa Gray referred to as "Dreamer-in-Chief," always had a strong, clear "big picture" vision for what Foto Fest could become but operational details were not his forte. Petra, as a businesswoman, had a good sense of planning and organization, but figuring out how to make the dreams a reality fell primarily to Harla. Credited with helping the organization "through so many early crises," Fred, Wendy, and Petra relied on Harla's connections and troubleshooting abilities.[43] It was "heavy plate spinning, keeping them all spinning," Harla explains, "it also felt like a three-dimensional tic-tac-toe." At the beginning, Foto Fest was a great idea without much of a plan. "It was just a concept," Harla recalls. We were "not following in anybody's footsteps — it was creating as you go."

### *"Far beyond anyone's expectations"*

In addition to curiosity about Houston wildcatter and entrepreneurial spirit, an interest in Texas big hair, oil money and urban cowboys had become part of the broader popular culture in the 1980s. The highly ranked television show, *Dallas* (1978-1991) was at its peak, featuring the antics of the Texas super-rich. Paris-based photographer Marie Docher tells of hurrying home from school to watch episodes of *Dallas* at her childhood home in Clermont-Ferrand and thinking all of Texas must be like the program portrayed.[44] Additionally, two widely acclaimed movies filmed in Houston, *Urban Cowboy* (1980), which

brought two-stepping, cowboy hats, and mechanical bull riding into populari-
ty, and Academy Award winner for Best Picture, *Terms of Endearment* (1983),
which featured a wealthy socialite and her astronaut neighbor in the affluent
River Oaks neighborhood, brought those aspects of the city into view. With the
exception of those familiar with the Menil Collection, few would have thought
of Houston or Texas as a place for art, yet culturally it was on the international
radar. So, when it came time to invite photography experts from around the
world to come to the first Foto Fest, they came expecting some combination of
*Dallas* and *Urban Cowboy*.

The Foto Fest staff, Fred, Petra, Harla, and Susie with Wendy's help worked
tirelessly to make the first festival the biggest event they could. As a member
gallery, Petra persuaded Association of International Photography Art Deal-
ers (AIPAD) to bring their annual Photography event to Houston during the
first month of photography in 1986. Her gallery, Benteler Gallery, was an early
member of AIPAD and Petra was well-known in the organization. Formed in
1979, AIPAD had begun hosting an annual Photography show — a fair of select
dealers — the following year in 1980. Bringing this event to Houston in 1986
during the festival, was quite a coup for the directors as it linked the new fes-
tival with established photography dealers from around the world. Forty-five
dealers participated in the Houston event. Estimates of the number of photog-
raphy shows during the first Fest vary — the 1986 catalog lists 62 exhibitions,
but later overviews have higher numbers. Perhaps as the momentum grew it
became a moving target as more people wished to participate. Additionally,
a last-minute *Salon des Refusés* was organized in the warehouse district for
all the images that were banned from corporate spaces. From the beginning,
Foto Fest has been inclusive, broadly inviting partner organization spaces and
attracting participants who want to show their work. The exhibit spaces in-
cluded four museums, 15 alternative art spaces, 28 commercial galleries, and
16 corporate spaces, which were attended by an estimated 175,000.[45] Exhibi-
tions involved work by 783 photographers from 11 countries, including 52 from
Texas. Events during the month of photography also included 15 lectures and
symposia with participants from 11 countries.[46]

By all accounts, the first Foto Fest was a spectacular celebration of photogra-
phy. Lew Thomas, director of Houston Center for Photography wrote in *SPOT*
at the time, "... The Houston Foto Fest, Petra Benteler, and Frederick Baldwin,

created a free-flowing context for the photographic arts that went far beyond anyone's expectations. ..."[47] Indeed the 1986 Summer issue of Houston Center for Photography's magazine *SPOT* almost bubbled over with excitement, devoting the majority of its space to reviews of the various Foto Fest exhibitions and events. Internationally, *European Photography* proclaimed, "The first Foto Fest was like nothing the Americans had ever seen...As do its cousin events in Europe, the Houston Foto Fest in many ways reflected the character and personality of its host region: it was huge, free-wheeling, star-studded, and utterly sociable. For those Europeans who managed to come it was a Bonanza... it was a genuinely international gathering in composition, characterized overall by one German participant as, 'not just America's first Foto Festival, but really the first International Foto Festival anywhere.'" *Newsweek* proclaimed, "The numbers are pure Texas: 64 exhibitions, 783 photographers on display, 4,000 photographs spread across a mile of walls... the first Foto Fest has proved its mettle." Using their journalism contacts, Wendy and Fred managed to get Foto Fest 1986 written about in *Art Forum*, *ARTnews*, *Boston Globe*, *Chicago Tribune*, *Christian Science Monitor*, *Cosmopolitan*, *Herald Tribune*, *Texas Monthly*, *USA Today*, *Vanity Fair*, *Vogue*, and *Washington Post*. The event was mentioned by the BBC, Finnish TV, Italian radio, Japanese TV, among other broadcast media. This amazing feat of media reach for the first Fest included 33 local/regional publications, 26 national, and 33 international publications, with a combined circulation of 46.7 million people.[48] As Lew Thomas rightly predicted, "Foto Fest ... will radically enhance Houston's future as a center for international exchange of ideas affecting cultural communications and photography."[49] Indeed, Foto Fest marked Houston as *the* international photography scene.

Beyond the attendance numbers and the photography, perhaps even more surprising were all the Houston socialites that opened their homes for dinners and cocktail parties. After a day of looking at photography, gathering in one of Houston's elegant homes of the city's wealthy families was memorable. Fred explained that Houston is not "a beautiful small town like Arles" but he "tried to recreate the French festival's friendliness by organizing local social leaders to give private parties — 27 in the two-week period — in addition to dozens of public receptions in galleries and museums." The Cullens, Lynn Wyatt, and Carolyn Farb were among the hosts that opened their homes to the Foto Fest guests.[50] The South may be known for its hospitality, but Houstonians can also be starstruck. As blogger Robert Boyd surmised, "the social and political

leaders loved the fact that a bunch of the world's greatest photographers were here, in their homes, at their parties."[51] Guests of the festival were treated to a Texas-sized helping of wealthy Houston, elegant parties every night, and came away with a whole new idea of the city and its support for photography. If you happened to be invited, William Messer wrote in *European Photography*, "you were golden and you could forget about buying supper for two weeks. Caterer meals at magnificent homes with impressive art collections on the wall became the general rule."[52]

### The Meeting Place

An important, innovative aspect of the festival was the "Meeting Place" where young photographers could talk with influential photography professionals. Fred always wished he had this kind of opportunity when he started photographing. "One of the reasons ... that we did the meeting place is so photographers ... [could get] sufficient advice," Fred explained, "you meet somebody who can give you some good advice and it will change your life if you have any talent."[53] With that in mind, they invited over one hundred "international leaders in photography — critics, curators, writers, publishers, 'the kind of people you'd want to meet if you were a photographer, the best people we could get our hands on,'" Fred explained. Foto Fest paid for their travel and hotel, and in return, asked them to "spend nine hours reviewing photographers' portfolios on a first-come, first-serve basis, with no screening process."[54] Adding a structure to the review process, unlike the loose informal approach Wendy and Fred had found in Arles, each photographer was given 30 minutes to meet with a reviewer. In order to be reviewed, photographers would sign up every morning. Chris Rauschenberg remembers the initial process, "The photographers would get there at, like, 6am. And the guy in the front of the line had a little ticket, like a movie theater stub with their name on it, and there was a big board, and the names of the reviewers on one axis and the time slots — 9:00, 9:29, 9:59 — on the other axis, and you'd take your little ticket stub with your name on it, and put it on the first open slot, for whatever reviewer was your first choice, then you'd go around and get at the end of the line. And so, it took two hours to run the line to schedule this stuff."

The first Meeting Place was set up in the Palm Court of the historic Warwick Hotel. Located across the street from the Museum of Fine Arts, Houston, the Warwick was the only luxury hotel in town when it was built in 1926, and it had

been remodeled in the 1950s to an even more opulent style. "Warwick Hotel where all this happened is archetypical of Houston," wrote Colin Osman for the *British Journal of Photography,* "Just over twenty years old, it was built by yet another oil millionaire to hold his offices on the 11th floor and his superb collection of European artifacts on all floors. The lobby is decorated with tapestries, paneling, porcelain, and crystal chandeliers, all genuine, from various palaces of Europe."[55] Amidst this Houston-style lavishness, "an extraordinary cast of invited participants were stationed at tables to meet with whomever wished to meet with them, look at photographs or simply talk," marveled William Messer.[56] Compared with Arles and Paris, Houston's history is short but its ability to dazzle with Texas-sized extravagance can have its own allure. For Foto Fest, they attempted to pull out all the stops — showcasing all the most interesting aspects of Houston from oil money, to the rodeo, to the grand homes as a supportive venue for art and creativity.

This first Meeting Place had two five-day sessions open from 9am to 5pm. There was no cost to the photographers, the reviews were free and open to whomever came. Photographers only needed to cover their own travel costs. To help with this, Foto Fest partnered with several hotels to provide discounted rates, ranging from "Tourist Class Hotels" at $232 for seven nights to "Deluxe Hotels" at $420 for the week. Transportation was organized with Houston Metro, which had specific buses marked with "Foto Fest" that provided transit to all the exhibitions and all the participating hotels for a nominal fee. Reviewers for the initial Meeting Place included an amazing array of the "best people we could get our hands on" — Cornell Capa, Christian Caujolle, Robert Doisneau, Joan Foncuberta, Ralph Gibson, Howard Greenberg, Andy Grundberg, Francois Hebel, Nathan and Joan Lyons, Peter MacGill, Ray Metzker, Pedro Meyer, Andreas Müller-Pohle, Martin Parr, and Sam Wagstaff were among the over 100 participants. Additionally, Houston notables Suzanne Bloom, Peter Brown, Ed Hill, George Krause, Anne Tucker, and Geoff Winningham reviewed portfolios as well. Indeed, it was a spectacular gathering of the who's who of photography at the time.[57]

### Making photographic history

"Houston Foto Fest," Fred and Petra wrote in the introduction to the 1986 catalog, "sought some of the best art and the best people in photography around the world." Choosing photography to build the event around, Fred and Petra

argued, was "not only because we love photography and are personally involved with the medium, but also because photography is so much a part of everyday life. As an art form, it is popular. As a means of communication, it is uniquely suited to reach the broadest audience." Crediting their staff of three — Susie Morgan, Administrative Coordinator, Harla Kaplan, Executive Director, and Barbara Dillingham, Public Relations — as leading the way that provided for the organization's survival: "good work and good people."[58] Indeed, it was a host of volunteers, funders, and partner museums, galleries and other organizations that came together to make the event spectacular. "Foto Fest was a dream that we all shared," Harla Kaplan wrote at the time about the efforts of all involved, "Thanks again for helping us make photographic history."[59]

And make history they did. Executive Director of the Museum of Photographic Arts in San Diego, Arthur Ollman, exclaimed, "What an event! What an extravaganza! What a success! If putting Houston on the photo map was your goal, you more than accomplished it."[60] In addition to the Meeting Place and all the parties, there were lectures, workshops and symposia — sometimes

multiple ones on each of the first sixteen days of the event. Robert Frank, Van Deren Coke, Ernst Haas, Bernard Faucon, and Andy Grundberg gave some of the lectures. Sam Wagstaff and Daniel Wolf participated in a symposium on collecting. Additionally, there were slide show presentations by experts on photography in Lithuania, Britain, Sweden, Latin America, Spain, Germany, Japan, Belgium, Hungary, Czechoslovakia, South America, and the Netherlands. It was a nonstop, international whirlwind of photography — and that was only the first half of the month! "Visual exhaustion begins to set in," Colin Osman wrote, "and if the eyes do not give up, the back and feet do."[61]

The festival sponsored and/or curated fifteen of the sixty-some photography shows during the month of photography, including Houston Foto Fest Biennial Exhibition, *Houston and the Rodeo,* curated by Wendy Watriss at the Texas Commerce Tower, which included the rodeo photographs of Helmut Newton, William Klein, Franco Fontana, and Ikko Narahara. The festival exhibitions ranged from documentary to art to commercial to historical — all aspects of photography were welcomed. "I wanted photography to be everywhere," Harla recalls, "that was my mantra — I wanted blue bonnets [the state flower] in the malls." Participating spaces often showed images that related to their interests, like the Houston Police Museum exhibited *Jill Freedman: Street Cops*, *Houston Post* newspaper office exhibited *Contact Press Images* from the international photojournalism agency, and Detering Book Gallery showed *The World of Reading,* which brought together images of books and reading by André Kertész, Toni Schneiders, Karin Székessy, and Suzanne Szász. Libraries took the opportunity to show off some of their historical holdings in celebration of Texas' sesquicentennial. The Public Library exhibited photographs by Henry Stark that had been taken in Texas in 1895-96 and M.D. Anderson Library at University of Houston showed early 20th-century work by George Beach and Joseph Litterst. Galleries generally celebrated all the photographers in their stable — Harris Gallery showed *Three Houston Photographers* (Brown, Krause, Winningham), McMurtrey Gallery also offered a *Local Focus: Armstrong, Cozens, Cravens*, Moody Gallery showed nine photographers (Christenberry, Fridge, Hall, Kasten, Hill, Bloom, Metzker, O'Connor, Souza), and Texas Gallery had five photographers' work on display (Close, Mapplethorpe, Nicosia, McCollum, Friedlander). Additionally, Enzo Sellerio, Gay Block, Sally Gall, Frank Gohlke, Nakaji Yasui, Taishi Hirokawa, Mischa Bar-Am, Reinhart Wolf, Paul Hester, Joel Peter Witkin, Paul Caponigro, Robert Capa,

Alain Clement, Meridel Rubenstein, Barbra Riley, Russell Lee, Ernst Haas, Ben Shahn, Jerry Uelsmann, Tomiyasu Shiraiwa, Kristen Struebing-Beazley, and Valentine Gertsman had solo exhibitions at various venues around town.

Houston Center for Photography displayed a retrospective of Bernard Faucon's Fresson Color Prints. "One of the more remarkable achievements of the Houston Foto Fest was the ambition and desire of the artists' spaces and galleries to mount exhibitions of startling quality," HCP's Lew Thomas surmised, "such as *Contemporary Women in Documentary Photography* featuring the politicized photographs of Wendy Watriss and Ruth Gordon at The Firehouse Gallery; *Painted Pictures* curated by Andy Grundberg, The Midtown Center; *Interiors,* Rice Media Center; Barbra Riley's hand-colored photographs, Hadler/Rodriguez; *Meridel Rubenstein: Lifelines,* Jack Meier Gallery; *Alain Clement: New Photographs*, Graham Gallery; *Black, White & Color: Houston/ Los Angeles,* Diverse Works; *Paul Hester: Texas Monuments*, Farish Gallery, Rice University; to name just a few of the exhibits...."[62]

Other notable exhibitions included Robert Rauschenberg's photographs from 1949-1983 on view at the Contemporary Arts Museum, *The indelible Image: Photographs of War-1846 to Present* organized by the Corcoran Museum at Rice Museum, the last exhibition there under Dominique de Menil's leadership, *Self-Portrait in the Epoch of Photography* organized by Erica Billeter and shown at the Blaffer Gallery at University of Houston, and the highlight of the entire event, the Museum of Fine Arts, Houston, *Robert Frank: New York to Nova Scotia.* Curated by Anne Tucker and Philip Brookman, this exhibition surveyed Frank's photographs from 1947 to 1985 and also included some of his recent videos and autobiographical photographs. "The pictures are at once a social epic and a personal lament about the American social landscape," Anne wrote at the time, "Frank freely employs irony, distrust, and irreverence, and occasionally generosity and delight."[63] Robert Frank came to Houston for the exhibition, introducing many of his films, giving an artist's talk and participating in a symposium on his work.

"A centerpiece of the opening of the '86 festival was a film series by Robert Frank thanks to Anne Tucker," Wendy remembers, "that we did in the old Tower Theater on Alabama and it was packed."[64] Anne had been working towards the Frank retrospective when Wendy and Fred approached her with the

idea of Foto Fest. The timing turned out to be good for both the new organization and the museum, "it just worked out," Anne explains, "but it was great because it got us a lot more press than we would have gotten otherwise." The exhibition opening reception, symposium, and the accompanying film series was the highpoint of the kickoff for the first Houston Foto Fest. It tied the new event to the legitimacy of a museum and the prestige of an important, internationally acclaimed photographer.

The first Foto Fest concluded with "Rendezvous Houston: A City in Concert," a light-and-sound show by Jean-Michel Jarre that was organized as part of the Houston International Festival. A *Washington Post* reporter described it as "electronic music droned from a hundred thousand radios, his corny colored slides (bucking broncos, oil wells) lit up the city's glass-sheathed towers, fireworks exploded, lasers swept the skies. Jarre's show, although Texas-sized, was hokey and chaotic. But the party was terrific. It had been going on all day." Earlier, Houston's glitterati had gathered for the opening of the $3.5 million Cullen Sculpture Garden at the museum where John Cage had premiered his composition *Ryoanji*. Designer Isamu Noguchi, at 82, also attended. He had designed the space with granite paths and grassy mounds specifically as a site for sculptures. The garden includes works by David Smith, Henri Matisse, Louise Bourgeois, Dan Graham, and Auguste Rodin surrounded by 99 native trees, bamboo, and flowering crepe myrtle.[65] In addition to a vibrant party scene, those who had come to Houston for Foto Fest found international art celebrities there too.

### *"Boom Town of the Arts"*

In March 1986, all the dreams and hard work had come together creating a memorable and impressive citywide celebration of photography. Beyond perhaps what anyone but Fred and Wendy could have imagined, it far exceeded what most others would have thought possible in as unlikely a place as Houston. The *Washington Post* reporter Paul Richard declared Houston "Boom Town of the Arts."[66] Photographer Peter Brown, who had been at many of the early planning and discussion meetings, remembers, "At the time I think everybody thought this was a real pipe dream to pull something like this off and it is something miraculous — but this is the kind of city that Houston is ... if you have a good idea in Houston, you have energy, and you have any small set of connections that think it is a good idea, you can get it done." Just as

John de Menil had predicted about Houston all those years before — in the [cultural] desert is where miracles can happen. Foto Fest '86 was certainly one of those Houston miracles born of vision, passion, lots of hard work, funders, and volunteers who believed in the possibility of building an international community around photography. Fred, Wendy, and Petra with staff members Harla and Susie had created "an international showplace for photography," Cornell Capa, executive director of New York's International Center for Photography exclaimed, "out of nowhere."[67] When the dust settled, Foto Fest was $100,000 in the red, but they had done the seemingly unimaginable and set a high bar for the biennials to follow. "After 31 days, 26 private parties, 63 gallery and museum receptions, a 3-inch stack of international press clippings and the attendance of 98 invited artists, critics, and collectors from more than 20 countries," *Houston Chronicle*'s Patricia Johnson wrote, "I found the event both an education and visually sumptuous, and am thankful for the two-year rest period before the next photography month to digest what I saw — and rest my feet."[68]

In addition to bringing together photography experts, photographers, museums, galleries, community spaces, and sponsors of all kinds (corporate, socialites, grants, and individuals), Foto Fest also needed numerous volunteers to help with every aspect from gallery-sitting to installing and deinstalling to taking admission tickets to driving guests around. "The volunteers are wonderful," Fred spoke of the several hundred that helped with the Fest, "they're our life blood."[69] Volunteers came from all social groups. Photography students and Houston Center for Photography members got involved but so did River Oaks housewives and businessmen who found themselves unemployed with the oil bust. Photographer Sally Gall remembers being excited about the idea, "as a young photographer I just thought, 'yeah, great, fabulous' and I remember saying 'I'll help. I'll do something.'" To recruit volunteers, "I went to everything I could find that people were at," Harla explains, "*Houston Press* was a wonderful resource for volunteers — we put ads in the back of the *Houston Press*, volunteers needed for this upcoming festival." While Foto Fest benefited from the volunteers, the volunteers also benefited. Photographer Sharon Stewart remembers volunteering at the table with the catalogs and "this curator from the Museum of Photography in Belgium comes by and started looking at the catalogs and he asks if I was a photographer, 'Well yes,' and he said, 'Well could I see your work?' and it ended up being in a triennial."

Other volunteers, like Joan Morgenstern, became serious photography collectors through their experiences with Foto Fest and meeting photographers — often early in their careers.

One Month of Photography, though grand, does not a biennial festival make. As much effort as went into the initial event, each subsequent biennial would require more. Dreamer-in-chief Fred in concert with Wendy continued to think bigger and bigger — the budget for the 1988 biennial was $600,000 and he was planning for $1 million for the 1990 event. Foto Fest was set to grow bigger as with each festival they planned to do more and more. As David Crossley wisely predicted in Houston Center for Photography's magazine, *SPOT*, "We expect Foto Fest to change the nature of American photography, and we (HCP) plan to be a central part of the new international view. Between Anne Tucker at the Museum of Fine Arts, Houston, and Fred Baldwin at Foto Fest, Houston is going to be the most exciting photographic city on earth."[70]

# III   Making a Scene: MFAH, HCP, and FotoFest

# Chapter 9

# MFAH: Writing New Chapters in the History of Photography

At the museum, Anne continued with an intense work schedule, or as she wrote to a friend, with a schedule that was "tighter than a tick on a hog's back."[1] The success of the *Target Collection* exhibition inspired her to attempt more large-scale projects. With a second Target grant, Anne focused on work by Adolphe de Meyer, Clarence White, Alfred Stieglitz, Paul Strand, and Edward Weston for *Target II: Five American Photographers*. In the exhibition and catalog, Anne charted the aesthetic transitions from pictorialism to modernism from 1889 to 1945. In addition to four smaller shows, Anne closed the decade with the *Anthony G. Cronin Memorial Collection* — a tribute to Tony Cronin, after his sudden death in 1978, which included 107 images from 67 donors as well as a catalog.

In 1980, Anne began the year with a MANUAL retrospective of University of Houston faculty, *Suzanne Bloom and Ed Hill (MANUAL): Research and Collaboration*. In addition to the extensive exhibition, a catalog was co-published by the museum and "Seashore Press" which was invented for this purpose. It was the name Betty and Freck Flemings used to disguise their donation. Though they had known Anne socially, Betty remembered going to the museum to discuss funding the catalog, "I was intimidated, and I just walked into her office and all of a sudden we were talking about horoscopes and fun things. It was like she was one of my friends that I'd grown up with ... it was just so disarming." After the MANUAL retrospective, Anne did two other photography shows for the museum that year. In her own life, things were stressful, as her marriage to Cal was ending. They separated in the summer, Anne kept the art and left Cal with everything else. "I just wanted out," Anne explains, "I am a bridge burner, once something isn't working, I'm gone." Despite the turmoil of transition, Anne now

had more time to devote to her work and she plunged passionately into creating an exhibition of Sidney Grossman's work.

Anne's interest in doing a Grossman show came "out of the Photo League [research] and adoring his wife, his widow, [Miriam] and just believing in the photography." Grossman had died in 1955 at the age of 42 without ever having a major exhibition of his work. Though Anne had mounted retrospectives of the work of George Krause (1978) and MANUAL (1980), this was the first time she had curated a major show with only archival and secondary information. In many ways, the Grossman exhibition was pivotal in Anne's career, showcasing her abilities as a serious researcher and her willingness to take risks. Additionally, it was with the Grossman show that she began her targeted fundraising and stance on collecting the work she exhibited.

> ... when I did the Grossman show I really did a push to get people to help me buy pictures out of the show. We did the show, we did all the research, we did all the scholarship. That was another important philosophical position for me because I had seen so often at the Eastman House that they did these shows and they never purchased work and I know I would go to a show, and I would see work and there would be no work in the collection so I very consciously made the decision that we would always buy work when we did a show.

Collecting from the exhibitions was also a means to increase the museum's collection of photography. "It was all strategy," Anne explains, "the shows were a way to get donors familiar with the work."[2] Through individual donors and matching grants from NEA and Polaroid, Anne was able to acquire 49 of the Grossman images from the exhibition. Donors included Betty and Freck Flemings, Louisa Sarofim, Len Kowitz, Gay Block, Clint Willour, and Sally and Joe Horrigan, in addition to funds from Target and fifteen images purchased with museum funds. The exhibition opened to much fanfare on February 19, 1981. Anne ordered large corsages for visitors Miriam Grossman Cohen, Mrs. Adam Grossman — the wife of Sid's son — and Margaret Moore, who had cataloged the Grossman archive. The exhibition was reviewed well and traveled for the next three years. It received some media attention including a positive review in the March 28, 1981, issue of *Artweek* by Suzanne Bloom. The MFAH collection currently includes 235 photographs by Sidney Grossman.[3]

Putting together such an extensive exhibition was not without its challenges, some of which were quite unusual. One of the glitches, surprisingly, came from the Houston Garden Club, which had been overseeing the museum grounds since 1930.[4] During the fall of 1980, the garden club had installed a sprinkler system in a side garden. To activate the new system, it needed to be 'plugged in' and the only proximate plug was in Anne's office "behind cabinets which now hold all the Grossman photographs and negatives." Through a delicate negotiation, they were able to get the Garden Club to agree to postpone the 'plug-in' for a month so all the materials could be safely moved.[5] However, more importantly, the museum was unable to fund a catalog for the exhibition, so Anne looked for donors and even considered funding a smaller version of it herself.[6]

> I mean it is hard to raise money and of course you know I never got it done [the catalog] and that the sadness for me of the craziness of that time is I just couldn't pull that off. But writing is much easier now. Writing was really, really hard for me. Writing is something I learned; it did not come easily.

When one looks at everything Anne was juggling in 1981, it's amazing that she had time to even think about fostering a photographer's co-op, let alone provide and nurture the spark that became Houston Center for Photography. Interest and enthusiasm for photography seemed to be growing in the city. *Houston City* magazine had singled out photography as "one of the most robust areas of the Houston art scene."[7] Dominique de Menil had just invited Beaumont Newhall to town to select photographs from her collection for the show *Transfixed by Light* at the Rice Museum (March 21-May 24, 1981) and the MFAH had just received a third grant from Target to purchase more work for a *Target III* exhibition and catalog. And then, without much warning a sudden, unexpected storm broke over the art community. It's not clear where the rumbling began but once it erupted in mid-March, it was not to be contained. Anne found herself surrounded by controversy at the museum and with many of her closest friends on the opposing side.

## The Community Rises Up

Bill Agee began being questioned on all sides. He had hired Barbara Rose, a leading art critic in New York, who had been writing for leading art journals since the 1960s. The fact that she would continue to live in New York City, and only visit Houston, was not well received by Houstonians. Additionally, within

days of Barbara Rose's appointment, another storm hit the newspapers, questioning the recent sale of five paintings by her husband, music composer Jerry Leiber to the Houston museum. Though the museum spokesman said the negotiations for the paintings had begun over a year ago and were completed in January of 1981, two months prior to Rose's appointment, the community was not appeased. Hiring Barbara Rose seems to have been the catalyst for further uprising as more and more attention was being paid to the management of the museum, resulting in more complaints.

Most of the exhibitions were "essentially modern and contemporary during Bill's tenure," Anne explains, "and a lot of people didn't like contemporary art, and there were a lot of people who felt that Bill's shows were not to their tastes." Indeed, some remember a growing split privately among the museum's Board of Trustees regarding support for Bill and his ideas. Additionally, there was some discomfort brewing about the deaccessioning of "more than 35 works by recognized artists"[8] to raise funds to purchase paintings that fell within Bill Agee's area of specialization, Abstract American Expressionism. "It started when we had sold a bunch of paintings to pay for the Picasso. We sold Andrew Wyeth, we sold a [Diego] Rivera," Anne recalls. The deaccessioning started a flurry of newspaper articles by a young art writer at the *Houston Post*, Mimi Crossley. Anne remembers feeling trepidation every time she went out to get the morning newspaper. "What was going on at the museum was heartbreaking for Bill and what angered me is that a lot of the trustees who sided against Bill had been sitting there when they voted to buy that art and to accept that art," Anne explains, "... the museum was attacked every day ... it felt like it; you just never knew when the next blast was coming."

At the museum's Accession Committee Meeting on February 16, 1981, Bill presented the list of works to be deaccessioned, which was approved by the trustees. He also mentioned that Charles Hooks of Hooks-Epstein gallery in Houston had a buyer in Mexico for *La Huella, 1953* by Gunther Gerzso. In discussing this with the committee, Bill pointed out that if they accepted this offer there would be no transportation or insurance costs to the museum. Bill further proposed that the museum might consider having Hooks handle the sale of other Latin-American works, such as the Diego Rivera, *Kneeling Woman with Sunflowers, 1946*. The committee authorized Bill to move forward on both sales.[9] The following day, Bill contacted Charles Hooks and jotted a note to himself "2/17 2PM Hooks Client wants Gerzso — 12,000 net to us ... Client

will be here 2/26 with check. Will look at Rivera then (offered at 125,000)."[10] This offer was higher than the Sotheby's auction estimate Bill had received for these two pieces and there would be no transportation cost as the buyer would pick up the art at the museum. For the remaining works to be deaccessioned, Bill contacted David Nash at Sotheby Parke Bernet, Inc. in New York City to discuss placing the works at public auction.[11]

When Hooks' buyer arrived from Mexico City and purchased both paintings, there was speculation that the museum was selling directly to collectors. Though Bill had worked with the Houston gallery and acted with the support of the Accession Committee, when the transaction appeared in the newspaper, those details were not included. Rather, the article reported that the collector drove north to Houston, handed Bill Agee a certified check and walked out with Diego Rivera's *Kneeling Woman with Sunflowers*, which he then loaded into his motor home, and drove back to Mexico.[12] Later, it was reported that "The *Post* learned that two works — a painting by Mexican master Diego Rivera and a work by Gunther Gerzso — were sold privately to a Mexican collector, who purchased the art in Director Agee's office in March for a total of $122,000." [13] Ironically, neither Charles Hooks nor the gallery are mentioned in any of the newspaper accounts. Attempting to explain, Bill Agee admitted the deaccessioning "ended up looking like a fire sale." He added that he was "trying to do things quietly so we could get the best price."[14]

The art community galvanized around the quiet deaccessioning and conflict of interest concerns. "Art worlds never come together," artist Lynn Randolph remembers, "like they did over this issue." In addition to the frequent newspaper articles, the local Women's Caucus for Art wrote an open letter to the museum Board of Trustees. The Houston Women's Caucus for Art (HWCA) had been initiated during the first National Women's Conference that was held in Houston in November 18-21, 1977. When the controversy at the museum arose, HWCA mobilized. As artist and University of Houston faculty Suzanne Bloom wrote in the July issue of the HWCA newsletter, the Caucus gave the art community a "ready-made organ" through which "the arts community can collectively respond to urgent situations of common concern."[15] Copies of the letter were also sent to the *New York Times* as well as three local news outlets. In the letter, HWCA raised several concerns surrounding Barbara Rose, her curatorial position, and her possible conflicts of interest, in addition to broader concerns about museum management and deaccessioning activities.

On May 5, Chairman of the Board of Trustees, Isaac Arnold, Jr. on behalf of the Executive Committee of the museum,[16] responded to recent "interest in Museum activities from the local community and various art groups" which he noted had been at an "all-time high." Without mentioning the Caucus or their letter, Arnold briefly addresses "four areas — first, hiring of curatorial expertise; second, acquiring and disposing of works of art to improve the collection; third, potential conflict of interest; and fourth, the Alfred C. Glassell, Jr. School of Art." Arnold maintained that "we have an outstanding Staff and know that their activities are conducted with integrity, skill, and thoughtfulness." He closed with an invitation to the museum's Annual Membership Meeting on May 20, 1981 at 4pm in the Brown Auditorium.

The museum's Meis van der Rohe-designed Brown Auditorium was filled for the annual meeting "by an overflow crowd of several hundred," wrote Ann Holmes for ARTnews.[17] By all accounts it was a passionate exchange. "I mean the whole establishment was there to defend Agee, it was really interesting," Lynn Randolph remembers, and "[George] Bunker stood up and let him have it, about all the deaccessioning." Characterizing her comments as "vituperative and inflammatory," Barbara Rose was reported to have dismissed the Caucus letter as "a group of middle-aged housewives who are envious of her success and achievements and wish they, too, could be museum curators."[18] The annual meeting did nothing to dispel the controversy; discontent continued to brew, and the disquiet of the art community showed no signs of letting up. In response, the museum board of trustees called a special meeting in May. In an attempt to quell the storm, a vote of confidence was taken, resulting in a resolution that "hereby unanimously reaffirms the support of William C. Agee."[19] This had little effect in the community.

The deaccessioning to pay for the Picasso continued and community concerns remained, to use Arnold's words, "at an all-time high." There are many stories in the city's history of Houston elites getting together to quietly resolve problematic situations. Some think that Alice Pratt Brown, widow of builder George R. Brown and the first woman to be elected Chairman of the Board of Trustees at the museum, came to an agreement with Oveta Culp Hobby, widow of the former Texas Governor William P. Hobby and publisher of the *Houston Post*, that resulted in an endowment for Bill Agee to work at the Archives of American Art for two years and a fellowship to graduate studies for Mimi Crossley,

the investigative reporter, but none of that, of course, was made public. "The tensions in town were getting so bad people used to joke that they did it because it was beginning to disrupt dinner parties in River Oaks — I don't know if that is true," Anne recalls, "but it got really bad." Whatever happened behind the scenes, after eight years as the director of the Museum of Fine Arts, Houston, Bill Agee resigned February 15, 1982. He continued as a consultant to the museum for a year, working from home, and eventually left Houston in June.[20]

The whole episode had been wearing on Anne, "The whole campaign against the museum was very painful for us on the inside."[21] Her close friends Lynn Randolph, Suzanne Bloom, Gay Block and others were active in the HWCA. Anne "held her own council for the most part, you could tell she was stressed but she pulled it together," Lynn Randolph recalls, "she really had a hard time when all that was going on, because she had a feeling of loyalty to Agee." Anne managed to stay professionally unscathed but personally it weighed on her. Bill Agee had hired and supported her as a curator and shared her passion for photography. He had been a pivotal person in her career. "Somehow she was always able to manage those things," Suzanne Bloom marvels, "she never took sides." With Bill Agee's departure in February of 1982, the museum controversy dissipated, and the trustees drafted a new, comprehensive deaccessioning policy that no longer allowed for deaccessioning in order to make specific purchases.[22] The Caucus continued its work supporting women artists and invited Anne to join them as a Community Advisor in August. In a memo to the museum's Interim Director David Warren, Anne asked if it would be wise to accept and he replied, "Yes, it would be good for the museum if you can stand it! - DBW."[23]

It is amazing that somehow in the middle of all this, Houston Center for Photography was born. It must have seemed like an oasis in many ways, away from the museum fray, where the focus stayed on what was new and interesting in photography. Anne continued to work steadily throughout the controversy, continuing to promote photography both inside and outside the museum. Following her Grossman exhibition, she brought a retrospective on Frederick Sommer to the museum and curated two smaller shows — one of Baron Adolphe de Meyer's work, and one with photographs by Karl Blossfeldt and Ernst Fuhrmann — all while working on the *Target III* exhibition which would open in September of 1982. Anne also continued to promote photography by giving talks in the community.

**Peter Marzio,
1980s.**
From the
Collection of the
Museum of Fine
Arts, Houston
Archives.

After the dust settled, Anne found herself in the midst of another kind of mishap. In the fall of 1982, the museum was exhibiting *Paper and Light: The Calotype in France and Great Britain, 1839-1870* when the air-conditioning at the museum went out. Elsewhere in the country this might not have been a major problem in October. In fact, in most other places, people would have already turned off their air-conditioning and had turned on their heaters. In Houston, though, October was still hot and humid and with all those irreplaceable images on loan, desperate measures were needed. "The crisis is passed," Anne later wrote to the lenders, "the Houston fire department came to our rescue by running a hose to our roof and supplying the air-conditioning unit with water until the water main could be fixed 17 hours later. The temperatures and humidity did rise beyond what any of us would have wanted before we were rescued by the firemen. In the large room, the temperatures reached 78° and 57% humidity; in the Talbot/Hill and Adamson room it reached 70° and 63% humidity. It began to rise at 4 pm and was back to normal by 9 pm.[24] After being rescued, museum staff contributed to the Fire Department Fund in appreciation. This was the same month that the new director came to the museum.

### New Leadership and Changes for Photography

Peter Marzio had been the director of the Corcoran Gallery of Art and worked at the Smithsonian before he was hired by the Houston museum as their seventh director. Arriving in Houston in October of 1982, Anne wrote to a friend at the time:

The Photography Accessions Committee touring soon to be opened new
photography print room in MFAH Beck Building, 2000. Front row, left to right, Leslie
Blanton, Anne Tucker, Pampa Risso-Patron, Max Herzstein. Back row, left to right:
Anne Bushman, Joe Mundy, Joan Alexander, Joan Morgenstern,
Isabell Herzstein, Clint Willour, Temple Webber.
From the Collection of the Museum of Fine Arts, Houston Archives.

> Last Friday was Peter Marzio's first day and it's too early to have an impression yet, but it's clear that he's going to be very different. Decisions are made quickly and with authority. He's very intent on the Museum operating in the black and on our having a first-class reputation. His only comments so far about the curators is that we are not scholarly enough.[25]

The shift from working with Bill Agee to Peter Marzio was not easy for Anne. "Peter and I kind of clashed when he first came," Anne recalls, "I didn't like all the changes he was making." On the positive side while Peter was at the Corcoran, Jane Livingston had directed a very strong photography program so Peter had come from "an institution where there was a woman curator doing important photography shows," which helped Anne feel encouraged that he could be supportive of her efforts. Though the beginnings were less than smooth, it was a working relationship that later developed into one of great respect, mutual trust, and a common goal to strengthen the Houston museum's standing in the art world.

Anne Tucker, Annie Leibovitz and Joan Alexander at the Museum of Fine Arts, Houston, 1993.
Courtesy of Anne Tucker.

## *A Sub-Committee for Photography*

At the museum, Peter made several budget-focused, organizational changes that impacted photography. Initially, he limited the photography exhibitions to three per year. "Our new director has cut back on the number of touring exhibitions and exhibitions of contemporary work," Anne wrote to a New York gallerist Robert Freidus, "in preference for exhibitions of works in our collection."[26] Additionally, he had each division create their own sub-committee from the museum board members. This allowed curators to work more closely with trustees and board members. Anne asked Joan Alexander to be the first chair of the photography sub-committee and to assist her in organizing the membership. The initial sub-committee in 1983 included Isabell Herzstein, S.I. Morris, Kathy Reiser, Wallace Wilson, Mike McLanahan, and Richard "Rusty" W. Wortham — all wealthy, well-connected Houstonians. The group met regularly beginning in 1983 and served as an acquisition committee, voting on which photographs to acquire for the museum collection, assisting with funding various purchases, and generally supporting the efforts of the photography department.

Though all the sub-committee members became strong supporters of Anne and photography, she remembers how important Isabell Herzstein became as a mentor. Like her relationship with Joan Alexander from the beginning with the initial Target donation, Anne credits these two women as essential to her success. "Isabell and Joan Alexander were critical. Joan was critical from day one. I wouldn't have a job without Joan. But Isabell and Joan gave me just great

advice about how to thank people and how to maneuver certain situations and ... just a kind of social mother wit," Anne explains, "I had smart parents but I didn't have sophisticated parents and so I was not used to moving in a high-level social world, and Isabell and Joan were ... just wise women in the old-fashioned sense of the world and passionately in love with the museum."

Since Anne's arrival in Houston, she actively worked to engage the community around photography. At the museum, she regularly wrote long informative letters to trustees telling them about photography exhibitions and collections, often enclosing an article or a catalog. Sometimes she would give them private tours of the exhibitions. Early on, Joan Alexander wrote to Anne, "One of the great pleasures of my association with the museum has been getting to know you — the more I know, the better I like you. I look forward to a continuing and growing friendship."[27] Audrey Jones Beck, for whom the second museum building is named, wrote to thank Anne for the "long, newsy letter of October 25th, a joy to receive." She closes by writing, "As far as compliments go, I am not very free with them. In your case, I am afraid I have been very lax."[28] At other times, Anne would travel with trustees interested in collecting to visit galleries in New York. She remembers the first time she was invited to go in a private plane. "Louisa [Sarofim] invited me and we went in her private plane and then when we landed in New Jersey. I said out loud 'How are we getting to New York?' ... and the ramp comes down from the plane and there is the limousine right here, and we went to the galleries in a limousine ... it was a great way to go to galleries."

### *Photo Forum*

In addition to the sub-committees, the other change that Peter initiated was to have each museum department cultivate their own support group. Bill Agee had started the Museum Collectors group in 1979 as a general support group for museum acquisitions. Members paid dues and were treated to special, private events. Once a year they would meet to vote on artworks to acquire with the membership dues.[29] To start a support group for photography, Anne approached Joan Morgenstern to be the first President of the newly-formed group, Photo Forum, in 1988 to coincide with the 12th anniversary of the department. Joan had become a strong supporter of photography both at HCP and the museum and agreed to the challenge. The initial dues were $150 per year and members were promised four meetings each year plus bonus events.

The dues would be used to purchase photographs for the collection.[30] Photo Forum appealed to those who had a little extra money, wanted to know more about photography and might be interested in collecting. Three early members were Joan Morgenstern, who would later become a museum trustee as well as gift over 15,000 images to the museum, Mike Marvins, who organized the donation of the Kaye and Sonia Marvins Portrait Collection and would later donate his personal collection to the museum as well, and Clint Willour, who as a gallerist and curator in Houston never made more than $40,000 per year, yet gifted or contributed to the purchase of 1,481 artworks valued now at well over $1 million for the museum.[31]

Though the museum had an acquisitions endowment that the Cullen Foundation had begun in 1970, Anne recalls, "I was on my own to raise purchase money" as the limited endowment funds were reserved for major acquisitions. She often jokes that the museum let her spend whatever funds she could raise to add to the collection. "Thankfully," Anne adds, "photographs were inexpensive in the 70s and 80s." At an early accessions meeting, Anne recalls, "the trustees voted to acquire a 17th-century Japanese screen, the 13th-century French Gothic Head of an Apostle, a 19th-century sculpture by Medardo Rosso, and Richard Diebenkorn's painting Ocean Park. These very expensive works totaled much more than our new endowments could cover. Then I stood up and requested $200 to purchase Neil Selkirk's portrait of Catfish Hunter, the Chairman of the Board leaned forward and pealed out two $100 bills" no doubt relieved at the affordability.[32] In general, though, fundraising was a large part of Anne's job. "Most of my early supporters came as cold calls," Anne explains there "were phone calls and they said they were interested in what I was doing, and they would like to support it." Allan Chasanoff was a cold call and he ended up donating nearly 1,000 photographs to the collection. Other times, it was much more difficult to raise money needed, especially in the depressed 1980s economy. In trying to raise $100,000 for work by László Moholy-Nagy, Anne thought she had come to a dead end, "I went to see somebody in Dallas and he turned me down and I got in my car and just cried ... because I didn't think I was going to be able to do it."[33] But she persevered, and "just kept going" eventually piecing together the needed funds.

The following year, 1983, turned out to be an exciting one for Anne full of much more pleasant events. After many transatlantic letters written on air-

mail onion skin to various museums, consulates, and collectors to make arrangements, the museum sent Anne to Europe. From March 16 through April 11, Anne traveled to London, Amsterdam, Paris, Germany, and Czechoslovakia, meeting photography colleagues and visiting important European collections. In a letter to her friend, photographer Wanda Hammerbeck, Anne had written "I'm on my way to Europe 'til mid-April … I'm both apprehensive and delighted about the trip. Traveling alone in foreign lands does provoke anxiety. It is, nonetheless, exciting to be seeing so many pictures and meeting my European colleagues."[34]

Traveling to Europe by herself for the first time, Anne remembers being a bit nervous, "I was certainly insecure — this little girl from Baton Rouge going to these big cities." While in Amsterdam, Anne learned of a man with Bauhaus photographs for sale. Needing funds, he was planning to sell one third of his collection, keep one third himself, and had promised one third to the Stedelijk Museum.

> I called him and … he said, 'Look I can't see you until about 9 o'clock at night because I have a job,' and so the cab drops me off and he has this house on a canal and I am thinking 'Ahh, am I crazy? I don't know this guy and is he going to kill me and throw me in the canal?' and I go in and he has laid out all these pictures on the floor and he said I had to choose that night. I had to commit for certain in two weeks.

Even in the 1980s, museum acquisitions were not this spontaneous or informal. Anne quickly looked through the hundreds of photographs from the Bauhaus spread out all over the floor. She remembers "there had been a book that had just come out which I had flipped through but not studied" so with very little familiarity with the Bauhaus photographers, "I did it blind," selecting one third of the images on instinct for the Houston Museum. Then she had two weeks to get the purchase approved. Wisely, Anne called museum trustee S.I. Morris, who had been supportive of photography and her efforts. "God love him," Anne recalls, "he said those magical words, 'I'll either give or get.'" With that promise, Anne called her new director, Peter, asking "Can I commit? S.I. said he'll either give or get." After a series of transatlantic phone calls at what were odd hours for one party or the other, Peter gave his approval and S.I. wired the funds. This unusual transaction netted the museum 49 images for $10,000 — two of which

are now individually worth well beyond the total sum paid. It also was the beginning of expanding the collection, originally a survey of American photography, it would now also include European work.

### *A life preserver*

In addition to traveling and weathering changes at the museum, Anne mounted an average of six photography shows each year, traveling to give lectures on American photography throughout the country, assisting and nurturing HCP activities, Anne still hoped to finish her book on the Photo League. She had an agent and a publication contract, just not much time to devote to the thinking and writing that such an extensive project requires. Having conducted most of the interviews and read through seemingly "miles of microfiche" documents before moving to Houston, Anne had completed most of the data collection. Even with everything else she was involved in, Anne remained undeterred, continuing to explore related documents when she could and writing proposals to fund the book.

Wonderful news reached Anne while she was in Cologne, Germany. Her tenacity and belief in her Photo League project as well as her continued proposal writing finally paid off and paid off in a big, prestigious way. She had been visiting *Galerie Rudolf Kicken* when she received the news later that evening that she was to be awarded a Guggenheim fellowship. "I didn't know Rudy well enough to call him — he scolded me later — so I invited strangers at the table that evening just to be my guests for dinner," Anne recalls, "they had no idea what I was talking about, but they accepted … I wanted to celebrate. I didn't want to celebrate alone." Her Guggenheim fellowship would begin in the summer of 1983 and afford her a year to work on the Photo League book. With this award, Anne became the first curator at the Houston museum to receive such a significant honor. The Guggenheim also meant that she was the first curator to request a sabbatical year away. Additionally, the grant funds allowed her to buy a computer — the first personal computer at the museum. Writing at the time, Anne explained her decision to forgo the purchase of a painting for the computer, "I am more and more in love with the Max Ernst *Microbe*, but have decided, for the time being at least, to be practical. I need a word processor. Won't say I need it more than the painting because the needs that are satisfied by a painting and a word processor are too different to compare. Someday maybe I can have both."[35] Having just completed a detailed catalog, Anne had heard

that if you deleted a footnote on the computer, it would automatically renumber all the remaining footnotes, eliminating the laborious need to white out previous numbers and type in the new numbers with each edit. Anne bought what was considered a portable computer at the time. Called a 'compact' computer, it weighed about seventy-five pounds and had sixty megabytes of memory — and, most importantly, it could run word processing software.

The *Houston Chronicle* ran an article on Anne's Guggenheim award under a section titled, "Amusements." Of the 3500 applicants for the 59th annual competition, Anne was named as one of the 292 awardees.[36] After applying "close to ten times" and working on the project for ten years,[37] Anne's proposal had been successful[38] and would grant her a year to focus on her book project, *The History of the Photo League, 1936-1951*. Writing to photographer Robert Adams at the time, Anne mentions, "It's wonderful to have the Guggenheim — time, money, and a bit of certification. I feel as though someone has thrown me a life preserver."[39] Though Anne's sabbatical year turned out to be much shorter than she'd hoped, and she published a number of articles, the book about the Photo League did not get completed. Anne did, however, mount a number of notable exhibitions while on sabbatical, including solo shows for Paul Strand, Eliot Porter, Eugene Atget, and Edward Steichen.[40] Additionally, Anne traveled to Philadelphia during the year to begin work on her next major exhibition, *Unknown Territory: Photographs by Ray K. Metzker, 1957-83* (November 17, 1984 to January 29, 1985).

### *"Going around the periphery"*

After her sabbatical, during which she seemingly worked throughout, Anne returned to her hectic museum schedule. Anne had been fortunate enough to have people around her who were supportive and believed in what she was doing. Peter Marzio became one of her strongest supporters. Gwen Goffe remembers, "Peter hated to say no to any good idea." Anne would bring him ideas like doing a show about Czech or Japanese photography, and she remembers Peter would say "Well let's do it here. Let's do it." Anne remembers, "once Peter gave you the green light it was, it just was so permission giving." As with her earlier exhibition of Sid Grossman's work, Anne developed her successful strategy of "going around the periphery, always going around the periphery in terms of the shows that I did." With Peter's support, Anne was able to go "places where nobody else was going," she clarifies, "I was not trying to compete." A large part

**Anne Tucker and Robert Frank at the Museum of Fine Arts, Houston, 1983.** Courtesy of Anne Tucker.

of being able to mount an exhibition is "getting the material, getting the loans, having access to the research," Anne explains, "we were doing shows where people were thrilled to work with us." Indeed, Anne's most important shows during the 1980s were those that went into unexplored areas. Returning from her sabbatical year sequestered away in a "cabin-in-the-ranchland" near Weimar, Texas, she rented from friends of Wendy and Fred,[41] Anne's next major exhibition was a full retrospective and catalog of Ray Metzker's work.

Anne had known Ray when she lived in Philadelphia, and they had kept in touch. "I just thought he was this incredibly prolific and most articulate verbally and visually person who just hadn't gotten the recognition he deserved. And it is just, for me it was an easy choice, no question about the sheer power of the imagery." Going into uncharted territory adds to the curatorial challenge. "Because I kept choosing people who hadn't been written about before," Anne recalls the difficulties in "assimilating a lot of information and then trying to make it coherent for your audiences." Very little had been written about Metzker and Anne found "Ray is not an easy person to write about. It's too easy to dismiss the work as graphic and not find the metaphors. ... just getting Ray right was hard."

In 1986, Anne mounted the Robert Frank exhibition[42] that was the centerpiece of the first FotoFest. Even though much had been written about Frank, very little had been written about him as a filmmaker, so Anne was still charting new territory. The Robert Frank exhibition came about rather serendipitously but in a very Houston way. Anne had been on a New York state panel with a

woman that co-owned the Bleeker Street residence with Robert Frank. "The three of them had bought three floors and she called me to say that Robert was trying to sell a set of *The Americans*," Anne recalls, "and Peter [Marzio] had just come and understood the importance of *The Americans*." Anne and Peter pieced the funding together with an NEA matching grant, funds from Target and from museum supporters, Jerry E., and Nanette Finger to purchase the entire set of images. Then, when Robert Frank came to Houston to deliver the prints, "I asked him if I could do a show," Anne says, "and he was nervous about me so he asked me to do the show with Philip Brookman, who had done a show of his work in California, ... and I said, 'Sure that would be great.'" The Houston museum got to do the exhibition "because we came up with the money he needed at the time for personal reasons," Anne explains, "so it was a trade, if you will, that he was giving us the show to do, plenty of other people would have liked to have done it because we stepped forward and bought the set of pictures." *Robert Frank: New York to Nova Scotia*, curated by Anne Tucker and Philip Brookman, surveyed Frank's photographs from 1947 to 1985 and included some of his recent videos and autobiographical photographs. The opening reception, symposium, and the accompanying film series was the highpoint of the kickoff for the first Houston FotoFest in 1986.

Anne's next major exhibitions were *American Prospects: The Photographs of Joel Sternfeld* (April 5-June 7) and *American Classroom: The Photographs of Catherine Wagner* (September 10-November 27, 1988). Anne finished the decade with the groundbreaking *Czech Modernism: 1900-1945* (October 8, 1989-January 7, 1990). "With Czech [photography] nothing had been written in English," Anne remembers that much to the Czech's displeasure, "we edited the floweriness of natural Czech writing — it is very florid, and we just didn't think American audiences would read it." Between the Metzker retrospective and Czech Modernism show, in addition to the major curatorial exhibitions mentioned above, Anne also organized six shows drawn from the museum's collections, curated three smaller ones, and coordinated five borrowed from other institutions. Photography exhibitions were included regularly in the museum's offerings. The photography department was garnering a national reputation, and Anne was at its core.

## A Game City

By the close of the 1980s, the Houston economy was depressed but the community's excitement for photography was high. Two successful FotoFest biennials

had definitely put the city on the international radar and Houstonians relished the attention from abroad. As the 1990s dawned, Houston had become the fourth largest city in the nation.[43] Though the financial downturn of the 1980s made a significant dent in Houston's economy, city leaders continued to develop Houston optimistically — opening a brand new $104.9 convention center in 1987 in the middle of the recession, and in 1990 opening a new 12-gate Mickey Leland International Terminal at Houston's Intercontinental Airport, named after the recently deceased Houston congressman. Additionally, Houston was gaining national attention politically as its adopted son, George H.W. Bush, had been elected the 41st President of the country in 1989. The following year, Bush hosted the leaders of the wealthiest industrialized nations in Houston.

The city spent "something approaching $20 million on civic beautification, in anticipation of the 1990 G7 Summit.[44] After meeting, the summit leaders declared the toothless outcome of their meetings, "We are determined to take action to increase forests while protecting existing ones."[45] The optimism of the city leaders paid off, and by February of 1990, Houston had returned to the pre-boom levels of economic activity after a "rapid 21.1 percent climb from the bottom." Analysts reported that "the entire cycle of bust and recovery took seven years and 11 months."[46]

However, when the economic dust cleared, not everyone had survived. Casualties included Sakowitz, Houston's premiere luxury department store, which declared bankruptcy in 1985 before closing its doors in 1991. One of the largest family-owned department store chains, Sakowitz was started by Ukrainian immigrants Tobias and Simon Sakowitz. They opened a Houston store in 1911, making the city their headquarters.[47] Sakowitz had weathered the Great Depression of the 1930s but did not make it through the downturn of the 1980s. Another Houston icon died a slower death. The city's morning newspaper, the *Houston Post*, put out its last paper in April of 1995 when its assets were quietly purchased by its rival, the *Houston Chronicle*. The *Houston Post* had been started in 1880 by Gail Borden Johnson, grandson of the inventor of condensed milk, though it folded four years later due to financial troubles. Soon resurrected with a merger in 1885, the newspaper boldly declared, "In a hundred years Houston will probably be a city." And indeed the prediction was accurate, as a hundred years later, with the acquisition of the *Post's* subscribers, the *Houston Chronicle* became the ninth-largest daily and Sunday newspaper in the U.S.[48] Elsewhere, the city's economy appeared to be making a "slow but steady revival after going bust" as various sections slowly began

hiring again.[49] The ratification of the North American Free Trade Agreement (NAFTA) in 1994 contributed to the growth of the Port of Houston and boosted the city's trade with Mexico and Canada.[50]

The downturn had been difficult all round, but art organizations had a longer climb to recovery. Even Dominique de Menil, whose fortune and generosity seemed to have known no bounds, began to have serious financial concerns. As early as 1989, the Menil Foundation Board expressed apprehension that expenditures were no longer in line with revenues. In addition to her Menil Collection museum, which opened in 1987, Dominique had committed to restoring the 13th-century Lysi frescoes and building the Byzantine-style Chapel to house them, organizing the Father Couturier archive, and the extensive *The Image of the Black in Western Art,* among other costly projects. Never having set clear budgets for staff, she was beginning to feel as though her fortune was draining away. Dominique discovered that in the first seven years of her museum, she had signed over $15.5 million of her estate for its operating expenses. Taking stringent measures in 1994, she brought in Susan J. Barnes to oversee all aspects of the de Menil endeavors. Strict budgets were imposed, and some staff were let go, but a $4 million dollar-debt remained to be solved. Dominique continued to develop the Menil Collection; in addition to the main museum building that opened in 1987 and the Rothko Chapel previously finished in 1971, the Cy Twombly Gallery was completed in 1995, followed by the Byzantine Fresco Chapel in 1997, and her final project, the Dan Flavin permanent installation at Richmond Hall was completed in 1998, the year after her death. At the time of her death in 1997, her non art assets were said to total $79 million, quite modest compared to others in Houston.[51]

At the Museum of Fine Arts, Houston, the new director Peter Marzio was making his mark, and also dealing with budget deficits. Longtime colleague Gwen Goffe recalls, "Peter would say he spent the first year in Houston doing everything wrong — that's how he would describe it." Coming from the Corcoran in Washington, DC, Peter had initially assumed that the local government leaders would have more of a role in the cultural organization, so he met with "all the wrong people" and began making budget cuts to address the deficit he inherited. Additionally, Peter cut travel funds for the curators "which was the wrong thing to do," Gwen adds. Not surprisingly, Anne Tucker and Peter got off to a bit of a rocky start. "I had to figure out the relationship with him," Anne recalls, "I mean he was finding his way."

During the recession, the museum took multiple hits — less income on their endowments, donors with less discretionary funds, and lower state grants available resulting from the lower tax revenue. Wisely, Peter had enticed his former colleague from the Corcoran Museum, Gwen Goffe, to come to Houston in 1988 to take over the financial and administrative roles at the museum, which included looking after the endowment. When Gwen arrived, "The endowment really wasn't all that big," she remembers, "it was $84 million dollars." In his quest for solvency, Peter was able to negotiate a challenge grant with the local Brown Foundation — if the museum met its targets with operation costs and membership enrollment, then the foundation would donate a specified amount to the operating endowment and the accessions endowment each year. With the market down, Gwen recalls, "it was the perfect time to be putting money in [the endowment]." The museum continued to meet its targets and the large annual gifts to the museum endowments helped them grow significantly. When the Brown Foundation agreement ended, local philanthropist Caroline Wiess Law continued the challenge grant for ten more years.[52] With Peter's creativity in fundraising and Gwen's astute management, the museum was back in strong financial shape sooner than many arts organizations. This was especially true for newer groups like Houston Center for Photography and FotoFest. However, by the end of the decade, both nonprofit organizations would have stabilized their position as important players in the photography world. During the lean years of the 1990s, they refined their programing and continued to build their audience and reputations both locally and internationally — continuing toward their goal of making Houston *the* place to be for photography.

For Anne, the 1980s had been a momentous decade. Her marriage to Cal had ended, she'd won a prestigious Guggenheim award, and taken a year's sabbatical from the museum in addition to being appointed first Gus and Lyndall Wortham Curator[53] when the museum received an $840,000 grant from Wortham Foundation, Inc. Anne had curated a number of groundbreaking exhibitions that traveled widely, receiving substantial media attention. She had been to Europe as a curator and begun building her international network. In her personal life she had met and married Joe Wheeler, a research engineer she had met at a dinner party at photographer Gay Block's home. Joe was an arctic ice specialist who worked for Exxon doing probability studies. They married in 1985 and honeymooned in Greenland, where Joe was presenting

a paper at a scientific conference. Joe had two children, Coy and Leigh, who lived with them at various times. It had been an eventful time, with ups and downs, but by the end of the 1980s, Anne was successful and happy personally and professionally. And the little community of photography supporters she had nurtured had given birth to both a center and a festival.

**Adding Artists to the Pantheon**

The 1990s began with national acclaim for Anne's exhibition, *Czech Modernism: 1990-1945* (October 8, 1989 to January 7, 1990). *ARTnews* called it "an epic survey" that demands "not only our admiration but a transformation of our vision of modernist art." The exhibition was the culmination of five years of work. Anne assembled a curatorial team that included museum curator Alison de Lima Greene, independent curator Jaroslav Anděl, Willis Hartshorn at the International Center for Photography, and Ralph McKay, director of the museum's film program. "Together they spent five years conducting groundbreaking research, resulting in a survey of over 350 works of art, documents, and films." Director Peter Marzio said of the show, "To write new chapters in the history of creativity and to add artists to the pantheon of artistic leaders has been the mission of the Museum of Fine Arts, Houston, since it opened in 1924. *Czech Modernism: 1900-1945* is a major effort in that tradition." *Art Daily* called the exhibition "a defining introduction" to an aspect of modernism that had been erased by the Cold War.[54] The Czech Modernism exhibition traveled extensively to wide acclaim.

This was followed closely with Anne being awarded a National Endowment for the Arts Fellowship for Museum Professionals (1990) to support her projects, and two important gifts to the museum's photography collection. The first was a surprise gift of over 950 photographs from New York collector Allan Chasanoff. One day without warning, Anne received a call from Chasanoff offering the museum half of his collection — the other half was going to Yale. The images he offered included some major works by Irving Penn and some of the tougher Robert Mapplethorpe pictures — "works I'm not sure I could have ever bought," Anne recalls thinking of the sensibilities of her donors.[55] Indeed, many notable photographers were represented, and the museum's photography holdings increased substantially. This led Anne to curate the *Tradition and the Unpredictable: the Allan Chasanoff Photographic Collection* exhibition (January 16-March 27, 1994).

Anne Tucker, Kaye Marvins, Maggie Olvey, Sonia Marvins, and Buzz Marvins at the opening of *The Sonia and Kaye Marvins Portrait Collection,* 1985. Photo: © Michael Marvins, 1985. From the collection of Michael Marvins.

The second gift was of 150 photographs from *Songs of My People.* Under Peter Marzio's direction, the museum was also trying to better reflect the diversity of the city. By the 1990s, 47.3% of Houston's population of 1,630,553 was African American (28.1%), Asian (4.1%) or other races (15.1). Additionally, 27.6% identified themselves as Hispanic on the 1990 Census, and could be of any race.[56] In 1991, with this in mind, Anne organized two exhibitions, *Martin Luther King and the Civil Rights Movement* and *From Harlem to Hollywood: American Race Movies 1912-1948* that included works from the museum collection. Then, in 1991, the museum was awarded a $1.5 million grant from the Lila Wallace-Reader's Digest Fund to "encourage culturally diverse communities to become more actively involved in the museum." This five-year grant provided funds for outreach to three nearby neighborhoods where residents were primarily Hispanic and African American. Additionally, the museum formed the African American Art Advisory Association (Five-A) support group, which focused on expanding awareness of art by African Americans and their representation in the museum's permanent collection. For photography, Five-A was instrumental in the major gift from *Songs of My People,* "a landmark collection of contemporary photographs documenting the national experiences of African Americans and their contributions to American culture."[57] Included in the gift was also an extensive archive containing contact prints, work photographs, videotapes, press clippings, and correspondence. Later, the exhibition *Songs of My People,* organized by the Corcoran Gallery, was shown in the Houston museum during fall 1994.

Additionally, the *Sonia and Kaye Marvins Portrait Collection* had been completed. Previously in 1984, to celebrate the successful operation of their Houston photography studio for nearly forty years, the Marvins sought to build a

portrait collection for the museum. Though a number of donors had provided funds for acquisition of work, or donated photographs to the museum, this was the first time donors built a collection specifically to be gifted to the Houston museum. The Marvins relied on their son, Mike, a photographer and collector himself, and consulted with Anne as they selected images to acquire. This gift added thirty-two portraits to the museum collection and was exhibited in 1995.

Throughout the decade, the Photography Department organized from three (1993) to seven (1998) exhibitions per year, with Anne curating a number of them. Four shows featured Houston photographers. George Krause had a solo show, *George Krause: Universal Issues* (1992), and after it was shown at the Museum of Modern Art in New York, *Rescuers of the Holocaust: Portraits by Gay Block* was exhibited in Houston (1992). Later, both in 1998, Alain Gerard Clement, who had moved to Houston in 1978, had a joint exhibition with New Orleans artist George Dureau, *Classical Sensibilities: Images of Alain Gerard Clement and George Dureau,* and two artists who had been active with the Women's Caucus for Art in Houston had their work shown in *In Situ: Responses from Charles Mary Kubricht and Ann Stautberg* (1998).

Additionally during this decade, the Photography Department partnered with a local high school, Yates Magnet School, on an exhibition called *Eye on Third Ward*. Initiated by Ray Carrington III, the former chief photographer for the Port of Houston before starting the photography program in 1993 at Yates. A three-year program, Carrington, who discovered photography while studying art at Texas Southern University with noted painter John Biggers, took his students out of the classroom and into their neighborhood to photograph. Asking them to take pictures that express the distinctive identity of the Third Ward, a historically African American community, they captured the quotidian and the extraordinary. At the end of each school year, the best images are chosen for the exhibition at the Museum of Fine Arts, Houston. *Eye on Third Ward* continued annually from 1995 to 2013, when it was expanded to other high schools in the city and renamed *Eye on Houston*.[58] In a talk she gave at Kincaid, a private school in Houston, Anne spoke of Ray as a model of someone who had dedicated their lives to helping others. "I've watched Ray with those kids. I know that when they lack money for film or the school lacks money for equipment, that Ray finds the funds, often from his own pocket," Anne told the students. "He has defined education as something of value, conceived how he can contribute, and committed himself to those values with resources

of time, passion, knowledge, and funds." For Anne, "the arts and culture are essential to a healthy community," and working at the museum afforded her the ability to be "engaged in scholarly pursuits and in my community."[59] *Eye on Third Ward* was a very concrete demonstration of how the museum could serve the community.

### Hard work and recognition

As with the highly praised Czech Modernism show, Anne continued her approach to curating by discovering or rediscovering work "around the periphery" to create innovative exhibitions. Over the decade, Anne curated 16 shows, eight of which had catalogs. One of her most intriguingly creative exhibitions was *Years Ending in Nine* (March 1 to April 26, 1998), in which images made in years ending in "9" were featured. Many of her exhibitions were beginning to travel widely, bringing broader awareness to her curatorial talents and the Houston museum. These included *Paul Strand* (Nov 10, 1991 to Jan 12, 1992), *Contemporary Mexican Photography* (May 3, 1992), *Josef Sudek Photographs* (Dec 26, 1993 to Mar 27, 1994), *Crimes and Splendors: The Desert Cantos of Richard Misrach* (Jun 6 to Aug 25, 1996) for which she won a Golden Light Award[60] for the catalog, and *Brassaï: The Eye of Paris* (Dec 6, 1998 to Feb 28, 1999). Anne's work also began being recognized with awards. In addition to the NEA fellowship in 1990, Anne was given the Alumnae Achievement Award by her alma mater Randolph-Macon Woman's College (1993), a Getty Center Research Support Grant (1995), the Maine Photographic Workshop's Golden Light Award for the Misrach catalog (1996), the Photo-Eye Best Contemporary Monograph Award for her essay in *Toshio Shibata: Landscape* (1996), and was named "America's Best Curator" by *TIME* magazine in their 2001 "America's Best" issue. Before she retires, Anne will go on to receive nearly twenty more awards for exhibitions, catalogs, and research projects.[61]

As her reputation grew, Anne was invited to give lectures all over the world. From 1990 to 1999, she gave 48 talks and lectures in addition to being asked to serve on fifteen juries and panels. Anne's career was flourishing, and the photography community in Houston, through FotoFest and the museum exhibitions, had definitely found its way to international recognition. Increased awareness of what was happening in Houston led to more international travel for Anne. With all her travels, she managed to be in Japan during the Sarin gas attack in March 1995. The Tokyo Metropolitan Museum had invited Anne to give a lecture and asked that she speak specifically on FotoFest, the muse-

um's photography department, and the Houston cultural scene. "They are as fascinated as we are all proud of the phenomenal growth of arts institutions in Houston in the last few decades," Anne wrote to Wendy and Fred.[62] Later the same year, Anne was in Paris in July when the Algerian Armed Islamic Group (GIA) was setting bombs off in metro stations. Known for her thorough and detailed research, Anne traveled widely as she put together various exhibitions and catalogs, in addition to her lectures and participation in award panels.

The 1990s were a pivotal decade for Anne. Her career successes increased, and her dedication and hard work seemed to be paying off. Her exhibitions and writings were being recognized widely nationally and internationally. Not surprisingly, Anne began receiving job offers from prestigious museums. Yet, in March of 1995, Anne's personal life took priority. Family has always been important to Anne, and when her mother Geraldine was diagnosed with Alzheimer's disease, Anne became her caregiver, going to her mother's house twice a day for the next seven years.[63] Five months later on August 18, 1995, Anne's beloved husband Joe Wheeler died suddenly leaving Anne a widow just two months before her fiftieth birthday. "Needless to say, we did not have a party that year," Anne recounts. Once her mother needed her, Anne did not entertain offers to leave Houston. She and museum director Peter Marzio used to joke with each other, "I won't leave if you won't." And indeed, to the great good fortune of Houston, both stayed at the museum for the remainder of their careers.

Looking back, Anne recounts her friendships with photographers that she worked with on mid-career or full retrospective exhibitions as some of the high points of this time. "I still wonder how I merited precious friendships with Robert Frank and Mr. Penn," Anne muses, "who set high standards I was honored to assimilate." Both men shunned publicity, Anne recalls, "out of a modesty that blended awkwardly with … fierce pride" in the work.[64] When Anne met Irving Penn, "we had lost spouses at the same time, and it was a bonding for us," she says. Later, while sitting for her portrait with Penn, who did not talk about his process, Anne was delighted to have the opportunity to watch him work. Penn had asked her to wear a hat and a scarf to the shoot but "eventually, the hat went, the scarf went, the jewelry went; … He kept simplifying and simplifying. It was two hours," she remembers. In the final image, Anne is looking off to the side, holding the collar of her blouse against her neck with her thumbs, and her hands clasped under her chin. Penn focused on Anne's strength and intensity — there is no ornament, nothing to distract from the central figure.[65]

**Lifelong friends, Anne Tucker and Clint Willour were honored at 2017 HCP Auction.** Photo: Laura Corley Burlton. Courtesey of Houston Center for Photography.

### Supporters that had her back

Anne also credits the generosity and civic support of the community that helped her build the museum collection to over 10,000 photographs by 1999. "Houston is a town that will get behind a project. It's a city that is not afraid of something new and people have really responded to photography," Anne told an interviewer at the time.[66] *Time* magazine called Anne a "donor magnet"[67] because of her extraordinary success in cultivating support for museum acquisitions. "Since I must raise the funds for every photograph that the museum purchases," Anne explains, "donors play an important role in what the museum acquires." She adds, "I enjoy the collaboration." Engaging donors in the choices of work to purchase is "an important part of people feeling vested in the museum," Anne wrote in a 1999 essay about how she built the collection.[68] Many of her supporters became close friends. Both Clint Willour and Joan Morgenstern became collaborators and conspirators with Anne, each becoming significant donors to the museum. Clint's donations including art he gifted or funded the purchase of 1,481 artworks. As of June 2022, Joan's donations amount to 1,641 works.[69] Early in their friendship, Clint and Joan would sit with Anne "shopping" at some of the first benefit auctions in Houston. "For years, they made a practice of buying works they would donate to the museum in honor of the auction chairs."[70]

Clint and Anne's friendship began over a photograph. Clint was trying to decide whether to buy a photograph at the Contemporary Arts Museum's auction to raise funds after their 1975 flood. He asked Anne's advice. She asked Clint, "Do you like it? Can you afford it?" He answered affirmatively, so Anne advised him to buy it and thus began their forty plus-year friendship. They shared a passion for buying and supporting younger artists. "One of the things we're both proud of is ... being the first museum to purchase the work of [many]

artists: Lauren Greenfield, John Baldessari, Annie Leibovitz. I mean the list is long," Anne explains. Clint once described their relationship as Siamese twins joined at the eyeball. "Since that first photograph, we have collaborated on my — or our — purchase of hundreds more photographs for the museum," Clint said, "we have co-curated and co-juried a number of exhibitions in Texas and elsewhere." As a curator, Anne credits Clint's "eye" as helping the structure of the museum collection with his numerous gifts. In addition to the artworks Clint donated, he also gave over 2,500 books to the museum's Hirsch Library Rare Book Collection. "We have truly traveled the world together" Clint added, thinking of their many trips to review work, do research or just look at art. "It's a kind of real moral bond. We share a commitment to the importance of community," Anne says, "we share a love of art, not just photography."[71]

Supporters are like "a solid wall at your back if you need it," Anne says, "It's just a lot easier to do what you do when you have people who are backing you up." Over the years, there have been many, many individuals who have provided funds or resources to the photography department. Yet Clint and Joan were two of the most active for the longest time. Joan met Anne when she came to speak to a history of photography class Joan was taking. Impressed, Joan joined a group of collectors Anne was taking to the auctions in New York, "It was marvelous," Joan recalls, "she made sure that we had private tours of the works being sold at the different auction houses plus invitations to private parties." Photography, with Anne's guidance, opened up a whole new world for Joan. "Sitting next to Anne when she reviewed photographers' work at FotoFest was like taking a graduate course in critiquing," Joan explains, "it was a wonder to watch Anne question a photographer and get them to realize how they could take their work to the next level." Joan began to play an important role, "Joan Morgenstern and I are a duo," Anne describes their joint reviewing process. "Sitting next to Joan, Joan would look at me and she ... would nod" when they came to a print Joan wanted to buy for the museum. Playfully, Anne would turn to the photographer, "Say thanks, Ms. Morgenstern ... she just purchased your photograph for the museum's collection." Joan credits Anne's "patience and generosity of spirit" as she would stay and continue to review anyone who wanted to see her after the formal reviews had finished for the day. This "is why we have one of the best collections of young and emerging contemporary photographers," Joan says proudly. Many photographers who were lucky enough to come to their table, went away smiling with an envelope of money and boosted confidence in their work, as the museum collection grew and grew.[72]

# Chapter 10

# HCP: Debating Artistic Identity

Houston Center for Photography drew Houstonians interested in photography together. A passionate group, they had an active membership, an exhibition and workshop schedule, plus a magazine. The next step was to create their own space. The community needed a nexus, a location to anchor their efforts to become an active and engaged scene. With the successful auction and the hiring of Administrative Director, Lynn McLanahan, HCP members felt ready to take on the expense of a building.

### *"We needed a space..."*

HCP was evolving quickly and began thinking about an exhibition space of their own. Some remember there might have been a fire at the church which resulted in smoke damage to some images that provided an impetus to begin looking for a new venue. Others, like Muffy McLanahan, thought it "ridiculous we couldn't have wine at our openings, so we needed a space." The search was on for a suitable space when one day David Crossley was walking from his studio across the street to the Shopkwik for a coffee as he did most every day. This day, however, he learned that the business was leaving the space. It didn't take David long to think this might be a good place for HCP — it had a parking lot, was on a main street with good visibility and David knew the property owners, the de Menils. "So, I talked to Dominique about it and she agreed to let us have the space for HCP." Writing about it in the September 1983 issue of *Image*, David explains

> Of course this new building will require big rent checks and somewhere in the neighborhood of $20,000 for renovation. ... Still, we've got a great new space with a parking lot, in a high-traffic location smack dab on Alabama, just a couple of hundred feet from the new Menil Collection museum, which will house the largest art collection in the city.[1]

245

Proposed plan for the 'new HCP headquarters' in *Image*,
September 1983 issue, page 3.

He included a drawing with his essay. From the beginning, three gallery spaces
were planned with a workroom and a classroom in addition to an office for the
recently hired director, Lynn McLanahan, and storage space. In true HCP style,
many people were responsible for getting the new space ready — the third pres-
ident Sally Horrigan writes in *Image* to thank "Wei-i Chiu and Tom Philbrook
for overseeing the conversion; Gerald Moorhead and Amanda Whitaker for
designing the space; Dominique de Menil for donating materials, equipment
and labor; Ralph Ellis and Susan Kmetz for overseeing the Menil work; and
Paul Koster, Al Santamaria, and Ruth McKee for donating their services." The
community came together to make the new space a reality.[2]

Moving into their new home at 1441 W. Alabama, the organization was ready
for their grand opening on September 9, 1983. There were two exhibitions.
One, curated by Lynn McLanahan, called *Ten Photographers from New Mexico*,
that featured the work of Tom Barrow, Larry Borgeson, Betty Hahn, Jim
Jacob, Rod Lazorick, Beaumont Newhall, Anne Noggle, Dan Peebles, Hol-
ly Roberts, and Joel Peter Witkin. In the smaller gallery, a solo show *From
China* exhibited the work of Dazhen Wu. They estimated 600 people came to
the event and during their opening month the membership swelled to 270.[3]

In addition to their first director, a new home and a telephone, HCP also bought
a computer — a state-of-the-art Osborne computer that "was this big suitcase

kind of thing" with a tiny screen and no hard drive, Paul Hester recalls. David set about writing an accounting program that HCP used for years. "HCP was the first nonprofit in Houston in the art world to have a computer," David says proudly. New technology, however, was not without its challenges. Paul remembers, "it reminded me of old film strip projectors, it had these clamps like an old-fashioned suitcase, you'd lift that off and that was the keyboard — it would come off … and I was sitting in this un-air-conditioned apartment … typing away [on an article for SPOT] and the whole thing went away, it heated up, it got too hot."

### *A fund drive during the economic downturn*

Nonprofits always need funding and HCP was no different. Early on, David and Paul were successful in receiving a grant from the state of Texas, that "gave us some cred [and] was very helpful."[4] Indeed, it is impressive that they were able to garner as much support as they did, given the downturn in oil prices and the city's slide into a bust economy. Betty Flemings remembers "so many lost their jobs … it was rough." She remembers Wally Wilson of Wilson Oil saying 'We went to lunch and came back, and the oil business was over. It was like it happened over lunch. Oil business is fine, and you go to lunch, and it's all gone.' While the downturn hurt Betty and Freck's restaurant business, HCP seemed to stay slightly ahead of the economy. Despite the depressed financial climate, the organization had begun its first fund drive under the direction of Muffy McLanahan with a goal of $180,000. Once HCP moved into the new space with rent and utilities to pay, "I said we'll raise money and we'll have a fund drive," Muffy remembers. Of course, most of the members were struggling photographers who didn't have the connections or skills to "go out and raise money," so Muffy took on the task. Given that the oil bust was in full swing, this was quite ambitious for the young organization.

Muffy had come back with her family to Houston in 1947 and as was expected of young women in her social set, began volunteering in various cultural organizations. Attending a Taft-Eisenhower event in downtown Houston, Muffy met a young Frenchman who had recently moved to Houston for work named Alexander but whom everyone called Mike. At the time, Muffy was dating Mike's roommate but began to think she might be more interested in the dashing Frenchman. After setting Mike up on double dates with some of her friends and getting to know him, she "sort of thought he was nice." So Muffy

broke it off with her boyfriend and crossed her fingers, "and finally Mike called and asked me out." That was in 1952, and they've been a formidable team ever since.

Fundraising was a skill Muffy had honed through years of volunteering in Houston, and it was fortuitous that she was willing to help HCP. "So, for three years I struggled with Mike's help, and we went far afield. We went to our friends in the east; we went all over to raise money to get it going." Eventually surpassing the goal and raising $183,000, her husband, Mike McLanahan adds, "Today that would be the equivalent of almost ten times that amount. And this didn't come from the big foundations. It came from our friends really and our pocketbooks. ... she [Muffy] would be looking at the mail every day to see if we'd gotten a letter from Santa Fe or New York or some other part of the world that we knew that we'd asked." Muffy continues the story

> After two years we were able to get an NEA[5] grant. We had to be in existence for two years before we could tap into the NEA, which meant I could then start going to corporations and all. And it was 'are you art'? You know 'is it really art?' So, we had some success there and it grew ... and for two years the NEA gave us a grant. The first year they gave us $4,000 and said you must spend it on upgrading your telephone system or a new computer, which was just coming in, but you have to spend it right away on just physical things. Then we are going to come down and monitor you and you're going to be working on a long-range plan. The second year we're going to get more serious about it and you'll get what we think [is right] up to $75,000 as far as what kind of a job you've done. And we got the full $75,000. ... And they [NEA] were invaluable to us. They came down and gave us a lot of good advice.

Muffy led the successful campaign from 1983 to 1986, which resulted in three years of operating expenses that provided a strong financial foundation for the young and ambitious organization. One of the early members of HCP, Muffy and several other women had become quite engaged with photography by taking classes with George Krause. In many ways, George had played an important role in generating interest in the medium by teaching people in the community how to photograph, and created a strong following in Houston. With George, and Ed and Suzanne at University of Houston, and Geoff and Peter at Rice University, there were many opportunities for interested people

in the community to take classes. And many of these turned out to be married women who were free during the day when the courses were offered. A number of these more established women students became very instrumental in keeping the organization running during its formative years. These women brought time and resources as well as lots of volunteer hours to HCP. They used their networks to leverage opportunities, their time to paint walls and write for the magazine, and their pocketbooks in times of need.

By 1986, with three years of operating funds in the bank, NEA support, a well located exhibition space, a quarterly magazine, a computer and telephone, the five-year-old organization was well positioned to continue to grow. They were also experiencing their first staff transition. After overseeing 20 exhibitions and the early growing pains of the organization, Lynn McLanahan resigned in the summer of 1985 to get married and move to Chicago, so HCP needed a new director. While the board began the search, a friend of Peter Brown from

**David Crossley, Sally Horrigan, and Paul Hester (at the center) and others at the ribbon cutting for the HCP building, 1983.**
Courtesy of David Crossley.

Stanford suggested that conceptual photographer Lew Thomas might be a good fit for the position. Lew was both an accomplished photographer — his work, *9 PERSPECTIVES* (1972),[6] had been included in John Szarkowski's landmark 1978 MOMA exhibition *Mirrors and Windows* — and he was a published author of three books. Prior to arriving in Houston, Lew had been in San Francisco where he had founded a publishing company in addition to curating important exhibitions at the San Francisco Art Institute and the San Francisco Museum of Modern Art. By Houston standards, Lew was a 'big deal.' One of the original members, Herman Detering, who owned a rare book business in Houston, was the board president at the time. With their mutual interests in publishing, Herman and Lew became friends. As with any organization, each new director brings new interests and skills to the group. With Lew's arrival, HCP began its next chapter. Capitalizing on his writing and editorial skills, Lew took over the editorship of *SPOT* and began to advocate for the inclusion of more conceptual photography in the exhibition schedule. Paul Hester appreciated Lew Thomas' efforts to raise the level of HCP's approach to photography. Lew "was a difficult person," Paul recalls, "but his curatorial positions were important infusions of new perspectives for our insular and conservative community."

## Growing Pains

Houston Center for Photography had its own building, staff, NEA funding, and a new director. However, Lew and HCP did not seem to fit well, as board member Peter Brown remembers "it was just not a happy match." In hindsight, Lew explained that his "strength was a conceptual emphasis with little administrative background in grants and funding." Additionally, he admits that in his desire "to exert a challenging influence" about contemporary photography, he did end up crosswise with several board members at times.[7] Photographer and weekend gallery assistant at the time, Debra Rueb, recalls Lew as a "quiet person, he wasn't real talkative, and when he would talk he was so intellectual. ... I wouldn't know what he was talking about." Lew Thomas left HCP in 1987, and board member April Rapier stepped in as the interim director.

Towards the end of Lew's tenure, a "debate over HCP's artistic identity [came] to a head." There had been disagreements and rumbles before. During the fundraising campaign, an exhibition of political images by Paul Hester caused a stir. He had been photographing nudes with Ronald Reagan face masks

**David Crossley and Muffy
McLanahan inspect prints
at NASA for the *In Space:
A Photographic Journey*
exhibition, 1987.**
Courtesy of Houston Center for
Photography.

mocking the "media coronation of this ex-actor and mouthpiece for corporate America," Paul explains, "I used a carrousel for postcards to make a totemic installation calling out his 'trickle-down' economics and other dishonest politics." This caused some concern that these images might alienate wealthy, republican River Oaks donors, and Paul was asked to remove his work. Another issue arose, though it wasn't a political disagreement but a difference in perspective as to what photography was appropriate for HCP to show. Board members David Crossley and Muffy McLanahan curated an exhibition of photographs from space that promoted a discussion of whether the organization should focus on "art photography, reportage, or a diversity of views." The exhibition included both NASA photographs and some "spectacular deep space images made with a telescope by Australian astronomer David Malin" David recalls.[8] All the exhibition images were printed by NASA.

The final compromise was that the NASA exhibition would be shown at the Transco Tower (now Williams Tower) rather than at HCP. This gave Muffy and David the opportunity to turn it into a much larger exhibition and a gala fundraiser as well. The opening event of *In Space: A Photographic Journey* (May 12-June 17, 1987) was a huge success, raising $30,000 for HCP. Boeing and Continental were two of the major underwriters for the event as were many notable old Houston families. Muffy and her husband Mike used their connections to engender important support for a Houston-sized gala with celebrity astronauts that was far beyond the capacity of most small nonprofits. "We had the first ten astronauts, and they all came," Muffy remembers, "John Glenn gave the major address, and we had a little booth where you could put your head through and have your picture taken with them and all this kind of stuff." Making the most of the expansive Transco Tower, the exhibition included im-

ages that could not have fit in HCP — a 15-foot high photographic mural of the moon and seven by nine-foot image of a horsehead nebula.[9] Additionally, HCP partnered with the Museum of Natural Science and Burke Baker Planetarium, Rice University and Transco Energy Company to organize a series of five lectures by noted astronomers and photographic scientists. Funds for the lecture series came from the Lynn M. Herbert Endowment Fund at HCP set up by their first director. Shortly after this exhibition, Lew Thomas left HCP.

Jean Caslin became the third, and longest serving, executive director (1988-2005). Peter Brown had known Jean during his time at Stanford and suggested she apply. After earning her M.A. at Stanford, Jean had gone to Boston to work at the Photographic Resource Center. Jean "came down and interviewed," Peter summarizes, "and she is a really nice person, and she really knows photography well and she got the job." After arriving, Jean wrote in *SPOT* that HCP had upgraded their technology and now had a Macintosh II with a color video monitor and 400 dpi scanner, Apple LaserWriter II NT printer and "state-of-the-art" Quark Xpress. HCP will also begin offering workshops through "Mac-interfaces, a new Houston firm that is the first Apple System dealer in the nation." To kick off the new direction for the organization, they would show *Digital Photography* curated for San Francisco Camerawork by Marnie Gillet and Jim Pomeroy. This traveling exhibition included a "variety of provocative photomontage work using the new computer-related material.[10] Convinced that computers would be "as important a tool for an artist as a pencil or a camera," Pomeroy[11] was an advocate for this new digital technology that HCP would show in the fall of 1988. With their new technology, and new executive director, HCP was ready to look to the future.

### "There used to be arguments and hugs; now there are committee reports"

It fell to new executive director Jean Caslin to guide the transition of a photography collective into a more stable and formalized visual arts organization. HCP was seven years old when Jean arrived in 1988, and still a rather young organization. Prior to coming to Houston, Jean had worked for nine years with Chris Enos, and later Stan Trecker, at the Photographic Resource Center (PRC) in Boston. As second staff member hired at PRC, Jean had experienced the organization's evolution from a young, start-up into a more robust organization and knew what infrastructure was needed to make that leap.

At PRC, Jean had been involved with strategic planning and applications for NEA stabilization grants to facilitate their growth. During this time, Jean had been attending Oracle, the international photography curators' conferences that built her network among professionals. Additionally, early in her tenure at HCP, Jean served four years on the Board of Directors for Society for Photographic Education (SPE), which broadened her understanding of how other photography-based groups operated.

When Jean arrived, Houston Center for Photography was well positioned to grow to the next level. They had an active board, *SPOT* magazine, and ongoing exhibition and event programing. What they were yet to have was a strategic plan for development into a midlevel visual arts organization, nor did they have the infrastructure to support it. Among the board members and supporters, there was a general understanding that HCP had to grow in order to gain an international reputation and importance in the photography world. Paid staff increased to two full-time positions, Jean and an assistant, with a part-time weekend gallery monitor. Early on, Jean oversaw the enactment of new policies and the updating of the bylaws to formalize practices, such as a Conflict of Interest policy that made board and staff members ineligible for monetary fellowships. Membership exhibitions, rather than selection by member vote, would now be juried by professional curators. The committee structure became more organized, and a long-range planning committee was initiated. Muffy McLanahan, summed up some of the changes, "There used to be arguments and hugs; now there are committee reports."[12]

**Exhibition space in the new building. The remaining Shopkwik windows can be seen on the right.**
Courtesy of Houston Center for Photography.

Through the strategic planning process, a number of goals were identified: "to engage in long-term planning, to stabilize the organization by diversifying income sources; to enhance HCP artists' reputation nationally and internationally through *SPOT*, traveling exhibitions and collaborations; to expand educational outreach programs; to make facility improvements including lighting and flooring; and to enlarge the space."[13] Ambitious goals to be sure, especially for a two and a half person staff, but essential infrastructure the organization would need to move forward.

When Jean arrived, HCP still looked like the "converted Shopkwik" that it was, with florescent lighting and floor-to-ceiling front windows. Though change was not immediate, Jean sought to improve the aesthetics of the building to make it more like a quality gallery space. Eventually, more appropriate track lighting was installed, and exhibition space was increased as HCP was able to acquire adjacent spaces. In increments, HCP was eventually able to acquire all three retail spaces in the strip mall. Expanding from their initial space, in 1998, into the middle shop to create an additional two small galleries, exhibition storage, and a preparation area. Then finally taking over the third unit in 2005, HCP gained room for an additional small gallery, library, meeting room, and digital darkroom (opened in 2006). It was during this final expansion that a wall covering was built to block the top two-thirds of the floor-to-ceiling "Shopkwik" windows.

### *"A pie with lots of slices"*

HCP was on a growth trajectory organizationally, though their financial development lagged. The aftermath of the 1986 bust was still being felt by small nonprofits and fundraising was always at the forefront. Jean had begun writing grants for HCP even before she moved to Houston to take up the director position. Resource development, Jean explains, "was always a pie with lots of slices." The 'pie' consisted mainly of grants from arts agencies and foundations, membership fees, business partnerships, individual donations, and the annual auction. Filling all the 'slices' remained at the forefront of Jean's efforts throughout the 1990s for HCP.

During the decade, Jean wrote several successful grant proposals. HCP received two Advancement Grants from the National Endowment for the Arts (1990, 1991) and later was awarded a Planning and Stabilization grant also

from NEA in 1998. Jean was also able to get additional NEA funding for various projects (publication of *SPOT* and special exhibitions) throughout the decade. Through her efforts, HCP was accepted into the Stabilization Enterprise Program of the Cultural Arts Council of Houston and Harris County (CACHH) and later received the highest implementation grant ($52,500) awarded at the time. Jean also wrote three successful proposals to the Institute of Museum and Library Services, which provided operating funds (1996-98; 1999-2001; 2001-2003). Other funding came from the Texas Committee on the Humanities, and three Houston-based foundations: Houston Endowment, Brown Foundation, Wortham Foundation.[14]

The annual HCP auction continued as the largest fundraising event for the year. Seeking to "amplify the auction," Jean used her connections in the northeast to bring a broad array of photographers' works as well as sending out request letters to artists throughout the country. Additionally, in 1990, Anne introduced Jean to Dale Stulz, an internationally known art consultant and appraiser from California who regularly traveled to Houston to appraise work for the Museum of Fine Arts, Houston. Jean quickly asked Dale to preside over the HCP auction as their first professional auctioneer (he served from 1990 to 2006). The annual auction would be held in various places over the years, a design center, an auditorium at University of St. Thomas, Gremillion Gallery, and the gym at the Greek Orthodox school. A buffet dinner was served, and the auction lots were exhibited at HCP for the month prior to the event. Jean believed in keeping the cost to participants low, the auction catalog was $5 (plus $2 for mailing) and tickets eventually rose to $25 for the 1999 auction. By the end of the decade (1999), the annual auction was raising over $70,000 for HCP, which constituted a significant portion of their operating funds.[15]

While Jean brought new perspectives to the day-to-day running of HCP, leadership of the board of directors also began to transition from founder/artists to a new orientation with collectors, art enthusiasts, and businesspeople, beginning with the two-year appointment of gallerist Clint Willour in 1988 as president. After 18 years as a gallery director of Tibor de Nagy and later Watson Gallery, Clint brought a business sensibility to the HCP board. Clint was also known as a strong supporter of artists and making sure they were treated fairly by gallerists. When his gallery closed in 1989, Clint used his own funds to rent a truck and return all the work to artists throughout the state.[16]

Then during the second year of his term as HCP President, Clint became the curator for Galveston Art Gallery in 1990. Following Clint's term, Joan Morgenstern (1990-1993) began a three-year term as board president. In addition to her support of Anne's efforts at the museum, Joan had previously worked in nonprofits. "I have had every job in a nonprofit except the director," Joan explains, "so I bring a different viewpoint on what a board member should be doing … I don't believe board members should have their hands held. They should be able to understand what is going on, that is part of supporting the organization; it is not just showing up for meetings." Both Clint and Joan, Jean remembers, "were both instrumental in strategic planning at HCP."[17]

Joan began her term as HCP was still climbing out from the economic downfall of the 1980s. Before accepting the position, Clint told Joan that HCP's financial situation was precarious and that she would be coming into a challenging situation. Board members remember difficult times of passing the hat at meetings to pay utilities. Knowing this when Joan accepted the position, she was very clear, "If I have to be the President to close the door, I will close the door … and I can't save this organization by myself, so we are either going to get it straightened out … [or] close the door." Joan brought a clear collaborative approach to the board and tasked members to think of fundraising as a shared responsibility between the staff and the board. Onboarding of business owners such as gallerist John Cleary and photography studio owner Mike Marvins to the HCP board started to broaden the skill set and connections the growing organization would need. This transition phase of organizational development necessitated that board members take on new kinds of responsibilities. To grow, HCP would need board members who took on the responsibility for fiscal oversight, advocacy, and accessing their personal networks for fundraising. Rather than a board that focused on programing as in HCP's early years, board development was a crucial aspect of the infrastructure necessary for growth. Much later (mid-2000s), HCP would institute an annual "give or get" pledge policy for board membership but earlier contributions were voluntary. Despite the usual growing pains, under Joan's leadership, the board began to play a greater role in fundraising. Thankfully, Joan's willingness to "close the door" never happened, but not without a concerted effort by both staff and board members.

In addition to the economic downturn, another factor HCP faced was the loss of a number of the original supporters who were affluent women interested in

photography. Mary Margaret Hansen, who had been donating $2000 a year to HCP in its early years, explains, "There were a lot of women involved ... you had highly intelligent, creative women who did not have full-time jobs. Once they got divorced — the second wave of feminism — they went to law school or whatever." Many, like Mary Margaret, who divorced in 1987, now needed to work full time. A latent consequence of the second wave was less resources for HCP, as well as other nonprofits, in terms of dollars and volunteer hours. Individual donors constituted an important "slice" of the HCP financial pie, and with the loss of these women due to the recession or feminism, the result was that HCP lost a group of active supporters that had been crucial in its beginning.

During Joan's three years as board president, Jean oversaw a number of new fundraising efforts. In 1991, they began a "Collectors Print Program" where membership levels of $200 or more came with a choice from six original signed prints. At the $200 level, one could choose from prints by Vincent Borrelli or Lorie Novak; at $300 the member could choose a photograph by Keith Carter, Robert Dawson, David Graham, or George Krause; and for $500, one could choose a print from each category. Each year, there would be work from new artists to choose from. The Collectors Print Program was quite successful and continued into the early 2000s. HCP also began hosting holiday fundraising parties with $10-15 tickets, increasing their workshop offerings, and organizing portfolio reviews with local curators and gallerists once a month.

Houston Center for Photography celebrated its ten-year anniversary in 1991 with a large fundraising event honoring Mike and Muffy McLanahan as "founding donors of HCP." Past presidents and past directors (Lynn Herbert and Lew Thomas) were also recognized as making important contributions to HCP. The party was held at James Gallery with a Zydeco band.[18] Ellen Lang charted the successes from the last ten years in an article in *SPOT*. "While a ten-year tenure for any medium-sized artists organization is awe-inspiring and cause for celebration, its early history resembles a myth, complete with proud heroes and dark horses," Lang writes, "Its founding members recount those first few years with pride and emotion."[19] Joan Morgenstern reflected on HCP's "record of providing direct support to emerging artists at a crucial point in their careers," referring to the HCP fellowships, she continues, "Over the past decade, thirty-nine Houston artists have received important recog-

nition and a vital boost to their careers." After the success of the ten-year anniversary party, celebrating HCP's birthday each year became a regular event throughout the decade.

In 1993, Ed Osowski, a librarian who had overseen several publications with photographs for Houston Public Library, was elected president of the HCP board (1993-1997). Prior to this, Ed had been overseeing the book review section for *SPOT* and had greatly expanded both the books he was able to request and the stature of the reviewers, which included the likes of Vicki Goldberg and others from outside Houston. As president, Ed brought new additional fundraising ideas to the board. Ed shared his idea of giving honorary gifts to HCP for birthdays and other celebrations by example, giving a number of donations in honor of friends and artists himself. "Be part of the picture" membership drives also received more focus with "Bring a friend to Lunch" events and encouragement of gift memberships at $35, or $50 for a household, and $15 for seniors and students. An Excellence Fund was started in 1995 with the idea of creating corporate memberships. Early members of the Excellence Fund were Mundy Companies, Cooper Industries Foundation, Hines Interests Limited Partnership, Exxon, and Shell Oil Company Foundation.

A successful fundraiser during Ed's tenure was a 1994 birthday party for Joan Morgenstern to honor her support of HCP. Chaired by Joan's friend, Isabell Herzstein, an influential supporter of the arts, the evening began with a champagne tour of the Keith Carter exhibition at HCP followed by a buffet dinner catered by Anthony's in the Penthouse Board Room of Compass Bank-River Oaks. Tickets were $75 and Jean reported this was "one of the most successful events in HCP's history" as they raised $23,000 that evening.[20] Then, to reinvigorate the annual fund drive, which had previously included a two-evening "phonathon" to solicit donations, HCP tried a novel approach in 1995 and held a Phantom Gala instead. Invitees were encouraged to RSVP 'Yes, I will *not* attend' with their checks. There were incentive gifts offered at each level of support. Invitations were sent and $11,564 in donations were received.[21] The following year, 1996, HCP held an upscale "Collectors Auction" at the Memorial area home of Eitan and Nili Levy. It included work by 99 artists, and tickets were $25, with a $15 credit towards the purchase of a print. The event successfully raised $23,476 with 150 people attending.[22]

Ed's presidency was followed by the election of Laura Morris, the Houston representative for Sotheby's Auction House. During her first year, HCP held "The Big Texas Shootout" fundraiser. For $150, one would be paired with a professional photographer to "shoot film." The resulting images would be juried for exhibition at HCP and participants would receive a t-shirt and complimentary matting of selected work. The 'pairings' would be announced at a reception in the home of Barney and Ellen Kogen. Creativity in fundraising continued with the addition of a new membership category, Photo-Op. For $150, members would receive all the usual HCP benefits in addition to invitations to special events like a private tour of the Print Room at the museum and a visit to photographer Keith Carter's studio. In 1998, HCP also increased their board membership from 19 members to 24 in an effort to engage a broader network of support for the growing organization. Throughout the decade "there were lots of ups and downs financially," Jean reflects, "... resource development is always the main focus of nonprofits" and board members play an important role in the effort.

### *Engaging the community*

While keeping a focus on resource development, Jean also expanded HCP's collaborations and programing. During the 1990s, HCP collaborated with a variety of other Houston organizations to mount exhibitions, host events, and generally raise the profile of the arts in the city. These included HCP partnership with the Women's Caucus for Art to exhibit *The Stuff of Dreams* by Elise Mitchell (1992), co-hosting the Houston meetings of the Women in Photography Conference (1994), which drew a national audience of 300, and working with the Community Artists' Collective on an installation of Pat Ward's work (1994). In 1995, HCP hosted a special reception for the Asia Society during the exhibition *Picturing Asia America* and partnered with the Goethe Institute on two events. Additionally, HCP worked with Rice University to host a reception for Andres Serrano when he came to give a lecture there (1995), and with University of Houston's Blaffer Museum on their exhibition of *Asia/America* (1996). These strategic partnerships helped to nurture broader audiences for HCP as well as to increase the organization's visibility.

Looking back, one of the most visionary decisions of HCP leadership during this decade was to have their first website, www.mediaplace.com/hcp. One of the first visual arts organizations of its size to debut on the 'world wide web' on No-

vember 1, 1995, the HCP website was created by Sense Interactive Multimedia, a company owned by HCP founders David Crossley and Jeff DeBevec. The early website featured information about exhibitions and events as well as featuring the work of two HCP members. During her tenure, Jean would work with three different pro bono webmasters on the webpage. Eventually, moving beyond their first address, in 2001 HCP claimed its own domain name, hcponline.org, which remains its current website.

In addition to working with other organizations, Jean also designed and implemented several outreach efforts around the city. Focusing on middle school- and high school students, Jean was seeking to cultivate the 'next' audience for HCP. Using photography as a tool for building self-esteem, Jean came up with the idea for a pilot program for middle school girls (1994). Called *Girls' Own Stories,* its curriculum was developed by Suzanna Monteverde and was taught for several years in a variety of in-school and after-school settings in Houston. It was later adapted for *Boys' Own Stories* taught by HCP administrative director, Michael DeVoll, and implemented throughout the city. Later, Jean initiated the Community Outreach Teacher Training Institute, which offered an intensive two-day workshop for volunteers and arts professionals involved with community-based outreach programs. For the 1995 endeavor, HCP partnered with the Harris County Department of Education and received funding from Cultural Arts Council of Houston and Harris County (CACHH). The workshop focused on four areas: effective teacher strategies, conflict management, dealing with drugs, and coping with gangs. With funding from the Texas Commission on the Arts (TCA), Jean contributed to a 1998 workshop that focused on integrating art into the classroom, conflict management, and issues of diversity. Next came a curriculum for high school students, *Photography, Genealogy and Oral History,* that Jean designed with photographer and teacher Ray Carrington III at Jack Yates High School — the second oldest high school for African Americans in Houston. This program was also funded through CACHH and TCA. Selected student work was then shown at HCP. With funding from TAC, Jean contributed to a more general high school curriculum using photographs from the *Collection of Henry Mendelssohn Buhl* and was shown at the Museum of Fine Arts, Houston.[23] Buhl, a former photographer, collected over 400 images of hands.[24]

Another innovative outreach was a partnership with the Continental Airlines terminal at Bush International Airport in the outskirts of the city. For the ter-

minal, Jean organized an open call for images, and then an independent panel selected the final images for *Windows on Houston,* a rotating public art installation of mural-sized photographs featuring work by local commercial photographers. Annual calls for entry were held each of six years (1990-1996). Jean later created a similar iteration called *Windows of Wonder* for the Clinical Cancer Center of Texas Children's Hospital. These exhibitions both provided additional opportunities for Houston photographers to show work, as well as bringing awareness of Houston Center for Photography in wider, public settings.

### Finding and showing photography

Of course, exhibitions remained at the heart of HCP activities. Continuing an ambitious schedule, HCP mounted two to three new exhibitions every six weeks. "We all worked so hard ... just to make it happen," Jean remembers sometimes working up to 60 or more hours a week. "Jean would just barrel in there all hours of the day or night and do what needed to be done," HCP Administrative Director Diane Griffin Gregory (2000-2005) recalls. The exhibition schedule included the annual juried member show, and the exhibitions of the fellowship winners as well as exhibitions by guest curators. Most exhibitions, however, were curated by Jean with the help of an assistant curator. In selecting work, Jean attempted to have a balance among the various genres of photography. Her exhibitions "featured both fine art and documentary photography from diverse multicultural and interdisciplinary perspectives."[25] Jean credits Clint Willour, Anne Wilkes Tucker, and Joan Morgenstern (as longtime exhibition committee members), as very instrumental in helping identify artists for HCP. "We always tried to have a real stunner during FotoFest," Jean explains. Along with HCP staff, Clint, Anne, and Joan would review at FotoFest's Meeting Place and identified exceptional photographers for the exhibition committee's consideration. Participating in FotoFest also brought HCP to the attention of several photographers and photography professionals from around the world. The biennials facilitated HCP's international reputation as an important place to show work and helped develop an international membership base.

Over the years, HCP has shown a number of important photographers who have gone on to acclaim. *The Scorched Earth: Oil Well Fires in Kuwait* (1991), co-curated by Jean Caslin and Dave Wilson, featured the three photojournalists, Sebastião Salgado, Steve McCurry, and Stephanie Compoint, who would

win World Press Photo awards in 1992 for this work. Photographer Gregory Crewdson credits HCP as the first place to show his work,[26] he and Maggie Taylor were both in 1992 exhibitions. Other notable artists included in early HCP exhibitions include Dawould Bey, Dan Burkholder, Roy DeCarava, Raymond Depardon, Larry Fink, Lee Friedlander, Juan Fontcuberta, Jim Goldberg, Graciela Iturbide, André Kertész, Mark Klett, Mary Ellen Mark, David Levinthal, Les Krims, Danny Lyon, Pedro Meyer, Osama James Nakagawa, James Nachtwey, Nic Nicosia, Luis Gonzales Palma, Martin Parr, Gilles Peress, Anders Petersen, Jeffrey Silverthorne, Bill Viola, Garry Winogrand, and Joel Peter Witkin among many, many others.[27]

During the decade, HCP grew from a local artist collective into a mid-level arts organization and gained a reputation for consistently exhibiting high-quality work. The *Wall Street Journal* acknowledged HCP as "a much coveted sponsor for emerging and mid-career artists" in 1996. Photographer Keith Carter concurs, "I think that HCP is the most important and accessible institution for mid-career photographers and artists." Willing to take a chance on a new artist or uncommon work, HCP also became known for its boldness, which artist Bastienne Schmidt appreciates, "HCP makes courageous and unusual decisions to show different types of photographic work, especially that of emerging artists who otherwise would have a hard time making a first step into public view."[28] Additionally, some of HCP exhibitions began to travel to other venues. The 1996 FotoFest show, *Kumao: Hidden Mechanisms*, a kinetic installation and catalog project funded by NEA and TCA, later went to a number of venues in South America under the auspices of HCP board member Pampa Risso-Patron of the Pan American Cultural Exchange. *Brazil without Frontiers* (2000) featured work by five Brazilian photographers, and after debuting at HCP, it traveled to Silver Eye Center for Photography in Pittsburgh, PA. During this time, HCP also began commissioning work, such as *Collected Visions: Lorie Novak* (May 1993), a site-specific projection and sound installation on gender identity, memories, and myth with original music by Elizabeth Brown.

As the import of HCP's exhibitions grew, Jean recognized the importance of documenting their programing. Articles about the exhibitions were regularly featured in *SPOT* as well as the HCP Newsletters, which were mailed to the membership. Wanting to have a more formalized documentation, Jean sought to have a catalog for significant exhibitions and was writing grants continu-

ously for this purpose. The catalogs, which would be distributed beyond the HCP membership, were helpful in promoting the organization's increasing role in photography.

Through the years, Anne served as an important mentor for Jean, encouraging her to always be "nurturing donors, nurturing audiences," and this advice guided her efforts. Photographer Debra Rueb, who for a time served as the weekend gallery monitor, remembers how friendly and outgoing Jean always was at the exhibition openings. "She was always greeting people and making small talk" helping visitors to feel welcome. Administrative Director Diane Griffin Gregory explains, "We (she and Jean) built relationships with about everyone that came through the door." Jean just "really loved photography, and she loved educating about photography," Diane recalls how much she enjoyed working with someone with the "vision that Jean had."

## Continuing to Grow

The new century dawned with HCP respected as an important part of the Houston photography community, and well thought of in the broader photography world. Jean remembers her challenge was always "keeping all moving parts moving, well-oiled and moving [forward]." Administrative Director Diane remembers always trying to be all things to all people, "We knew we couldn't limit ourselves and survive." In 1997, the former executive director of FotoFest, Harla Kaplan, was brought in on a contract basis to assist with a capital campaign and general fundraising. HCP's strategic plan included expansion into the last space in the strip mall as soon as it came available. As with growth spurts, expansion created some strain on the organization's finances. It became a challenge to concurrently mount a capital campaign and maintain their operating budget. Harla assisted with grant writing and fundraising events to raise the needed resources to acquire and renovate the additional space.

In the fall of 2000, Jean approached investment advisor and photographer Len Kowitz about becoming President of the board. A longtime supporter of HCP, Len had been on and off the board over the years. After giving it some thought, Len accepted the nomination and took on the role. His first impression of board member participation was that it was not as strong as it needed to be. Though they always had a quorum, "board meetings were small, just a few people," Len recalls. His first goal was to increase the number of strong,

active supporters on the board of directors, so he began asking his photography friends to accept appointments. Len explains that, as with most nonprofits, it quickly became "pretty evident that the real problem was money." The capital campaign stretched HCP resources and "it was very touch and go," Len remembers. As an investment advisor, Len focused on budget issues and continually worried about making sure the bills were covered. The Menil Collection, which owns the building HCP is located in, was a supportive landlord and could have increased the rent more than they did. "They were very agreeable with us for a long time," Len says, "they have continued to be very helpful to HCP." Previous board member Daphne Scarbrough, who has watched various arts organizations come and go in Houston, explains that photography organizations survive "only because you have people who care and enjoy it." Of those organizations

**HCP Founders were honored at the 2016 Auction. Front row, left to right: David Portz, Patsy Cravens, Clint Willour, Mary Margaret Hansen, Janice Rubin, Suzanne Bloom, Ed Hill. Back row: Len Kowitz, Debra Rueb, Gay Block, Sharon Stewart, Anne Tucker, Paul Hester, Muffy McLanahan, Jim Tiebot, David Crossley, Paul Judice.**
Photo: Laura Corley Burlton. Courtesy of Houston Center for Photography.

that survived, "every group has had someone who stepped in and cared," she recalls. Over the years, Houston Center for Photography has had many such individuals, both artists and collectors, some of whom with the deep pocket resources (or connections) that helped HCP over the rough patches.

Houston Center for Photography ended the decade much as it began — on a growth trajectory. The organization had evolved from an artists' collective and was recognized as a significant player in the photography community. Participating in the FotoFest biennials put HCP on the radar of international artists and photography professions and increased the visibility of their exhibitions. It had been a long road, and not without its challenges, but by 2000 the organization was well positioned for its next phase. The long-range planning, initiated upon Jean's arrival, guided HCP's development through the decade. One of the most essential goals was Jean's long-term plan to expand HCP to encompass the entire building. Expanding to the last remaining space allowed for the development of the digital darkroom and a permanent workshop space. Within a few years of the opening of the digital darkroom (in 2006), and expanding the educational programs, the significant revenue generated has become a substantial component of the organization's operating funds. "Despite the challenges," Jean recalls, "I found HCP to be a joy-filled environment."[29] Diane Griffin Gregory concurs, "Overall it was a good time; it was a great time."

# Chapter 11

## FotoFest: The Place to be for Photography

Amazed and delighted that they had pulled off the first photography festival in the United States, the idea of a biennial seemed more than possible. Shortly after the first Month of Photography was over, Fred decided to stop teaching at University of Houston and devote himself full time to FotoFest, while Petra left Houston. Petra had hired a lawyer to help her get a green card, and he told her, "There is no chance for you." Failing to be accepted by her adopted country, Petra returned to Germany. Leaving her inventory with her assistant Susie Morgan, they renamed the gallery Benteler-Morgan. Susie kept the gallery running until 1994, advertising in Houston Center for Photography's magazine *SPOT* and curating gallery exhibitions for the 1988, 1990 and 1992 FotoFest biennials.[1] Petra accepted a position with the *Museum für Kunst und Gewerbe* in Hamburg, continuing to work with her passion for European photography.

Running FotoFest then fell to Fred and Harla, and increasingly to Wendy. The first task was to sort out the $100,000 debt — "I took every call," Harla says, "I said, 'we're doing the best we can.'" They also had to begin the planning and funding for the 1988 event. Wendy continued to be supportive of FotoFest informally. "I didn't want it to look like a family affair, and that's why my participation was not formally identified in the beginning; It was a very deliberate decision," Wendy recalls, "I wanted it to look more professional." Although not initially listed as a founder, director or board member, Fred and Petra recognized Wendy's involvement with "every aspect of the organization, from the conceptual to the practical" in the 1986 catalog.[2] Wendy also continued to be very busy with her freelance photojournalism assignments and working on Human Rights issues. As a cofounder of the local Live Oak Fund for social change, Wendy assumed a leadership role with the organization. Fred joked

at the time, "Some people have two cars in the garage ... we have two nonprofit organizations."[3] At one point, Wendy traveled to Salvador with Dominique de Menil to "photograph when she gave the Oscar Romero Award for Human Rights to Bishop Medardo [E. Gomez Soto], the Lutheran minister who had been so helpful for human rights in Salvador." She also began photographing "Salvadoran refugees when the sanctuary movement was picked up by a number of churches particularly in the Northwest." While other assignments included a "Christmas in America" photo book project that had her traveling throughout the state, photographing Christmas in Pasadena, holiday travel at bus stations in Abilene, Sweetwater & Hearn, an annual cowboy ball in Anson; and Black church celebration in Navasota.[4]

Along with Wendy, "Dreamer-in-chief" Fred continued to think bigger and bigger — the budget for the 1988 biennial was $600,000 and he was planning for $1 million for the 1990 event. FotoFest was set to grow bigger with each festival as they planned to do more and more. This was in part because they wanted to outdo themselves, but also they were driven by "being curious, and searching for new things," Fred explained. "We wanted to keep learning that was ... one of the exciting parts of it," Wendy adds. To this end, Wendy and Fred traveled constantly, attending other photo events, but mainly searching out new work to bring to Houston. In 1988, Wendy joined the board of directors and began taking a more formal role in the organization. AIPAD returned to Houston for the '88, '90, and '92 biennials. Society of Photographic Educators (SPE) held their events in Houston during the '88 biennial, which marked SPE's 25th anniversary with a keynote by John Szarkowski and a panel of founders including Andy Grundberg, Nathan Lyons, Aaron Siskind, Jerry Uelsmann, Jerome Liebling, Robert Heinecken, and Martha Strawn.[5] Additionally, the Southwestern Photographers Association held their annual convention during the '88 biennial. By this second biennial, FotoFest had become one word and reviews at the Meeting Place became 20 minutes each, now the industry standard.

"What saved us was Kodak," Harla explains. Kodak gave FotoFest funds but also "they gave us all these Kodak bags, and they emptied out their books — they had the *Day in the Life* series — we got thousands of books," Harla recalls, "we could sell them in our bookstore, and we got to keep all the money." In the 1988 catalog, Fred credited Ray DeMoulin of Eastman Kodak as the man

Harla Kaplan at the information table of the 1988 festival. Courtesy of Harla Kaplan.

"responsible for more hopeful dreams in the hearts of photo curators and organizers around the world than any man alive." Ray believed in what FotoFest was doing and was very supportive. Fred remembers Ray as "a very imaginative man who got them [Eastman Kodak] moving in the direction of digital." Eastman Kodak, through Ray's support, covered half the $600,000 budget for the 1988 festival.[6] With corporate funding, international media attention, and growing excitement in Houston and abroad, FotoFest seemed to have achieved some stability. *Boston Globe* writer, Kelly Wise, saw the success of FotoFest as the result of a "game city that got behind two of its citizens who had a big idea." Houston was the place that such a big idea could take hold, with its culture of audacious entrepreneurs and wildcat speculators. Fred, Wise continued, was "a white-haired Merlin of sorts, a man who brings people together and makes things happen."[7]

### *Debt and Cash Flow*

After leaving Benteler Gallery's back room, the FotoFest office frequently relocated — with a different address in each biennial catalog until 1998 when they moved to their Vine Street space, where they stayed until 2014. Before this, they were often in empty buildings owned by board members. With the turndown in oil prices, there were a lot of empty office spaces in Houston. Board member John Hanson owned a bank building at the corner of Montrose and Richmond. "Then the bank went belly-up, so they gave us the bank space," Harla recalls. Later, "Alan Buckwalter ... the President of the Texas Commerce Bank at that time" became FotoFest board chair and when a local

design center went bankrupt and the building went back to the bank, "I asked Alan, begged him for space," Harla says, "and he said, I'll give you space — he gave us 6,000 square feet for $500 a month, just to cover part of the utilities." As with many nonprofits, cash flow was a continual problem. Running on philanthropy, grant writing and fundraising events, the margins were always thin. Fred, Wendy, and Harla all used their own funds at various times to make ends meet. "The funding was so awful, I had to use my father's CDs," Harla explains, "I cashed them in to make payroll, knowing that there was a grant coming from the Brown Foundation."

With two successful festivals completed, FotoFest had amazed and astounded the photography world but also left Fred and Wendy with a fair amount of debt that would continue to grow with each biennial until it reached $750,000 in 1994. Undaunted, Fred and Wendy continued refining and growing with each event — adding and subtracting components based on feedback. In 1990, they began charging $50 for the Meeting Place portfolio reviews, which, after many improvements had increased to $1,150 in 2022. In 1992, nightly cocktail hours and slide shows for the Meeting Place participants were instituted to promote more informal networking opportunities. Later they added an Open Portfolio Night, where photographers could display their work to the public. They also learned from other photo events, "For example, in places where they have particularly good coffee, like Argentina," Fred said, "they have a nice sugary, very strong cup of espresso that you get as you review," so FotoFest began offering good coffee to the reviewers.

Early on, they also partnered with the Maine Photography Workshops (1988) and the Santa Fe Photographic Workshops (from 1990 forward) to offer a number of workshops during the Fest. In 1990, they began the *FotoFest Literacy through Photography* program. Based on the workshop Wendy Ewald had offered at the Houston Children's Museum during the 1988 biennial that had been featured on the NBC TODAY show, this added the first year-round component to their programing. In her work, Ewald helped children visualize and write about their lives and their dreams through photography. Excited about Ewald's innovative approach, Fred and Wendy hired local poet and teacher David Brown to create a full year curriculum based on her work. Widely used, this curriculum is offered to teachers all over the nation. Many of the children's images are then exhibited on a Foto Fence during each biennial. Fo-

toFest continued to take shape and move forward, and Fred, "a man of tireless zeal,"[8] kept working towards the vision of making Houston an international destination for photography.

Kodak, which had begun underwriting a significant amount of the festival's budget in 1988, by 1992 was providing nearly half of FotoFest's $1 million budget. Additionally, for the '92 biennial, Kodak collaborated with FotoFest to create the laser disc library of over 6,000 images from the portfolios of 300 international photographers. The printed images were sent to Kodak in Rochester, NY, for digitization, and then the laser discs were available to view during the festival. In 1992, this was cutting edge technology — the predecessor of CD technology. The seemingly stable Kodak support also allowed FotoFest to consolidate their exhibitions in the new George R. Brown Convention Center on the south end of downtown. At a cost of $104.9 million, the new convention center was built on land donated by Brown and Root cofounder and philanthropist George Rufus Brown and opened in 1987. Securing the convention center for a month-long event was a very costly proposition but it mitigated the need for transportation between exhibitions, a challenge in a city as spread out as Houston. Also, hosting so many exhibitions in the same space led Fred and Wendy to begin creating themes for the FotoFest exhibitions. In 1990, they built on their international foci with a "Global Village" and with the '92 biennial, the festival theme became a bit more formalized with "Europe and Latin America 1860-1992." For this biennial, FotoFest mounted "13 exhibits by European artists and 15 exhibits by Latin American artists to reflect important political, economic, and cultural/aesthetic directions on both continents."[9] All future festivals would continue this tradition of announcing a theme to encompass the exhibitions.

The '90, '92, and '94 biennials were held in the convention center. Unfortunately, Kodak began having financial difficulties and as part of a major downsizing they retired Ray DeMoulin, FotoFest's patron saint, in 1993. This left Fred and Wendy scrambling as they had already made several commitments based on the promised, but now withdrawn, Kodak funds. Seeing the writing on the wall, Harla resigned from FotoFest in 1993, "When I left, there was a $700,000 deficit." After Harla resigned, FotoFest further reduced their staff from eight to three paid positions. "When we had to pay off that huge debt," Fred said, "that was awful. We were doing everything, we had to let staff go, and

we were doing administrative work, but also doing just filing and typing and the parts that absolutely have to be done. We did everything ... 12 hours a day, 7 days a week, and that was something I wouldn't want to have to try to do again."

Fred and Wendy also moved the '94 biennial from the usual February/March Month of Photography timeframe to November 10-30 so they would have more time to raise the needed funds and changed the tagline to the International Festival of Photography. Many of the board members believed the nonprofit should declare bankruptcy. Wendy remembers a very tense board meeting where finally Alan Buckwalter, the then Chairman of the FotoFest board, said "'We are not going to declare bankruptcy. The only way to get out of this is to be able to pay off the debt.' So he had a lot of authority," Wendy explains, "everybody else fell right in line with him." After the meeting, Wendy recalls asking Alan for advice on how they could possibly pay it all back, "We were a little scared, that was so much money," Wendy says, "and there were six lone backers."

**FotoFest biennial exhibitions in the George R. Brown Convention Center, 1992.**
Courtesy of Harla Kaplan.

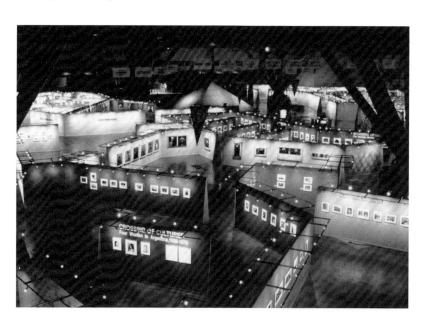

***"The only way to get out of this is to be able to pay off the debt ..."***

"One of our jobs was," Fred recalled, "I had to call up every creditor once a month." Each month they would "pay off a little bit and made them feel never that they were neglected," Wendy adds. One of the individual backers had loaned them over $200,000, but "after three or four months, she forgave that," Wendy marvels, "wiped it off." Another lender had been a bank that went bankrupt, leaving Wendy and Fred to work with their creditors. Later, a new board member loaned FotoFest $100,000 so they could hire Daphne Murray (later Gawthrop), who "was absolutely fantastic" at fundraising. "She came from a moneyed family ... she was part of the Houston society," Fred remembered. She had served on the boards of several Houston arts organizations and was a longtime friend of first lady Barbara Bush. During his presidency, George H. Bush appointed Daphne as Director of the Institute of Museum Services, so when she returned to Houston, she was well connected both locally and nationally. Wendy and Fred both credit Daphne as bringing in new institutional funding to support FotoFest programing.[10]

With the reduction in staff, Wendy became more and more involved in the day-to-day running of FotoFest. In 1988, Wendy had joined the board of directors, for the 1992 biennial Wendy is listed as the festival curator, and by 1994 she is the Artistic Director and listed as a cofounder of the organization. Involved informally from the beginning, Wendy had been especially involved with the Czech and Bulgarian photographer's exhibitions in 1990 and the Latin American photography showcased in 1992 that lead to her coedited book, *Image and Memory: Photography from Latin America, 1866-1994*.[11] Wendy's freelance work slowed down after she had a major disagreement with *LIFE* magazine photo editor John Loengard. Wendy had been on assignment for *LIFE* photographing Salvadoran refugees. The refugees fearing for their safety, "would have these bandanas on and they wouldn't agree to being photographed without the bandanas on," Wendy explains, "but then I was able to establish enough rapport with them I was able to get a number of profile shots that were very good." The church that was sheltering them "got them very frightened about how they let their guard down a little bit," Wendy continues, "they pleaded with me to let them look at their contact sheets. ... they were afraid that they were going to be killed and that the church was going to get into a huge amount of legal problems or trouble of some kind." *LIFE* had developed the negatives and Wendy did show the contact sheets to her subjects.

"I went and met the two … union leaders who had been threatened with assassination several times," Wendy says, "we went over all of the pictures and I actually allowed them to scratch about 12 of the best [negatives]." When she called Loengard to tell him about this, he was furious. "'You'll never work with *LIFE* again,'" Wendy recalls him saying, "And I didn't actually. It was a horrible experience, but morally I felt like I did the right thing."

The experience with *LIFE* magazine gave Wendy pause about the way in which journalism seemed to be heading. "It took me several weeks to live with that experience and get through it, but I realized that photojournalism was going in a different direction than morally and ethically I wanted to go in," Wendy explains, "I think that played a role in my feeling that the world of photography and photojournalism was changing, I wasn't sure if I wanted to be a journalist in that world anymore and maybe I can do more being with FotoFest."

To keep FotoFest on the public radar between biennials, Wendy and Fred began organizing other events. To do this they partnered with various Houston cultural organizations, mounting three exhibitions in the lobby of the Wortham Center: *Four Decades of Mexican History: Mexican Photography 1905-1945* in conjunction with Houston International Festival's Salute to Mexico (April 20-May 2, 1993); *Guillermo Kahlo: Photographs of Colonial Mexico* to coincide with Houston Grand Opera's production of Frida (June 3-16, 1993); and *Scala diva: Photographs of Erico Piccagliano* shown during Houston Grand Opera's productions of La Traviata and Turandot in honor of Houston International Festival's *Salute to Italy* (April 18-May 8, 1994). FotoFest also partnered with one of the largest high schools in Texas, Milby Senior High School in Houston, to bring *Brian Weil: The AIDS Photographs* (November 29 to December 3, 1993) to be shown at the school. The exhibition was the focus of a week of HIV/AIDS awareness activities in conjunction with World AIDS Day. In Galveston, FotoFest worked with the Galveston Renaissance Foundation to organize *A Greek Portfolio: Photographs by Constantine Manos* (February 4-18,1994).[12]

The financial crunch caused Wendy and Fred to be extremely strategic as they thought about how to go forward. The '94 Biennial was still under contract to be held in the expensive convention center, but by delaying it until November 10-30, they would have more time to raise the needed funds, also shortening it to only three weeks from the previously month-long celebration reduced the

cost. However, anticipating the biennial, museums, galleries, and other part-ner organizations were already planning photography exhibitions for March of that year. FotoFest, too, had a number of exhibition events lined up as well. Among these was a very important, first group exhibition of post-revolution-ary Cuban contemporary photography they had organized in cooperation with Fototeca Havana. Featuring the work of fifteen Cuban photographers, it was to be shown at the Menil Collections' Richmond Hall (March 19-April 17). Making the best of the situation, FotoFest sponsored "Photography Houston Spring '94" (March 19-28), in partnership with Houston Center for Photogra-phy, Houston Art Dealers Association and DiverseWorks, an alternative art space. Promoted as "A ten-day tribute to photography," that included exhibi-tions, panel discussions, and portfolio reviews and culminated with National Women in Photography Conference (March 24-27) held in Houston that year.[13]

Then in November, FotoFest held its '94 biennial, which continued to draw photography professionals and collectors from around the globe, as well as offer the popular portfolio reviews. They announced three rather unconnect-ed themes for the FotoFest exhibitions: *American Voices: Latino Photography in the U.S.*, *The Global Environment*, and *Fashion: Evolution/Revolution*. In the introduction to the '94 catalog, Fred and Wendy likened creating a fes-tival to "shaping a season of operas" claiming that there doesn't need to be a direct connection between each opera but that the season "should repre-sent a breath of creative vision." The '94 biennial, they continue, "represents a concatenation of interests and ideas related to art, politics, history, and ... the future."[14] For a touch of the spectacular, Fred and Wendy worked with Roy Flukinger, Curator at the Harry Ransom Center at University of Texas at Aus-tin, to bring the "first photo" to be shown during the festival. The 1826 helio-graph made by Joseph Nicéphore Niépce of the courtyard of his country es-tate in Gras, France, had been found and purchased by Helmut Gernsheim in 1952 and acquired by the Ransom Center when they purchased the Gernsheim Collection in 1963. Given its rarity and fragility, this image was seldom seen outside the Ransom Center, and even there only seldom on view.[15] In the '94 biennial, FotoFest claimed to cover the gamut from the "first photo" to the fu-ture technology, with the development of "The Earth Forum" referred to as "a simulation of the information highway of the future." Remembering that the internet was still in its infancy as a public medium in the early 1990s, this was a revolutionary technology. The Earth Forum consisted of six computer work-

stations, each representing a continent, "that gave viewers instant access to images and environmental databases from the National Geographic Society, NASA, the World Resources Institute, and Robert Fox's population research" and would be donated to Houston Museum of Natural Sciences after the biennial.[16] Unfortunately, even with all the spectacle, the number of visitors was down to only 62,000 compared to the estimated 230,000 in 1992.[17]

### Discover Photography, Discover Houston

Between 1994 and 1996, with the fundraising help of Daphne Murray (later Gawthrop), Wendy and Fred focused on paying down their debt. Though they had made great strides with the debt, the board nervously suggested they skip the '96 biennial as a money-saving measure. Wendy recalls, "And Fred and I said, 'No, no, no we are not going to skip a biennial. We are going to do '96." They agreed not to use the convention center again due to costs, "Half of the board was terrified that we thought we could," Wendy says. So, with an anxious board, Wendy and Fred needed a financially astute plan and they needed a new location for the biennial. First, they trimmed the budget down from the earlier high of $1.2 million to a frugal $350,000. Then, in a brilliant move, they decided to utilize the empty buildings in the downtown area of Houston. We thought it was "something that was very good for the city and that would stand us in good stead with the downtown district and the historic management districts, which it did," Wendy explains. So, Fred and Wendy went looking for possible spaces. Many buildings remained vacant from the oil bust, and others for much longer as the area had become less desirable.

Wendy remembers contacting the owner of a building that had been empty for over fifteen years, "A curmudgeonly Greek landowner owned it, nobody could get to him, and I figured maybe with my connection with Greeks that I can." She was a bit taken aback when he suggested that they meet for coffee in a rundown hotel known for prostitution. "We talked about Greece for a while, I used about 10 words [of Greek] that I remember," Wendy says, and at the end of the meeting, "he handed me the keys to the building." By the time of the biennial, they had the cooperation of many of the buildings in downtown Houston near Market Square, which became the central location for the festival exhibitions and activities. In total, FotoFest opened eight empty downtown buildings and created temporary art galleries. They also commissioned eight Houston-based artists to create art installations in the downtown historic dis-

trict. For the festival opening, FotoFest hosted a large, opening night street party. An estimated 50,000 people attended and walked through the exhibitions and were treated to music on the streets. Wendy and Fred had hired a lighting specialist, Wendy explains, "we want to make it look like Verona." In the end, it was very bright and looked more like a "small circus" than a town in Italy, but the lights did lend a festive mood to the event. An estimated 195,000 people attended the '96 festival (March 1-31).

The theme announced for the '96 biennial was *Discover Photography, Discover Houston*. Orienting from the historic Market Square, the original town square platted as the city's center by the Allen Brothers in 1839, the FotoFest biennial brought the urban past and future together. In the 1960s, after the 1904 City Hall burned down, the fourth City Hall on that location to be destroyed by fire, the block had been turned into a parking lot and the surrounding buildings became an entertainment center of nightclubs and restaurants. Later, as a gift to the city for the 1976 bicentennial, the Junior League of Houston provided the funds to turn Market Square into a city park. In the 1980s, the alternative art space DiverseWorks spearheaded a multiphase redesign of the park by local artists.[18] Given this history, FotoFest's choice of Market Square as the center of the downtown exhibitions was a recognition of the role the arts can play in the revitalization of an urban center. In many ways, they were both capitalizing on and furthering the work begun by DiverseWorks. That year, FotoFest was awarded the Texas Downtown Association award for the Best Downtown Event in the state.

In keeping with the biennial theme of discovery, Wendy and Fred instituted the first *Discoveries of the Meeting Place* exhibition. Previous year's reviewers were asked to nominate photographers whose work they had "discovered" at the Meeting Place reviews to be designated as "discoveries." From these nominations, FotoFest selects artists to be included in the biennial exhibition, and thus, they will have their work seen by all the most important people in photography from around the world and be included in the FotoFest catalog. *Discoveries of the Meeting Place* continues as an established part of the festival to this day, though it has been renamed to *Ten by Ten*. Other FotoFest curated exhibitions during the '96 biennial included Susan Meiselas' work from her book project, *Kurdistan, In the Shadow of History* (March 2-April 23), which was shown in the Menil Collection's Richmond Hall. FotoFest also sponsored

*The Mountain People of Yunnan Province*, by previously unknown Chinese photographer, Wu Jialin, at the Rice Media Center. Fred had discovered the work of Wu Jialin while visiting French photographer Marc Riboud. Riboud, opening his mail while talking with Fred, received a package from Jialin. Both men were impressed with his work, and Fred invited Jialin to show at the biennial.

Not skipping the '96 biennial turned out to be a wise decision in many ways. Importantly, a FotoFest board member, came up to Wendy during one of the big parties during the festival. Wendy recalls him telling her, "'I'm so impressed that you went ahead and did this.'" In fact, he was so captivated that he forgave their debt to him on the spot. Wendy sighs with relief, "I'll just never forget that moment." This put FotoFest back in the black; the majority of their debt was retired in early 1996. To put this effort in context, Chris Rauschenberg, a cofounder of Blue Sky Gallery, remembers organizing a photo event in Portland, Oregon in October 2011 — one month after the 9/11 tragedy and people were leery of flying. "We were at $90,000 in debt," Chris explains, "and it took a decade to pay that off." In Houston, with Daphne's help and generous donors, Wendy and Fred paid their $750,000 debt off in approximately two years. "We didn't dodge that [the debt]," Fred said, "we just faced it and we came through it."

Though funds for arts organizations are seldom stable, from 1996, FotoFest became much more financially astute. The festival broke even on the $350,000 budget for the '96 biennial. It was estimated that 195,000 visitors attended the festival.

### Back in the black

After the success of the '96 biennial, Wendy and Fred used the format of exhibiting in downtown spaces for the next two festivals, '98 and 2000. The theme for the '98 festival was *Discoveries and Collaborations* and included 18 exhibits organized by FotoFest: contemporary Slovak staged photography; contemporary photography from Mexico; a photographic exhibit from South Africa, with one of the first U.S. presentations of South African artist, William Kentridge; Finnish master photographer Pentti Sammallahti; Brazilian artist Eustaquio Neves; large-scale contemporary Italian landscape photography; and historical Peruvian work by Eugene Courret. During the festival, FotoFest had a meeting with other festival organizers who were in Houston serving as reviewers

at the Meeting Place. From this biennial, FotoFest initiated a global network of major photography events in 22 countries and called it the *Festival of Light* (FoL). Their first act was to develop a website, www.festivaloflight.org, which premiered on Santa Lucia Day, December 13, 1999. This network included 30 festivals across three continents, and "expands international awareness of photography events and encourages international photography, ... exhibition exchanges and internship programs."[19] *Festival of Light* formalized a network of festivals that had been informally brought together through FotoFest.

With their new-found financial stability, Wendy and Fred sought a more permanent space for FotoFest. They had used and rented inexpensive or donated office space throughout the city but wanted to build a more consistent presence. "I remember being on the prowl for interesting buildings, new kinds of buildings in '97," Wendy recounts, "I heard about this building at Vine Street." A Houston developer, Fletcher Thorne-Thomsen, Jr., was redoing an old warehouse north of downtown and turning it into office spaces and artists'

**Opening night, FotoFest Biennial 2008** *Photography from China 1934-2008,* **at Vine Street Studios.** Courtesy of FotoFest.

studios. "It was being redone very beautifully," Wendy explains. Vine Street Studios had exposed beams and brickwork, with lots of white wall space and a functioning loading dock. It became one of the venues for the '98 biennial, and later in 1999, FotoFest moved into a ground floor office and Vine Street Studio became their first permanent office and gallery space. (FotoFest would remain there until 2014, when they would move to a newly-opened Silver Street Studios in Arts District Houston near downtown in the Historic First Ward.) With the move and access to their own gallery space, FotoFest began inter-biennial exhibition programing in earnest, further stabilizing the organization. The ongoing programing helped even out staffing needs as well as keeping FotoFest in the public eye throughout the months between biennials.

By the time FotoFest 2000 occurred, Wendy and Fred had institutionalized most of the core aspects of the festival. Reviews at the Meeting Place, Literacy through Photography Foto Fence of children's work, an auction fundraiser, festival themes, and *Discoveries of the Meeting Place* became the standard fare. Maintaining their international focus, FotoFest exhibitions continued to promote new and important work from around the globe. Wendy and Fred had developed a festival format that began being copied around the globe. Even François Hébel, the then director of the Arles festival that had sparked their imagination, came to learn how FotoFest was operating their portfolio reviews. Additionally, Wendy and Fred had figured out a path to financial stability. Still relying heavily on donor funds and grants, they began to implement other means of raising funds as well. With their new location, FotoFest was able to maintain an ongoing exhibition schedule that allowed them to begin to grow their staff with the hiring of Betsy Phillips as Executive Director. Thus in 2000, after sixteen years of producing eight biennial festivals, FotoFest had become one of the most important photography events, as well as the largest, in the world.

# Conclusion

## Doing the unimaginable

"On a recent trip to New York, a top gallery director dealing with high-end art photography said that Houston is now considered to be second only to New York in this area due to Anne Tucker's extraordinary successes at the Museum of Fine Arts, Houston and our founding of FotoFest. This would have been unimaginable in 1986." Fred Baldwin

The story of how Houston became "second only to New York" is a confluence of timing, vision, and engagement. Hindsight always adds an interesting perspective and the preceding pages have been an attempt to provide the social history of 'who did what and when' to create this international photography scene in such a seemingly unlikely place as Houston. From Bill Agee's idea of a photography department, a vibrant and engaged photography scene grew. What was once unimaginable became imaginable and then continued to grow and flourish. The community of photographers, professionals, collectors, and supporters that Anne and Fred and Wendy fostered in Houston is nothing short of remarkable.

### A City Built on Speculation and Optimism

Houston has always been an entrepreneurial city, a place where you can make things happen. Like many frontier towns, Houston was built on speculation and optimism. Starting with the Allen brothers, who purchased the six thousand swampy acres along Buffalo Bayou with the idea of creating a city,[20] many others followed in hopes of making their fortunes. From its inauspicious beginnings as a wide spot in the sparsely populated, swampy lowlands, individuals have found Houston to be their *tabula rasa*. It has been a place where new, and sometimes seemingly outrageous, ideas can catch on and be supported. As Fred described it, "Houston was a city where early entrepreneurs learned to poke holes in the ground — a million dollars a poke until they went broke or became multi-millionaires."[21] Indeed, Houston is full of stories of grandiose endeavors, some that succeed, and others that do not. In the lore of the city, the losses just become good stories on your way to success. An optimism predominates that smart ideas, with hard work, can be realized in Houston. It is a "can-do" city of entrepreneurial idealists where a few dedicated visionaries with seemingly quixotic ideas could find support to create an internationally recognized photography scene.

It's been almost five decades since museum director Bill Agee promised to build a photography department, and even he didn't dream that it would lead to an internationally recognized photography scene. The Houston story highlights the various push and pull factors that all arts organizations face. Other cities have visionary individuals and have tried to build photography communities, and most have not been able to maintain their organizations. In Houston the core leaders came from outside — Anne, Wendy, and Fred — and found fertile ground and support for new ideas and possibilities in the city.

By the end of the twentieth century, the three core organizations at the heart of the Houston photography scene had claimed their role. As organizations, they had stabilized their programming, built their infrastructure, cultivated financial support, and continued to grow their audience and supporters. Though Houston Center for Photography would continue to struggle financially through the next decade, they had carved out their niche as an important place to see and show photography as well as an organization that supported member photographers through fellowships and exhibition opportunities. While many community members, like Anne Tucker, Clint Willour, and Joan Morgenstern, were involved with supporting multiple organizations, each group played an important and distinct role in creating the Houston photography scene. The photography department at the museum brought a kind of credibility and legitimacy to the Houston efforts as Anne supported and collaborated with HCP and FotoFest events. Houston Center for Photography provided a place for the community to gather, network, and

**Steven Evans, Wendy Watriss, and Fred Baldwin during FotoFest 2016.**
Photo: Laura Corley Burlton.
Courtesy of Laura Corley Burlton.

see photography, while FotoFest brought international attention to photography in Houston. Indeed, Houston, especially during the FotoFest biennials, had become *the* place to be for photography.

## Transitioning from Founders to the Future

With the transition in leadership in the photography department at the museum and FotoFest, and a search for a new executive director at HCP, the photography community has entered a new phase. As it seems with all arts organizations, the challenge for the photography organizations in Houston is to continue to remain relevant, grow their audiences and especially to attract younger photography enthusiasts into the community.

The Houston scene benefited greatly from passionate individuals who arrived in town at the right time, with the right experience, skills, and important connections needed to bring their vision into reality. Moreover, key individuals stayed in Houston, and continued to build their respective organizations. Anne's tenure of 39 years at one museum is unusual. Fred, until his death December 17, 2021, and Wendy have been stalwart Houstonians since beginning FotoFest 39 years ago. Having founders stay the course for so long, until the community became international, vibrant, and sizeable, no doubt contributed to organizational successes. In September of 2013, after curating over 150 exhibitions, Anne announced her upcoming retirement from the museum in June of 2015, and the appointment of her successor Malcolm Daniel, who had been curator at New York's Metropolitan Museum of Art, in December of 2013 —

**Malcolm Daniel and Anne Tucker announce her retirement and his new position as department head, 2013.**
Photo: F. Carter Smith. Courtesy of the Museum of Fine Arts, Houston.

providing for 18 months of overlap to transition leadership of the photography department. FotoFest hired Steven Evans as their Executive Director in February 2014, allowing Fred and Wendy to step back from the day-to-day running of the organization, and remain as involved as they chose. These planned transitions that allowed for involvement of both the founders and their successors for a lengthy period facilitated a smoother shift in both organizations.

In contrast, Houston Center for Photography (HCP), the third pillar of the community, has had a number of leaders over the years, some leaving abruptly. A handful of the founders have continued to support the organization in that time, though their participation has ebbed and flowed. By now, over forty years since its beginning in 1981, most of the original founders are no longer participating, some have moved away, and sadly some have died. Though the museum and FotoFest had lean times and challenges to overcome, HCP has been the most precarious organization financially, in part because there has not been the long-standing involvement of a dedicated founder/leader with a clear, consistent vision who engendered a number of committed, well-resourced supporters like Anne, Wendy, and Fred have done. HCP has had more than thirteen executive directors and interim directors in the nearly four decades since they hired their first in 1983. This is not an unusual challenge for an arts nonprofit

**HCP staff in a moment of joyousness, 2010. Photo: Laura Corley Burlton.**
Courtesy of Laura Corley Burlton.

but it stands out as the difference among the three core Houston organizations. Whereas a number of the initial FotoFest board members are still in place, and the core group of supporters that Anne cultivated are still active at the museum, HCP has not had similar stability of leadership or supporters. Like many other photography centers around the country, HCP has struggled. What appears to have saved them, at least financially, has been the robust educational programming they began after creating a 'digital darkroom' computer lab in 2006. The ongoing courses provide HCP with a steady income stream which makes a significant contribution to the organization's stability.

### And then came COVID

In March 2020, the FotoFest 18th biennial was in full swing. The exhibitions had opened March 8th, and the first group of reviewers and photographers were in town for the Meeting Place, when everything shut down within a week. The Museum of Fine Arts, Houston and the Houston Center for Photography also closed. While there was a great deal of uncertainty as to how long the shutdown would last, the photography scene went on hiatus, and everyone returned home.

As the pandemic dragged on, programming moved to online presentations and staff working remotely. While FotoFest (https://www.youtube.com/user/FotoFestIntl) started their YouTube channel in 2011, and the Museum of Fine Arts, Houston (https://www.youtube.com/c/TheMuseumofFineArtsHouston) began theirs in 2012, Houston Center for Photography did not start theirs until November of 2020. The shutdown led to more active use of the online platforms. In April 2020, FotoFest began a video series of "Creative Conversations" with artists and curators around the world, artist spotlights, and Literacy through Photography activities. Also in April, the museum began hosting "Coffee with a Curator" videos on their channel as well as exhibition tours, family activities, and movie trailers for their film series. It wasn't until November that Houston Center for Photography started posting videos of exhibition tours, lectures, workshops and "Collaborations Conversations." Previously, HCP had sporadically uploaded videos to Vimeo. In addition to the uploaded events on YouTube channels, or Vimeo, other virtual programming was offered as well. At the museum, the photography department hosted a number of live online exhibition tours and conversations for Photo Forum supporters that were not posted online.

In November 2020, the Museum of Fine Arts, Houston was the first arts organization in Houston to reopen their doors with the inauguration of the new Kinder building — the third structure on the museum campus. The major building expansion brought about several changes to the museum. Most striking are those that have impacted access: almost all the talks and events, previously free, now cost up to $25 per ticket, numerous "blockbuster" exhibitions have separate entrance tickets, and the free parking lot has been eliminated. Dues for all the support groups at the museum have also been increased, though free general admission every Thursday, sponsored by Shell Oil Company, continues.

Upon her retirement, Anne was named Curator Emerita and the *Anne Wilkes Tucker Center for Photography*, a study center in the Audrey Jones Beck Building, funded through a donation from longtime supporters Joan and Stanford Alexander, has been named in her honor. Additionally, the *Clint Willour and Anne Wilkes Tucker Young Photographers Endowment* will continue Anne and Clint's passion for identifying and supporting photographers early in their careers. The museum's photography department, now under the direction of Malcolm Daniel, has gained an expanded study room, more onsite storage and a new state-of-the art conservation center with the new museum building. The ongoing photography exhibitions from the collection have been given more wall space, increasing the number of images that can be shown. The department continues to organize four to six major photography exhibits each year.

FotoFest hosts their 19th biennial during fall of 2022 (September 24 to November 6) with the theme *If I Had a Hammer.* As in the past, there are exhibits throughout the city, the Meeting Place reviews, and *Ten by Ten* (previously called the *Discoveries of the Meeting Place*). Under Steven Evans' leadership, FotoFest continues to draw international attention and bring international work to Houston. Many places have sought to replicate FotoFest in their town, so the Houston festival now finds itself one among many. Though it remains one of the largest photography festivals in the world, it now has more competition. FotoFest's new location, since 2014, in Silver Street Studios, a former distribution warehouse that has been redeveloped into an arts complex with workspaces and event venues that hold monthly "Open Studio" Saturdays that are well attended, has increased an ongoing local audience for FotoFest exhibitions.

Houston Center for Photography resumed their exhibition schedule in September 2020 and allowed attendance by appointment only. Exhibition openings were held virtually. It wasn't until the 2022 *Print Auction Walk-Through* (February 11 to March 11, 2022), that regular open hours resumed. In addition to the pandemic, HCP experienced several staff turnovers, including the executive director. Lack of consistent staff and leadership hindered HCP's ability to pivot as well as others during the pandemic. Recently, their thirteenth executive director resigned, and an interim director is now overseeing the organization as they begin recruiting for their next leader. Meanwhile, there remains much to get caught up on. Their magazine publication is delayed over a year and their upcoming exhibition schedule is still being formed. HCP's ongoing challenge in maintaining staff, in combination with rotating board membership, creates a continual uncertainty and instability for the organization. Prior to the shutdown, the educational programming was a significant revenue stream, though this reduced with the move to virtual workshops. Additionally, HCP has ceased print production of its magazine, *SPOT*, which is now only available digitally.

**The joy of photography continues. Group photo of Peter Brown's Continuing Education class at Rice University, 2017.**
Photo: Marybeth Flaherty. Courtesy of Peter Brown

Though so much has happened in the Houston photography scene since Anne arrived in 1975 with all the excitement and passion that went into making the city an international destination for photography, it now seems precarious, or perhaps nascent, once again. It is with optimistic anticipation that we wait to see what the post-COVID scene in Houston will be, and how each organization will adapt, reinvent, and reemerge. Just as Anne wrote in 1977, "For now, the scene, so optimistic on the surface, hangs at a point of fragile balance."[22] COVID has been a catalyst to rethink and reengage; a chrysalis that removes all but the most vibrant aspects that may produce a metamorphosis even more un-imaginable and exciting than the first forty years.

# Endnotes | References | Names Index

# Introduction | Acknowledgements | Chapter 1

1 | Interview with photographer Peter Brown, 17 April 2014.
2 | Irwin, John. 1977. *Scenes*. Beverly Hills, CA: SAGE Publications, p. 84.
3 | Conversation with the author.
4 | e.g., Montgomery, R., T.X. Karner and K. Kosloski. 2003. "Weighing the Success of a National Demonstration to Create State Responsibility for Long Term Care," *Journal of Aging and Social Policy*, 14(3-4): 119-139. Reprinted in: F. Caro & R. Morris (Eds.), *Devolution and Aging Policy*.
New York: Haworth, (2002); Starns, M., T.X. Karner, and R. Montgomery. 2002. "Exemplars of Successful Alzheimer's Demonstration Projects," *Home Health Care Quarterly*, 21 (3-4): 141-175. Reprinted in *A New Look at Community Respite Programs: Utilization, Satisfaction, and Development* (R. Montgomery, editor) Binghamton, NY: Haworth Press, Inc. 2002; Karner, T.X. and Hall, L.C. 2002. "Successful Strategies for Serving Diverse Populations," *Home Health Care Quarterly*, 21 (3-4): 107-132. Reprinted in *A New Look at Community Respite Programs: Utilization, Satisfaction, and Development* (R. Montgomery, editor) Binghamton, NY: Haworth Press, Inc. 2002.
5 | *WAR/PHOTOGRAPHY: Images of Armed Conflict and Its Aftermath*, November 10, 2012–February 2, 2013, exhibition at the Museum of Fine Arts, Houston. https://www.mfah.org/exhibitions/warphotography-photographs-armed-conflict-and-its. Retrieved 23 February 2020.
6 | In 2001 St. Paul's became the first Methodist church in the world with change-ringing bells which are hung in frames that allow them to swing through 360 degrees.
7 | Agee, William C. 1977. "Preface," *Target Collection of American Photography*, exhibition catalog, Houston, TX: Museum of Fine Arts, Houston, p. 4.
8 | Tucker quoted in Avedon, Elizabeth. 2011. "La Lettre de la Photographie: Interview with Anne Wilkes Tucker," http://elizabethavedon.blogspot.fr/2011/07/anne-wilkes-tucker-curator-of.html. Retrieved 23 February 2020.
9 | MFAH director, September 1969-January 1974.
10 | Letter from William "Bill" Agee to Beaumont Newhall, 3 March 1975, RG# 2:6-2-Box 3, File 47, Museum of Fine Arts, Houston (MFAH) Archives, Houston, Texas.
11 | Interview with Anne Wilkes Tucker, 21 November 2013.
12 | Letter from Beaumont Newhall to William C. Agee, 3 March 1975, ©1975 Beaumont Newhall, ©2022, the Estate of Beaumont and Nancy Newhall. Permission to quote courtesy of Scheinbaum and Russek Ltd, Santa Fe, New Mexico; Letter courtesy of the MFAH Museum of Fine Arts, Houston (MFAH) Archives, RG# 2:6-2-Box 3, File 47.
13 | Letter from Anne Tucker to William C. Agee, March 8, 1975. Courtesy of the MFAH Archives, RG# 2:6-2-Box 3, File 47.
14 | Letter from William C. Agee to Anne Tucker, March 24, 1975. Courtesy of the MFAH Archives, RG# 2:6-2-Box 3, File 47.
15 | Anne Tucker Facebook post, May 15, 2017.
16 | Tucker, 2017.
17 | Feed and flour were sold in sacks of cotton fabric printed in floral or other patterns that could be used to make clothing. A typical woman's dress would take three sacks.
18 | Tucker, Anne Wilkes. "Biography2" personal correspondence with author, 26 November 2013.
19 | Tucker, 2013.
20 | Tucker, Anne Wilkes. 2007. "Me/Mine/I" (no page numbers) in *A Girl and Her Room* by Rania Matar. Brooklyn, NY: Umbrage Editions.

288

21 | Morris, Willie. 1967. *North Toward Home*. New York: Houghton Mifflin.

22 | Lifetime Achievement Award Presentation to Anne Tucker (Wendy Watriss interviewer), Houston Fine Art Fair, September 20, 2014.

23 | http://www.census.gov/population/www/documentation/twps027/tab19.txt. Retrieved 15 September 2014.

24 | Tucker, 2013.

25 | Tucker, Anne Wilkes. 2012. "Testimonials from Students of the Visual Studies Workshop, 1999," pp. 259-260 in *Nathan Lyons: Selected Essays, Lectures, and Interviews* (Jessica S. McDonald, editor), Austin, TX: Press Harry Ransom Center Photography Series.

26 | McDonald, Jessica. 2012. "Persistence of Vision," pp. 1-33 in *Nathan Lyons: Selected Essays, Lectures, and Interviews* (Jessica S. McDonald, editor), Austin, TX: Press Harry Ransom Center Photography Series, p. 14.

27 | Tucker, 2012.

28 | Tucker, Anne, "The Eye of the Curator: Honoring Anne Wilkes Tucker," CENTER, Santa Fe, NM, 13 June 2015.

29 | Tucker, 2012.

30 | Tucker, Anne, personal communication with the author, August 1, 2016.

31 | McDonald, 2012, p. 11.

32 | Located at 4 Elton Street.

33 | "Photography," Harry Ransom Center, University of Texas, Austin, Texas. http://www.hrc.utexas.edu/collections/photography/holdings. Retrieved 8 September 2014.

34 | Letter from Harry Ransom Center Archives; read by Wendy Watriss at Lifetime Achievement Award Presentation to Anne Tucker (Wendy Watriss interviewer), Houston Fine Art Fair, September 20, 2014.

35 | Tucker, Anne, personal communication with the author, August 1, 2016.

36 | This is the only publication where Anne is listed as Anne Tucker Cohn–in all her subsequent publications she used Tucker.

37 | Tucker, 2015.

38 | Tucker, Anne Wilkes. 2007. "Lyons, Szarkowski, and the Perception of Photography," *American Art*, 21(3):25-29.

39 | Tucker, 2015.

40 | *PM* was a liberal-leaning daily newspaper published in New York City by Ralph Ingersoll from June 1940 to June 1948 and financed by Chicago millionaire Marshall Field III.

41 | Anspon, Catherine D. 2015 "The Photo Lady: Venerable Curator Brought Houston's Most Striking Images Into the Light," *Paper City*, October 12, https://www.papercitymag.com/arts/photo-lady-venerable-curator-brought-houstons-striking-images-light. Retrieved August 2, 2021.

# Chapter 2

1 | Handbook of Texas Online, Haynes, David, "PHOTOGRAPHY," Uploaded on June 15, 2010. Published by the Texas State Historical Association. http://www.tshaonline.org/handbook/online/articles/kjp01. Retrieved 20 February 2020; "Frederick Scott Archer," International Photography Hall of Fame and Museum, https://iphf.org/inductees/frederick-scott-archer. Retrieved 10 July 2020; Curlee, Kendall, Revised by Randolph B. "Mike" Campbell and Brett J. Derbes, "Stanley, John H. Stephen," Handbook of Texas Online, https://www.tshaonline.org/handbook/entries/stanley-john-h-stephen. Retrieved February 23, 2022.

2 | Galvani, Paul 1983. "Anytown, USA" *Image* (later renamed SPOT), 1(March):6.

3 | Crofford, Ava. 1975. *The Diamond Years of Texas Photography*. Houston: Texas Professional Photographers Association.

4 | "Kaye Marvins Photography," http://www.kayemarvins.com/index.html, Retrieved 4 August 2014.

5 | Part 1, section A, *Scrapbook, 1900–1924*, p. 4, Courtesy of the Museum of Fine Art Houston (MFAH) Archives, RG# 19 Houston Art League Records, digital image, /downloads/5423bf12-c8a8-4628-ab21-81cb1c4e4cd7/view/, Museum of Fine Arts, Houston, Archives, http://www.mfah.org/research/archives. Retrieved 24 May 2014. (Hereafter cited as *Scrapbook*, MFAH Archives.)

6 | Recollection of Miss Roberta Lavender, a member of the first official Board of the Houston Art League and later an instructor in Latin in the University of Texas. From Part 1, Section B, *Scrapbook*, p .78, MFAH Archives; Chautauqua was an adult educational movement popular in the United States around the turn of the twentieth century.

7 | Price, Sarah Renee. 2005. *Plain Living and High Thinking: The Bluebird Club in Boulder*. Thesis. Museum and Field Studies, University of Colorado. p. 8.

8 | Price, 2005, p. 11

9 | p. 4 part 1, section A, *Scrapbook*, MFAH Archives.

10 | Chapman, Betty Trapp, "Ladies' Reading Club (Houston)," Handbook of Texas Online, https://www.tshaonline.org/handbook/entries/ladies-reading-club-houston. Retrieved Aug 4, 2014.

11 | McArthur, Judith N. 1998. *Creating the New Woman: The Rise of Southern Women's Progressive Culture in Texas, 1893-1918*. Urbana-Champaign: University of Illinois. p. 77.

12 | The library opened in 1904 in an Italian Renaissance building in downtown Houston at 550 McKinney Street with 13,228 volumes. Kleiner, Diana J., "HOUSTON PUBLIC LIBRARY," Handbook of Texas Online (http://www.tshaonline.org/handbook/online/articles/lch02). Published by the Texas State Historical Association. Retrieved May 26, 2014; Sharon Bice Endelman, "Ideson, Julia Bedford," http://www.tshaonline.org/handbook/online/articles/fid01. Published by the Texas State Historical Association. Retrieved October 05, 2016.

13 | Part II, Section B, *Scrapbook*, p. 62, MFAH Archives.

14 | Part 1, section A, *Scrapbook*, p. 10, MFAH Archives.

15 | "Emma Cherry, one of the earliest professional women artists in Houston, worked in oils, watercolors, pastels, pencil, and charcoal; though at least one critic referred to her use of "modern" laws of color, she painted a number of traditional portraits while living in Houston and experimented with a number of styles. She was known for her paintings of flowers and in 1937 did a study of oleanders to be presented to President Franklin Roosevelt during his visit to Galveston. Her other subjects include landscapes and figures." Henson, Margaret Swett, "CHERRY, EMMA RICHARDSON," Handbook of Texas Online

(http://www.tshaonline.org/handbook/online/articles/fch24), Uploaded on June 12, 2010. Published by the Texas State Historical Association. Retrieved May 27, 2014.

**16** | Part 1, section A, *Scrapbook,* p. 10, MFAH Archives.

**17** | Kirkland, Kate Sayen. 2009. *The Hogg Family and Houston.* Austin: University of Texas Press. p. 202.

**18** | Part 1, section A, *Scrapbook,* p. 12, MFAH Archives.

**19** | Part I, Section A, *Scrapbook,* p. 17, MFAH Archives.

**20** | Part I, Section A, *Scrapbook,* p. 15, MFAH Archives.

**21** | Gray, Lisa. 2011. "Julia Ideson Library is a treasure reclaimed," *Houston Chronicle*, Dec 3. http://www.chron.com/life/gray/article/Gray-Julia-Ideson-Library-is-a-treasure-reclaimed-2338604.php#item-38488. Retrieved July 20, 2017.

**22** | Part I, Section A, *Scrapbook,* p. 29, MFAH Archives.

**23** | *The Key to the City of Houston, 1908,* found in *Scrapbook,* p. 73. MFAH Archives.

**24** | Part 1, Section A, *Scrapbook,* p. 58, MFAH Archives.

**25** | Part I, Section A, *Scrapbook,* p. 75, MFAH Archives.

**26** | Part II, Section B, *Scrapbook,* p. 66, MFAH Archives.

**27** | Membership brochure, "Work Accomplished 1912-1913,"Part 1 Section A, *Scrapbook*, p. 77, MFAH Archives.

**28** | The Curran remains in the MFAH collection (https://www.mfah.org/art/detail/14345).

**29** | Part I, Section B, *Scrapbook*, p. 14, MFAH Archives.

**30** | Part II, Section B, *Scrapbook,* p. 67-68, MFAH Archives.

**31** | Moore, Hank. 2015. *Houston Legends: History and Heritage of Dynamic Global Capital.* New York: Morgan James Publishing, p.31.

**32** | Correspondence from J.S. Cullinan to Mrs. G Waldo, June 22, 1916. Part 1, Section B, *Scrapbook,* pp. 64-5, MFAH Archives.

**33** | Kirkland, 2009, p. 205.

**34** | Newspaper clipping, Part II, Section A, *Scrapbook,* p. 90, MFAH Archives.

**35** | Reynolds, Sarah. 2007. "Houston Reflections: Art in the City, 1950s, 60s, and 70s," Houston: Rice University Connexions. pp. 139- 144. http://cnx.org/content/col10526/1.2. Retrieved 1 August 2016.

**36** | Newspaper clipping, Part II, Section B, *Scrapbook,* p.77, MFAH Archives.

**37** | Newspaper clipping, Part II, Section B, *Scrapbook,* p.77, MFAH Archives.

**38** | Kirkland, 2009, p. 199.

**39** | Kirkland, 2009, p. 208.

**40** | 1925 Annual Report, Art League, Part II, Section B, *Scrapbook,* p. 6. MFAH Archives.

**41** | Newspaper clipping, Part II, Section A, *Scrapbook,* p. 90. MFAH Archives.

**42** | 1925 Annual Report, Art League, Part II, Section B, *Scrapbook,* p. 6. MFAH Archives.

**43** | Curlee, Kendall, "MUSEUM OF FINE ARTS, HOUSTON," Handbook of Texas Online, http://www.tshaonline.org/handbook/online/articles/klm04. Uploaded on June 15, 2010. Published by the Texas State Historical Association. Retrieved June 30, 2014.

**44** | Duffus, R. L. 1928. *The American Renaissance.* NY: AA Knopf.

**45** | Duffus, 1928, p. 269.

**46** | http://www.mfah.org/research/archives/archives-archival-exhibitions. Retrieved 2 September 2018.

**47** | Kirkland, 2009, p. 206.

**48** | Kirkland, 2009, p. 225.

**49** | Office of the Director, RG# 02:02:01. Courtesy of the MFAH Archives; Biographical Note. http://fa.mfah.org/eadprint.asp?id=93; Retrieved 2 September 2018.

**50** | Nina Cullinan gave an additional gift of $100,000 for maintenance; Kirkland, 2009, p. 226.

**51** | "Museum of Fine Arts Architectural History," http://www.mfah.org/about/mfah-architectural-history. Retrieved 1 July 2014.

**52** | Herbert, Lynn M. 1997. "Seeing was Believing: Installations of Jermayne

MacAgy and James Johnson Sweeny," CITE *magazine*. 40 (Winter): 30-33, p. 31.

**53** | "Museum of Fine Arts Architectural History;" Brown, Carol, "CULLINAN, NINA J.," Handbook of Texas Online, http://www.tshaonline.org/handbook/online/articles/fcu46, Uploaded on June 12, 2010. Published by the Texas State Historical Association. Retrieved July 01, 2014.; Curlee, Kendall, "MUSEUM OF FINE ARTS, HOUSTON," Handbook of Texas Online http://www.tshaonline.org/handbook/online/articles/klm04, Uploaded on June 15, 2010. Published by the Texas State Historical Association. Retrieved June 30, 2014.

**54** | Museum of Fine Arts, Houston 1958 Annual Report.

**55** | Marzio, Peter C. 2008. "Introduction." pp. 10-13 in CORE: *Artists and Critics in Residence*. Houston, TX: Museum of Fine Arts, Houston.

**56** | Quoted in Reynolds, 2007. p. 23.

**57** | Marzio, 2008. pp. 10-13.

**58** | "The Short History of Race-Based Affirmative Action at Rice University," 1996. *The Journal of Blacks in Higher Education*, (13), 36-38.

**59** | "History" Texas Southern University, http://www.tsu.edu/About/History.php. Retrieved 5 July 2014.

**60** | Davis-Jones, Jo Anne. 2010. "Legacy of the Pride," *The University of Houston Magazine*, http://www.uh.edu/magazine/10s/features/legacy-of-pride. Retrieved 5 July 2014.

**61** | William Reaves Fine Art, "A Texas Artist Abroad: A Selection of Early Works by Frederic Browne, September 10 - October 2, 2010," exhibition catalog, Houston, Texas.

**62** | Davis-Jones, 2010.

**63** | "Happy Birthday to Hugh Roy Cullen" http://uhdigitallibrary.blogspot.com/2012/07/happy-birthday-hugh-roy-cullen.html. Retrieved 5 July 2014.

**64** | "Happy Birthday to Hugh Roy Cullen"

**65** | "Roy Gustav Cullen Memorial." *UH Through Time: Buildings. UH* special collections, University of Houston Libraries. Retrieved 30 May 2008.

**66** | "History"

**67** | "History"

**68** | "Moments from MFAH History," Courtesy of the MFAH, RG# 05:01, box 7, folder 59, https://www.mfah.org/research/archives/archives-archival-exhibitions#&gid=2f8914d7ee694de1ab-52712990b76e0f&pid=27127943. Retrieved 1 August 2016.

**69** | Reynolds, 2007. pp. 217-224.

# Chapter 3

1 | Following the custom of primogeniture, John's father inherited the title of Baron at the death of his brother, Baron Felicien Menu de Menil who, rather than use the title himself, transferred it to his son; Middleton, William. 2018. *Double Vision*. New York: Knopf.

2 | Karaim, Reed. 2013. "How the de Menils and Their Art Museum Changed Houston," *The Journal of the American Institute of Architects*, uploaded 19 June 2013. http://www.architectmagazine.com/awards/aia-honor-awards/how-the-de-menils-and-their-art-museum-changed-houston_o. Retrieved 28 July 2017.

3 | Aramanda, Geraldine, William Camfield, Clare Elliot, and Don Quaintance. 2010. "Chronology," pp. 272-299 in *Art and Activism: Projects of John and Dominique de Menil*, Laureen Schipsi (Editor), Josef Helfenstein (Introduction), Houston: Menil Collection, p. 276.

4 | Glueck, Grace. 1986. "The De Menil Family: The Medici of Modern Art," *New York Times*, May 18, 1986, Section 6, Page 28, https://www.nytimes.com/1986/05/18/magazine/the-de-menil-family-the-medici-of-modern-art.html. Retrieved 5 July 2014.

5 | Glueck, 1986.

6 | Camfield, William. 2010. "Two Museums and Two Universities: Toward the Menil Collection" pp. 49-73 in Art and Activism, p. in *Art and Activism: Projects of John and Dominique de Menil*, Laureen Schipsi (Editor), Josef Helfenstein (Introduction), Houston: Menil Collection, p. 49.

7 | Smart, Pamela G. 2010. "Aesthetics as a Vocation" pp. 21-40 in Art & Activism, p. in *Art and Activism: Projects of John and Dominique de Menil*, Laureen Schipsi (Editor), Josef Helfenstein (Introduction), Houston: Menil Collection, p. 23.

8 | Quoted in Smart, 2010, p. 23-24.

9 | Quoted Reynolds, Sarah. 2007. "Houston Reflections: Art in the City, 1950s, 60s, and 70s," Houston: Rice University Connexions, p. 24. http://cnx.org/content/col10526/1.2. Retrieved 1 August 2016.

10 | Colacello, Bob. 1996. "Remains of the Dia," *Vanity Fair* Vol 9, September, http://www.vanityfair.com/magazine/archive/1996/09/colacello199609. Retrieved 1 August 2016.

11 | Smart, 2010, p.24.

12 | Brown, Dominique, 1983. "What I admire I Must Possess," pp. 140-147; 192-209 in *Texas Monthly*. https://www.texasmonthly.com/articles/what-i-admire-i-must-possess. Retrieved July 5, 2014.

13 | Glueck, 1986.

14 | Brown, 1983.

15 | Smart, 2010, p.34.

16 | Middleton, William 2018. "The High Society Love Story Behind Dominique and John De Menil's Legendary Art Collection," *W Magazine*, March 7, https://www.wmagazine.com/story/dominique-john-de-menil-art-collection. Retrieved 26 March 2018.

17 | McNamara, Denis. 1999. "Almost Religious: Couturier, LeCorbusier and the Monastery of La Tourette," *Sacred Architecture Journal*. 2(1): 22-26. https://www.sacredarchitecture.org/articles/almost_religious_couturier_lecorbusier_and_the_monastery_of_la_tourette. Retrieved 6 July 2014.

18 | Introduction to the Couturier Collection at Yale University, Archival Register. https://web.library.yale.edu/sites/default/files/files/CouturierCollection.pdf. Retrieved 11 June 2018.

19 | Aramanda, et al., 2010, p. 277.

20 | Brown, 1983.

21 | Russell, John. 1998. "Dominique de Menil, 89, Dies; Collector and Philanthropist," *New York Times*, Jan 1, 1998. http://www.nytimes.com/1998/01/01/arts/dominique-de-menil-89-dies-collector-and-philanthropist.html. Retrieved 6 July 2014.

22 | Quoted in Camfield, 2010, p.51.
23 | Edwards, Katie Robinson. 2014. *Mid-century Modern Art in Texas*. University of Texas Press, ProQuest Ebook Central, http://ebookcentral.proquest.com/lib/uh/detail.action?docID=3443745, p. 176. Created from uh on 2018-06-04 08:36:44.
24 | It was located at the corner of Lamar and W. Dallas, where the Heritage Society is now.
25 | Quoted in Reynolds, 2007, p. 31.
26 | Reynolds, 2007, p. 10.
27 | Aramanda, et al., 2010, p. 278.
28 | Reynolds, 2007, p. 10.
29 | Quoted in Reynolds, 2007, p. 240.
30 | Quoted in Reynolds, 2007, p.25.
31 | Arnold, Miah. 2010. "Vim and Vigor, Indelicate Language and Bursts of Temper: The Story of the de Menil Cadre and the Emergence of Houston's Counterculture Arts and Politics," *CITE magazine*, 82 (Summer): 33-37, p. 34.
32 | Quoted in Reynolds, 2007, p. 31.
33 | Camfield, 2010, p.53-54.
34 | Brutvan, Cheryl with Marti Mayo and Linda Cathcart. 1982. *In Our Time: Houston's Contemporary Art Museum 1948-1982*. Houston, TX: Contemporary Arts Museum, p.23.
35 | Reynolds, 2007, p. 5.
36 | Quoted in Reynolds, 2007, p.123.
37 | Reynolds, 2007, p.123-4.
38 | de Menil, Dominique. 1968. *A Life Illustrated by an Exhibition*. Houston, TX: University of St. Thomas, p.10.
39 | Smart, 2010, p.26.
40 | Camfield, 2010, p. 55.
41 | Aramanda, et al., 2010, p.281.
42 | Camfield, 2010.
43 | Aramanda, et al., 2010, p.282.
44 | Aramanda, et al., 2010, p.283.
45 | Reynolds, 2007, p. 47.
46 | Middleton, 2018, p. 497.
47 | Quoted in Reynolds, 2007, p.212.
48 | Quoted in Smart, 2010, p.23.
49 | Lucas, Peter. 2020. "Gerald O'Grady and the Houston Media Experiment" *Glasstire*, January 25, https://glasstire.come/2020/01/25/gerald-ogra-dy-and-the-houston-media-experiment. Retrieved Feb 17, 2020.
50 | O'Grady, Gerald. 2010. "Lessons in Development: John and Dominique de Menil and the Media Arts," pp. 77-89 in *Art and Activism: Projects of John and Dominique de Menil*. Laureen Schipsi (Editor), Josef Helfenstein (Introduction), Houston: Menil Collection, p. 78.
51 | Lucas, 2020.
52 | Quoted in Reynolds, 2007, p. 250.
53 | Aramanda, et al., 2010, p. 285-6.
54 | O'Grady, 2010, p.82.
55 | Temkin, Ann. 2007. *A Modern Patronage*. Houston: Menil Collection, p. 64.
56 | Quoted in Reynolds, 2007, p.213.
57 | Camfield, 2010, p. 65.
58 | O'Grady went on to initiate media studies curricula at four other universities: University of Texas in Austin, SUNY Buffalo, Columbia University, and New School in New York City; Lucas, 2020.
59 | Camfield, 2010, p. 68-9.
60 | Quoted in Reynolds, 2007, p.13.
61 | Browning, 1983.

# Chapter 4

1 | Audrey Jones Beck later donated her entire collection of impressionist and post-impressionist paintings to the Museum of Fine Arts, Houston. The Audrey Jones Beck Building at the Museum of Fine Arts, Houston, is named in her honor; Kever, Jeannie. 2003. "Houston philanthropist Audrey Jones Beck dies," *Houston Chronicle*, August 25, 2003, https://www.chron.com/news/houston-deaths/article/Houston-philanthropist-Audrey-Jones-Beck-dies-2131456.php. Retrieved 5 May 2012.

2 | Schjeldahl, Peter. 1980. "Art and Money in the City of the Future-Think," *Houston City Magazine*, 4(2): 46-54,97-101, p.50.

3 | Dianne David Obituary. *Houston Chronicle*, March 4-5, 2012. http://www.legacy.com/obituaries/houstonchronicle/obituary.aspx?pid=156247739. Retrieved 30 October 2014.

4 | David Gallery records, 1963-1982, finding Aid, Smithsonian Archives of American Art. https://www.aaa.si.edu/collections/david-gallery-records-10068. Retrieved 3 May 2020.

5 | Howard, Jeremy (editor). 2010. *Colnaghi: The History*. London: Colnagi.

6 | Gee, Helen. 1983. *Photography of the Fifties: An American Perspective*. Tucson, AZ: Center for Creative Photography, University of Arizona, p. 15.

7 | Colorado Photographic Arts Center is still in existence, though Gould severed his ties with the organization in 1980 and opened Camera Obscura Gallery which he ran until 2011; Paglia, Michael. 2015. "Hal Gould, Legendary Figure in the Colorado Photography Scene, Dies at 95," *Westworld*, http://www.westword.com/arts/hal-gould-legendary-figure-in-the-colorado-photography-scene-dies-at-95-6845730. Retrieved 22 May 2018.

8 | Siembab Gallery closed in 1983 after twenty eight years; Focus Gallery closed in 1985 after nineteen years.

9 | Watriss, Wendy. 1984. "Geoff Winningham: In the Beginning," *SPOT*, Fall 2(3):13-15.

10 | Tucker, Anne. 1986 "In Only Sixteen Years," 6 pgs. (no page numbers) in *Houston Foto Fest: The Month of Photography 1986*, Houston, TX: FotoFest.

11 | Pugh, Clifford. 2002. "Texas Gallery owner stretches the boundaries of contemporary art," *Houston Chronicle*, http://www.chron.com/entertainment/article/Texas-Gallery-owner-stretches-the-boundaries-of-2122529.php. Retrieved 17 September 2014.

12 | Hardy, Michael. 2005. "MFAH Donor Gives Beyond His Means," *Houston Chronicle*, August 14. http://www.chron.com/entertainment/article/MFAH-donor-gives-beyond-his-means-1939602.php. Retrieved 2 November 2014.

13 | Schjeldahl, 1980, p. 51.

14 | [no author], 1974. Touts. *Texas Monthly*, July. http://www.texasmonthly.com/content/touts-9. Retrieved 2 November 2014.

15 | Gray, Lisa. 2000. "Revolution in Chrome," *Houston Press*, July 6. http://www.houstonpress.com/2000-07-06/news/revolution-in-chrome/full. Retrieved August 7, 2014.

16 | Gray, 2000.

17 | Gray, 2000.

18 | Quoted in Gray, 2000.

19 | Gershon, Pete. 2014. *Painting the Town Orange: The Stories Behind Houston's Visionary Art Environments*. Charleston, SC: History Press, p. 52.

20 | Fredericka Hunter quoted in Gray, 2000.

21 | The Handbook had been initiated by Philippe de Montebello, but the printing was not completed until after Bill Agee arrived.

22 | Gene Thornton letter to William Agee, 24 January 1975, Courtesy of Museum of Fine Arts, Houston (MFAH) Archives, Houston, Texas, RG# 2:6-2-Box 3, File 47.

**23** | In a letter from William Agee to Beaumont Newhall on 3 March 1975, Bill writes that 365 people attended the lecture. Courtesy of MFAH Archives, RG# 2:6-2-Box 3, File 47,

**24** | Letter from Beaumont Newhall to William C. Agee, 3 March 1975, ©1975 Beaumont Newhall, ©2022, the Estate of Beaumont and Nancy Newhall. Permission to quote courtesy of Scheinbaum and Russek Ltd, Santa Fe, New Mexico; Letter courtesy of the Museum of Fine Arts, Houston (MFAH) Archives, RG# 2:6-2-Box 3, File 47.

**25** | John Szarkowski letter to William Agee, 17 June 1975, Courtesy of MFAH Archives, RG# 2:6-2-Box 3, File 45.

**26** | William Agee letter to John Szarkowski, 23 July 1975, Courtsey of MFAH Archives, RG# 2:6-2-Box 3, File 45.

**27** | Rowell, Charles Henry. 2009. "An Interview with Alvia Wardlaw," *Callaloo*, 32(1): 261-276. p. 265.

**28** | Woodward, Richard B. 2014. "Picture-Perfect Career: A Cultural Conversation With Anne Wilkes Tucker," *Wall Street Journal*. http://online.wsj.com/news/articles/SB10001424052702304914904579439602433136322. Retrieved 10 April 2014.

**29** | Tucker, Anne and John Scarborough. 1977. "Contemporary Photography in Houston," *ArtSpace* 1(4): 4-8, p. 6.

**30** | Houstonians tell the story that at the end of Edward Weston's exhibition he offered to sell the museum his prints for $5 apiece, but the museum declined. They would be worth a small fortune today.

**31** | Aramanda, Geraldine, William Camfield, Clare Elliot, and Don Quaintance. 2010. "Chronology," pp. 272-299 in *Art and Activism: Projects of John and Dominique de Menil,* Laureen Schipsi (Editor), Josef Helfenstein (Introduction), Houston: Menil Collection, p. 282.

**32** | Tucker, Anne, communication with the author, 1 August 2016.

**33** | De Montebello had come to Houston from the MET in 1969, at the age of 33, and is remembered for being uninterested in mingling or even understanding Houston society. "He was never that comfortable here" one person recalled. Montebello's most notable achievement was the museum's first major capital campaign, which exceeded its goal of 15 million dollars.

**34** | Barnstone, Howard, Henri Cartier-Bresson (Photographs), Ezra Stoller (Photographs), Peter Brink (Afterword). 1994 [1966]. *The Galveston that Was*, Houston, TX: Rice University Press. Book jacket text.

**35** | Trustee Meeting 17 March 1976 minutes. Courtesy of MFAH Archives, RG# 1:1 series 1 Trustee Records.

**36** | Handwritten correspondence from Joan Alexander to William C. Agee, 22 February 1977. Courtesy of MFAH Archives, RG# 5, Series 1, Box 84, Files 6-25.

**37** | Scarborough, John. 1977. "The museum's new photo treasure" *Houston Chronicle Magazine*, Sunday, March 6, pp. 7-11,12.

**38** | Scarborough, 1977.

**39** | Quoted in Dayton Hudson Corporation Foundation. 1977. "Community Giving for 1977," *1977 Annual Report*, pp. 20-21.

**40** | Brutvan, et al., 1982, p.51.

**41** | Brutvan, et al, 1982, p.52.

**42** | Hardy, 2005.

**43** | Trustee Meeting Minutes,15 September 1976. Courtesy of MFAH Archives, RG# 1:1 series 1.

**44** | At the time, the Library of Congress was printing the Farm Security Administration images from the original negatives.

**45** | Trustee Meeting Minutes, 20 October 1976. Courtesy of MFAH Archives, RG# 1:1 series 1.

**46** | This building was razed in 2016 as a part of the museum's expansion plan.

**47** | "MFAH Architectural History," http://www.mfah.org/about/mfah-architectural-history. Retrieved 23 Sept 2014.

**48** | Quoted in Scarborough, 1977.

**49** | Tucker, Anne. 1986. "In Only Sixteen Years," 6 pgs. (no page numbers) in *Houston Foto Fest: The Month of Photography 1986*, Houston, TX: FotoFest.

**50** | Scarborough, 1977.

**51** | Letter from John Szarkowski to William Agee, 10 September 1976. Courtesy of MFAH Archives, RG# 5, Series 1, Box 84, Files 6-25.

**52** | Letter from John Szarkowski to William Agee, 10 September 1976. Courtesy of MFAH Archives, RG# 5, Series 1, Box 84, Files 6-25.

**53** | Press Release and Wall Text, *The Photographic Process*. Courtesy of the MFAH Archives, RG# 5 Series 1 Box 84 Files 6-25.

**54** | Scarborough, 1977.

**55** | Crossley, Mimi. 1977. "Target Collection debuts at MFA ," *Houston Post*, Friday, Feb 25, 1977, page 1C.

**56** | Thornton, Gene. 1979. "Photographic View," *New York Times*, Sunday Aug 5, p. D 29.

**57** | Tucker and Scarborough. 1977, p. 8.

**58** | Tucker, Anne Wilkes. 2015. "The Eye of the Curator: Honoring Anne Wilkes Tucker," CENTER, Santa Fe, NM, June 13.

**59** | Tucker and Scarborough. 1977, p. 8.

# Chapter 5

| Agee, William C. 1979. Untitled Essay in *The Anthony G. Cronin Memorial Collection* (Anne Tucker, editor), Houston, TX: The Museum of Fine Arts, Houston.

**2** | Interview with Ed Hill and Suzanne Bloom, 10 February 2014.

**3** | Tucker, Anne and John Scarborough. 1977. "Contemporary Photography in Houston," *ArtSpace* 1(4): 4-8, p. 6.

**4** | Philadelphia College of Art later became University of the Arts in 1985 when it merged with Philadelphia College of the Performing Arts.

**5** | Sozanski, Edward J. 1993. "Remembering a teacher-artist who worked here," *Philly.com*, http://articles.philly.com/1993-10-08/entertainment/25935850_1_cezanne-bibemus-quarry-richard-diebenkorn retrieved 19 Sept 2013.

**6** | Interview with George Krause, 1 April 2014.

**7** | https://www.moma.org/calendar/exhibitions/3441. Retrieved 12 June 2018.

**8** | Museum of Modern Art (MOMA) Press Release, 28 March 1963. https://www.moma.org/momaorg/shared/pdfs/docs/press_archives/3131/releases/MOMA_1963_0043_42.pdf?2010. Retrieved 11 Aug 2015.

**9** | Ennis, Michael. 2001. "Image Conscious," *Texas Monthly*. http://www.texasmonthly.com/content/image-conscious/page/0/1 Retrieved 24 Oct 2014.

**10** | Ennis, 2001.

**11** | Hill, Edward. 1966. *The Language of Drawing*. New York: Prentice-Hall.

**12** | Ennis, 2001.

**13** | Ennis, 2001.

**14** | Hill quoted in Ennis, 2001.

**15** | Schjeldahl, Peter. 1980. "Art and Money in the City of the Future-Think," *Houston City Magazine* 4(2): 46-54,97-101, p.52.

**16** | Geoff Winningham interview in Reynolds, Sarah. 2007. *Houston Reflections: Art in the City, 1950s, 60s and 70s*, p.251.

17 | Peter's ongoing contributions to photography in Houston have included teaching community courses at Rice University's Glasscock School for over 40 years. In recognition of his work, an art gallery at the Glasscock School was created in his honor and named for him in 2014, and November 3, 2008 was declared "Peter Brown Day" by Bill White, mayor of Houston in recognition of Brown's service to the arts.

18 | Winningham quoted in Reynolds, 2007, p.253.

19 | http://www.petertbrown.com/biocv. Retrieved 28 October 2014.

20 | Brown, Peter T. 1988. *Seasons of Light*. Houston, TX: Rice University Press.

21 | Lohse, Bernd. 1981. "Photography Europe 1," Houston, TX: Benteler Galleries, Inc.

22 | 1981 Houston Arts Calendar, Wordworks, Inc. Houston, TX. (no page number).

23 | Hall, John. 1983. "Hallowed Walls." *SPOT* Spring. 1(1): 14.

24 | Tucker, Anne. 1986. "In Only Sixteen Years," (no page numbers) in *Houston Foto Fest: The Month of Photography 1986*, Houston, TX: FotoFest.

25 | Graham Gallery/William A. Graham Archives, 1964-1992, Museum of Fine Arts, Houston Archives, Biographical or Historical Note. http://fa.mfah.org/main.asp?target=eadidlist&id=58&action=3. Retrieved 23 May 2018.

26 | http://lawndaleartcenter.org/about/index.shtml. Retrieved 14 August 2015.

27 | http://www.thehoustonartcarparade.com/art-car-parade. Retrieved 14 August 2015.

28 | Hall, 1983. p. 14.

29 | Tucker, 1986. (no page numbers).

30 | Hall, 1983. p. 14.

31 | MacMillan, Margaret. 2009. "Rebuilding the world after the Second World War," *The Guardian*. 11 September. https://www.theguardian.com/world/2009/sep/11/second-world-war-rebuilding. Retrieved 21 December 2018.

32 | Plate, Markus and Torsten Groth. 2011. *Große Deutsche Familienunternehmen: Generationenfolge, Familienstrategie und Unternehmensentwicklung*. Göttingen, Germany: Vandenhoeck & Ruprecht, p.74.

33 | "Values and Traditions," Benteler Corporation. https://www.benteler.com/about-us/values-and-tradition. Retrieved 20 December 2018.

34 | Gymnasium is the highest form of German secondary school.

35 | Baldwin, Frederick and Wendy Watriss. 2010. *Looking at the U.S. 1957-1986*. Amsterdam: Mets and Schilt Publishers.

36 | de Menil, Dominique. 1980. "Foreword" in *Transfixed by Light*, Houston, TX: Menil Foundation.

37 | "History," Blaffer Museum, University of Houston, Houston, Texas, http://www.blafferartmuseum.org/musuem-history. Retrieved 28 October 2014.

38 | "History."

39 | Tucker and Scarborough, 1977.

40 | Tucker and Scarborough, 1977, p. 8

41 | Tucker and Scarborough, 1977, p. 8

42 | Tucker, 1986. (no page numbers).

43 | 1981 Houston Arts Calendar, June 1.

44 | "Sally Gall: Artists Statement" Saul Gallery. http://www.saulgallery.com/artists/sally-gall/show:statement. Retrieved 5 November 2014.

45 | 1981 Houston Arts Calendar, August 24.

46 | 1981 Houston Arts Calendar, inside front cover.

47 | Karl Killian letter to Anne Tucker, 3 February 1979. Courtesy of MFAH Archives, RG# 4:6 Series: 1.2.1, Box 1.

48 | "Oil bust, space tragedy and Chronicle sale," 2001. *Houston Chronicle*, October 14, http://www.chron.com/about/first-100/article/Oil-bust-space-tragedy-and-Chronicle-sale-2069956.php. Retrieved November 4, 2014.

# Chapter 6

1 | "Oil bust, space tragedy and Chronicle sale," 2001. *Houston Chronicle*, October 14, http://www.chron.com/about/first-100/article/Oil-bust-space-tragedy-and-Chronicle-sale-2069956.php. Retrieved 4 November 2014.

2 | Christopher Byron (1981-06-21). "Problems for Oil Producers," *Time Magazine*. http://content.time.com/time/magazine/article/0,9171,950550,00.html. Retrieved 4 November 2014.

3 | Belkin, Lisa. 1989. "NOW, IT'S REMEMBER THE OIL BUST!" *New York Times*, October 22, 1989. http://www.nytimes.com/1989/08/22/business/now-it-s-remember-the-oil-bust.html. Retrieved 4 November 2014.

4 | Robert D Hershey, Jr. (1981-06-21). "How the oil glut is changing business," *The New York Times*. http://www.nytimes.com/1981/06/21/business/how-the-oil-glut-is-changing-business.html?pagewanted=1. Retrieved 4 November 2014.

5 | "Oil bust, space tragedy and Chronicle sale,"2001.

6 | Thompson, Derek. 2013. "Houston is Unstoppable," *The Atlantic*. May 28, 2013. http://www.theatlantic.com/business/archive/2013/05/houston-is-unstoppable-why-texas-juggernaut-is-americas-1-job-creator/275927. Retrieved 4 November 2014.

7 | Belkin, 1989.

8 | "Oil bust, space tragedy and Chronicle sale,"2001.

9 | Trafton, Lynn. 1983. "Gallery Circuit Ups and Downs" *Image* (later renamed *SPOT*), Spring 1983, http://spot.hcponline.org/pages/gallery_circut_ups_and_downs_1194.asp. Retrieved 5 November 2014.

10 | Trafton, 1983.

11 | Trafton, 1983.

12 | Watriss, Wendy. 1984. "Anne Tucker Changes" *Image* (later renamed *SPOT*), 2(Spring):11,24.

13 | Crossley, David. 1983. "The Short Hectic Life of a Photo Group," *Image* (later renamed *SPOT*), Spring 1983. http://spot.hcponline.org/pages/the_short_hectic_life_of_a_photo_group_1180.asp. Retrieved 5 November 2014.

14 | Tucker, 1986.

15 | Crossley, 1983.

16 | Crossley, 1983.

17 | Watriss, 1984.

18 | Crossley, "The Short, Hectic Life of a Photo Group," 1983; Trafton, 1983; The Cronin Gallery, which had been an important hub for the community, "had ceased to be a photography gallery and the number of people wanting to show work was much greater than the space available that a crisis had arisen." Perhaps to remain financially viable, Cronin gallery had diversified and begun to show paintings and ceramics in addition to photography. Elsewhere in the U.S., LIGHT Gallery and Photographers Gallery in New York City had quietly closed to the public in 1980. LIGHT Gallery was later resurrected under director Robert Mann in 1983 and closed for good in 1987. http://www.nytimes.com/2001/06/04/arts/tennyson-schad-70-lawyer-founded-photography-gallery.html. Retrieved 28 August 2015.

19 | Tucker, Anne, personal papers; Paradise Bar and Grill was located at 401 McGowen.

20 | A number of galleries were opening in the museum district. Cronin Gallery was next door to Texas Gallery on Bissonnet; Later both moved to the River Oaks area where Moody Gallery had opened in 1975.

21 | Tucker, Anne, personal papers.

22 | Houston was one of the main re-settlement cities for individuals leaving Vietnam in the late 1970s.

23 | *CITE Magazine*. http://www.ricedesignalliance.org/programs/cite-magazine. Retrieved 24 September 2015.

**24** | HWCA Newsletter, December 1981, p. 3, Houston Women's Caucus for Art Records, Courtesy of Carey C. Shuart Women's Archives and Research Collection, University of Houston Libraries.

**25** | Maggie Olvey worked at the museum and was a founding member of HCP.

**26** | Crossley, David in "35 Years of HCP" (video), http://www.hcponline.org/give/hcp35. Retrieved 24 September 2015.

**27** | Lang, Ellen. 1992. "Delving into HCP's Ten-Year History" *SPOT*, 11(1):5-7.

**28** | Lang, 1992.

**29** | Lang, 1992.

**30** | The review was later published in the first edition of HCP's magazine. Crossley, Mimi. 1983. "Members' First Exhibition," *Image*. 1 (March): 8.

**31** | Crossley, Mimi. 1983, p. 8. Paul Hester donated the print mentioned, *Colorado River, Smithville, Texas*, to the Museum of Fine Arts, Houston in honor of Charles Schorre, https://emuseum.mfah.org/objects/41825/colorado-river-smithville-texas?ctx=8e938ce565a7fb740b0d99f-f8607e558070f15b6&idx=8.

**32** | Crossley, Mimi. 1983, p. 8.

**33** | Crossley, 1983, p. 3.

**34** | Walter Hopps, the director of the Menil Collection, hired David Crossley to print Hopper's negatives for an exhibition in London. While printing, David asked Hobbs if Houston Center for Photography could have a set of these prints for a show, and Hopps agreed, which is how the HCP's *Dennis Hopper and His Friends* came about. Crossley, David. 1983. "Dennis Hopper and Friends" *Image* 1(Spring): 21.

**35** | Crossley in "35 Years of HCP."

**36** | Located at 5020 Montrose.

**37** | McLanahan, Lynn. 1983. "Going, Going, Gone" *Image* 1(Spring):2.

**38** | McLanahan, 1983, p. 2.

**39** | The Shamrock Hotel was rumored to be the inspiration for Edna Farber's Jett Rink in Giant. It was a Texas sized extravaganza with a swimming pool large enough to hold water skiing events. In *Painting the Town Orange* (Charleston, SC: History Press, 2014), author Pete Gershon writes, "Frank Lloyd Wright purportedly turned to his apprentice Fay Jones and said, 'That, young man, is an example of the effects of venereal disease on architecture.'" p. 36.

**40** | Limmer, Hans and David Crossley. 2013. *Paulinchen*. Tulipan; Auflage.

**41** | "About KPFT," http://kpft.org/about/#1429296836-2-22. Retrieved 7 August 2015.

**42** | "About KPFT."

**43** | Crossley in "35 Years of HCP."

**44** | Crossley, 1983, p. 3.

**45** | Hidalgo, Marty.1983. "The Nude Censored," *Image/SPOT* 1 (Winter): 3.

**46** | HCP Newsletter, July 1984, Anne Tucker personal papers.

**47** | HCP Newsletter, July 1984, Anne Tucker personal papers.

**48** | Crossley, David. 1984. "Why not SPOT?" *SPOT*, 2(3 Fall):4.

**49** | Crossley, 1984, p. 4.

**50** | Crossley, 1984, p. 4.

**51** | Crossley, 1983, p 3.

**52** | Lang, 1992.

**53** | *Image* magazine was later renamed *SPOT* in 1984.

**54** | Lang, 1992.

**55** | Byrne-Dodge, Teresa. 1983, "Anne Tucker," *Houston Post*, Face to Face section, Sunday August 14, p. 8F.

**56** | McLanahan, Lynn. 1983. "Photography in Houston," *Art Space*, Spring: 30-33.

# Chapter 7

1 | Eaton, Collin. 2016. "1980s oil bust left a lasting mark," *Houston Chronicle*, Wednesday August 31, 2016. https://www.chron.com/local/history/economy-business/article/The-1980s-oil-bust-left-lasting-mark-on-Houston-9195222.php#photo-10854489. Retrieved 26 February 2018.

2 | Watriss, Wendy. 1984. "Anne Tucker Changes" *Image* (later renamed *SPOT*), Houston: Houston Center for Photography. http://www.hcponline.org/publications/spot-issues/spring-1984/anne-tucker-changes. Retrieved 26 February 2018.

3 | Hurt III, Harry. 1986. "Hard Times in River Oaks: How Houston pinches pennies," *Vanity Fair*, 49(5, May): 24; Thompson, Derek. 2013. "Houston is Unstoppable," *The Atlantic*. May 28, 2013. http://www.theatlantic.com/business/archive/2013/05/houston-is-unstoppable-why-texas-juggernaut-is-americas-1-job-creator/275927. Retrieved 4 November 2014.

4 | Initially the festival was two words, Foto Fest, and later became one word, FotoFest. The European spelling "foto" was chosen to reflect the international approach of the festival.

5 | Wendy Watriss and Fred Baldwin, awardees, (Anne Tucker, interviewer), Lifetime Achievement Award, Houston Art Fair. 21 September 2013.

6 | Baldwin and Watriss, talk at Menil Collection, Houston, Texas, 17 March 2014.

7 | Estrin, James. 2012. "Partners in Words, Pictures and Life," Lens blog, *New York Times*. 8 March 2012. https://lens.blogs.nytimes.com/2012/03/08/partners-in-words-pictures-and-life. Retrieved 28 February 2018.

8 | WTOC. 2011. "The Truth about Tiger Ridge," WTOC.com, http://www.wtoc.com/story/16104720/the-truth-about-tiger-ridge?clienttype=printable. Retrieved 1 March 2018.

9 | Rosen, Kenneth R. 2014. "We Are Not Inbred," Narratively.com, http://narrative.ly/we-are-not-inbred. Retrieved 1 March 2018.

10 | "Tiger Ridge" n.d. Keepsavannahstrange.com, http://keepsavannahstrange.com/places.html. Retrieved 1 March 2018.

11 | Wendy Watriss and Fred Baldwin, awardees, (Anne Tucker, interviewer), Lifetime Achievement Award, Houston Art Fair. 21 September 2013.

12 | Canonne, Xavier. 2009. "Surviving in Beauty," pp. 13-21 in *Looking at the U.S. 1957-1986* (by Frederick Baldwin & Wendy Watriss), Amsterdam: Mets & Schilt Publishers.

13 | Kiely, Declan. 2016. "Paging Dr. Baldwin," The Morgan Library and Museum, http://www.themorgan.org/blog/paging-dr-baldwin. Retrieved 7 August 2017.

14 | The Newsletter of the W. H. Auden Society, September 1993, Newsletter No 10-11. http://www.audensociety.org/10-11newsletter.html. Retrieved 7 March 2018.

15 | The Newsletter of the W. H. Auden Society, September 1993.

16 | "Robert Gamble Baldwin '45," Princeton Alumni Weekly Memorials Online. https://paw.princeton.edu/memorial/robert-gamble-baldwin-%E2%80%9945. Retrieved 2 February 2021.

17 | Drukker, Leendert. 1972. "Fred Baldwin: Adventure is my bag" *Popular Photography*, June, 70(6): 102-103, 132-133.

18 | Baldwin and Watriss talk, 2014.

19 | Baldwin, Fred. 2007. *Dear Monsieur Picasso*. www.zonezero.com. Retrieved 10 March 2018. A more detailed account was later published in Baldwin, Fred. 2019. *Dear Mr. Picasso: An illustrated love affair with freedom*, Amsterdam: Schilt Publishing.

20 | Baldwin and Watriss talk, 2014.

21 | Baldwin, 2007.

22 | Baldwin, 2007.

23 | Baldwin and Watriss talk, 2014.

24 | Baldwin, 2007. The images were lost for several years, and the unstable film transparencies faded. The some of the resulting images were exhibited at the Menil Collection (13 March to 6 July 2014) as well as reproduced in the later book, Baldwin 2018.

25 | Baldwin and Watriss talk, 2014.

26 | Drukker, 1972.

27 | Artist's Statement, "Fred Baldwin: Saturday in Reidsville, Georgia 1957." Houston Center for Photography. Exhibition 6 November – 12 December 1982.

28 | Baldwin and Watriss talk, 2014.

29 | Drukker, 1972

30 | Baldwin, 2007.

31 | Drukker, 1972.

32 | Baldwin, Fred. 1983. "We ain't what we used to be": Photographs, Savannah, GA: Telfair Academy of Arts and Sciences.

33 | March 10, 1963.

34 | Frank H. Ames home was 420 Roblar Ave., Hillsborough, CA 94010.

35 | LIFE Magazine, 8 June 1942. Cover photo caption. http://www.cbi-theater. com/life060842/life060842.html. Retrieved 12 September 2016.

36 | "F.N. Watriss to Wed H.B. Alexander," Brooklyn Daily Eagle. New York. April 10, 1917. p. 2.

37 | Frederic Newell Watriss. 1912. "Secretary's Report: For the Twentieth Anniversary." No. V. (Harvard College, Class of 1892), p. 166.

38 | Diliberto, Gioia. 1987. Debutante: The Story of Brenda Frazier. New York: Alfred A. Knopf.

39 | Diliberto, 1987, p. 36.

40 | Diliberto, 1987, p. 61.

41 | "James Barney Watriss Obituary," 1998. Baltimore Sun, June 6, 1998. http:// articles.baltimoresun.com/1998-06-06/ news/1998157063_1_nathan-briggs-watriss-church-of-baltimore. Retrieved 10 March 2018.

42 | [no author listed] 1942. "Lorraine Ames married; Ex-Millbrook Student Bride of James B. Watriss of New York." New York Times, April 28, p. 17.

43 | 622 Hurlingham Ave, San Mateo, CA 94402.

44 | Diliberto, 1987.

45 | This is the ship featured in the movie, An Affair to Remember with Deborah Kerr and Cary Grant.

46 | Hatzinikolaou, Prokopis. 2012. Business. 9 April. http://www.ekathimerini. com/144364/article/ekathimerini/business/where-do-the-richest-and-poorest-greeks-live. Retrieved 10 March 2018.

47 | "Psychiko" https://en.wikipedia.org/ wiki/Psychiko. Retrieved 10 March 2018.

48 | "Katherine Delmar Burke School History," https://www.kdbs.org/page/ about-old/our-school/history. Retrieved 20 March 2018.

49 | "Potomac School. 100-plus years," https://www.potomacschool.org/about-us/100-plus-years. Retrieved 20 March 2018.

50 | Bryan, C.D.B. 1976. Friendly Fire. New York: Penguin.

51 | "Obituaries: Frederic W. Watriss," 1997. MIT News, March 19. http://news.mit. edu/1997/obits-0319. Retrieved 23 March 2018.

52 | Cook, Joan. 1979. "Archibald Alexander, 72," New York Times, September 6, p. 21. https://www.nytimes.com/1979/09/06/ archives/archibald-alexander-72-lawyer-served-as-army-under-secretary-on-a.html. Retrieved 23 March 2018.

53 | Robinson, Mary. 2012. Everybody Matters: A Memoir. London: Hodder & Stoughton Ltd., pp. 24-25.

54 | de Brèadùn, Deaglàn. 2012. "Shy, deeply spiritual and almost an actor. The lesser-known Mary Robinson," interview. Irish Times, 15 September. https://www. irishtimes.com/culture/books/shy-deeply-spiritual-and-almost-an-actor-the-lesser-known-mary-robinson-1.531452. Retrieved 20 March 2018.

55 | The St. Petersburg Times was renamed the Tampa Bay Times in 2012.

56 | At the time, public stations were called Educational Television and were operated independently. Friendly sought

to create an interconnection between the various stations with PBL by broadcasting the same show at the same time on every National Educational Television (NET) station. His efforts were the beginning of what is now known as Public Broadcasting Service. PBL was on air 1967-1969 and produced 53 episodes.
Ledbetter, James. 1997. *Made Possible By... :The Death of Public Broadcasting in the United States.* London: Verso, U.K.

**57** | Advertisement. *New York Times*. 5 November 1967: E12. https://www.tvob-scurities.com/spotlight/pbl-public-broad-cast-laboratory. Retrieved 24 March 2018.

**58** | Avram Westin on "Public Broadcasting Laboratory" - emmytvlegends.org; https://www.youtube.com/watch?v=r00M-Jc4OPU4. Retrieved 24 March 2018.

**59** | The entire PBL program from 28 April 1968 which includes the "Marijuana — A Proposal" segment is online at https://www.youtube.com/watch?v=O2WMu2eb-QS4 (as of 24 March 2018).

**60** | "Marijuana — A Proposal," Public Broadcasting Laboratory, April 28, 1969. Joseph M. Russin and Wendy V. Watriss, producers.

**61** | No author listed. 1968. "Closed Circuit," *Broadcasting: The Business Weekly of Television and Radio* (Dec 9), 75(21):5.

**62** | "Closed Circuit," 1969. (Feb 24), 76(8): 5.

**63** | Wolff, Perry. 2017. "I was never in the CIA," *Perry Wolff: Odd Man In* (Blog post 3 May 2017). http://perrywolff.info/2017/05/03/i-was-never-in-the-cia. Retrieved 25 March 2018.

**64** | Canonne, Xavier. 2009. "Interview by Xavier Canonne," pp. 196-205 in *Looking at the U.S. 1957-1986* (by Frederick Baldwin & Wendy Watriss), Amsterdam: Mets & Schilt Publishers, p. 198.

**65** | Simon, Paul. 1972. "America," single by Simon and Garfunkel. Columbia Records.

**66** | Daloz, Kate. 2016. *We Are As Gods: Back to the Land in the 1970s and the Quest for a New America.* New York: Public Af-fairs, Excerpted in *Utne Reader*, September 2016. https://www.utne.com/environment/back-to-the-land-movement-ze0z1609zfis. Retrieved 27 March 2018.

**67** | Canonne, 2009, p. 199.

**68** | Canonne, 2009, p. 199.

**69** | Canonne, 2009, p. 200.

**70** | Estrin, 2012.

**71** | Baldwin & Watriss talk, Museum of Fine Arts, Houston, 27 October 2009.

**72** | Watriss, Wendy and Fred Baldwin. 1975. *Wendy Watriss and Fred Baldwin, January 10-March 5, 1975* [Exhibition catalog]. Washington, DC: Phillips Collection (no page number).

**73** | Watriss and Baldwin, 1975 (no page number).

**74** | Juneteenth refers to the "celebration commemorating the ending of slavery in the United States. Dating back to 1865, it was on June 19th that the Union soldiers, led by Major General Gordon Granger, landed at Galveston, Texas with news that the war had ended and that the enslaved were now free. Note that this was two and a half years after President Lincoln's Emancipation Proclamation–which had become official January 1, 1863." http://www.juneteenth.com/history.htm. Retrieved 28 March 2018.

**75** | Guest Book, *Frederick Baldwin and Wendy Watriss: Photographs from Grimes County* Exhibition files. Courtesy of Menil Archives, The Menil Collection, Houston.

**76** | Castro R., Fernando. 2012. "A Life Involved, Part II," *Literal Magazine*, 28. http://literalmagazine.blogspot.com/2012/04/life-involved-wendy-watriss_16.html. Retrieved 3 July 2017.

**77** | Scarborough, John. 1977. "Grimes County show broad," Art section. *Houston Chronicle*. June 8. Courtesy of Menil Archives, The Menil Collection, Houston. *Frederick Baldwin and Wendy Watriss: Photographs from Grimes County* Exhibition files.

**78** | Crossley, Mimi. 1977. "Symphonic Photography," *Houston Post*. April 17. p.36. Courtesy of Menil Archives, The Menil Col-

lection, Houston. *Frederick Baldwin and Wendy Watriss: Photographs from Grimes County* Exhibition files.

**79** | Watriss, Wendy and Fred Baldwin. 1991. *Coming to Terms*. College Station: Texas A&M Press.

**80** | Tackett, Helen. 1975. "The Changing Face of Austin," ON CAMPUS for March 3-9, University of Texas. p. 4. Courtesy of Menil Archives, The Menil Collection, Houston. *Frederick Baldwin and Wendy Watriss: Photographs from Grimes County* Exhibition files.

# Chapter 8

**1** | Canonne, Xavier. 2009. "Interview by Xavier Canonne," pp. 196-205 in *Looking at the U.S. 1957-1986* (by Frederick Baldwin & Wendy Watriss), Amsterdam: Mets & Schilt Publishers, p. 201.

**2** | Bennett, Elizabeth. 1981. "At Home: Fred Baldwin and Wendy Watriss," *The Houston Post*, section AA, Saturday, June 27.

**3** | Wendy and Fred did eventually marry in June of 2003 in New York City at the dying request of Fred's brother Gamble, who passed away in December 2003.

**4** | Sherman, Rebecca. 2015. "Inside The Menil's Odd Montrose Bungalow: FotoFest's Founders Thrive in a Unique Home," *Paper City*, 07.31.15, http://www.papercitymag.com/interiors/menil-odd-montrose-bungalow-fotofest-founders-unique-home. Retrieved July 6, 2016.

**5** | Emerson, Gloria. 1976. *Winners and Losers: Battles, Retreats, Gains, Losses, and Ruins From the Vietnam War*. New York: Random House.

**6** | Thomas, C. David and Lucy R. Lippard. 1991. *As Seen by Both Sides: American and Vietnamese Artists Look at the War*. Amherst, MA: University of Massachusetts Press, p. 110.

**7** | Horne, Jed. 1981. "Tracking Agent Orange," LIFE, 4(12):65 – 70. Photographs by Wendy Watriss.

**8** | The images and information about the awards can be seen at https://www.worldpressphoto.org/collection/photo/1982. Retrieved 30 March 2018.

**9** | Baldwin, Frederick C. and Petra E. Benteler. 1986. "Introduction" in *Houston Foto Fest, The Month of Photography 1986*. Modena, Italy: Edizioni Panini. (no page numbers).

**10** | The festival name was shortened in 1986 to its current *Rencontres d'Arles*.

**11** | Baldwin, Fred. 2012. "The story behind FotoFest: How a "poke" in the ground

led to the largest international photography festival in America," *Culturemap*, http://houston.culturemap.com/news/entertainment/03-17-12-02-39-the-story-behind-fotofest-how-a-poke-in-the-ground-led-to-the-largest-international-photography-festival. Retrieved 6 July 2016.

**12** | Baldwin, 2012.

**13** | Feltus, Anne. 1986. "Houston Foto Fest: A Month of Photography," *Photo District News*, May, p. 112. Courtesy of Petra Benteler, personal papers.

**14** | Portz, David. 1986. "Cultural Memory: Interview with Wendy Watriss and Fred Baldwin, December 15, 1985," *SPOT*, Spring issue, pp. 9-12.

**15** | Baldwin, 2012.

**16** | Introduction by Anne Tucker, Wendy Watriss and Fred Baldwin talk, Museum of Fine Arts, Houston, Houston, Texas, 27 October 2009.

**17** | Introduction by Anne Tucker, 2009.

**18** | Baldwin, 1983.

**19** | Johnson, Patricia C. 1984. "Directors of Houston Foto Fest making big plans for 1986 show" *Houston Chronicle*, May 2. Clipping courtesy of Menil Archives, The Menil Collection, Houston. *Indelible Image, The: Photographs of War, 1848 to the Present* [FotoFest] Exhibition files).

**20** | Baldwin, 2012.

**21** | Chadwick, Susan. 1986. "Photo festival's focus citywide," *Houston Post*, March 2; page 4F.

**22** | Baldwin, 2012.

**23** | Middleton, William. 2018. *Double Vision: The Unerring Eye of Art World Avatars Dominique and John de Menil*. New York: Knopf. pp. 554-560.

**24** | Quoted in Middleton, 2018, pp. 561-562.

**25** | No author listed, 1984. "America's Foto Fest debuts in Houston during March 1986," *Mediterranean Photography* 20, October/November/December, (no page number). Courtesy of Menil Archives, The Menil Collection, Houston. *Indelible Image, The Photographs of War, 1848 to the Present* [FotoFest] Exhibition files.

**26** | "America's Foto Fest debuts in Houston during March 1986," 1984.

**27** | Everingham, Carol. J. 1984. "'86 Houston Foto Fest has international scope," *Houston Post*, Sunday July 22. Clipping Courtesy of Menil Archives, The Menil Collection, Houston. *Indelible Image, The: Photographs of War, 1848 to the Present* [FotoFest] Exhibition files.

**28** | Johnson, 1984.

**29** | Johnson, 1984.

**30** | Boyd, Robert. 2010. "FotoFest: How to Run an Art Festival, Part I," *The Great God Pan is Dead blog*, July 4, http://www.thegreatgodpanisdead.com/2010/07/fotofest-how-to-run-art-festival-part-1.html. Retrieved 6 July 2016.

**31** | Boyd, 2010.

**32** | Wendy Watriss and Fred Baldwin, awardees, (Anne Tucker, interviewer), Lifetime Achievement Award, Houston Art Fair. 21 September 2013.

**33** | Letter from Fred Baldwin to Mrs. John de Menil, January 26, 1985. Courtesy of Menil Archives, The Menil Collection, Houston. *Indelible Image, The: Photographs of War, 1848 to the Present* [FotoFest] Exhibition files.

**34** | Sherman, 2015; Ewing, quoted in Boyd, 2010..

**35** | Lifetime Achievement Award, 2013.

**36** | Lifetime Achievement Award, 2013.

**37** | Lifetime Achievement Award, 2013.

**38** | The Meridien hotel later became the Doubletree Hotel, which was the festival hotel for several biennials.

**39** | Houston Foto Fest Press Release, February 1, 1985. Courtesy of Menil Archives, The Menil Collection, Houston. *Indelible Image, The: Photographs of War, 1848 to the Present* [FotoFest] Exhibition files).

**40** | Ewing, quoted in Boyd, 2010.

**41** | Boyd, 2010; Oil hit low of $10 a barrel in January of 1986; "Oil bust, space tragedy and Chronicle sale." *Houston Chronicle*, October 14, 2001. http://www.chron.com/about/first-100/article/Oil-bust-space-tragedy-and-Chronicle-sale-2069956.php.

Retrieved 4 November 2014.

**42** | Baldwin, 2012.

**43** | Baldwin and Benteler, 1986. (no page numbers).

**44** | Author conversation with Marie Docher, February 2008.

**45** | All the early attendance statistics were "best guesses." There was no real way to track visitors in all the various locations. "We could make up some numbers – we were here for 30 days, we have 109 exhibits," Harla explains, "That's at least one person per exhibit, times 300."

**46** | "Foto Fest Fact Sheet," n.d. Courtesy of Menil Archives, The Menil Collection, Houston. *Photographs: Henri Cartier-Bresson, Walker Evans* [FotoFest] Exhibition files.

**47** | Thomas, Lew. 1986. "Editors Comments," *SPOT*, 4(2) Summer, p. 3.

**48** | Messer, William. 1986. "Houston Foto Fest: Lowdown on Ewing and Main," *European Photography*, 27, pp. 12-15; Davis, Douglas and Tessa Namutin. 1986 "A 'Foto Fest,' Houston Style," *Newsweek*, 31 March (no page number), Courtesy of Menil Archives, The Menil Collection, Houston. *Photographs: Henri Cartier-Bresson, Walker Evans* [FotoFest] Exhibition files; "Highlights of FotoFest," Updated February 2016. Emailed to author by Fred Baldwin, 14 July 2017.

**49** | Thomas, 1986.

**50** | Gray, Lisa. 1989. "What's a Nice Show like FotoFest Doing in a Place like Houston?" *Seven One Three*. June. pp. 41-43.

**51** | Boyd, 2010.

**52** | Messer, 1986.

**53** | Wendy Watriss and Fred Baldwin talk, 2014.

**54** | The Warwick Hotel is now the ZaZa Hotel.

**55** | Osman, Colin. 1986. "Houston Foto Fest: It was in Texas, so it was big," *British Journal of Photography*. 133(6559): 496-499, 503. The hotel was originally built in 1926, but had been acquired and refurbished in 1962 by oil man John Mecom,

Sr, Dawson, Jennifer. 2005. "Historic Warwick to Close, reopen as Hotel ZaZa," *Houston Business Journal*. April 3. https://www.bizjournals.com/houston/stories/2005/04/04/story2.html. Retrieved 19 April 2018.

**56** | Messer, 1986.

**57** | FotoFest Brochure. 1986. "1986 Houston Foto Fest" Courtesy of Menil Archives, The Menil Collection, Houston. *Indelible Image, The: Photographs of War, 1848 to the Present* [FotoFest] Exhibition files.

**58** | Baldwin and Benteler, 1986. (no page numbers).

**59** | Kaplan, Harla. Executive Director Houston Foto Fest, Inc. letter to Menil staff (Walter Hobbs, Katheryn Davidson, James Hou) 2 April 1986. Courtesy of Menil Archives, The Menil Collection, Houston. *Indelible Image, The: Photographs of War, 1848 to the Present* [FotoFest] Exhibition files.

**60** | Quoted in Johnson, Patricia C. 1986. "Rousing Success," *Houston Chronicle*, Sunday March 30, p. 12.

**61** | Osman, 1986, p.503.

**62** | Thomas, 1986.

**63** | Museum of Fine Arts. 1986. "Robert Frank: New York to Nova Scotia," in *Houston Foto Fest, A Month of Photography*. Modena, Italy: Edizioni Panini, (no page numbers).

**64** | Lifetime Achievement Award, 2013.

**65** | Richard, Paul. 1986. "Houston: Boom Town of the Arts," *Washington Post*, April 13; p.H1.

**66** | Richard, 1986, p.H5.

**67** | Quoted in Gray, 1989, p. 41.

**68** | Johnson, 1986, p. 12.

**69** | Karkabi, Barbara. 1988. "FotoFest Dilemma: Baldwin likes Houston but San Francisco has good offer," *Houston Chronicle*. P. 1K and 16K. Sunday, September 11.

**70** | Crossley, David. 1988. "News: HCP Gets New Director," *SPOT*, Summer, p. 23.

# Chapter 9

1 | Anne Tucker letter to Victor Schrager, 19 October 1982. Courtesy of Museum of Fine Arts, Houston (MFAH) Archives, RG# 4:6 Series 1.2.2 Box 7.

2 | Anne Tucker, personal communication with the author, 6 November 2016.

3 | Jason Dibley, MFAH Works on Paper Manager, email communication with the author. 13 August 2015.

4 | Kirkland, Kate Sayen. 2009. *The Hogg Family and Houston*. Austin: University of Texas Press. p. 218.

5 | Anne Tucker memo to Bill Agee. 9 December 1980. Courtesy of MFAH Archives, RG# 4:6 Series 1.1 Box 1.

6 | Anne Tucker letter to Anne F. MacFarlane. 3 May 1983. Courtesy of MFAH Archives, RG# 4:6 Series 1.1 Box 1.

7 | Moser, Charlotte. 1980. "But on the other hand," *Houston City Magazine*. 4 (2 February): 54-57.

8 | Women's Caucus for Art. "Open Letter to the Board of Trustees of the Museum of Fine Arts, Houston." 22 April 1981. Houston Women's Caucus for Art Records, Courtesy of Carey C. Shuart Women's Archives and Research Collection, University of Houston Libraries, Houston, Texas.

9 | Accessions Committee Meeting Minutes February 16, 1981. Courtesy of MFAH Archives, RG# 1:2 series 1 Box 10, File 3.

10 | Bill Agee handwritten note February 17, 1981. Courtesy of MFAH Archives, RG# 2:6 Series 3 Box 3 File 6.

11 | Bill Agee letter to David Nash, March 9, 1981. Courtesy of MFAH Archives, RG# 2:6 Series 3 Box 3 File 6.

12 | Crossley, Mimi. 1981. "MFA director allowed 2 private sales to art collector," *Houston Post*, April 9, p. 12B.

13 | Crossley, Mimi. 1981. "Matisse work returning," *Houston Post*, April 21, p. 8B.

14 | Crossley, Mimi. 1981. "MFA deal for Picasso work stalled," *Houston Post*, April 24, p. 14E.

15 | HWCA Newsletter, April 1981, p. 1.

Houston Women's Caucus for Art Records, Courtesy of Carey C. Shuart Women's Archives and Research Collection, University of Houston Libraries, Houston, Texas.

16 | Letter from Isaac Arnold, Jr., on behalf of the Executive Committee of the MFAH, to the membership, 5 May 1981. Courtesy of MFAH Archives, RG# 2:6-2-Box 3 File 21.

17 | Reprinted in HWCA Newsletter, November 1981, p. 1-2. Houston Women's Caucus for Art Records, Courtesy of Carey C. Shuart Women's Archives and Research Collection, University of Houston Libraries, Houston, Texas.

18 | HWCA Newsletter, July 1981, p. 2-3, Houston Women's Caucus for Art Records, Courtesy of Carey C. Shuart Women's Archives and Research Collection, University of Houston Libraries, Houston, Texas.

19 | Holmes, Ann. 1981. "Museum Gives Agee confidence vote," *Houston Chronicle*. Clipping in Houston Women's Caucus for Art Records, Courtesy of Carey C. Shuart Women's Archives and Research Collection, University of Houston Libraries, Houston, Texas.

20 | Holmes, Ann. 1982. "Warren may be named MFA interim director," *Houston Chronicle*. Clipping in Houston Women's Caucus for Art Records. Courtesy of Carey C. Shuart Women's Archives and Research Collection, University of Houston Libraries, Houston, Texas.

21 | "Presentation of Pow Wow: Contemporary Artists Working in Houston, 1972-1985," Panel organized by Pete Gershon, 17 May 2015, Glassell School, Freed Auditorium. https://www.youtube.com/watch?v=pXSmYYIhAXk. Retrieved 1 September 2015.

22 | Holmes, 1982.

23 | Anne Tucker memo to David Warren (interim director) 30 June 1982. Courtesy of MFAH Archives, RG# 4:6 Series 1.2.2 Box 6.

**24** | Anne Tucker letter to lenders of Calotype exhibition (MFAH, 24 September to 21 November) 5 October 1982. Courtesy of MFAH Archives, RG# 4:6 Series 1.2.2 Box 6.

**25** | Anne Tucker letter to Linda Henderson, 11 October 1982. Courtesy of MFAH Archives, RG# 4:6 Series 1.2.2 Box 4.

**26** | Anne Tucker letter to Robert Freidus (Robert Freidus Gallery, NYC), 16 June 1983. Courtesy of MFAH Archives, RG# 4:6 Series: 1.2.1 Box 3.

**27** | Joan Alexander card to Anne Tucker, 21 December 1978. Courtesy of MFAH Archives, RG# 4:6 Series: 1.2.1 Box 1.

**28** | Audrey Jones Beck letter to Anne Tucker, 8 November 1982. Courtesy of MFAH Archives, RG# 4:6 Series: 1.2.1 Box 1.

**29** | https://www.mfah.org/patron-groups/#patron-group-museum-collectors. Retrieved 8 June 2018.

**30** | Morgenstern, Joan. "Photo Forum," *SPOT*, spring, p. 23.

**31** | Hardy, Michael. 2005. "MFAH Donor gives beyond his means," *Houston Chronicle*. August 14, http://www.chron.com/entertainment/article/MFAHdonorgivesbeyondhismeans1939602.php. Retrieved 6 July 2017; Anne Tucker's remarks, "The Eye of the Curator: Honoring Anne Wilkes Tucker" CENTER, Santa Fe, NM, 13 June 2015.

**32** | Tucker, 2015.

**33** | Anne Tucker, Lifetime Achievement Award, Houston Art Fair. 20 September 2014.

**34** | Anne Tucker letter to Wanda Hammerbeck, March 15, 1983. Courtesy of MFAH Archives, RG# 4:6 Series 3 Box 2.

**35** | Anne Tucker letter to Timothy Baum, 6 October 1983. Courtesy of MFAH Archives, RG# 4:6 Series 1.2.1 Box 1.

**36** | [no author] 1983. "MFA curator wins grant for photo history book," *Houston Chronicle*, Amusements, April 12, Section 4, p. 4.

**37** | Anne Tucker letter to "Dear Friends who have waited patiently for the Photo League Book" 18 April 1983. Courtesy of MFAH Archives, RG# 4.1/6 Series #3 Box 4.

**38** | Byrne-Dodge, Teresa. 1983. "Anne Tucker," Face to Face section, *Houston Post*, Sunday August 14, p. 8F, Courtesy of the Hirsch Library ephemera files, Museum of Fine Arts, Houston.

**39** | Anne Tucker letter to Robert Adams, 24 May 1983, Courtesy of MFAH Archives, RG# 4:6 Series: 1.2.1 Box 1.

**40** | *Photographs and Portfolios by Paul Strand* (May 6 to July 3, 1983), *Eliot Porter: Intimate Landscapes, 1950-1977* (August 6 to October 2, 1983), *Eugene Atget: Ancien Regime* (October 13 to December 18, 1983) and *Edward Steichen: The Condé Nast Years* (January 24 to April 18, 1984).

**41** | Anne Tucker letter to Fred Baldwin, 12 August 1983, Courtesy of MFAH Archives, RG# 4:6 Series: 1.2.1, Box 1; Anne Tucker letter to Marian Hills, RG# 4:6 Series: 1.2.1, Box 4.

**42** | *Robert Frank: New York to Nova Scotia, February 15-April 27, 1986,* Museum of Fine Arts, Houston.

**43** | Moore, Hank. 2015. *Houston Legends: History and Heritage of Dynamic Global Capital.* New York: Morgan James Publishing.

**44** | Apple, R. W. "Reporter's Notebook; British Hosts, Being British, Plan an Understated Splendor," *New York Times*. July 15, 1991. https://www.nytimes.com/1991/07/15/world/reporter-s-notebook-british-hosts-being-british-plan-an-understated-splendor.html?sq=G-7+summit+Houston&scp=6&st=nyt. Retrieved 23 April 2019.

**45** | Sadruddin, Aga Khan. "It's Time to Save the Forests," *New York Times*. July 19, 2000. https://www.nytimes.com/2000/07/19/opinion/IHT-its-time-to-save-the-forests.html. Retrieved 23 April 2019.

**46** | Gilmer, Robert W and Iram Siddik. 2003. "1982–90: When Times Were Bad in Houston," *Federal Reserve Bank of Dallas*, Houston Branch, June, pp. 1-5. https://www.dallasfed.org/~/media/documents/research/houston/2003/hb0304.pdf. Retrieved 31 July 2018.

**47** | UPI Archives, "Sakowitz, the exclusive department store chain that last week..." https://www.upi.com/Archives/1985/08/09/Sakowitz-the-exclusive-department-store-chain-that-last-week/9098492408000. Retrieved July 15, 2019; Anspon, Catherine D. 2018. "The Real Story of the Sakowitz Department Store Empire," *Paper City*. December 12, 2018. https://www.papercitymag.com/home-design/sakowitz-department-store-houston-bygone-area-retail-shopping. Retrieved 15 July 2019.

**48** | Deam, Jenny. 2016. "Born in 1880, Houston Post was a feisty, daily diary of city," *Houston Chronicle*, September 21, 2016. https://www.chron.com/local/history/economy-business/article/Houston-news-9191757.php. Retrieved 15 Jul 2019; Handbook of Texas Online, Kleiner, Diana J. "HOUSTON POST," http://www.tshaonline.org/handbook/online/articles/eeh04. Retrieved 15 July 2019.

**49** | Hayes, Thomas C. 1990. "Economic Pulse: Texas — A special report; Slow but Steady Revival after Going Bust in Texas," *New York Times*, December 9, p.1001001. https://www.nytimes.com/1990/12/09/us/economic-pulse-texas-special-report-slow-but-steady-revival-after-going-bust.html. Retrieved 31 Jul 2018.

**50** | "According to the U.S. International Trade Administration, Houston has been the nation's top exporter since 2013. Because of NAFTA, Mexico has solidified its position as the Houston region's top trading partner, representing more than $16.8 billion in trade annually. Trade with Canada on the other hand, represents more than $1 billion in annual economic activity, making it a critical trading partner for the region." Murillo, Laura. 2018. "Op-Ed: Why the new NAFTA is good for business in Houston," *BizJournals.com*, 2 November 2018. https://www.bizjournals.com/houston/news/2018/11/02/op-ed-why-the-new-nafta-is-good-for-business-in.html. Retrieved 15 July 2019.

**51** | Middleton, William. 2018. *Double Vision: The Unerring Eye of Art World Avatars Dominique and John de Menil*, New York: Alfred A. Knopf, pp. 642-647; Menil Collection. 2010. *Art and Activism: Projects of John and Dominique de Menil* Houston: Menil Collection, p. 298-299.

**52** | By the time Gwen retired in 2013, she had shepherded the MFAH endowment to $1.2 billion, making it the largest museum endowment in the U.S., second only to the Metropolitan Museum in New York. Upon her death in 2003, Caroline Weiss Law left her entire estate of $450 million to the Houston Museum, making her the largest donor to a U.S. museum to date, and significantly increasing the value of the endowment. Anspon, Catherine D. 2015. "Who Was Caroline Wiess Law?" *Papercity Magazine*, March 6, 2015. https://www.papercitymag.com/arts/eye-past-caroline-wiess-law. Retrieved 31 July 2018.

**53** | May 15, 1984.

**54** | [no author listed] n.d. "MFA Houston Presents Private Collection of the Czech Avant-Garde Art and Glass," *Artdaily.com*, http://artdaily.com/news/49969/MFA-Houston-Presents-Private-Collection-of-the-Czech-Avant-Garde-Art-and-Glass#.XT3WG-hKhPY. Retrieved 28 July 2019.

**55** | Glentzer, Molly. 2015. "Museum's curator selects highlights from an influential career," *Houston Chronicle*, June 26, 2015. https://www.houstonchronicle.com/entertainment/arts-theater/article/Museum-s-curator-selects-highlights-from-an-6352203.php?t=df4d95ad-7d&cmpid=email-premium. Retrieved 15 Jul 2019.

**56** | https://www.census.gov/population/www/documentation/twps0076/twps0076.pdf. Retrieved 15 July 2019.

**57** | "Chronology of Events in MFAH History," https://prv.mfah.org/archives/pdf/mfah_chronology.pdf. Retrieved 3 August 2014.

**58** | "HCC Features Photography About Houston Life," *Forward Times*, http://forwardtimes.com/hcc-features-photography-houston-life. Retrieved 25 July 2019;

Fowler, Gene. 2018, "Photographer Earlie Hudnall: 'Art Is Life,'" *Glasstire* https://glasstire.com/2018/11/12/photographer-earlie-hudnall-art-is-life. Retrieved 25 July 2019.

**59** | Anne Tucker, "Weiner Fellowship Program lecture," February 20, 1997. Courtesy of MFAH Archives, RG# 4.06 Series 1.3, Box 6.

**60** | Golden Light Awards Book of the Year, sponsored by The Maine Photographic Workshops, award for first place in the retrospective category for the book, *Crimes and Splendors: The Desert Cantos of Richard Misrach*, 1996, published by the Museum of Fine Arts, Houston in association with Bullfinch Press, 1996.

**61** | Anne Wilkes Tucker, Resume, Revised 2013, Courtesy of Anne Tucker.

**62** | Anne Tucker letter to Wendy Watriss and Fred Baldwin, 21 January 1995. Courtesy of MFAH Archives, RG# 4.6 series 1.3 Box 2 File 18.

**63** | Anne cared for her mother from 1995 to her death in 2002. When Geraldine's husband, Paul, had a stroke, Anne lived with them for eight months caring for them both.

**64** | Tucker, Anne Wilkes. 2015. "The Eye of the Curator: Honoring Anne Wilkes Tucker," CENTER, Santa Fe, NM, June 13.

**65** | Glentzer, 2015.

**66** | Price, Anne. 1999. "Career Curator," Magazine, November 21. Baton Rouge, La. Courtesy of MFAH Archives, rg# 04.06-1.3-6, file 3.

**67** | Lacayo, Richard. 2001. "The Exhibitionist," *TIME magazine*, September 17: 73.

**68** | Tucker, Anne Wilkes. 1999. "Building a Museum Collection," *ArtLies*, Summer 1999:12-13.

**69** | Selina Lamberti, Senior Cataloguer, Photography Collection, Museum of Fine Arts, Houston. Email communication with the author. 23 June 2022.

**70** | Glentzer, Molly. 2018. "A patron saint of the Museum of Fine Arts, Houston is still giving," *Houston Chronicle*, August 9. https://www.houstonchronicle.com/entertainment/arts-theater/article/The-patron-saint-of-the-Museum-of-Fine-Arts-13146652.php. Retrieved 25 Aug 2018.

**71** | Cronin, Morgan. 2015. "Iconoclasts: A Conversation between stars, Anne Tucker and Clint Willour, 40 years of art and friendship," *Art Houston*, 2: 62-64.

**72** | Anspon, Catherine D. 2015. "The Photo Lady: Venerable Curator Brought Houston's Most Striking Images to Light," *Paper City*, October 12. https://www.papercitymag.com/arts/photo-lady-venerable-curator-brought-houstons-striking-images-light. Retrieved 29 July 2019.

# Chapter 10

1 | Crossley, David. 1983. "State of (part of) the Nation" *Image*/spot 1(September):3.

2 | Horrigan, Sally. 1983. "Front and Center" *Image*/spot 1 (Winter): 3.

3 | Horrigan, 1983, p. 3.

4 | David Crossley communication with the author, 5 June 2022.

5 | National Endowment for the Arts.

6 | Martin, Philip. 2014. "Lew Thomas, 22 Mar–26 Apr 2014," *Artmap*. https://artmap.com/philipmartin/exhibition/lew-thomas-2014. Retrieved February 2, 2021.

7 | Lang, Ellen. 1992. "Delving into HCP's Ten-Year History," *spot*, spring, p. 7.

8 | David Crossley communication to the author, 5 June 2022.

9 | Quoted in Lang, 1992, p. 5-6.

10 | Caslin, Jean. 1988. "Messages," *spot*, Fall 7(3): 3.

11 | Van Peer, Rene. 1987. "Art Has Become Mute," http://www.jim-pomeroy.org/interview.html. Retrieved 7 June 2018.

12 | Muffly McLanahan quoted in Lang, 1992.

13 | Caslin, Jean. 1998 "Director's Note," HCP Newsletter, September/October, p. 2.

14 | Jean Caslin correspondence to the author, October 9, 2019.

15 | HCP Newsletter, 1999. May/June, p. 2.

16 | Printed Program, Houston Center for Contemporary Craft, "Crafting a Legacy: Spring Luncheon 2019," Honoring Clint Willour, River Oaks Country Club, Houston, TX, 24 April 2019.

17 | Jean Caslin correspondence to the author, 16 February 2020.

18 | HCP Newsletter, 1992. January/February, p. 3.

19 | Lang, 1992.

20 | HCP Newsletter. 1994. January/February, p. 2.

21 | HCP Newsletters. 1995. November/December, p. 1; January/February 1996, p. 2; 1996. March, p. 2.

22 | HCP Newsletter. 1996. July/August, p. 2.

23 | Jean Caslin correspondence to the author, October 9, 2019; 16 February 2020.

24 | Courville, Marianne. 1996. *Collection in Context: Henry Mendelssohn Buhl*. New York: Soho Partnership.

25 | Jean Caslin correspondence to the author, October 9, 2019.

26 | Shapiro, Ben (Director). 2012. *Gregory Crewdson: Brief Encounters*. Zeitgeist Films, 1h 17min.

27 | [no author] 1997. "Artists who have exhibited at HCP since its beginning," *spot*, XVI(2):26.

28 | [no author] 1997. "Highlights of 16 years at HCP," *spot*, XVI(2):14-20.

29 | Jean Caslin correspondence to the author, 16 February 2020.

# Chapter 11

1 | By the 1994 Biennial, Benteler Morgan Gallery closed, and Wendy Watriss is listed as a founder of FotoFest.

2 | Baldwin, Fred and Petra Benteler. 1986. *Houston Foto Fest, A Month of Photography.* Modena, Italy: Edizioni Panini, (no page numbers).

3 | Baldwin quoted in Gray, Lisa. 1989. "What's a Nice Show like FotoFest Doing in a Place like Houston?" *Seven One Three,* June. pp. 41-43.

4 | Newspaper clippings from *Houston Post,* 25 December 87 and *Houston Chronicle,* 26 December 1987. Courtesy of the Hirsch Library ephemera files, Museum of Fine Arts, Houston.

5 | No author listed. 1988. "Foto Frenzy in Houston" *The Photograph Collector Newsletter,* IX (3):1-2. Courtesy of Menil Archives, The Menil Collection, Houston. *Photographs: Henri Cartier-Bresson, Walker Evans* [FotoFest] Exhibition files.

6 | Wise, Kelly. 1988. "FotoFest '88 is a richly rewarding, international event." *Boston Globe,* (no date; no page number), Clipping courtesy of Menil Archives, The Menil Collection, Houston. *Photographs: Henri Cartier-Bresson, Walker Evans* [FotoFest] Exhibition files.

7 | Wise, 1988.

8 | Wise. 1988.

9 | "Highlights of FotoFest." 2017. Draft document by Fred Baldwin.

10 | When Daphne Murray died in 2005, her obituary noted, "In lieu of flowers, the family suggests that charitable donations be made to: FotoFest, Literacy Through Photography Program" to continue her support for the organization and its efforts. "Gawthrop, Daphne Wood, Obituary, November 20, 2005," *Chicago Tribune.* http://articles.chicagotribune.com/2005-11-20/news/0511200127_1_daphne-wood-murray-museum-of-fine-arts-houston-ballet. Retrieved 28 April 2018.

11 | Coedited with Lois Zamora, University of Texas Press, 1998.

12 | *FotoFest '94: The Fifth International Festival of Photography,* November 10-30 (catalog), 1994. Houston, TX: FotoFest, Inc.

13 | FotoFest '94 catalog; FotoFest brochure, "Photography Houston Spring '94." Courtesy of Menil Archives, The Menil Collection, Houston. *The New Generation: Contemporary Photography from Cuba* Exhibition files.

14 | Baldwin, Fred and Wendy Watriss. 1994. "What is the Logic?" pp. 9-12 in *FotoFest '94: The Fifth International Festival of Photography,* November 10-30 (catalog). Houston, TX: FotoFest, Inc., p. 9.

15 | FotoFest '94 catalog. This is the same Gersheim Collection that Anne Tucker had interned with while working on her master's degree at the Visual Studies Workshop.

16 | Baldwin and Watriss. 1994, p.10.

17 | Johnston, Patricia. 1996. "Arts notes: '96 a year in contrast for FotoFest," *Houston Chronicle.* Clipping courtesy of the Menil Archives, The Menil Collection, Houston. *Kurdistan: In the Shadow of History* [FotoFest] Exhibition files.

18 | Historic Market Square, https://marketsquarepark.com/history. Retrieved 14 September 2019.

19 | FotoFest. 2005. "Highlights of Foto-Fest," Houston, TX, p. 19. http://fotofest.org/highlights.pdf. Retrieved March 1, 2012.

20 | Jones, Nancy Baker. 2010. "Allen, Charlotte Marie Baldwin," *Texas State Historical Association.* https://tshaonline.org/handbook/online/articles/fal84. Retrieved 11 June 2018.

21 | Baldwin, 2012.

22 | Tucker, Anne and John Scarborough. 1977. "Contemporary Photography in Houston" *ArtSpace* 1(4): 4-8, p. 8.

# References

"100-plus years." n.d. Potomac School. Retrieved March 20, 2018 (https://www.potomacschool.org/about-us/100-plus-years).

*1981 Houston Arts Calendar*. 1981. Houston, TX: Wordworks, Inc.

Agee, William C. 1977. "Preface." *Target Collection of American Photography* (Exhibition catalog). Houston, TX: Museum of Fine Arts, Houston.

Agee, William C. 1979. "Untitled Essay." in *The Anthony G. Cronin Memorial Collection* (Anne Tucker, editor). Houston, TX: The Museum of Fine Arts, Houston.

"America's Foto Fest debuts in Houston during March 1986." 1984. *Mediterranean Photography* 20 (October/November/December). Courtesy of Menil Archive, The Menil Collection, Houston. *Indelible Image, The: Photographs of War, 1848 to the Present* [FotoFest] Exhibition files.

Anspon, Catherine D. 2015. "The Photo Lady: Venerable Curator Brought Houston's Most Striking Images to Light." *Paper City* October 12. Retrieved July 29, 2019 (https://www.papercitymag.com/arts/photo-lady-venerable-curator-brought-houstons-striking-images-light).

Anspon, Catherine D. 2015. "Who Was Caroline Wiess Law?" *Paper City* March 6. Retrieved July 31, 2018 (https://www.papercitymag.com/arts/eye-past-caroline-wiess-law).

Anspon, Catherine D. 2018. "The Real Story of the Sakowitz Department Store Empire." *Paper City* December 12. Retrieved July 15, 2019 (https://www.papercitymag.com/home-design/sakowitz-department-store-houston-bygone-area-retail-shopping).

Apple, R. W. 1991. "Reporter's Notebook; British Hosts, Being British, Plan an Understated Splendor." *The New York Times*. July 15. Retrieved April 23, 2019 (https://www.nytimes.com/1991/07/15/world/reporter-s-notebook-british-hosts-being-british-plan-an-understated-splendor.html?sq=G-7+summit+Houston&scp=6&st=nyt).

Aramanda, Geraldine, William Camfield, Clare Elliot, and Don Quaintance. 2010. "Chronology." pp. 272-299 in *Art and Activism: Projects of John and Dominique de Menil*. Laureen Schipsi (Editor), Josef Helfenstein (Introduction), Houston: Menil Collection.

Arnold, Miah. 2010. "Vim and Vigor, Indelicate Language and Bursts of Temper: The Story of the de Menil Cadre and the Emergence of Houston's Counterculture Arts and Politics." CITE *magazine* 82 (Summer): 33-37.

"Artists who have exhibited at HCP since its beginning." 1997. SPOT 16(2):26.

Avedon, Elizabeth. 2011. "La Lettre de la Photographie: Interview with Anne Wilkes Tucker." Retrieved May 22, 2018 (http://elizabethavedon.blogspot.fr/2011/07/anne-wilkes-tucker-curator-of.html).

Baldwin, Fred. 2007. *Dear Monsieur Picasso*. Retrieved March 10, 2018 (www.zonezero.com).

Baldwin, Frederick. 2019. *Dear Mr. Picasso: An illustrated love affair with freedom*. Amsterdam: Schilt Publishing.

Baldwin, Fred. 2012. "The story behind Fo-toFest: How a "poke" in the ground led to the largest international photography festival in America." *Culturemap. com*. Retrieved July 6, 2016 (http://houston.culturemap.com/news/entertainment/03-17-12-02-39-the-story-behind-fotofest-how-a-poke-in-the-ground-led-to-the-largest-inter-national-photography-festival).

Baldwin, Fred. 2017. *Highlights of FotoFest*. Unpublished draft document.

Baldwin, Fred and Petra Benteler. 1986. *Houston Foto Fest, A Month of Photography*. Modena, Italy: Edizioni Panini.

Baldwin, Frederick C. and Petra E. Benteler. 1986. "Introduction." in *Houston Foto Fest, The Month of Photography*. Modena, Italy: Edizioni Panini.

Baldwin, Fred and Wendy Watriss. 1994. "What is the Logic?" pp. 9-12 in *Foto-Fest '94: The Fifth International Festival of Photography, November 10-30* (catalog). Houston, TX: FotoFest, Inc.

Baldwin, Frederick and Wendy Watriss. 2010. *Looking at the U.S. 1957-1986*. Amsterdam: Mets and Schilt Publishers.

Barnstone, Howard, Henri Cartier-Bres-son (Photographs), Ezra Stoller (Photographs), Peter Brink (Afterword). [1966] 1994. *The Galveston that Was*. Houston, TX: Rice University Press.

Belkin, Lisa. 1989. "NOW, IT'S REMEM-BER THE OIL BUST!" *The New York Times*. October 22. Retrieved November 4, 2014 (http://www.nytimes.com/1989/08/22/business/now-it-s-remember-the-oil-bust.html).

Bennett, Elizabeth. 1981. "At Home: Fred Baldwin and Wendy Watriss." *The Houston Post*. June 27, Section AA.

"Biographical or Historical Note." n.d. Graham Gallery/William A. Graham Archive, 1964-1992. Museum of Fine Arts, Houston Archive. Retrieved May 23, 2018 (http://fa.mfah.org/main.as-p?target=eadidlist&id=58&action=3).

Boyd, Robert. 2010. "FotoFest: How to Run an Art Festival, Part I." *The Great God Pan is Dead blog*. July 4. Retrieved July 6, 2016 (http://www.thegreatgodpanis-dead.com/2010/07/fotofest-how-to-run-art-festival-part-1.html).

Brown, Dominique. 1983. "What I admire I Must Possess." *Texas Monthly* 11(4):140-147,192-209. Retrieved July 5, 2014 (https://www.texasmonthly.com/articles/what-i-admire-i-must-possess).

Brown, Peter T. 1988. *Seasons of Light*. Houston, TX: Rice University Press.

Brutvan, Cheryl with Marti Mayo and Linda Cathcart. 1982. *In Our Time: Houston's Contemporary Art Museum 1948-1982*. Houston, TX: Contemporary Arts Museum.

Bryan, Courtlandt D.B. 1976. *Friendly Fire*. New York: Penguin.

Byrne-Dodge, Teresa. 1983. "Anne Tucker." *Houston Post*. Sunday August 14, p. 8F.

Camfield, William. 2010. "Two Museums and Two Universities: Toward the Menil Collection." pp. 49-73 in *Art and Activism: Projects of John and Dominique de Menil*. Laureen Schipsi (Editor), Josef Helfenstein (Introduction). Houston: Menil Collection.

Canonne, Xavier. 2010. "Interview by Xavier Canonne." pp. 196-205 in *Looking at the U.S. 1957-1986* (by Frederick Baldwin and Wendy Watriss). Amsterdam: Mets & Schilt Publishers.

Canonne, Xavier. 2009. "Surviving in Beauty." pp. 13-21 in *Looking at the U.S. 1957-1986* (by Frederick Baldwin & Wendy Watriss). Amsterdam: Mets & Schilt Publishers.

Carol Brown,2010. "CULLINAN, NINA J." Handbook of Texas Online, Texas State Historical Association. Retrieved July 1, 2014 (http://www.tshaonline.org/handbook/online/articles/fcu46).

Caslin, Jean. 1988. "Messages." *SPOT* 7(3): 3.

Caslin, Jean. 1998. "Director's Note." *Houston Center for Photography Newsletter*. September/October, p. 2.

Castro R., Fernando. 2012. "A Life Involved, Part II." *Literal Magazine* 28. Retrieved July 3, 2017 (http://literalmagazine.blogspot.com/2012/04/life-involved-wendy-watriss_16.html).

Chadwick, Susan. 1986. "Photo festival's focus citywide." *Houston Post*. March 2, p. 4F.

Christopher Byron (1981-06-22). "Problems for Oil Producers." *Time Magazine*. Retrieved November 4, 2014 (http://content.time.com/time/magazine/article/0,9171,950550,00.html).

"Closed Circuit." 1968. *Broadcasting: The Business Weekly of Television and Radio*. 75(21):5.

Colacello, Bob. 1996. "Remains of the Dia." *Vanity Fair* 9 (September). Retrieved August 1, 2016 (http://www.vanityfair.com/magazine/archive/1996/09/colacello199609).

Cook, Joan. 1979. "Archibald Alexander, 72." *New York Times*. September 6, p. 21. Retrieved March 23, 2018 (https://www.nytimes.com/1979/09/06/archives/archibald-alexander-72-lawyer-served-as-army-under-secretary-on-a.html).

Courville, Marianne. 1996. *Collection in Context: Henry Mendelssohn Buhl*. New York: Soho Partnership.

Crofford, Ava. 1975. *The Diamond Years of Texas Photography*. Houston: Texas Professional Photographers Association. Austin: Published by author.

Cronin, Morgan. 2015. "Iconoclasts: A Conversation between stars, Anne Tucker and Clint Willour, 40 years of art and friendship." *Art Houston* 2: 62-64.

Crossley, David. 1983. "Dennis Hopper and Friends." *Image* (later renamed *SPOT*) 1 (March): 21.

Crossley, David. 1983. "State of (part of) the Nation." *Image* (later renamed *SPOT*) 1 (September):3.

Crossley, David. 1984. "Why not *SPOT*?" *SPOT* 2(3):4.

Crossley, David. 1988. "News: HCP Gets New Director." *SPOT* 7(2): 23.

Crossley, David. 1983. "The Short Hectic Life of a Photo Group." *Image* (later renamed *SPOT*) 1(March): 3. Retrieved November 5, 2014 (http://spot.hcponline.org/pages/the_short_hectic_life_of_a_photo_group_1180.asp).

Crossley, Mimi. 1977. "Target Collection debuts at MFA ." *Houston Post*. Feb 25, p. 1C.

Crossley, Mimi. 1977. "Symphonic Photography." *Houston Post*. April 17. p. 36. Courtesy of Menil Archive, The Menil Collection, Houston. *Frederick Baldwin and Wendy Watriss: Photographs from Grimes County* Exhibition files.

Crossley, Mimi. 1981. "Curator's husband recently sold paintings to MFA ." *Houston Post*. March 27, p.12E.

Crossley, Mimi. 1981. "Matisse work returning." *Houston Post*. April 21, p. 8B.

Crossley, Mimi. 1981. "MFA deal for Picasso work stalled." *Houston Post*. April 24, p. 14E.

Crossley, Mimi. 1981. "MFA director allowed 2 private sales to art collector." *Houston Post*. April 9, p. 12B.

Crossley, Mimi. 1983. "Members' First Exhibition." *Image* (later renamed *SPOT*) 1 (March): 8.

**316**  Curless, Kendall. 2010. "Museum of Fine Arts, Houston." Handbook of Texas Online, Texas State Historical Association. Retrieved June 30, 2015 (http://www.tshaonline.org/handbook/online/articles/klm04).

Daloz, Kate. 2016. *We Are As Gods: Back to the Land in the 1970s and the Quest for a New America*. New York: Public Affairs, Excerpted in *Utne Reader*. September. Retrieved March 27, 2018 (https://www.utne.com/environment/back-to-the-land-movement-zeoz-1609zfis).

"Daphne Wood Gawthrop Obituary." 2005. *Chicago Tribune*. November 20. Retrieved April 28, 2018 (http://articles.chicagotribune.com/2005-11-20/news/0511200127_1_daphne-wood-murray-museum-of-fine-arts-houston-ballet).

Davis, Douglas and Tessa Namutin. 1986 "A 'Foto Fest,' Houston Style." *Newsweek* March 31 (no page number). Courtesy of Menil Archive, The Menil Collection, Houston. *Photographs: Henri Cartier-Bresson, Walker Evans* [FotoFest] Exhibition files.

Davis-Jones, Jo Anne. 2010. "Legacy of the Pride." *The University of Houston Magazine*. Retrieved July 5, 2014 (http://www.uh.edu/magazine/10s/features/legacy-of-pride).

Dawson, Jennifer. 2005. "Historic Warwick to close, reopen as Hotel ZaZa." *Houston Business Journal*. April 3. Retrieved April 19, 2018 (https://www.bizjournals.com/houston/stories/2005/04/04/story2.html).

de Brèadùn, Deaglàn. 2012. "Shy, deeply spiritual and almost an actor: The lesser-known Mary Robinson." *Irish Times*. September 15. Retrieved March 20, 2018 (https://www.irishtimes.com/culture/books/shy-deeply-spiritual-and-almost-an-actor-the-lesser-known-mary-robinson-1.531452).

de Menil, Dominique. 1968. *A Life Illustrated by an Exhibition*. Houston, TX: University of St. Thomas.

de Menil, Dominique. 1980. "Foreword"(no page numbers) in *Transfixed by Light*. Houston, TX: Menil Foundation.

Deam, Jenny. 2016. "Born in 1880, Houston Post was a feisty, daily diary of city." *Houston Chronicle*. September 21. Retrieved July 15, 2019 (https://www.chron.com/local/history/economy-business/article/Houston-news-9191757.php).

Diana J. Kleiner. n.d. "Houston Post." Handbook of Texas Online, Texas State Historical Association. Retrieved July 15, 2019 (https://www.tshaonline.org/handbook/entries/houston-post).

Diana J. Kleiner, n.d. "Houston Public Library." Handbook of Texas Online, Texas State Historical Association. Retrieved May 26, 2014 (http://www.tshaonline.org/handbook/online/articles/lch02).

Dianne David Obituary. 2012. *Houston Chronicle*, March 4-5. Retrieved Octo-

ber 30, 2014 (http://www.legacy.com/obituaries/houstonchronicle/obituary.aspx?pid=156247739).

Diliberto, Gioia. 1987. *Debutante: The Story of Brenda Frazier*. New York: Alfred A. Knopf.

Drukker, Leendert. 1972. "Fred Baldwin: Adventure is my bag." *Popular Photography* 70(6): 102-103, 132-133.

Duffus, R. L. 1928. *The American Renaissance*. New York: AA Knopf.

Eaton, Collin. 2016. "1980s oil bust left a lasting mark." *Houston Chronicle*. August 31. Retrieved February 26, 2018 (https://www.chron.com/local/history/economy-business/article/The-1980s-oil-bust-left-lasting-mark-on-Houston-9195222.php#photo-10854489).

Edwards, Katie Robinson. 2014. *Midcentury Modern Art in Texas*. Austin, TX: University of Texas Press. ProQuest Ebook Central, http://ebookcentral.proquest.com/lib/uh/detail.action?docID=3443745, Created from uh on 2018-06-04 08:36:44.

Endelman, Sharon Bice. 1976. "IDESON, JULIA BEDFORD." Handbook of Texas Online, Texas State Historical Association. Retrieved October 5, 2016 (http://www.tshaonline.org/handbook/online/articles/fid01).

Ennis, Michael. 2001. "Image Conscious." *Texas Monthly* 29(7). Retrieved October 24, 2014 (http://www.texasmonthly.com/content/image-conscious/page/0/1).

Estrin, James. 2012. "Partners in Words, Pictures and Life." Lens blog, *New York Times*. March 8. Retrieved February 28, 2018 (https://lens.blogs.nytimes.com/2012/03/08/partners-in-words-pictures-and-life).

Everingham, Carol. J. 1984. "'86 Houston Foto Fest has international scope." *Houston Post*. July 22. Clipping Courtesy of Menil Archives, The Menil Collection, Houston. *Indelible Image, The: Photographs of War, 1848 to the Present* [FotoFest] Exhibition files.

Exhibition Guest Book. 1977. Houston, TX: Menil Collection. Courtesy of Menil Archives, The Menil Collection, Houston. *Frederick Baldwin and Wendy Watriss: Photographs from Grimes County* Exhibition files.

Feltus, Anne. 1986. "Houston Foto Fest: A Month of Photography." *Photo District News* May, p. 112.

"F.N. Watriss to Wed H.B. Alexander." 1917. *Brooklyn Daily Eagle*. April 10, p. 2.

FotoFest. 1994. *FotoFest '94: The Fifth International Festival of Photography, November 10-30*. Houston, TX: FotoFest, Inc.

FotoFest. 2005. "Highlights of FotoFest." Houston, TX. Retrieved March 1, 2012 (http://fotofest.org/highlights.pdf).

Fowler, Gene. 2018. "Photographer Earlie Hudnall: 'Art Is Life.'" *Glasstire*. Retrieved July 25, 2019 (https://glasstire.com/2018/11/12/photographer-earlie-hudnall-art-is-life).

"Frederick Scott Archer, 1813-1857" n.d. International Photography Hall of Fame and Museum. Retrieved July 10, 2020 (https://iphf.org/inductees/frederick-scott-archer).

Galvani, Paul 1983. "Anytown, USA." *Image* (later renamed SPOT) 1(March):6.

Gee, Helen. 1983. *Photography of the Fifties: An American Perspective*. Tucson, AZ: Center for Creative Photography, University of Arizona.

Gershon, Pete. 2014. *Painting the Town Orange: The Stories Behind Houston's Visionary Art Environments*. Charleston, SC: History Press.

Gershon, Pete (Organizer). 2015. "Presentation of Pow Wow: Contemporary Artists Working in Houston, 1972-1985" (Panel). May 17, Freed Auditorium, Glassell School. Retrieved September 1, 2015 (https://www.youtube.com/watch?v=pXSmYYIhAXk).

Gibson, Campbell and Kay Jung. 2005. "Historical Census Statistics On Population Totals by Race, 1790 to 1990, and by Hispanic Origin, 1970 to 1990, For Large Cities And Other Urban Places In The United States." Retrieved July 15, 2019 (https://www.census.gov/content/dam/Census/library/working-papers/2005/demo/POP-twps0076.pdf).

Gilmer, Robert W and Iram Siddik. 2003. "1982–90: When Times Were Bad in Houston." *Federal Reserve Bank of Dallas, Houston Branch*. June: 1-5. Retrieved July 31, 2018 (https://www.dallasfed.org/~/media/documents/research/houston/2003/hb0304.pdf).

Glentzer, Molly. 2015. "Museum's curator selects highlights from an influential career." *Houston Chronicle*. June 26. Retrieved July 15, 2019 (https://www.houstonchronicle.com/entertainment/arts-theater/article/Museum-s-curator-selects-highlights-from-an-6352203.php?t=df-4d95ad7d&cmpid=email-premium).

Glentzer, Molly. 2018. "A patron saint of the Museum of Fine Arts, Houston is still giving." *Houston Chronicle*. August 9. Retrieved August 25, 2018 (https://www.houstonchronicle.com/entertainment/arts-theater/article/The-patron-saint-of-the-Museum-of-Fine-Arts-13146652.php).

Glueck, Grace. 1981. "The Talk of Houston." *The New York Times*. April 3, Section C, p. 21.

Glueck, Grace. 1986. "The De Menil Family: The Medici of Modern Art." *New York Times*. May 18, Section 6, p. 28. Retrieved July 5, 2014 (https://www.nytimes.com/1986/05/18/magazine/the-de-menil-family-the-medici-of-modern-art.html).

Gray, Lisa. 1989. "What's a Nice Show like FotoFest Doing in a Place like Houston?" *Seven One Three*. June: 41-43.

Gray, Lisa. 2000. "Revolution in Chrome." *Houston Press*. July 6. Retrieved August 7, 2014 (http://www.houstonpress.com/2000-07-06/news/revolution-in-chrome/full).

Gray, Lisa. 2011. "Julia Ideson Library is a treasure reclaimed." *Houston Chronicle*. December 3. Retrieved July 20, 2017 (http://www.chron.com/life/gray/article/Gray-Julia-Ideson-Library-is-a-treasure-reclaimed-2338604.php#item-38488).

Gray, Lisa. 2012. "Air-conditioning capital of the world." *Houston Chronicle*. June 22. Retrieved June 11, 2018 (https://www.chron.com/life/gray/article/Gray-Air-conditioning-capital-of-the-world-3653254.php).

Hall, John. 1983. "Hallowed Walls." *SPOT* 1 (March): 14.

Hardy, Michael. 2005. "Museum of Fine Arts Houston donor gives beyond his means." *Houston Chronicle*. August 14. Retrieved November 4, 2014 (https://www.chron.com/entertainment/article/MFAH-donor-gives-beyond-his-means-1939602.php).

Hardy, Michael. 2013. "Art Insider: Clint Willour." *Houstonia Magazine*. August 16. Retrieved February 26, 2018 (https://www.houstoniamag.com/articles/2013/8/16/arts-insider-clint-willour-august-2013).

Hayes, Thomas C. 1990. "Economic Pulse: Texas — A special report; Slow but Steady Revival after Going Bust in Texas." *New York Times*. December 9, Section 1, p. 1. Retrieved July 31, 2018 (https://www.nytimes.com/1990/12/09/us/economic-pulse-texas-special-report-slow-but-steady-revival-after-going-bust.html).

Haynes, David. 2010. "PHOTOGRAPHY." Handbook of Texas Online, Texas State Historical Association. Retrieved February 20, 2020 (http://www.tshaonline.org/handbook/online/articles/kjp01).

"HCC Features Photography About Houston Life." *Forward Times*. Retrieved July 25, 2019 (http://forwardtimes.com/hcc-features-photography-houston-life).

Herbert, Lynn M. 1997. "Seeing was Believing: Installations of Jermayne MacAgy and James Johnson Sweeny." *CITE Magazine* 40 (Winter): 30-33.

Hershey, Robert D., Jr. 1981. "How the oil glut is changing business." *The New York Times*. June 21, Section 3, p. 1. Retrieved November 4, 2014 (http://www.nytimes.com/1981/06/21/business/how-the-oil-glut-is-changing-business.html?pagewanted=1).

Hidalgo, Marty. 1983. "The Nude Censored." *Image* (later renamed *SPOT)* 1 (Winter): 3.

"Highlights of 16 years at HCP." 1997. *SPOT* XVI (2):14-20.

Hill, Edward. 1966. *The Language of Drawing*. New York: Prentice-Hall.

"Historic Market Square." n.d. *Marketsquarepark.com*. Retrieved September 14, 2019 (https://marketsquarepark.com/history).

Holmes, Ann. 1981. "Change at the MFA : Is the museum losing some friends as well as paintings?" *Houston Chronicle*. Clipping courtesy of Carey C. Shuart Women's Archive and Research Collection, University of Houston Libraries. Houston Women's Caucus for Art Records.

Holmes, Ann. 1981. "Museum Gives Agee confidence vote." *Houston Chronicle*. Clipping courtesy of Carey C. Shuart Women's Archive and Research Collection, University of Houston Libraries. Houston Women's Caucus for Art Records.

Holmes, Ann. 1982. "Warren may be named MFA interim director." *Houston Chronicle*. Clipping courtesy of Carey C. Shuart Women's Archive and Research Collection, University of Houston Libraries. Houston Women's Caucus for Art Records.

Horne, Jed and Wendy Watriss (photographer). 1981. "Tracking Agent Orange." *LIFE* 4(12):65–70.

Horrigan, Sally. 1983. "Front and Center." *Image* (later renamed *SPOT)* 1 (Winter): 3.

Houston Center for Contemporary Craft. 2019. "Crafting a Legacy: Spring Luncheon 2019 Honoring Clint Willour" (Printed Program). April 24. River Oaks Country Club, Houston TX.

Houston Center for Photography. 2015. "35 Years of HCP." (video) Retrieved September 24, 2015 (http://www.hcponline.org/give/hcp35).

Howard, Jeremy (editor). 2010. *Colnaghi: The History*. London: Colnagi.

Hurt, Harry, III. 1986. "Hard Times in River Oaks: How Houston pinches pennies." *Vanity Fair* 49(5): 24.

"Introduction to the Couturier Collection at Yale University." Archival Register. n.d. Retrieved June 11, 2018 (https://web.library.yale.edu/sites/default/files/files/CouturierCollection.pdf).

Irwin, John. 1977. *Scenes*. Beverly Hills, CA: SAGE Publications.

"James Barney Watriss Obituary." 1998. *Baltimore Sun*. June 6. Retrieved March 10, 2018 (http://articles.baltimoresun.com/1998-06-06/news/1998157063_1_nathan-briggs-watriss-church-of-baltimore).

Johnson, Patricia C. 1984. "Directors of Houston Foto Fest making big plans for 1986 show." *Houston Chronicle*. May 2. Clipping courtesy of Menil Archives, The Menil Collection, Houston. *Indelible Image, The: Photographs of War, 1848 to the Present* [FotoFest] Exhibition files.

Johnson, Patricia C. 1986. "Rousing Success." *Houston Chronicle*. March 30, p. 12.

Johnston, Patricia. 1996. "Arts notes: '96 a year in contrast for FotoFest." *Houston Chronicle*. May 5 (no page number). Clipping courtesy of Menil Archives, The Menil Collection, Houston. *Kurdistan: In the Shadow of History* [FotoFest] Exhibition files.

Jones, Nancy Baker. 2010. "ALLEN, CHARLOTTE MARIE BALDWIN." Texas Handbook Online, Texas State Historical Association. Retrieved June 11, 2018 (https://tshaonline.org/handbook/online/articles/fal84).

Karaim, Reed. 2013. "How the de Menils and Their Art Museum Changed Houston." *Architect Magazine* June 19. Retrieved July 28, 2017 (https://www.architectmagazine.com/awards/aia-honor-awards/how-the-de-menils-and-their-art-museum-changed-houston_o).

Karkabi, Barbara. 1988. "FotoFest Dilemma: Baldwin likes Houston but San Francisco has good offer." *Houston Chronicle*. September 11, pp.1K, 16K.

Karner, Tracy Xavia and Lisa Cox Hall. 2002. "Successful Strategies for Serving Diverse Populations." *Home Health Care Quarterly*, 21 (3-4): 107-132. Reprinted in *A New Look at Community Respite Programs: Utilization, Satisfaction, and Development* (R. Montgomery, editor). Binghamton, NY: Haworth Press, Inc. 2002.

Katherine Delmar Burke School. n.d. "Katherine Delmar Burke School History." Retrieved March 20, 2018 (https://www.kdbs.org/page/about-old/our-school/history).

Kennedy, John F. 1962. "Address at Rice University on the Nation's Space Effort." Retrieved on May 21, 2014 (https://www.rice.edu/kennedy).

Kiely, Declan. 2016. "Paging Dr. Baldwin." The Morgan Library and Museum. Retrieved August 7, 2017 (http://www.themorgan.org/blog/paging-dr-baldwin).

Kirkland, Kate Sayen. 2009. *The Hogg Family and Houston*. Austin: University of Texas Press.

Lacayo, Richard. 2001. "The Exhibitionist." *TIME magazine* September 17: 73.

Lang, Ellen. 1992. "Delving into HCP's Ten-Year History." *SPOT* 11(1):5-7.

320

Ledbetter, James. 1997. *Made Possible By... The Death of Public Broadcasting in the United States*. London: Verso, U.K.

Limmer, Hans and David Crossley. 2013. *Paulinchen*. Tulipan; Auflage: 2. Retrieved March 1, 2017 (http://www.amazon.de/Paulinchen-Hans-Limmer/dp/3864291259/ref=sr_1_6?ie=UTF8&qid=1438981183&sr=8-6&keywords=David+crossley).

Lohse, Bernd. 1981. *Photography Europe 1*. Houston, TX: Benteler Galleries, Inc.

"Lorraine Ames married; Ex-Millbrook Student Bride of James B. Watriss of New York." 1942. *New York Times*. April 28, p. 17.

Lucas, Peter. 2020. "Gerald O'Grady and the Houston Media Experiment." *Glasstire* January 25. Retrieved February 17, 2020 (https://glasstire.come/2020/01/25/gerald-ograd-dy-and-the-houston-media-experiment).

MacMillan, Margaret. 2009. "Rebuilding the world after the second world war." *The Guardian*. September 11. Retrieved December 21, 2018 (https://www.theguardian.com/world/2009/sep/11/second-world-war-rebuilding).

Margaret Swett Henson, 2010. "CHERRY, EMMA RICHARDSON." Handbook of Texas Online, Texas State Historical Association. Retrieved May 27, 2014 (http://www.tshaonline.org/handbook/online/articles/fch24).

Martin, Philip. 2014. "Lew Thomas, 22 Mar–26 Apr 2014." *Artmap*. Retrieved February 2, 2021 (https://artmap.com/philipmartin/exhibition/lew-thomas-2014).

Marzio, Peter C. 2008. "Introduction." pp. 10-13 in *CORE: Artists and Critics in Residence*. Houston, TX: Museum of Fine Arts, Houston.

McArthur, Judith N. 1998. *Creating the New Woman: The Rise of Southern Women's Progressive Culture in Texas, 1893-1918*. Urbana-Champaign: University of Illinois.

McDonald, Jessica. 2012. "Persistence of Vision." pp. 1-33 in *Nathan Lyons: Selected Essays, Lectures, and Interviews* (Jessica S. McDonald, editor). Austin, TX: University of Texas Press Harry Ransom Center Photography Series.

McLanahan, Lynn. 1983. "Going, Going, Gone." *Image* (later renamed *SPOT*) 1 (Spring): 2.

McLanahan, Lynn. 1983. "Photography in Houston." *Art Space* Spring: 30-33.

McNamara, Denis. 1999. "Almost Religious: Couturier, LeCorbusier and the Monastery of La Tourette." *Sacred Architecture Journal* 2(1): 22-26. Retrieved July 6, 2014 (https://www.sacredarchitecture.org/articles/almost_religious_couturier_lecorbusier_and_the_monastery_of_la_tourette).

Messer, William. 1986. "Houston Foto Fest: Lowdown on Ewing and Main." *European Photography* 27: 12-15. Courtesy of Menil Archives, The Menil Collection, Houston. *Photographs: Henri Cartier-Bresson, Walker Evans* [FotoFest] Exhibition files.

"MFA curator wins grant for photo history book." 1983. *Houston Chronicle*. April 12, Section 4, p. 4.

"MFA Houston Presents Private Collection of the Czech Avant-Garde Art and Glass." n.d., *Artdaily.com*. Retrieved July 28, 2019 (http://artdaily.com/news/49969/MFA-Houston-Presents-Private-Collection-of-the-Czech-Avant-Garde-Art-and-Glass#.XT3WG-hKhPY).

Middleton, William 2018. "The High Society Love Story Behind Dominique and John De Menil's Legendary Art Collection." *W Magazine* March 7. Retrieved March 26, 2018 (https://www.wmagazine.com/story/dominique-john-de-menil-art-collection).

Middleton, William. 2018. *Double Vision: The Unerring Eye of Art World Avatars Dominique and John de Menil*. New York: Knopf.

Montgomery, Rhonda, Tracy Xavia Karner, and Karl Kosloski. 2003. "Weighing the Success of a National Demonstration to Create State Responsibility for Long Term Care." *Journal of Aging and Social Policy* 14(3-4): 119-139. Reprinted in: F. Caro & R. Morris (Eds.), *Devolution and Aging Policy*. New York: Haworth (2002).

Moore, Hank. 2015. *Houston Legends: History and Heritage of Dynamic Global Capital*. New York: Morgan James Publishing.

Morgenstern, Joan. 1988. "Photo Forum." *SPOT* 6 (1): 23.

Morris, Willie. 1967. *North Toward Home*. New York: Houghton Mifflin.

Moser, Charlotte. 1980. "But on the other hand." *Houston City Magazine* 4 (2): 54-57.

Murillo, Laura. 2018. "Op-Ed: Why the new NAFTA is good for business in Houston." *BizJournals.com* November 2. Retrieved July 15, 2019 (https://www.bizjournals.com/houston/news/2018/11/02/op-ed-why-the-new-nafta-is-good-for-business-in.html).

Museum of Fine Arts, Houston. n.d. "Chronology." Retrieved August 3, 2014 (https://prv.Museum of Fine Arts Houston.org/archives/pdf/Museum of Fine Arts Houston_chronology.pdf).

Museum of Fine Arts. 1986. "Robert Frank: New York to Nova Scotia." (no page numbers) in *Houston Foto Fest, A Month of Photography*. Modena, Italy: Edizioni Panini.

"Obituaries: Frederic W. Watriss." 1997. *MIT News*. March 19. Retrieved March 23, 2018 (http://news.mit.edu/1997/obits-0319).

O'Grady, Gerald. 2010. "Lessons in Development: John and Dominique de Menil and the Media Arts." pp.77-89 in *Art and Activism: Projects of John and Dominique de Menil*. Laureen Schipsi (Editor), Josef Helfenstein (Introduction), Houston: Menil Collection.

"Oil bust, space tragedy and Chronicle sale." 2001. *Houston Chronicle*. October 14. Retrieved November 4, 2014 (http://www.chron.com/about/first-100/article/Oil-bust-space-tragedy-and-Chronicle-sale-2069956.php).

"Organization History." n.d. Courtesy of Special Collections, University of Houston Libraries. Houston Women's Caucus for Art Records. Retrieved September 2, 2015 (http://www.lib.utexas.edu/taro/uhwarc/00002/warc-00002.html). Osman, Colin. 1986. "Houston Foto Fest: It was in Texas, so it was big." *British Journal of Photography* 133(6559): 496-499, 503.

"PBL (PUBLIC BROADCAST LABORATORY)." 2009. *tvobscurities.com*. November 5. Retrieved March 23, 2018 (https://www.tvobscurities.com/spotlight/pbl-public-broadcast-laboratory).

Plate, Markus and Torsten Groth. 2011. *Große Deutsche Familienunternehmen: Generationenfolge, Familienstrategie und Unternehmensentwicklung*. Göttingen, Germany: Vandenhoeck & Ruprecht.

Portz, David. 1986. "Cultural Memory: Interview with Wendy Watriss and Fred Baldwin, December 15, 1985." *SPOT* 3 (4): 9-12.

Price, Anne. 1999. "Career Curator." *Magazine* November 21. Baton Rouge, La. Courtesy of Museum of Fine Arts, Houston Archives, RG# 04.06-1.3-6, file 3.

Price, Sarah Renee. 2005. *Plain Living and High Thinking: The Bluebird Club in Boulder*. Thesis. Museum and Field Studies, University of Colorado.

"Psychiko." n.d. *Wikipedia*. Retrieved March 10, 2018 (https://en.wikipedia.org/wiki/Psychiko).

Public Broadcasting Laboratory. 1968. "Marijuana — A Proposal." (Joseph M. Russin and Wendy V. Watriss, producers, originally aired April 28) Retrieved November 1, 2017 (https://www.youtube.com/watch?v=O2W-Mu2ebQS4).

Pugh, Clifford. 2002. "Texas Gallery owner stretches the boundaries of contemporary art." *Houston Chronicle*. Retrieved September 17, 2014 (http://www.chron.com/entertainment/article/Texas-Gallery-owner-stretches-the-boundaries-of-2122529.php).

Reynolds, Sarah. 2007. *Houston Reflections: Art in the City, 1950s, 60s, and 70s*. Houston, TX: Rice University Connexions. Retrieved August 1, 2016 (http://cnx.org/content/col10526/1.2).

Richard, Paul. 1986. "Houston: Boom Town of the Arts." *Washington Post*. April 13; p.H1.

"Robert Gamble Baldwin '45." *Princeton Alumni Weekly Memorials Online*. Retrieved February 2, 2021 (https://paw.princeton.edu/memorial/robert-gamble-baldwin-%E2%80%9945).

Robinson, Mary. 2012. *Everybody Matters: A Memoir*. London: Hodder & Stoughton Ltd.

Rohleder, Anna. 2006. "Finest Places Houston." *Forbes*. Retrieved May 21, 2014 (https://www.forbes.com/2000/12/12/pphouston.html?sh=592101416ed9).

Rosen, Kenneth R. 2014. "We Are Not Inbred." *Narratively.com*. Retrieved March 1, 2018 (http://narrative.ly/we-are-not-inbred).

Rowell, Charles Henry. 2009. "An Interview with Alvia Wardlaw." *Callaloo* 32(1): 261-276.

Russell, John. 1998. "Dominique de Menil, 89, Dies; Collector and Philanthropist." *The New York Times*. January 1. Retrieved July 6, 2014 (http://www.nytimes.com/1998/01/01/arts/dominique-de-menil-89-dies-collector-and-philanthropist.html).

Sadruddin, Aga Khan. 2000. "It's Time to Save the Forests." *The New York Times*. July 19. Retrieved April 23, 2019 (https://www.nytimes.com/2000/07/19/opinion/IHT-its-time-to-save-the-forests.html).

"Sally Gall: Artists Statement." n.d. Saul Gallery. Retrieved November 5, 2014 (http://www.saulgallery.com/artists/sally-gall/show:statement).

Sandy, Stephen. 1993. "'Writing As A Career': An Early W. H. Auden Lecture in the States." *The Newsletter of the W. H. Auden Society*, September 1993, Newsletter No 10-11. Retrieved March 7, 2018 (http://www.audensociety.org/10-11newsletter.html).

Scarborough, John. 1977. "'Grimes County' show broad." *Houston Chronicle*. Art section. June 8. Clipping courtesy of Menil Archives, The Menil Collection,

Houston. *Frederick Baldwin and Wendy Watriss: Photographs from Grimes County* Exhibition files.

Scarborough, John. 1977. "The museum's new photo treasure." *Houston Chronicle Magazine* March 6, pp. 7-11,12.

Schjeldahl, Peter. 1980. "Art and Money in the City of the Future-Think." *Houston City Magazine* 4(2): 46-54,97-101.

Scrapbook, 1900–1924, RG# 19 Houston Art League Records, digital image, /downloads/5423bf12-c8a8-4628-ab21-81cb-1c4e4cd7/view/, Museum of Fine Arts, Houston, Archives, Retrieved May 24, 2014 (http://www.Museum of Fine Arts Houston.org/research/archives).

Scrapbook, 1925-1928, RG# 19 Houston Art League Records, digital image, /downloads/a20f949f-cf52-4172-ba2f-18bd-1f30865e/view/, Museum of Fine Arts, Houston, Archives, Retrieved May 24, 2014 (http://www.Museum of Fine Arts Houston.org/research/archives).

Shapiro, Ben (Director). 2012. *Gregory Crewdson: Brief Encounters*, Zeitgeist Films, 1h 17min.

Sherman, Rebecca. 2015. "Inside The Menil's Odd Montrose Bungalow: FotoFest's Founders Thrive in a Unique Home." *Paper City* July 31. Retrieved July 6, 2016 (http://www.papercitymag.com/interiors/menil-odd-montrose-bungalow-fotofest-founders-unique-home).

"Short History of Race-Based Affirmative Action at Rice University, The." 1996. *The Journal of Blacks in Higher Education* 13: 36-38.

Simon, Paul (Songwriter). 1968. "America." Vocals by Paul Simon and Art Garfunkel. Recorded February 1, Columbia Studio A, New York City. Columbia Records.

Smart, Pamela G. 2010. "Aesthetics as a Vocation." pp. 21-40 in *Art and Activism: Projects of John and Dominique de Menil*. Laureen Schipsi (Editor), Josef Helfenstein (Introduction), Houston: Menil Collection.

Smith, Roberta. 1993. "Tibor de Nagy, 85, Gallery Owner Who Helped Cultivate 50's Artists." *The New York Times.* December 28, Section D, p. 20. Retrieved February 26, 2018 (https://www.nytimes.com/1993/12/28/obituaries/tibor-de-nagy-85-gallery-owner-who-helped-cultivate-50-s-artists.html).

Sozanski, Edward J. 1993. "Remembering a teacher-artist who worked here." *Philly.com*. October 8. Retrieved September 19, 2019 (http://articles.philly.com/1993-10-08/entertainment/25935850_1_cezanne-bibemus-quarry-richard-diebenkorn).

Starns, Melanie, Tracy Xavia Karner, and Rhonda Montgomery. 2002. "Exemplars of Successful Alzheimer's Demonstration Projects." *Home Health Care Quarterly* 21 (3-4): 141-175. Reprinted in *A New Look at Community Respite Programs: Utilization, Satisfaction, and Development* (R. Montgomery, editor). Binghamton, NY: Haworth Press, Inc. (2002).

Tackett, Helen. 1975. "The Changing Face of Austin." *ON CAMPUS* for March 3-9, University of Texas, p. 4. Courtesy of Menil Archives, The Menil Collection, Houston. *Frederick Baldwin and Wendy Watriss: Photographs from Grimes County* Exhibition files.

Temkin, Ann. 2007. *A Modern Patronage*. Houston: Menil Collection.

Thomas, C. David and Lucy R. Lippard. 1991. *As Seen by Both Sides: American and Vietnamese Artists Look at the War*. Amherst, MA: University of Massachusetts Press.

Thomas, Lew. 1986. "Editors Comments." *SPOT* 4 (2): 3.

Thompson, Derek. 2013. "Houston is Unstoppable." *The Atlantic* May 28. Retrieved November 4, 2014 (http://www.theatlantic.com/business/archive/2013/05/houston-is-unstoppable-why-texas-juggernaut-is-americas-1-job-creator/275927).

Thornton, Gene. 1979. "Photographic View." *The New York Times*. August 5, p D 29.

"Tiger Ridge." n.d. *Keepsavannahstrange.com*. Retrieved March 1, 2018 (http://keepsavannahstrange.com/places.html).

"Touts." 1974. *Texas Monthly* 2(7). Retrieved November 2, 2014 (http://www.texasmonthly.com/content/touts-9).

Trafton, Lynn. 1983. "Gallery Circuit Ups and Downs." *Image* (later renamed *SPOT*) 1(1):20. Retrieved November 5, 2014 (http://spot.hcponline.org/pages/gallery_circut_ups_and_downs_1194.asp).

Tucker, Anne and John Scarborough. 1977. "Contemporary Photography in Houston." *ArtSpace* 1(4): 4-8.

Tucker, Anne Wilkes. 1997. "Weiner Fellowship Program lecture" February 20. Courtesy of Museum of Fine Arts, Houston, Archives, RG# 4.06 Series #1.3, Box#6.

Tucker, Anne Wilkes. 1999. "Building a Museum Collection." *ArtLies* Summer:12-13.

Tucker, Anne Wilkes. 2007. "Me/Mine/I." (no page numbers) in *A Girl and Her Room* (by Rania Matar). Brooklyn, NY: Umbrage Editions.

Tucker, Anne Wilkes. 2012. "Testimonials from Students of the Visual Studies Workshop, 1999." pp. 259-260 in *Nathan Lyons: Selected Essays, Lectures, and Interviews* (Jessica S. McDonald, editor), Austin, TX: Press Harry Ransom Center Photography Series.

Tucker, Anne Wilkes. 2014. "Remarks." Lifetime Achievement Award Presentation, Houston Art Fair. September 20.

Tucker, Anne Wilkes. 2015. "The Eye of the Curator: Honoring Anne Wilkes Tucker." CENTER, Santa Fe, NM, June 13.

Tucker, Anne. 1980. *Suzanne Bloom and Ed Hill (MANUAL): Research and Collaboration*. Museum of Fine Arts, Houston. Houston, TX: Seashore Press.

Tucker, Anne. 1986. "In Only Sixteen Years." (no page numbers) in *Houston Foto Fest: The Month of Photography 1986*. Houston, TX: FotoFest.

University of Houston special collections. n.d. "Roy Gustav Cullen Memorial." UH Through Time: Buildings. University of Houston Libraries. Retrieved May 30, 2015 (http://info.lib.uh.edu/sca/digital/time/buildings_large.html?ID=62&type=).

UPI Archives. 1985. "Sakowitz, the exclusive department store chain that last week..." Retrieved July 15, 2019 (https://www.upi.com/Archives/1985/08/09/Sakowitz-the-exclusive-department-store-chain-that-last-week/9098492408000).

"Values and Traditions." n.d. *Benteler Corporation*. Retrieved December 20, 2018 (https://www.benteler.com/about-us/values-and-tradition).

Van Peer, Rene. 1987. "Art Has Become Mute." (no page numbers) in *Interviews with Sound Artists* published by Eindhoven, The Netherlands: Apollo Books, 1992. Retrieved June 7, 2018 (http://www.jim-pomeroy.org/interview.html).

Watriss, Frederic Newell. 1912. "Secretary's Report: For the Twentieth Anniversary." *Harvard College, Class of 1892* V: 166.

Watriss, Wendy. 1984. "Anne Tucker Changes." *Image* (later renamed *SPOT*) 2(1): 11.

Watriss, Wendy. 1984. "Geoff Winningham: In the Beginning." *SPOT* 2(3):13-15.

Watriss, Wendy and Fred Baldwin. 1975. *Wendy Watriss and Fred Baldwin, January 10-March 5, 1975* (Exhibition catalog). Washington, DC: Phillips Collection.

Westin, Avram. n.d. Interviewed in "Public Broadcasting Laboratory." emmytvlegends.org. Retrieved March 24, 2018 (https://www.youtube.com/watch?v=r00MJc4OPU4).

William Reaves Fine Art. 2010. *A Texas Artist Abroad: A Selection of Early Works by Frederic Browne, September 10 - October 2, 2010* (Exhibition catalog). Houston, TX: William Reaves Fine Art.

Wise, Kelly. 1988. "FotoFest '88 is a richly rewarding, international event." *Boston Globe*. Clipping courtesy of Menil Archives, The Menil Collection, Houston. *Photographs: Henri Cartier-Bresson, Walker Evans* [FotoFest] Exhibition files.

Wolff, Perry. 2017. "I was never in the CIA." *Perry Wolff: Odd Man In* (Blog post 3 May). Retrieved March 25, 2018 (http://perrywolff.info/2017/05/03/i-was-never-in-the-cia).

Woodward, Richard B. 2014. "Picture-Perfect Career: A Cultural Conversation With Anne Wilkes Tucker." *Wall Street Journal*. April 9. Retrieved April 10, 2014 (http://online.wsj.com/news/articles/SB1000142405270230491490457943960243313632 2).

WTOC. 2011. "The Truth about Tiger Ridge." *WTOC.com*. Retrieved March 1, 2018 (http://www.wtoc.com/story/16104720/the-truth-about-tiger-ridge?clienttype=printable).

# Names Index

328

329

330

331

ISBN 978 90 5330 955 1

*Design*
Victor Levie, Amsterdam
levievandermeer.nl

*Print & Logistics Management*
Komeso GmbH, Stuttgart
komeso.com

*Printing*
Offizin Scheufele GmbH, Stuttgart
scheufele.de

*Binding*
Josef Spinner Grossbuchbinderei GmbH, Ottersweier
josef-spinner.de

*Distribution in North America*
Ingram Publisher Services
One Ingram Blvd.
LaVergne, TN 37086
IPS: 866-765-0179
E-mail: ips@ingramcontent.com

*Distribution in the Netherlands and Flanders*
Centraal Boekhuis, Culemborg

*Distribution in all other countries*
Thames & Hudson Ltd
181a High Holborn
London WC1V 7QX
Phone: +44 (0)20 7845 5000
Fax: +44 (0)20 7845 5055
E-mail: sales@thameshudson.co.uk

*Cover photo*
Opening night of the FotoFest Biennial 2020 exhibition
*African Cosmologies: Photography, Time, and the Other,*
at Silver Street Studios, Houston, TX.
Photo: Os Galindo. Courtesy of FotoFest

Schilt Publishing & Gallery books, special editions and
prints are available also online via schiltpublishing.com
Inquiries via sales@schiltpublishing.com